盈握神奇

鸿远阁藏索振海内画鼻烟壶

王习三题

盈握神奇

鸿远阁藏索振海内画鼻烟壶

紫禁城出版社

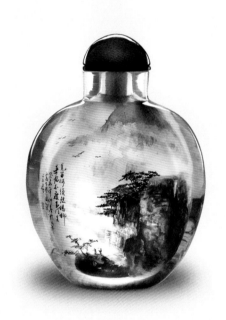

图书在版编目（CIP）数据

盈握神奇／马毓鸿主编 .——北京：紫禁城出版社，
2011.12
ISBN 978-7-5134-0187-6

Ⅰ.①盈… Ⅱ.①马… Ⅲ.①鼻烟壶－中国画－作品
集－中国－现代 Ⅳ.① J222.7

中国版本图书馆CIP数据核字（2011）第185500号

盈握神奇
鸿远阁藏索振海内画鼻烟壶

撰　　文：马毓鸿
英文翻译：马瑞琦　马瑞璞
摄　　影：刘志岗
责任编辑：徐小燕
封扉治印：沈　伟
装帧设计：王　梓
出版发行：紫禁城出版社
　　　　　地址：北京市东城区景山前街4号　邮编：100009
　　　　　电话：010-85007808　010-85007816　传真：010-65129479
　　　　　网址：www.culturefc.cn
　　　　　邮箱：ggcb@culturefc.cn
制版印刷：北京圣彩虹制版印刷技术有限公司
开　　本：787×1092毫米　1/12
印　　张：22.5
字　　数：70千字
图　　版：486幅
版　　次：2011年12月第1版
　　　　　2011年12月第1次印刷
印　　数：1－1000册
书　　号：ISBN 978-7-5134-0187-6
定　　价：280.00元

出版说明

　　每当提及我国文化艺术瑰宝的历史积累，首先被人想起的往往是品类繁多、珍宝无数的历朝皇家收藏。实际上自古以来，私人鉴藏家的收藏和交流活动，也是文物流传和积累的重要组成部分。在某些特殊时刻，民间私人收藏的意义甚至更为巨大。我国的文化瑰宝在历史上曾经历过无数浩劫，每当改朝换代、社会动乱之际，往往是众多私人鉴藏家将内府散佚出的珍宝名迹逐渐收拢聚集，使其不至于长期流落乃至毁于战乱，而后或在某个特定的历史时机被新的统治阶级所收入内府。从这层意义上来看，古代所谓皇家内府收藏实际上便是构建在无数民间收藏的基础之上。

　　民间收藏长期以来没有得到与其实际地位相符的重视，以至大众普遍认为精美的藏品大都收藏在博物馆和国家收藏机构。其实不然，故宫博物院所藏的文物就脱离不了和民间收藏的深刻渊源。以书画为例，属清宫旧藏的精品很多是清乾隆内府《石渠宝笈》著录的藏品，表面看来这些国宝是乾隆皇帝以帝王势力毫不费力搜罗而来的，实际上却有很大一部分是梁清标、安岐等几个民间收藏家对明末散佚书画珍品鉴定收藏的成果积累。及至近代，如果没有张伯驹、孙瀛洲、陈万里等收藏大家的出现，中国的很多宝物恐怕摆脱不掉或流散海外、或毁于动乱的命运。正是有他们对大量散佚文物的保护和其后向故宫博物院的文物捐赠，才使今天的我们有幸一睹这些艺术瑰宝的庐山真面目。又何止故宫一地，中国历史上许多珍贵文物，都是通过民间渠道保存延续下来的。

　　中国的民间收藏历史源远流长。私人收藏家的出现，根据现有资料，最早可追溯到东晋；明清时期的鉴赏和收藏人群范围已经超出了士大夫阶层，新兴的市民阶级开始不甘落后的步入收藏者的行列。自此打破士族垄断的真正意义上的民间收藏开始兴盛，藏品丰富、藏者甚众的现代民间收藏初现端倪。

　　民间收藏活动日渐活跃并逐渐成为一个重要文化现象。当今社会的收藏人群中不乏各行各业的专家，他们集结自身微薄之力，引导整个民间收藏有了可喜的发展，转向更具内涵的层面：许多民间研究学会的成立，标志着民间研究性的专家群体开始形成；收藏家根据多年的收藏实践和深入研究，敢于突破旧束缚，提出新观点，使一些传统观念受到冲击，造就了尊重权威又不迷信权威的新文化理念；大量收藏者以收藏文化为己任，抢救了许多可能外流的珍贵文物，还不断办展览、办博物馆、开研讨会，这些文物在他们手中不再是单纯有价值的文化遗存，更是教育群众、传承历史的教具。单从这几点看来，出版书籍来鼓励和宣传民间收藏就极富意义。

　　为人所知的民间收藏精品数量往往只是实际数量的冰山一角。百分之九十以上的古墓在不同历史时期被盗，而国家发掘不足古墓总数的百分之五，加上抢救性发掘也不足总数的百分之十。其中的很多器物，如出土玉器等，是不可能全部人间蒸发的；由此可知，有多少稀世珍宝流落民间或国外。试想我们的学术研究仅以博物馆藏品为根据，不仅论据不充分，研究也不够全面。

　　正因如此，故宫博物院所属紫禁城出版社编辑出版民间典藏系列，不仅是对博物馆收藏的有效补充，也是通过将民间收藏成果的一次集中展示，让读者真正了解和认识民间收藏的价值，从而更完整的理解中国传统文化。希望该系列的出版能够为学者带来可供研究的实物资料，为欣赏者呈现不同时期的文化宝藏，为广大读者提供增强民族自豪感和爱国主义热情的良好教材。

目 录

007／ **自 序** 马毓鸿

010／ **前 言** 付彦珍

012／ **德艺双馨索振海** 王习三

016／ **小中见大 情景交融**

　　　——索振海内画艺术欣赏 薄松年

021／ **寸天厘地绘乾坤**

　　　——内画鼻烟壶之沿革 张荣

026／ **叶派传人索振海** 叶澍英

027／ **索振海简介**

029／ **内画鼻烟壶图版**

030／ 山 水

106／ 花 鸟

156／ 人 物

192／ 走 兽

234／ 仿 古

252／ 特 制

264／ **图版索引**

268／ **后 记** 马毓鸿

Contents

008 / **Preface of the Collector** Mike Y. H. Ma

011 / **Foreword** Fu Yanzhen

014 / **Suo Zhenhai : A Virtuoso of Virtue** Wang Xisan

018 / **Capturing the Universe in a Small Bottle ;**

　　a Delicate Fusion of the Artist's Feelings and his Art

　　-The Review of Suo Zhenhai's Inner Painting Art

　　Bo Songnian

023 / **Painting the Universe within Inches of Space**

　　-A History of the Inside-painted Snuff Bottle

　　Zhang Rong

026 / **Suo Zhenhai** *-the Pupil of the Yeh School*

　　Ye Shuying

028 / **Brief Biography of Suo Zhenhai**

029 / **Inside-Painted Snuff Bottles**

030 / Landscape

106 / Birds and Flowers

156 / People

192 / Animals

234 / Imitation of Ancient Master Pieces

252 / Custom Made

266 / **Index**

269 / **Postscript** Mike Y. H. Ma

自 序

马毓鸿

马毓鸿（左）和索振海（右）

鼻烟壶内画一直被认为是传统的民俗艺术，和国画文人写意趣味相距甚远。偶然的机缘让我接触到索振海的内画作品，才惊其天外之笔，竟能在方寸壶内，容下千山万水，花鸟虫草、笔墨人物跃然壶上。再深交往，才知道索老作品不俗，其来有自，索老熟稔国画笔墨在先，曾就教于李苦禅、吴作人、董希文、蒋兆和、王叔晖、任率英等大师，早年北京故宫欲延揽其为专任画师，因为家庭户口原因，只好放弃。他多才多艺，国画、剪纸、漫画作品得奖甚多，曾受益清末内画大师叶仲三传人叶晓峰和叶菶祺兄弟，并师承中国鼻烟壶研究会荣誉会长王习三先生，潜心内画创作。索老的创作天分，可从其随意绘成作品，胸中自有画谱，毋需临摹造作，略见端倪。

在我得知索老艺术悟性过人之后，曾向他提出过绘壶的请求，作为我幼子弥月的纪念礼品。壶一面绘一女二男下雪天玩耍（因我三个孩子都是下雪天出生），其中一小男生燃放爆竹；壶另一面绘蛇（幼子属蛇）。由于当时和索家初交往，因而壶最初是由别人操笔，经我多次退件；最后索老亲自出马，一次搞定，得礼品者皆爱不释手。此后我又曾提供先岳祖父马寿华的全身照及其画作图片，索老拈来神笔，发挥传神写照的精湛功力将肖像画的神形兼备栩栩如生。尤其所临画作，非笔笔抄袭，却精气神韵完全重现，这全得靠其深厚的国画底子和艺术修养。

除了特别订制索老的壶之外，还有些壶系索老利用有色玛瑙和水晶天然纹路为衬精制而成，巧妙设色构图，都成了不可多得的孤品。而索夫人常偏心地把好的作品留给我，好像在替我准备索老内画作品的完整收藏。

在和索老打交道的数年中，觉得他文人傲骨，不像坊间某些从业者，汲汲于名利。我订制一些特别费功夫的壶，索老完成后，坚持像朋友交往一般，分文不取，让我想起古时文人间诗画交游与人共享的情怀。曾闻索夫人提起，索老擅画山水，在老内画厂工作时期，被指定画民俗画，别人画山水，他就不露所长，怕影响他人生计。有次大规模展览，因展出条件索老本不愿参展，主办方认定索老为"内画文人画代表大家"，特意安排免去条件以便其展出。索老后来对参与作品评比，颇不热衷，也不愿去拿一些头衔。他更在意的是能不能留些好作品给后代世人。

可惜他英年早逝，文化部有一收藏家，初闻死讯，竟嚎淘大哭。有一批海外索老作品收藏家，辗转找到索家，却发现索老已故，不胜唏嘘。因为对索老作品的共同喜好，我和他们成了好朋友，相信索老作品能变成一种艺术语言，联系着海内外的知音和未来感受到他作品魅力的同好。其于死后亦被追封"冀派内画元老"的尊称。

我一向喜欢收藏艺术品，旧的或是新的。我不敢自称是内画鼻烟壶收藏家，更愿意能被称为索老内画作品的知音。因此本图册为纪念与索老的友情，特别收录了我收藏索老作品中一些具有代表性的作品系列（如：渔樵耕读，四季山水，花鸟虫草，风雨云月，十二生肖，仿古系列，西游记），天然玛瑙和水晶内画孤品，订制壶，其他精品（如：京戏人物，外国风光，仕女，清江渔隐，冬，游虾），题材稀品（如：武松，清明上河图，寨外，梅兰竹菊）和他极少画的内画屏等。索夫人以其夫创作能力虽强，惟市面流传多是少量同样题材之作，此图册较能完整呈现他的创作风貌，而且多是极少重复的作品。同时也想藉此图册抛砖引玉，得到共鸣，为弘扬冀派内画鼻烟壶艺术，为传承索老的内画鼻烟壶艺术贡献绵薄之力。

于鸿远阁　2010 年 10 月 26 日

Preface of the Collector

Mike Y. H. Ma

Inside-painted snuff bottles have always been considered a traditional folke art; one that is quite different from the scholarly mind-depiction style of Chinese paintings. I came across Suo Zhenhai's inner painting art works by chance and was awed by his magical brushwork which could accommodate-within a bottle's inches' space-tremendous mountains and waters, elegant flowers and birds, realistic plants and insects and sophisticate ink-brushed human characters, all vividly painted on the bottles' inner surface. I soon befriended Suo and learned that his extraordinary artistic achievements in inner painting were due to his well established skill base/foundation in traditional Chinese painting. He had also courted teachings from master artists Li Kuchan, Wu Zuoren, Dong Xiwen, Jiang Zhaohe, Wang Shuhui and Ren Shuaiying. Earliar on the Beijing Forbidden City Museum tried to employ him as a professional painter but he passed on the opportunity because it required that he move his entire family to Beijing, which was difficult at the time. He was a very versatile artist and had been awarded many prizes for his Chinese paintings, paper-cuttings and comic strips. He learned the inner painting technique from Ye Xiaofeng and Ye Fengqi, the successors and sons of the Qing Dynasty inner painting master Ye Zhongsan. Furthermore, he also received instruction and inspiration from the China Snuff Bottle Association's emeritus President Wang Xisan and this made him truly commit to the art of inner painting. Mr. Suo's innate creativity is evident in his ability to complete a piece at will, painting drafts only in his mind. Few of his works are imitations; most are original works of art birthed from his own creativity.

After I realized Mr. Suo's outstanding artistic talent, I made a special request to have him paint several custom-made bottles. When my youngest son was born, I requested custom-made bottles with images symbolic of our family and my son to serve as gifts to give family and friends. One side depicted a girl and two boys playing with fireworks on a snowy day (because all three of my children were born on snowy days); the other side showed a snake (seeing as my youngest son was born in the year of the serpent). At the time, I hadn't yet been acquainted with Suo for a long period of time. The first bottles that Suo showed me were not painted by himself and I returned several of these prototypes to him as I found them unsuitable. Finally, Mr. Suo decided to paint one himself, and upon seeing his work I agreed to use his design right away. The recipients of the gifts loved them. Later on, I provided Mr. Suo with my late grandfather-in-law's portrait photo and copies of his artwork. Mr. Suo made the most of his abilities in realism, and with some magical brushwork was able to bring the portrait photograph to life. Furthermore, Mr. Suo's imitations of my late grandfather-in-law's artwork were not merely replications of each detail copied stroke by stoke, but rather a unique translation of the artwork that revealed the spirit of the original piece. Mr. Suo was able to achieve such incredible results because of his mastery of traditional Chinese painting.

Apart from these custom-made bottles, I have also collected several other exclusive pieces painted by Mr. Suo. These include bottles that are the color of agate and the grains of natural crystals, which lend themselves to ingenious color schemes and layout arrangements that result in some of the finest inner-painting pieces. Mrs. Suo has always prepared Mr. Suo's better work to show me, which was an honor and privilege as it has allowed me to own the entire collection of Mr. Suo's representative pieces.

In the period of time I was acquainted with Mr. Suo, I saw that he behaved with scholarly dignity, unlike several modern day inner-painting artists who seek nothing but fortune and fame. When I placed orders for special bottles that would require extra effort

to paint, Mr. Suo would finish the job and insist on giving the completed pieces to me for free. Such actions reminded me of those of scholars in the past, who often exchanged poems and paintings to share amongst themselves. I learned from Mrs. Suo that Mr. Suo was good at Chinese landscape painting but had hid his talents and only painted traditional folk paintings as he was instructed to at the inner-painting workshop, for fear of impacting the livelihoods of his fellow artists. Once, a large exhibition was to be held, and Mr. Suo refused to participate due to the monetary requirements. The host of the exhibition recognized him as "the Inner Painting Scholar Style's Representative Master" and waived those requirements in order to have Mr. Suo's work be shown at the exhibition. Mr. Suo was not particularly interested in joining contests or securing titles; he cared more about leaving good art work to the world.

It is a pity that Mr. Suo died at such a young age. When an art collector, a retired senior officer from the Ministry of Culture, heard of Suo's death, he could not help but cry openly out of sadness for the loss of such a talented artist. A group of collectors from overseas who collected Suo's artwork had tried to contact Suo's family, only to find out that Mr. Suo had passed away; they too were extremely sad. They and I have become good friends over our common love and appreciation of Suo's work. I trust that Suo's artwork will become an artistic language that connects those who admire his work both domestically and internationally. After Suo passed away, he received the honorary title "Ji Inner-painting School's Patriarch."

I have always enjoyed collecting arts, both antique and contemporary pieces. I will not claim to be an inside-painted snuff bottles collector, but rather would prefer to be known as a dedicated admirer of Suo's work. This book is published in memory of my friendship with Suo Zhenhai. It includes the meaningful pieces and representative series (e.g. the Fishing, Hogging, Farming, and Studying series; landscapes in four seasons series; flowers, birds, insects, and plants series; Wind, Rain, Clouds, and Moon series; Zodiac Animals series; master works imitation series; Journey to the West series) I have collected over the years I've known Suo. It also contains bottles made from natural agate or crystal, custom-made paintings and other fine works (e.g. Beijing opera characters, Foreign Scenery, Lady, Hidden Fisherman in a Clear Stream, Winter, Swimming Shrimps), rare and unique pieces (e.g. Wu Song, Qingming Scroll, Outisde a Stockade, and the Plum, Orchid, Bamboo, Chrysanthemum Series), and the few inside-painted glass shields Suo painted in his lifetime. Mrs. Suo believes that in spite of her husband's prolific creativity, most of his work on the market are of a very limited number of subjects. This book can better demonstrate his creative talents as the pieces that are included are mostly one of a kind. My sincerest hope is that this book might serve as a platform that might attract more of those who admire Suo's work. This is my humble way of promoting Ji Inner-Painting School's snuff bottle art and of continuing Suo's inner-painting legend.

Hong Yuan Villa October 26, 2010

前　言

付彦珍

毓鸿先生说索振海作品是他收藏内画鼻烟壶的滥觞。

　　在我的记忆中，只要是拿出先夫的作品，马先生几乎都愿意收藏，我也刻意提供振海各式各样精良的作品给马先生，庆幸能有一个收藏先夫作品质量均优的好归处。

　　马先生早年曾学习国画，而且其岳祖父马寿华先生素以书画著称，在世时一直是台湾美术家协会及书法家协会主席，所以特别欣赏振海能以内画技巧展现国画的风貌和创作的生命力，不同于传统内画的风格。

　　马先生收藏先夫的内画壶中有不少精品、孤品，或是同类形中的代表作品，都有选择性的收录至此图册中，可借此一窥振海内画内容的多样性和艺术表达语言。如：四季山水、虫草系列、仿古系列、西游记、花鸟、京剧人物、写意人物、泼墨山水、十二生肖、肖像、有色玛瑙和水晶内画孤品等。

　　马先生收藏索振海的内画壶，无论在质或量上，都有条件提供素材让本书成为精采展现先夫作品的图册，振海作品虽然在不同出版物和展览上有所发布，但有系统的编列，这也是第一回，这在内画艺术也属少见，相信能为海内外索振海内画收藏爱好者提供一个比较好的参考，并且留下见证。

　　索振海"以壶会友"有幸结识马先生，马先生"伯乐识马"和索振海在内画艺术世界里有了知音，盼望能借本书在艺术爱好大众引起更多共鸣。

<div align="right">2009 年 10 月 26 日</div>

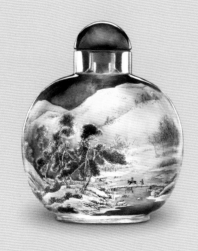

玻璃料内画雪山访友鼻烟壶

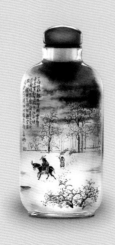

玻璃料内画诗中画鼻烟壶

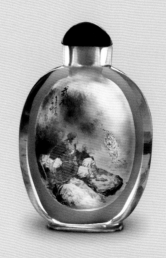

玻璃料内画武松鼻烟壶

Foreword

Fu Yanzhen

Mr. Mike Ma told me that his inner painting snuff bottle collection began when he started collecting Suo Zhenhai's work.

From what I remember, as long as I presented Mr. Ma with work by my deceased husband, he would be willing to add them to his collection, almost without exception. Whenever I could, I would provide Mr. Ma with Zhenhai's best work. To this day I am glad that there is a single collector who has a collection of my late husband's work that is unparalleled in both its size and quality.

Mr. Ma had learned traditional Chinese painting at an early age and his grandfather-in-law, Mr. Ma Shou-Hua, is well-known for his calligraphy and Chinese painting. Mr. Ma Shou-Hua served as the Chairman of the Taiwanese Artist Association and Calligraphy Association until he passed away. Thus, because of Mr. Ma's own background in traditional Chinese painting, he appreciated Zhenhai's ability to translate the resilience and creativity of traditional Chinese painting and apply the techniques and styles to inner painting; for Mr. Ma, this is what set Zhenhai's work apart from the inner painting work of other artists who were more conventional in their approaches.

Mr. Ma's collection of my late husband's inner-painting snuff bottles contains many exquisite, exclusive, and representative pieces; all of these have been selected to be included in this publication. This book displays the variety in artistic language expressed through Zhenhai's work; it includes: the landscapes in four seasons, the plants and insects series, the master imitations series, the Journey to the West series, the flowers and birds series, the Beijing opera characters, the zodiac animals, portraits, and exclusive natural agate and crystal pieces, etc.

Mr. Ma's collection of Suo Zhenhai's inside painted snuff bottles is large and of a high enough quality to provide the materials necessary for the publication of a book that can truly showcase my late husband's work. Although Zhenhai's work has been publicized in other publications and through exhibitions in the past, this will be the first time a comprehensive collection of his work will be made available to the public. Such a thoughtful project is rarely done for an inner painting artist. I believe that the publication of this book will provide those who collect and admire Suo Zhenhai's work with a reference source and will furthermore be a testimony to his artistic achievements.

Through my late husband's work in inside painting, Suo Zhenhai found a collector passionate about his work and Mr. Ma found an artist with unparalleled talent; but both found a friend. Mr. Ma became Suo Zhenhai's soul mate in the inner painting art world. My sincerest hope is that this publication resonates among those who love art.

October 26, 2009

德艺双馨索振海

王习三

中国工艺美术大师　全国政协委员

　　我同索振海的相识颇具戏剧性。那是 1968 年，史无前例的文化大革命还在进行着，我从北京被遣返回祖籍河北省阜城县杨庄后，为改变家乡的贫困落后面貌，冒着"复辟资本主义罪名"的风险，在杨庄以副业形式搞起内画、五金和制胶等几项效益较好的实业，从而使一穷二白的杨庄经济有了好转，村民生活也得到改善。可是好景不长，一场"一打双反"运动又扑面而来，在阜城县我被列为"阴谋篡党夺权、复辟资本主义的反革命分子"，揪出来批斗。1970 年初冬的一天，我正在挨斗，突然来了三个素不相识、手里提着糕点和水果的外乡人，说要找王习三学艺画内画。经过革委会主任的讯问，了解到三人是饶阳县的年青人，慕名而来想学内画，就扣下礼品放走他们。可想而知，他们不仅艺没学成，还差点成为我的批斗陪绑对象。直到 1973 年，我被平反安排在县综合厂恢复公职后，才得知那三个人的名字叫：索振海、刘子艺、刘双青。从那时开始，在我的指导帮助下，他们在饶阳老家开始画内画壶，并由我们交到天津口岸出口，从而为他们打开了内画艺术生涯之门。

　　1977 年，我被调到衡水地区创建特种工艺厂后，把索振海三人从饶阳县招进厂成为正式职工，从此成为内画专业艺人。直到 1988 年，我奉调文化局创办衡水市内画艺术院，十多年间我们始终工作生活在一起，所以建立了深厚的感情。

　　1944 年，振海出生在河北省饶阳县大尹村，幼时因病造成双腿残疾，但他身残志坚，好学上进的精神令我敬佩。当年，他们去杨庄学艺时，上百里的路是骑自行车去的。那么远的路程，即便是身体健全的人也会非常累，而双腿残疾的振海，

如果没有坚强的毅力和决心是难以成行的。振海为人厚道，性格内向，见人只会咧着长满胡髭的大嘴憨笑，不善于花言巧语与人打交道。个别有人针对他的憨厚加以戏谑，可心知肚明的振海对他们仍憨笑以对，从不计较。

　　由于振海家境贫寒，加上肢体残疾，直到三十多岁还未结婚。进厂后，别人给他在农机厂介绍了个对象，第二天我骑自行车驮他去相亲，一路上他忐忑不安地反复说："我这个样子人家能看上吗？"可是心地善良、宽厚仁爱的付彦珍不以貌取人，她欣赏的是振海的人品和技能，不顾亲友的反对，毅然和振海组成了家庭，相濡以沫几十年。如今两个笃学尚志的儿子，秉承父业奋进在文化艺术的征程上，为他们带来无尽的欢快和慰藉。

　　振海在内画领域可以说是另辟蹊径，在众多弟子中，他以写意的草虫花鸟走兽题材为主，比起精工细绘的作品，起初未被人重视，但随着振海笔墨的日臻成熟，意境的高雅深邃，构图的简明巧妙，气韵的生动洒脱，从而形成自己的特有风格，很快就引起人们的关注，尤其是他在山水方面的造诣更是达到独树一帜的境界。

　　在冀派庞大的群体中，振海堪称是德艺双馨的典范。2005 年，在海内外关心冀派内画人士的呼吁下，为了正本清源，理顺传承，在文化部门领导的关注下，我们搞了一次隆重的拜师仪。当时，振海已经重病在身行动困难，但他得知拜师的消息后，强忍病痛，在两个人的搀扶下，艰难的赶到现场。从内画展览馆的一楼到三楼，他两步一停，三步一歇，整整用了二十多分钟，上到三楼振海早已大汗淋漓，气喘嘘

嘘。这时来自台湾、北京、山东、陕西以及河北的在场人员，无不为之动容。这与头顶"双冠大师、民协官封的德艺双馨艺术家"光环，却干尽盗名窃誉、弄虚作假、欺师忘祖的无耻之徒相比，形成了鲜明的对照。饱经文革洗礼的我，尽管性格刚毅，面对此情此景，再也忍不住内心的激动，竟在大庭广众的拜师现场老泪纵横泣不成声！

20世纪90年代后，振海曾因住房问题离开衡水。一年后，他返回衡水家中时蓬头垢面，骨瘦如柴，同事和家人都认不出他了，从而导致重病染身。此后，为了治病花光家中所有积蓄，振海为了维持生计及两个孩子上学，仍强忍病痛坚持

创作，尽了一家之长的天职，同时也为他的知音马毓鸿先生提供了一批经典之作，此次部分作品收录本图册中。

遗憾的是，就在拜师仪式半年后，振海永远离开了人间，冀派内画失去了一位德艺双馨的艺术家。光阴似箭，在他辞世后的三年时间里，冀派内画先后被国家列入"首批非物质文化遗产名录"，联合国教科文组织授予"世界杰出手工艺品徽章"，文化部命名衡水为"国家级文化产业基地"等多项殊荣。生为冀派内画骨干的振海，九泉之下，一定又会展现出他特有的憨笑面容。安息吧！振海！

己丑仲冬大雪后记

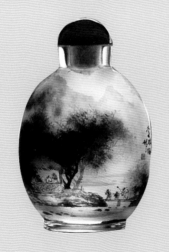
玻璃料内画读鼻烟壶

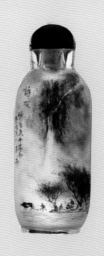
玻璃料内画访友鼻烟壶

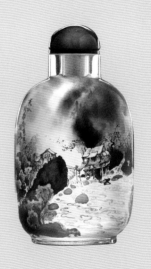
玻璃料内画寨外鼻烟壶

Suo Zhenhai : A Virtuoso of Virtue

Wang Xisan
China Handicraft Master Artist
Chinese National Political Consultation Committee Member

My first encounter with Suo Zhenhai was somewhat dramatic. It happened in 1968, during which the unprecedented Cultural Revolution was underway and gaining momentum; I was exiled from Beijing to my hometown Yangzhuang, Fuchen County, Hebei Province. In order to improve the condition of my poverty-stricken hometown, I risked being incriminated for attempting to "reinstate capitalism;" I started this endeavor by taking on a number of side jobs—including inner painting, working with hardware and plastics—these more lucrative businesses, which had improved Yangzhuang's impoverished economy and the living of villagers. This effort, however, did not last for long, as the movement of "one to quench two rebellious acts" drew near, I was labeled "a rebel who conspired to steal the communist party's power and reinstate capitalism" and was condemned for my actions. In one early winter day of 1970 while I was being scolded, three strangers from out of town, holding cakes and fruits in their hands approached me unexpectedly and asked to learn the art of inner painting. After an interrogation of these men conducted by the director of the Revolution Committee, it became clear that these three young men from Laoyang County had the desire to become my pupils. They were released after the interrogation without the gifts they were carrying. Naturally, they were not permitted to learn the art of inner painting from me and in fact almost became my companions in being persecuted and humiliated by the Red Army. It wasn't until 1973, after I was declared innocent and offered a position at the county's factory that I found out the names of the three young men: Suo Zhenhai, Liu Ziyi and Liu Shuangqing. From then on, under my guidance, they began to work with inner painting snuff bottles in their hometown, Laoyang; and the bottles they painted were passed through us for export from the Tianjin port. Those days marked the beginning of their inner painting art careers.

In 1977, after I was assigned to the Hengsui area to establish a special arts workshop, I hired Suo Zhenhai and the other two young artists from Laoyang County to be official employees at the workshop. Until 1988 I was reassigned to the Culture Bureau to set up the Hengsui City Inner Painting Art Institute, we had always worked together for more than a decade and bonded with a very solid relationship.

Zhenhai was born in 1944 in Dayi Village, Laoyang County, Hebei Province. He became crippled due to a childhood illness but despite his handicaps, possessed an incredible amount of willpower to succeed. I admired his studious attitude and spirit for learning. When they first travelled to Yangzhuang to learn inner painting skills, they had biked more than a hundred kilometers to reach their destination; biking such long distance is very exhausting even for someone who isn't handicapped. Therefore the task was no easy one for the crippled Zhenhai, and he would not have completed the journey had it not been for sheer willpower, persistence, and determination. Zhenhai was generous in nature and always smiled innocently at people with his big mustached mouth. He was not good with words or at dealing with people. There were those who took advantage of Zhenhai's generous and forgiving nature; and while Zhenhai's intrinsic wisdom made him aware of this, he did not mind at all and would merely smile in response to their teasing.

Because of Zhenhai's humble background and his handicaps, he did not marry until he was over thirty years old. One day after he came to the workshop, a match maker introduced a lady from the agriculture machinery plant to him. The next day I rode a bicycle to take him to meet the woman. He was very nervous and constantly asked "would the lady take someone like me?". But the kind-hearted and loving Fu Yanzhen eased his doubts. She did not judge him by his appearance; she appreciated Zhenhai's gentle personality and artistic talents and married Zhenhai against the will of her relatives and friends. Zhenhai and Yanzhen formed their own family and had a wonderful marriage that lasted for many decades. Today, their

two industrious and determined sons have followed in their father's footsteps, beginning art careers of their own. They continue to be sources of joy and pride for the family.

Zhenhai opened up a brand new world in the art of inner painting. Amongst many pupils, his free style (mind-showing /not imitation) artistic portrayals of flowers and birds, plants and insects, and animals did not draw too much attention at first. They were not detailed and precise drawings like those of his colleagues. However, as Zhenhai polished and refined his inner painting skills, his works began to evoke powerful feelings in those who laid eyes on them. The simple layouts of his inner paintings translated into simple beauty and elegance. His brushstrokes and technique made the subjects depicted in his paintings come to life, and soon enough, he had created a unique personal style that caught everyone's attention. In particular, his landscape (mountain water) paintings reached a level of artistry that remains unmatched to this very day.

Among the Ji (Hebei) School's large number of artists, Zhenhai is a prime example of both virtue and virtuoso. In 2005, as requested by the Ji School's domestic and oversea followers, we organized a grand master-pupils ceremony under the auspices of the Culture Department officials. The ceremony was held to clarify the heritage and succession of disciples. At the time, Zhenhai was already seriously ill and immobile. But when he learned of the ceremony, he endured severe pains and rushed to attend the ceremony, hand-carried by two helpers. He suffered severe pain in order to get from the first floor of the Inner Painting Exhibition Gallery to the third floor. He took two steps and paused; then took three steps and stopped for a long break; the entire process took him more than twenty minutes. When Zhenhai finally reached the third floor he was soaking wet from his own perspiration and was breathing heavily for a long period of time. Spectators from Taiwan, Beijing, Shangdong, Sanxi and Hebei were all deeply moved by Zhenhai.

Zhenhai's humble actions stood in stark contrast to what one might expect of a pupil honored with the title "double category master and private association's 'official' artist of virtue and virtuoso." He did not attempt to claim big titles as his own, make something out of nothing; nor did he forget his art heritage for the sake of reputation and fame. Having experienced the endless attacks and humiliation during the Culture Revolution, I thought I had the toughest character, but when I saw what Zhenhai had gone through to attend the ceremony I couldn't help but cry with emotion; I lost my voice in front of everyone at the ceremony.

In the late 1990's, Zhenhai had to leave Hengsui for a year due to housing issues. He arrived back home in Hengsui, skeleton-skinny, and his colleagues and family could hardly recognize him. He was seriously ill at the time. As a result, treating his illness used up all the family savings, and Zhenhai had to endure great pains and suffering to meet his duty as the head of the household and carry the financial burden of the household including the costs of his two sons' education. He continued painting despite his illness. During this time, he provided a significant number of his exclusive pieces to his dear friend Mr. Mike Ma and some of those pieces are included into this book.

Regrettably, just six months after the master-pupils ceremony, Zhenhai passed away, and the art community of the Ji School lost an artist of virtue and skill. In the three years after Zhenhai passed away, several things happened: the Chinese government included the art of inner painting of the Ji School in "the first group of non-material cultural heritage" list; UNESCO bestowed "the Medal of World's Outstanding Handicraft" on the school, and the Ministry of Culture named Hengsui a "National Cultural Production Base." As a leading artist of the inner painting art of the Ji School, Zhenhai, although in heaven, must have broken out in that unique and generous smile of his. Zhenhai! Rest in peace!

Written after a Mid-winter Snow in the Lunar Year of JiChou

小中见大 情景交融

—— 索振海内画艺术欣赏

薄松年

中央美术学院美术史教授

国家非物质文化遗产保护工作专家委员会委员

中国鼻烟壶内画艺术因其技艺的高难度和令人不可思议的装饰效果而享誉于世，创作者要通过如豆粒般大小的壶口将微型的小笔伸入壶内，在方寸之区反相写字作画，做到纤毫毕具。字有真草篆隶，画有各种题材门类，集绘画书法与工艺于一体，被列为特种工艺之列。成为具有民族风格的艺术品。

我对内画接触较少，偶而遇到一些优秀作品，常对其精雕细刻鬼斧神工的技巧赞叹不已。然而，面对索振海先生的内画作品，却更令我耳目一新；因为他不仅以内画之精巧取胜，而更具有高雅的格调和深邃的文化内蕴，显示着清雅脱俗的品味。

索先生掌握了高超娴熟的内画技艺，举凡山水、人物、花鸟、走兽、草虫以至肖像等可谓无一不能，但我最欣赏的还是他的山水内画作品，由于作者对传统绘画有着相当的修养，而且技巧全面，画来自可驾轻就熟，但内画的材料不同于纸绢，其画面亦非卷轴册页，且展示才能仅局限在方寸之地，将传统绘画成功地移植到玛瑙或料器的壶体上本身就是一番再创造的功夫。特别是索振海运用的技巧不是简单的勾描设色，而是将传统绘画中复杂变化的皴擦点染成功的施于内画之中，因此具有更高的难度。他的山水内画无论是造型、章法、笔墨都极为讲究，更重要的是作品中的优美意境时时打动着欣赏者的心扉，这才是他艺术上的卓绝之处。

中国的山水画非常注重师法造化，但又不是自然形象的机械模拟和罗列，讲求以情写景，情景交融；无论是千山万壑、重峦叠嶂，或小桥流水、田野村居，都能将画家的思想情趣浓缩于精粹的造景之中。它的表现技巧多种多样，或以绚丽的华彩，或用漓淋的泼墨，或工致的描绘，或大笔挥洒，都是借笔墨以传情，达到情景交融的境地。意境是绘画作品的灵魂。塑造优美意境成为索振海艺术创作的追求，创作了不少的内画精品，这从本集中所收的作品可以得到展示。由于篇幅所限，仅举出其中数件和同好共同欣赏。

《平沙落雁》（图13）是"潇湘八景"之一，以往画家多表现荒寒的情调，但此壶画境却展开颇有气势的旷野景趣，隐隐远山、曲折江流，天空分布雁阵，沙滩群雁翔集，芦葭丛生，沙滩上一人对景抚琴，足见其高致。此内画壶意境幽远，画中有诗。

《寨外》（图22）别有奇趣地表现山路尽头的对岸崖脚处架起的水上房屋，两处以危桥相通，屋下流水潺湲，用浓郁的墨团表现山石，流水则用淡墨写出回旋流动之势，动静对比、虚实相应，使观者在欣赏幽僻的深山图景中仿佛听到水流的天籁之音。

《云山胜境》（图32）表现大山之巅建有殿堂，左上方留出大片空白表现迷漫的烟云，其间又隐现高山巨岭，鹰隼翱翔于广阔无垠的天空，在小画面中却展现出大气势，予人以无穷的遐想。画中的山石兼皴带染，气势雄厚，显示出作者出众的国画功力。

《松岭探幽》（图9）此图左上方以大斧劈皴表现奇峭的群山，山体下方隐于烟云之中，益显其高峻，近处山路点缀以虬松红树，皆甚有姿态，树上垂藤因山风而飘拂，一人牵驴踽踽徐行，在山水中寻幽探胜。此图借鉴了宋代马远的画风，章法虚实相间，剪裁巧妙，笔法苍劲挺秀。

《风雪夜归人》（图14）取材于唐代诗人刘长卿《逢雪

宿芙蓉山人》脍炙人口的绝句："日暮苍山远,天寒白屋贫。柴门闻犬吠,风雪夜归人。"原诗即充满情景交融的画境,索振海成功的把握住暮寒的情景,画面上半部以简洁的笔墨画出巍巍雪山和阴霾的天空,冈阜一侧露出简陋的房舍,寒树在风中欹斜摇晃,前面雪地上有一串曲折的人行脚印,映衬着牵驴驮的旅人,引得远处小犬吠叫。笔墨不多,造景精粹,以水墨为主,只有人物袍服施以赭色,显得异常突出,处处体现出作者的独具匠心。

值得提出的是山水画作品中的人物,寥寥几笔,却有神完气足之妙,有时还起着点题的作用。《访友》(图2)在高山飞瀑之下画树下数人席地而坐亲切交谈,一旁有农民推犁耕作,表现出山区的乡情野趣。《读》(图7)中朋友们在亭中谈兴正浓,板桥上又有三人前来,使景色充溢着热烈欢快的情绪。这些点景人物可称是画中神来之笔。索振海长期生活于河北省的小城镇,对乡野生活有着切身体会,这种朴实的情感也凝聚在画作之中。

索振海的内画中绝少重复程式化的套路,即便是常见的题材,他的创作也总是予人以新颖之感,十二生肖是民间艺术中经常反复出现的内容,索振海的十二生肖套壶构思上别出新意,打破了一般单纯描绘动物的死板格式,着重表现动物的神情意态,将其置于特定的环境之中,并构想出一定情节,益显得丰富而耐人寻味。如《双牛图》中画一大一小的子母牛,表现出舐犊情深的情结。一对巴狗像孩子一样好奇地的注视着枯枝上的蜻蜓。两只老鼠在昏暗的油灯下偷食荔枝。猴子灵巧的攀援树枝,背景是湍急的飞瀑……这些匠心独运的画面增强了作品的艺术魅力。

作品中对几位京派前代内画大师的追仿,表现出画家对遗产的尊重。鼻烟自明末传入我国,至清而风行于世,从而产生了鼻烟壶工艺;但内画鼻烟壶的历史则从清代嘉道年间才创造出来,其后200年中分成京、冀、鲁等不同流派,各展所长,薪火相传,使内画艺术得到不断的提高。索振海正是综合了京派和冀派之长,转益多师,加以不断的钻研创造,以严肃的创作态度对待艺术,不流于一般的"行货",在内画上又有了新的突破。

马毓鸿先生慧眼识珠,对索氏的艺术深为倾倒,他们之间结成深厚的友谊,从而收藏了大量珍品。现在索振海已经作古,马毓鸿先生为了纪念他们之间的友谊,弘扬内画艺术,将其珍藏汇集出版,供同好欣赏,使索振海的内画艺术长留人间,也实在是一件值得称道的举措。

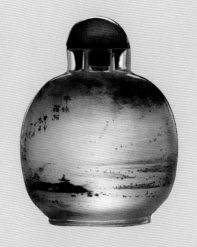

玻璃料内画平沙落雁鼻烟壶

Capturing the Universe in a Small Bottle ;
a Delicate Fusion of the Artist's Feelings and his Art

—The Review of Suo Zhenhai's Inner Painting Art

Bo Songnian
Art History Professor, China Central Art Institute
China Non-Material Culture Heritage Preservation Expert Committee Member

Chinese snuff bottle inner painting is well known internationally for its highly difficult techniques and incredibly decorative effects. The artists have to use a micro-brush pen to paint or write in the opposite direction from right to left through a bean-sized opening and within a few inches of space. The art has come to include a wide array of different calligraphy styles-Zhen (regular script), Cao (cursive script), Zhuan (Seal Character), Li (ancient style current in Han Dynasty), as well as all subject matters in painting. The craft combines painting, calligraphy, and handicraft and is categorized as a special handicraft art. Inner-painting has become a unique art form of the Chinese culture.

I do not frequently come in contact with inner painting pieces, and the few times that I do I occasionally see some fine works that allow me to admire the ingenious techniques and incredible detail of the craft. When I first saw Mr. Suo Zhenhai's inner painting pieces I found them surprisingly refreshing. His work not only demonstrates exquisite detail, but is extremely sophisticated in nature, exemplifying the elegance and unique essence of his craft.

Mr. Suo, highly skilled in the art of inner painting, was gifted in painting all subject matters: landscapes and people, flowers, birds, and animals, plants and insects, and even portraits. Personally, I appreciate his landscape inner painting pieces the most. Before he started painting snuff bottles, Mr. Suo already possessed excellent skills in traditional Chinese painting. With a strong foundation in traditional Chinese painting, applying his abilities to inner painting came naturally. For the inner painting artist, there is no canvas—the drawings are not completed on scrolls or paper pages. Suo displays his talents within inches of bottle space. Transferring the skills and knowledge he had in traditional painting to agate or glass bottle inner painting itself is an artistic endeavor of considerable difficulty. In particular, the techniques Suo Zhenhai applies in his pieces are not simple tracings that are later filled with colors; amazingly, he adapted the complicated Cun (brush strokes to draw the mountains and waters in Chinese landscapes), Cha (scratchy brush strokes), Dian (dotting brush strokes) and Ran (dyeing brush strokes) techniques of traditional Chinese painting for inner painting, which in itself is a challenge. The layout, methodology, brush strokes, and colors of his inner painting landscapes are all very refined. However, Suo's greatest achievement in his craft is creating works that resonate with and touch the hearts of those who lay eyes on his artwork.

Chinese landscape paintings stress the importance of emulating nature rather than mechanically imitating or allocating natural scenes. The artist must infuse his own feelings into the landscapes he wants to create in order to reveal genuine sentiments in his artwork. Whether it is mountain peaks and valleys or rivers running underneath little bridges beside a countryside cabin, any scene can be condensed into the essence of an artistic image by an artist's inspired brushstrokes. This is achieved through many different techniques and forms: the use of splendid colors or by slashing ink, by paying attention to detail and/or complete by careful imitation, while others employ big, bold brushstrokes. Whatever the methodology, the artists all use brushstrokes and colors to convey their innermost feelings through their artwork. Capturing the emotions in images creates a soul in painted pieces. Suo ZHenhai's primary artistic pursuit was to create extraordinary images of this kind. He created some exquisite inner painting pieces, as demonstrated by the pieces illustrated in this publication. Due to space limitations, I can only select a few pieces to comment on and share with those who appreciate Suo's work.

(Gliding Wild Geeses Landing on Sandy Shores)[picture 13] is one of the "Xiao Xiang Eight Scenes" (eight scenes of Hunan Province

mentioned in Song Dynasty Sen Kuo's Brush Talks from Dream Brook). In the past, artists generally emphasized the barren coldness of the scene; however, this bottle depicts a striking image of open fields—portraying elusive mountains in the distance, meandering streams, the silhouettes of wild geese flying in the sky, groups of geese playing on the beach, river reeds on the shore, a lone person playing the Guqin (an ancient string instrument). This inside painted bottle conveys a deep and sophisticated perspective, and the images themselves have poetic qualities.

(Outside a Stockade)[piture 22] presents a stockade above the water at the end of a mountain road with peculiar interests, both ends connected by a hanging bridge, water running under the stockade, using thick and rich ink marks to show the mountain rocks, using light inks to draw the detours and running patterns of the water, still and moving contrast echoing hollowness and hardness, making the viewers see the remote mountain picture feeling like hearing the sound of running water from the divine heaven.

(Paradise of Cloudy Mountains)[picture 32] illustrates palaces at the peak of the majestic mountain. The spacious upper left section of the inner painting shows high mountains and giant cliffs emerging through a film of fog and wispy clouds. Eagles and falcons are depicted gliding in the seemingly limitless sky, creating a magnificent feeling in a very limited amount of space; the scene evokes feelings of awe and arouses one's endless imagination. In the inner painting, the mountain rocks are created with adept brush strokes and dyeing techniques that show the artist's extraordinary Chinese painting talent and abilities.

(Pine Cliffs Excursion) [picture 9] The upper left corner of this inner painting shows a cluster of steep mountains painted with bold, chopping brushstrokes; the sheer height of the mountains and

the steepness of their slopes is emphasized by the fact that wispy clouds conceal the foot of each mountain. The mountain road in the foreground is lined with pine trees painted in interesting poses. The trees' climbing vines flutter about in the mountain winds; a lone individual drags a donkey slowly along the mountain path searching for isolation and beautiful scenery. This inner painting reflects Song Dynasty's Ma Yuan's painting style; the painting style is abstract but also contains elements of realism.

(A Man Returns Home in a Blizzard) [picture 14] draws its inspiration from a poem written by Dang Dynasty poet Liu Changqing (Caught Up by Snow and Put Up at a Hut at Mountain Peony). The lines that come to mind are "At dusk, green mountains appear far away; freezing weather humbles the white cottage; the dog's bark is heard through the wicker gate; a man returns home on a snowy, windy night". The poem is full of powerful imagery which is translated into the sentiments shown in the inner painting of this bottle. In this painting, Suo Zhenhai successfully conveys the atmosphere at dusk as well as the freezing temperatures of the scene. In the upper part of the painted image, he used concise brushstrokes to paint the majestic snow mountains against a hazy sky. In the rest of the painting a rundown hut sits on one side of the hills, frozen trees sway in the winds, a zigzag path of human footsteps is left on the snow covered field in the foreground, complementary to the traveler and his donkey walking in the direction of the little dog's barks in the distance. Suo Zhenhai used minimal brushwork to complete the essence of this scene; he essentially employed water and black ink to create most of the image, only applying purple colors on the traveller's robes, making it stand out. All these details combine to demonstrate the artist's ingenuity.

It is worth mentioning that in Suo's Chinese landscape pieces,

human characters are drawn in a few strokes and often add a magical touch to the entire painting. Oftentimes the human characters bring out the meaning of the title, as they do in (Visiting Friends)[picture 2]. At a waterfall in the mountains, squatting beneath a cluster of trees, there are people engaged in warm conversation while a farmer is shown working with a plough on the side; these images portray the pleasures of idyllic country life in the mountainous areas. (Study)[picture 7] shows a group of friends immersed in delightful conversation inside a pagoda; three more individuals approach the gathering from the nearby bridge, creating a lively and cheerful atmosphere in the painting. These human characters, although not the focal point of the paintings, are the magical touches that bring each painting to life. For a long period of time, Suo Zhenhai lived in a small to mid-sized township of Hebei Province and therefore had an intimate understanding of countryside living. He conveys his understanding through his inner paintings.

Suo Zhenhai does not approach inner painting with a formula; even for subject matters that are very commonly portrayed, his work is always refreshing and unique. The twelve zodiac animals are commonly portrayed in the folk art world. Suo Zhenhai's twelve zodiac animal series, however, is a novel creation—straying from the typical portrayal of the animals which emphasizes their expressions and moods. In Suo Zhenhai's pieces, the animals are positioned in specific circumstances that reveal a story behind the painting, making each of them significantly richer and intensely interesting. For example, in his painting of the cow zodiac, he included a mother cow and baby cow, creating an image that shows a deep mother-child relationship. Other bottles from the series depict a pair of pups staring intently like curious children at a dragonfly on a dry branch; two mice stealing red lychee fruits in the dim lighting of an oil lamp;

a skillful monkey climbing and hanging to tree branches against a backdrop of a splashing waterfall.

Some of Suo Zhenhai's work reflect the work of inner painting masters from the Jing School as a demonstration of his respect for his artistic heritage. Snuff bottles were first introduced in China in the late Ming Dynasty and became popular in the Qing Dynasty. It was at that time when snuff bottles became recognized as a handicraft. The history of inner painting snuff bottles began during the Qing Jiaqing-Daoguan eras and in the following two hundred years divided into the Jing, Ji, and Ru Schools of inner painting—each with its respective specialties. While traditions have been passed down from generation to generation, the art of inner painting has also been constantly improved. Suo Zhenhai combined the specialities of both the Jing and Ji Schools as he had learned from different mentors. In combining the different parts of his artistic heritage, he was able to further refine each. His attitude towards art was very serious and unlike the work of typical professionals, his work is considered a major breakthrough for inner painting.

Mr. Mike Ma has an eye for Suo's talents and has long been intrigued by his artwork. They shared a very solid friendship and in the time they knew each other, Mr. Ma collected a large quantity of Suo's exquisite pieces. Now that Suo Zhenhai has passed away, to commemorate their friendship and promote the art of inner painting, Mr. Ma has selected some of the finest pieces from his collection to include in this publication. Doing so will keep Suo Zhenhai's memory alive and allow his work to become immortalized in the world. This gesture itself is admirable.

寸天厘地绘乾坤

——内画鼻烟壶之沿革

张荣

故宫博物院研究馆员

鼻烟壶是中国古代文物中的一个独特类别，始于清康熙朝，在宫廷造办处和民间都大量制作，这与吸闻鼻烟的习俗在清代的广为盛行密切相关，也与皇帝的提倡和参与不无关系。鼻烟壶的制作与发展在清代的康熙、雍正、乾隆三朝达到鼎盛时期，成为集清代各种工艺、材质于一身的掌中珍品。嘉庆以降，鼻烟壶的制作同清代其他工艺一样，数量明显减少，工艺水平骤然下降。正是在这样的背景下，内画鼻烟壶这一崭新的艺术形式在鼻烟壶兴起并发展了 200 余年之后，以其鬼斧神工之魅力脱颖而出，并独树一帜，为晚清呆板单调的艺术平添了最后的、浓重的一抹余晖。

关于内画鼻烟壶创始的具体时间，由于文献所限，目前尚无定论。有的学者认为，内画鼻烟壶是由一个名叫甘桓的人在嘉庆年间发明的，早期作品以甘桓署名，后来也有以甘桓文、一如居士、半山、云峰等署名。最早的作品作于 1816 年，1860 年停笔。香港中文大学文物馆珍藏着甘桓的山水画作。

无论内画鼻烟壶是何时产生的，但有一点是肯定的，就是内画鼻烟壶的产生，与高度透明玻璃的炼制、掏膛技术的成功是分不开的。如果没有这两个基本条件，也就无从谈起内画鼻烟壶的产生和发展。

能够用于制作内画鼻烟壶的材料，主要有三种，即透明玻璃、无色水晶和茶晶。在选好材料并进行掏膛处理之后，还要用金刚砂、小铁球和水在壶内来回摇动，进行磨砂处理，直至内壁细而不滑，使颜料能够附着其上，再用弯曲成钩状的竹笔蘸上颜料在壶的内壁反向作画或写字。身怀绝技的内画大师们凭借其精湛的书法绘画技艺和敏锐的感觉，在方寸之间随心所欲，笔下生花，使小巧玲珑的内画鼻烟壶成为了

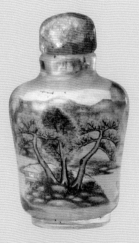

周乐元款
白玻璃内画山水鼻烟壶

精美的掌中珍玩。

从流传至今的大量内画鼻烟壶作品可以看出，在清代光绪年间，内画鼻烟壶的创作达到了高峰。名家辈出，有名姓的内画匠师就有三十多位，如周乐元、马少宣、叶仲三、毕荣九、丁二仲、孟子受、陈仲三、张葆田、汤子川、魁德田、陈少圃等，其中水平最高，对内画艺术影响最大的是京派大师周乐元、马少宣、叶仲三。

周乐元，北京人，生卒年月不详，是内画鼻烟壶的一代宗师。有的研究者认为，周乐元原是一位宫灯、纱灯画师，在文学、绘画方面有较高的造诣。目前已知周乐元最早的内画鼻烟壶作品创作于 1882 年，最晚的作品创作于 1893 年。周乐元的内画作品题材广泛，山水人物、花鸟鱼虫、书法等，无不精美，尤其擅长山水画。其山水画，设色以墨色为主，以淡彩作点缀，画面古朴精致。最能代表周乐元创作水平的内画鼻烟壶，是仿清代著名画家新罗山人的作品。周乐元凭借其扎实的绘画功底，将绘于宣纸上的中国传统绘画逼真地浓缩在寸天厘地的鼻烟壶内，令人叹为观止。

马少宣（1867 ~ 1939 年），名光甲，字少宣。回族，北京人。一生绘制了大量内画鼻烟壶，有许多优秀之作散见于世界各地，受到国内外收藏家的追捧。马少宣内画鼻烟壶最鲜明的特点是书画并茂，将唐代著名书法家欧阳询的楷书再现于小小的鼻烟壶中，成为空前绝后的创举。其作品最常见的形式是一面绘画，一面题字，既使是同一题材，也常配有不同的诗句，成为独家风格。马少宣的绘画题材也很广泛，山水、人物、花鸟无所不能，尤以肖像画见长。他所绘人物肖像善于用若明若暗的浅墨色调，一如黑白照片那样柔和、逼真，

使人物的性格、神韵栩栩如生。他一生中画过许多皇室成员、政界要人、艺术名家，如溥仪、袁世凯、李鸿章、张之洞、徐世昌、梁敦彦、黄兴、王文韶、英王乔治五世及皇后玛丽等。不过，马少宣最钟爱的还是描绘京剧艺术家谭鑫培饰演的《定军山》中的黄忠形象。正是由于马少宣在内画人物肖像方面的突出成就，在1915年举办的巴拿马万国博览会上，他的内画人物鼻烟壶曾获得银质奖章。

叶仲三（1869～1945年），北京人，堂号"杏林斋"。叶仲三的作品有别于周乐元的雄浑古朴和马少宣的淡雅清新，以雅俗共赏著称于世。叶仲三的内画作品，山水、鱼虫、人物，无所不能，尤其擅长描绘中国古代文学名著——《三国志》、《红楼梦》、《聊斋》、《封神榜》中的人物。叶仲三作品在施色方面别具一格，以大红大绿为主，形成强烈的对比效果，具有浓厚的民俗气息。叶仲三的儿子叶晓峰、叶菶祺继承父业，叶氏父子对内画鼻烟壶这一特种工艺的流传和发展起到了承前启后的作用。新中国成立后，叶晓峰、叶菶祺打破传统观念，将叶派技艺传给外姓弟子，当代著名内画大师王习三就是叶派的第一个外姓传人。

现代内画艺术分为四大流派，即京派、冀派、鲁派和粤派。当代京派内画代表人物是刘守本，冀派代表人物是内画大师王习三，鲁派领军人物是张广庆，粤派是赖乙宁。目前唯有王习三创立的冀派从事内画艺术的人数最多，自成体系。索振海即是王习三大师的第一代高徒，他历经磨难，身残志坚，克服了常人难以想象的困难，在内画艺术领域取得累累硕果。索振海凭借其个人中国传统画的扎实功底和艺术天赋，方寸之间绘出清雅脱俗的内画作品，其于山水、花鸟、虫草、走兽、人物、肖像、仿古，无所不能，皆令人耳目一新，爱不释手。其写意的花鸟走兽，构图简明，着重表现特定环境下的动物神态，气韵生动，意境高雅。索振海作品成就最高的是其内画山水，其作品达到情景交融、独树一帜的境界，无论是千山万壑、重峦叠嶂，或小桥流水、田野村居，都能将画家的人生感悟和思想情趣浓缩于寸天厘地的掌中珍玩中。索振海作品的整体风格具有浓郁的文人画风貌，自成体系，蔚为大家，享有"冀派内画元老"之美誉。

台湾收藏家马毓鸿先生珍藏的索振海内画鼻烟壶的出版，既是对内画鼻烟壶文化的传承与研究，也是对索振海先生艺术作品的回顾与总结，可喜可贺。奉鸿远阁主人马毓鸿先生之诚邀，草成此文，以享同好。

马少宣款
白玻璃内画黄忠像鼻烟壶

叶仲三款
白玻璃内画鱼藻鼻烟壶

Painting the Universe within Inches of Space

—A History of the Inside-painted Snuff Bottle

Zhang Rong
Research Expert of The Palace Museum

Snuff bottle is a unique category of Chinese antiques which have origins that trace back to the Qing Dynasty, during the reign of emperor KangXi. At the time, both the Palace's Treasures Bureau and the common craftsman produced these snuff bottles. The appearance and popularity of these bottles during the Qing Dynasty had to do with the common practice of snuff smoking; further promoted by the emperor's personal participation in such activities. The manufacturing and development of the snuff bottle peaked during the KangXi, YongZhen, and QianLong periods of the Qing Dynasty. The snuff bottle integrated the various kinds of handicrafts that were prevalent in the Qing Dynasty. Since emperor JiaQing, the manufacturing of snuff bottles decreased drastically in quantity and declined in quality. Under such circumstances, the new art form of inside painting emerged after snuff bottles had been in production for 200 years. At the time, the difficult techniques in creating an inside painted snuff bottle made those who mastered the art stand out as unique artists. The late Qing Dynasty was devoid of significant artistic developments; however, the emergence of inside painted snuff bottles changed this.

As for the specific year in which inside painted snuff bottles first appeared, no final verdict can be made due to the lack of formal documentation. Some scholars believe that the inside painted snuff bottle was invented by an artist named Gan Huan during the JiaQing period. His earlier works were signed under the name Gan Huan and his later works were signed under the names Gan Huan Wen, YiRu Monk, BanShan, YunFeng, etc. His earliest work was completed in 1816 and his latest in 1860. The Treasure House of the Hong Kong Chinese University keeps Gan Huan's landscape painting.

Regardless of when inside painted snuff bottles originated, it is certain that the art form could not have appeared before the techniques and technology that made highly transparent glass and allowed the hollowing of the insides of bottles did. Without such prerequisites, there wouldn't have been the invention and development of inside painted snuff bottles.

Transparent glass, rock crystal and tea-colored crystal are the three principal materials which are used to make inside painted snuff bottles. Once the bottle material has been chosen and the inside of the bottle hollowed out, the bottle maker must fill the bottle with small iron balls mixed with water inside the bottle and shake the mixture until the inner surfaces of the bottle are smooth but not slippery, in order for the colors to remain when painted on. This procedure makes the bottle translucent in color. The artists can then paint or write on the inner surface of the bottle using a hook-shaped bamboo pen to apply paint in the opposite direction, from right to left. The inner painting masters employ their excellent drawing and calligraphy skills to create ingenious pieces in a very limited amount of space. The results are exquisite works of art.

The art of inside painted snuff bottle reached its peak in the GuangXu period of the Qing Dynasty. During that time there were many famous artists, among those there are around thirty inner painting artists whose names are widely recognized, including Zhou Leyuan, Ma Shaoxuan, Ye Zhongsan, Bi Rongjiu, Ding Erzhong, Meng Zishou, Chen Zhongsan, Zhang Baotian, Tang Zichuan, Kui Detian, Chen Shaopu, etc. Of those who were considered famous, the ones who have the most influence in their craft are the Jing School's Zhou Leyuan, Ma Shaoxuan and Ye Zhongsan.

Zhou Leyuan, Pekinese, birth date unknown, is a first generation inside painted snuff bottle master. Some scholars believe that he was originally a palace lantern painting artist and

was skilled in both literature and painting. The present belief is that his earliest inside painted snuff bottles were completed in 1882 and his latest work in 1893. Zhou Leyuan's inner paintings cover a wide variety of subjects, including landscapes, people, flowers, birds, fish and insects, calligraphy, etc. All his pieces are fine works of art; however, he was particularly good at painting landscapes. In most of his landscapes, he used black ink as the foundation color and dotted with light colors. The landscape pieces have an antique feel to them and are elegant and refined. His representative piece is an imitation of the Qing Dynasty's famous artist Xin Luo San Ren's painting . Zhou Leyuan had a strong foundation in traditional Chinese painting, and he used those skills to transfer art from paper to the limited space within snuff bottles; this is truly amazing.

Ma Shaoxuan (1867-1939), a.k.a. Guangjia or Shaoxuan; Hui minority, Pekinese. He painted a large number of inside painted snuff bottles throughout his lifetime and many of his best pieces are scattered around the world; well received by both domestic and overseas collectors. The outstanding feature of his work is the combination of fine calligraphy and painting. He successfully replicated the regular scripts of Tang Dynasty's famous calligrapher, Au Yang Xun, inside the narrow space of a snuff bottle, which in itself is an original achievement. His work often shows a painting on one side of the snuff bottle and calligraphy on the other. Even for paintings of the same subject matter, he complements each with a different poem and has thus created a unique style. Ma Shaoxuan's paintings cover a wide range of subjects. He is skilled in painting landscapes, people, flowers and birds, and is especially gifted in painting portraits. He specializes in employing subtle ink colors for portraits, which often resemble black and white photographs; these black and white portraits are soft and realistic in appearance, allowing the personalities of the portraits' subjects to come alive. Shaoxuan has painted snuff bottle portraits for many royal family members, government officials, and famous artists such as Pu Yi, Yuan Shikai, Li Hongzhang, Zhang Zidong, Xu Shichang, Liang Dunyan, Huang Xing, Wang Wenshao, British King George V, and Queen Mary, etc. However, his favorite piece is painting of Huang Zhong of Ding Jun Shan played by the Peking opera artist Tang Xinpei. Ma Shaoxuan's outstanding achievements in painting portraits in snuff bottles won him the silver prize at the World Expo held in Panama in 1915.

Ye Zhongsan (1869-1945), Pekinese, Workshop name "Xin Lin Zai". His work differs from that of Zhou Leyuan and Ma Shaoxuan. While Zhou Leyuan's work was bold and elegant with an ancient feel and Ma Shaoxuan's work was graceful and refreshing, Ye Zhongsan's inner painting had strong folk art flavors. The works of Ye Zhongsan's were appreciated by both the upper class and the common people. The subjects of Ye Zhongsan's inner painting pieces include landscapes, fish and insects, and people. He is particularly skilled at painting characters from old Chinese legends and folktales—The History of the Three Kingdoms, Dream of the Red Chamber, Strange Tales of a Lonely Studio, the Legend and the Hero. His work demonstrates a unique coloring style by which he employs a lot of red and green colors; the contrast between the complementary colors creates a heavy folk art flavor in Ye Zhongsan's paintings. Ye Zhongsan's sons, Ye Xiaofeng and Ye Fengqi, continued their father's legacy. The Ye family was highly influential

in the development of the unique inner painting handicraft. After the establishment of new China, Ye Xiaofeng and Ye Fengqi passed the Ye School's technique to a non-Ye student; in doing so they broke the tradition of passing the craft on from father to son. The renowned inner painting master artist, Wang Xisan, became the first student of the Ye School who did not carry the Ye family name.

The four main schools of contemporary inner painting are the Jing (Beijing) School, Ji (He Bei Province) School, Ru (Shandong Province) School and Yue (Guangdong Province) School. The head of the contemporary Jing School is Liu Shouben; head of Ji School Wang Xisan; head of Ru School Zhang Guangqing and the head of Yue School Lai Yining. At present, the Ji School, which was established by Wang Xisan, has the most inner painting artists and artistic achievements. Suo Zhenhai is Master Wang Xisan's pupil of the first generation. Suo suffered greatly from his illness, but was exceptionally determined despite his handicaps. He overcame numerous obstacles to secure many outstanding achievements in the art of inner painting. Suo Zhenhai made the most of his solid traditional Chinese painting skills and artistic talent to paint elegant and refreshing pieces in the limited space of a snuff bottle. He was skilled at painting all subject matters: landscapes, flowers and birds, insects and plants, animals, people, portraits, and even imitations of ancient masterpieces. His work was always new and different like a breath of fresh air for the critics and art collectors alike. Those who laid eyes on his artwork would fall in love with it and find it hard to forget. Suo's free style paintings of flowers, birds, and animals have simple and clear layouts that vividly emphasize the appearances and behaviors of the animals in different settings.

Suo Zhenhai's most praised pieces are his inner painting landscapes; they allow the viewer to immerse himself or herself in his artwork by blending feelings with the aesthetic beauty of the setting. Whether he is painting thousands of mountains and valleys, bridges of running water, or a cottage in the countryside, Suo is able to convey his perception of life through the limited space of a snuff bottle, creating treasures one can hold in the palm of the hand. Suo Zhenhai's work shows a scholarly approach to painting and his development of a unique style that is appreciated by all makes him a true inner painting master artist. Suo holds the honorary title of "Ji School's Inner Painting Patriarch".

This book has been published in recognition of Mr. Suo Zhenhai's artistic work. Through publishing a record of some of Suo Zhenhai's most valuable and exquisite pieces, Taiwanese collector Mr. Mike Ma hopes to study and cultivate widespread appreciation and understanding of the legacy left by a master inner painting artist. Hopefully, the book will also promote the art of inside painted snuff bottles. I have written this article at the sincere request of Mr. Mike Ma to celebrate the completion of this worthy project.

叶派传人索振海

叶澍英

清末内画大师叶仲三孙女及传人

　　伯父叶晓峰、家父叶莑祺承袭祖父叶仲三衣钵，继续了内画艺术的创作和发扬光大。尤其在 70 年代，指导了王习三和索振海俩位年轻艺术家，王习三日后创设了中国鼻烟壶学会；索振海原本有国画绘画基础，更在传统内画艺术上增添了文人画色彩，走出一条较为与众不同的叶派路线。

　　伯父、家父都欣赏索振海朴实好学和不张扬的个性，虽然国画底子已很不错，还长期不辞路途不便上京求教。相处时久，知之较深，更愿意倾囊相授，也曾赠与笔、壶、颜料、宣纸，家父还特别一起同赴照相馆照相留念。

　　惜天妒英才，索振海在创作高峰期，不幸早逝，所幸有收藏家马毓鸿先生，认真负责的希望把他的作品印成图册，好为后人留下宝贵的记录。我很高兴能为文共襄盛举。

2010 年 5 月 2 日

索振海（左）与老师叶莑祺（右）

Suo Zhenhai
-The Pupil of the Ye School

Ye Shuying
Late Qing Dynasty Inner Painting Master Ye Zhongsan's
Granddaughter and a Pupil of the Ye School

　　My uncle Ye Xiaofeng, and father Ye Fengqi, continued my grandfather Yeh Zhongsan's artistic legacy, creating their own pieces and further promoting the art of inner painting. In particular, they took two young pupils, Wang Xisan and Suo Zhenhai, in the 1970's. Wang Xisan later founded the China Snuff Bottle Association. Prior to the tutelage he received on inner painting, Suo Zhenhai had a strong background in traditional Chinese painting and was able to apply his knowledge, technique and style to enrich the traditional art of inner painting. By incorporating techniques used in traditional Chinese scholar painting with those he learned for inner painting Suo was able to lead a nonconformist path in artistic development as a pupil from the Ye School.

　　My uncle and father both appreciated Suo's genuinely studious and humble personality. In spite of his already refined Chinese painting skills, Suo was more than willing to travel the long distance and bear the inconvenience of travelling from his hometown to Beijing in order to master the art of inner painting. Having spent time with him and gotten to know him well, my uncle and father were willing to teach him everything they knew about inner painting. They also provided him with special pens, snuff bottles, inks and papers; my father even made a special trip to the photo studio to take a photograph with Suo.

　　It is a pity that Suo passed away at such a young age when he was at the peak of his art career. Fortunately, the private collector Mr. Mike Ma, has tried his best to catalog Suo's inner painting art pieces for publication in order to keep a comprehensive record of his artworks. I am honored to be able to write this endorsement for the publication.

May 2, 2010

索振海简介

索振海工作照

索振海，笔名"一丁"、"一石"。河北省饶阳县尹村镇大尹村人。1944年1月16日生，2006年3月28日去世。1970年，拜冀派内画泰斗王习三为师，是大师的第一代高徒；1974年，又拜内画叶派传人叶菶祺（清末内画大师叶仲三之子）为师。为国画艺术家，美术教育家，工艺美术大师，冀派内画元老。

在从事内画创作前，已在国画，剪纸，漫画，金石，版画等方面，崭露头角。他才华横溢，属天份极高的艺术家，不受限于传统内画绘画题材和笔法规矩依样勾描的技法，挥洒成画，自成一格；胸中画稿无尽，有山水晕染者，人称"壶中傅抱石"。其用色高雅清逸，浓淡有致，构图简朴清丽，或巧妙安排，妙趣横生，又时有惊人之作，不愧为"内画文人画代表大家"。无论山水、花鸟、走兽、人物、肖像、仿古，样样精通。其先天敏锐的感知力、国画纯熟的笔墨功夫、西方的绘画技法，再加上后天的不懈努力，广纳群家所长，造就了其内画令人耳目一新，难以企及的境界。

索振海部分治印

索振海绘报刊画

Brief Biography of Suo Zhenhai

Suo Zhenhai, penname "Yi Ding" or "Yi Shi", is a renowned artist talented in many fields of art. He hails from Da Yi Village of Yi Village Town, Raoyang County, Hebei Province. He was born on January 16, 1944 and passed away on March 28, 2006. He became a member of the Ji School Inner Painting Master Wang Xisan's first class of students in 1970 and later became a student of the late Qing Dynasty Inner Painting Master Ye Zhongsan's successor and son, Ye Fengqi, in 1974. Suo was a traditional Chinese painting artist, art educator, master of industrial art and a patriarch of the Ji School of Inner Painting.

Before he endeavored to master the art of inner painting, Suo was already a well-established artist in the areas of Chinese painting, paper cutting, comics drawing, seal carving and block printing. He was a talented and gifted artist. He did not confine himself to the conventional inner painting subjects, the orderly brush patterns, and the careful outlining techniques. He drew freely, creating his own style, and adopting painting drafts born from his mind. His landscape paintings completed with dye effects have allegedly been called "Chinese Painting Master Fu Baoshi's Work in a Bottle." The colors he chose to use are elegant and refreshing as well as in appropriate contrast. The layout of each painting is simple yet beautiful, with subjects arranged in a thought provoking manner which creates intriguing results. He produced numerous astonishing works in his lifetime and is in all ways deserving of the title: "the Inner Painting Scholar Style's Representative Master." Regardless of whether his paintings depicted landscapes, flowers and birds, animals, human characters, portraits or imitations, his execution with the special fine-tipped brush was always impeccable.

索振海剪纸

索振海剪纸

内画鼻烟壶图版

Inside-painted Snuff Bottles

山水

Landscape

1. 渔

<u>高 6.8 厘米　腹宽 3 厘米</u>

<u>玻璃</u>

款识："渔。戊午夏七月上浣索振海一石作。"

自古多少文人墨客，寄情山水，以渔为题，独钓寒江，抒发己志，所以能让观者耳目一新，十分不易。

见此壶者，无不啧啧称奇，惊的是作品的不俗，赞的是作品的秀雅，叹的是笔法的洗练洒脱，奇的是这竟然是鼻烟壶内画作品。

1. Fishing

<u>Height 6.8 cm　Width 3 cm</u>

<u>Glass</u>

Marks: "Fishing. Suo Zhenhai Yi Shi painted in early summer July of the year of WuWu."

In the olden days, scholars and poets who were fond of landscapes often used fishing as a subject to express their inner most thoughts; therefore, it is not easy to trigger the emotions of those who look upon a painting of the same subject.

It is, however, difficult for the viewers of this bottle to be unimpressed by its refreshing images, elegant beauty, and skillful brushwork. The fact that this painting was painted inside a bottle is truly amazing.

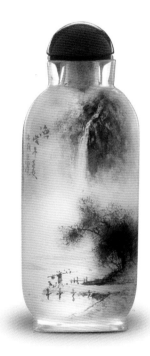 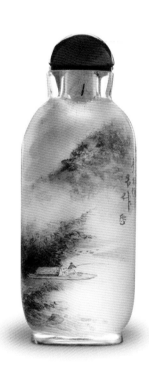

2. 访友

高 6.8 厘米　腹宽 3 厘米

玻璃

款识："访友。时在庚午暮春索振海于津南古城。"

此壶水墨之精彩和人物之生动，让人不自觉的会赞叹作者的水墨功力。较难想象的是，这完全是在倒钩笔透过小壶口反方向、又看不见笔尖的条件下，不容迟疑的挥洒即成。不同于传统内画的笔画临摹和细琢，观者感受的是一种惊艳，也是一种能量的释放，从中印证着索振海"笔墨神奇，妙法天地"的才情。

2. Visiting a Friend

Height 6.8 cm　Width 3 cm

Glass

Marks: "Visiting a Friend. Suo Zhenhai painted at the southern part of Jing Old Town in late spring of the year of GenWu."

When one lays eyes on this bottle and sees the splendid water ink and lively human characters, one cannot help but admire the artist's water-ink technique. It is hard to imagine that such delicate and beautiful images were painted with crooked, hook-shape brush pens through a narrow bottle opening. The artist must paint backwards and without seeing the brush tips. Each stroke must be done without hesitation, as there is no way of fixing mistakes. Unlike traditional inner painting works, which are typically careful imitations and tracings, spectators feel shocking beauty and free empowerment which echo Suo Zhenhai's "magical brush strokes following the nature" talent.

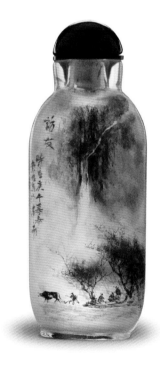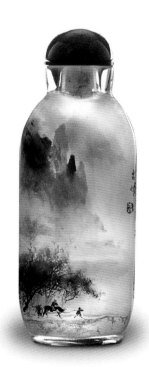

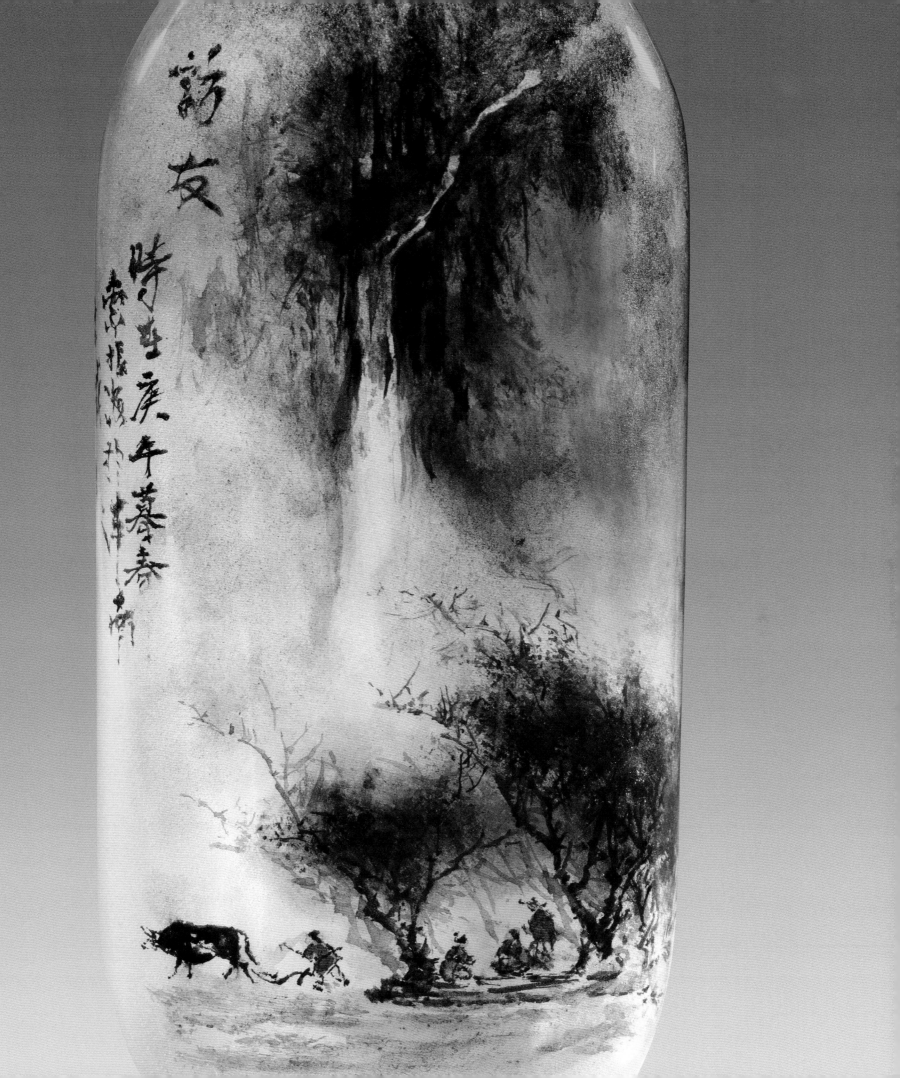

3. 寿山访友

高 7 厘米　腹宽 4.8 厘米

玻璃

　　款识："寿山访友。戊辰三月上浣索振海一石作。"

　　壶中山水画笔墨精湛，构图层次分明，画中人物融入景色，沁透清丽雅致的文人画风。作者虽有类似题材山水，但非一成不变，常因壶的形体、大小随机再创作。

3. Visiting a Friend at Shou Mountain

Height 7 cm　Width 4.8 cm

Glass

　　Marks: "Visiting a friend at Shou Mountain. Suo Zhenhai Yi Shi painted in early March of the year of WuChen."

　　The landscape paintings of this bottle demonstrate wonderful brushwork. The artist paints this bottle with distinct color gradations to show the different layers of the painting. The people blend in and become one with the scenery through the artist's elegant scholarly painting style. Although the artist has other similar landscape pieces, no two landscape paintings are the same as even the same subject matter must be approached differently depending on the size or shape of the bottles.

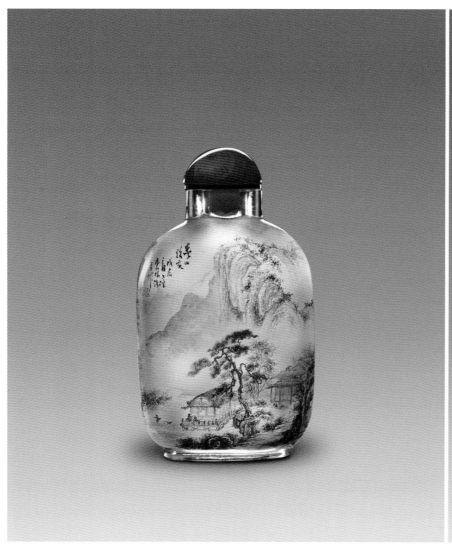
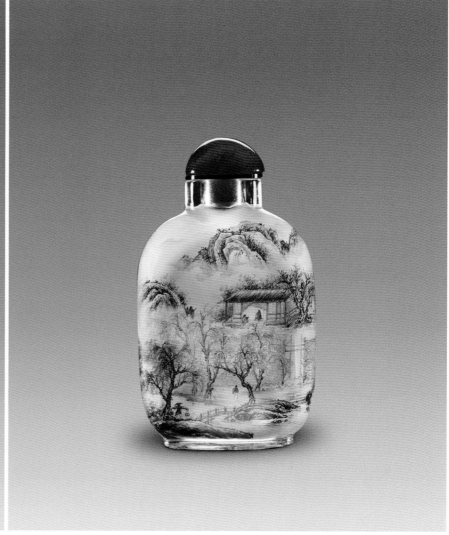

4. 秋林放牧

高 7.5 厘米　腹宽 5.5 厘米

玻璃

　　款识："戊午索振海作。"

　　此壶两面，一面是描绘风吹树动人欲止，生动地绘出风抓树梢，牧童握紧蓑衣、催牛逆风行和追落帽的动态景象；而另一面是恬静悠哉无所求，牧童树下小栖、牛儿湖边偷闲的景象，动静对比两样情。作者透过画面，轻易影响观画者的感触，即见作者功力。

4. Grazing in the Autumn Woods

Height 7.5 cm　Width 5.5 cm

Glass

　　Marks: "Suo Zhenhai painted in the year of WuWu."

　　Both faces of this bottle are painted: One side pictures a scene in which the wind is blowing and trees are swaying. The human characters are shown to want the wind to stop blowing; this creates a lively image of the wind catching the tree's branches and a herdsman chasing his hat. The other side of the bottle, on the other hand, shows a tranquil scene, with a herdsman resting underneath the tree and cows snatching a moment of leisure beside the lake. The moving contrasts the still. The artist's drawings evoke powerful emotions, hence demonstrating his artistic influence.

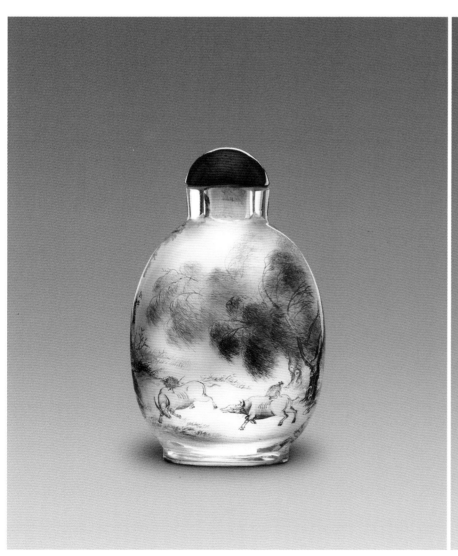

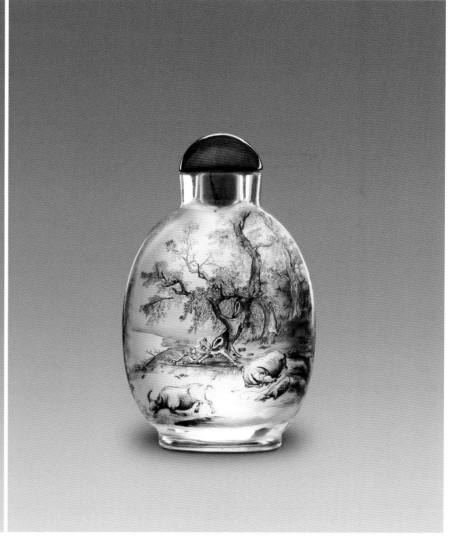

5. 四季山水 （一组四个）

高 7 厘米　腹宽 3.2 厘米

玻璃

春壶款识："戊午三月中浣一石索振海作于京南古城"；

夏壶款识："戊午夏月一石索振海作于京南古城"；

秋壶款识："戊午秋八月中浣一石索振海作于京南古城"；

冬壶款识："戊午冬十一月上浣一石索振海于津师。"

四季山水之于内画鼻烟壶，即是八帧山水依四季风貌，在方寸间展现天地节气。对壶型的熟悉，挥洒成画，不拘泥于一树一丁的相对位置。

作者追求完美画面的整体效果，胸有画稿，自然流露出对四季的礼赞。但也不放弃所有的细节，可远观，也可静赏细品之。无论春郊走驴、嫩芽初绽，夏雨访友、熟绿昌盛，或是秋江垂钓、枫红点点，冬雪过桥、枯木萧瑟，皆刻画生动，丝丝入扣。这不仅仅是精彩内画，即便以外画标准，亦是上乘之作。作者不常创作此类壶组，世面少见。

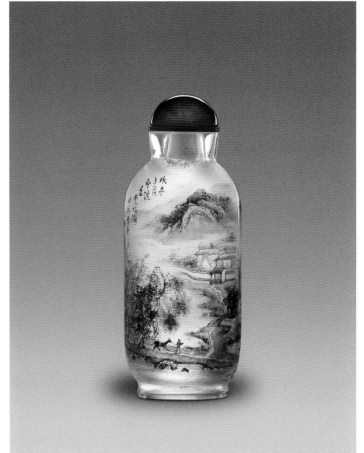

5. Landscapes in Four Seasons
(A Set of Four Bottles)

Height 7 cm　Width 3.2 cm

Glass

Spring bottle marks: "Yi Shi Suo Zhenhai painted at the south of Jing Old Town in mid-March of the year of WuWu;"

Summer Bottle marks: "Yi Shi Suo Zhenhai painted at the south of Jing Old Town in the summer month of the year of WuWu;"

Autumn bottle marks: "Yi Shi Suo Zhenhai painted at the south of Jing Old Town in autumn mid-August of the year of Wuwu;"

Winter bottle marks: "Yi Shi Suo Zhenhai painted at Jing Shi in the winter early November."

For the inside-painted bottles, there require eight pictures of landscapes for the four seasons showing the seasonal weather changes. The artist made the most of his training in traditional Chinese painting, drawing samples in his mind. He familiarized himself with the shapes of the bottles in order to freely express his painting desires. He was not confined by the relevant locations of a tree to a man.

He pursued the overall perfect art effects first; and, his praises of four seasons from the painting came through naturally. The paintings can be appreciated both from a distance and closely, regardless of the painting's subject matter: a donkey walking in the spring countryside, a scene of burgeoning green leaves, a man visiting a friend in the summer rain, a scene depicting prospering dark greens, a fishing excursion on the river in autumn, a dotty red maple scene, a person crossing a bridge in winter snow, or a scene showing withering dry woods. These images are all vivid and precise. They are not only outstanding inner paintings but are also considered to be very fine works of art when measured against the standards of traditional Chinese painting. It is rare that the artist created this series and there are very few of its kind on the market.

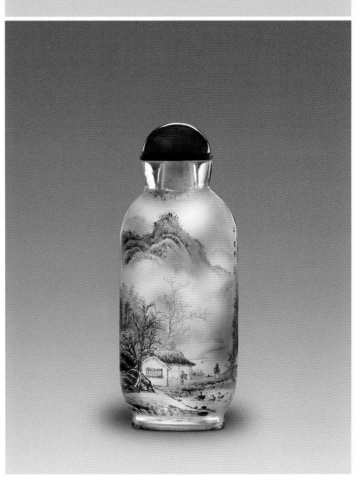

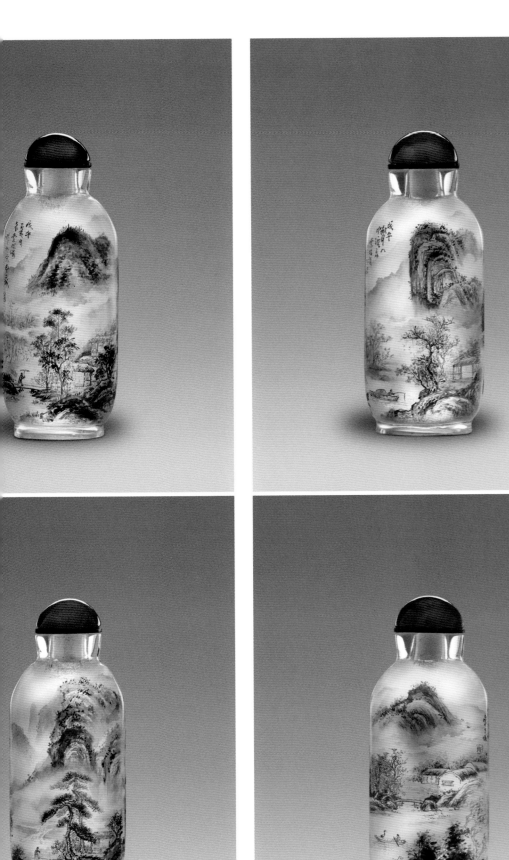

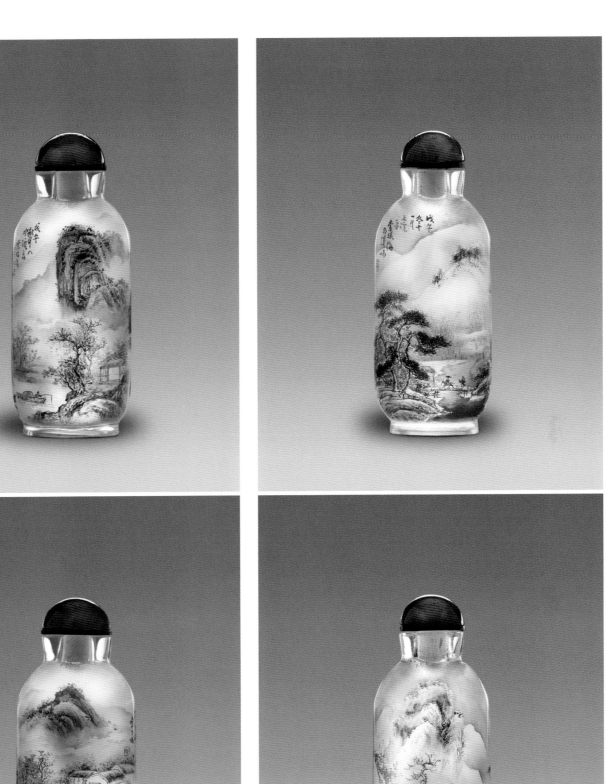

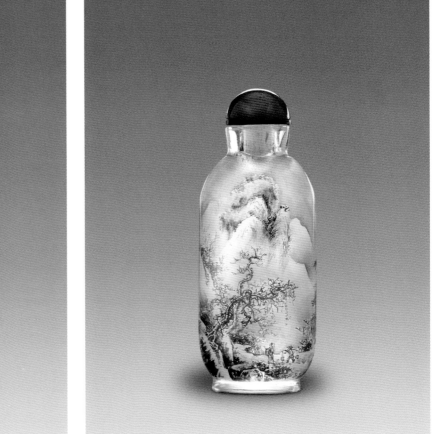

6. 飞瀑直下三千尺

高 5.7 厘米　腹宽 3.5 厘米

玻璃

款识："飞瀑直下三千尺。戊寅夏索振海作。"

水墨瀑布和树海是作者山水画的独到之处，纸上如能达到此渲染成果已属上品，遑论方寸间以倒钩笔流畅完美成就。再看其构图，瀑布巨石气势恢弘，背面树海云山，秀丽典雅，再观人物个个形态活灵活现，犹如画龙点睛。惜此主题作品并不多。

6. Falls Plummeting Three Thousand Feet

Height 5.7 cm　Width 3.5 cm

Glass

Marks: "Falls Plummeting Three Thousand Feet. Suo Zhenhai painted in the summer of the year of WuYin."

Water-ink waterfalls and trees are the artist's specialties. Had these images been created on paper, they would already be considered excellent works of art; to think that these were done in inches-space with the smooth and precise brush strokes of hooked-shape pens. If one were to look at the layout of the paintings, one would observe falls against majestic rocks; and on the other side the tree waves meshed with mountain clouds to create a graceful beauty, and the lively characters' movements and appearances like the final magic touch in the paintings. It is a pity that the artist did not work with this subject matter more.

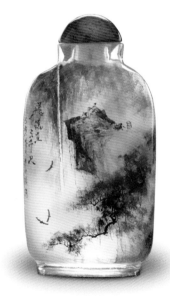
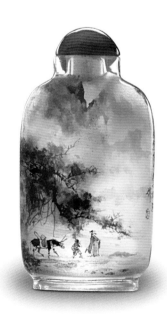

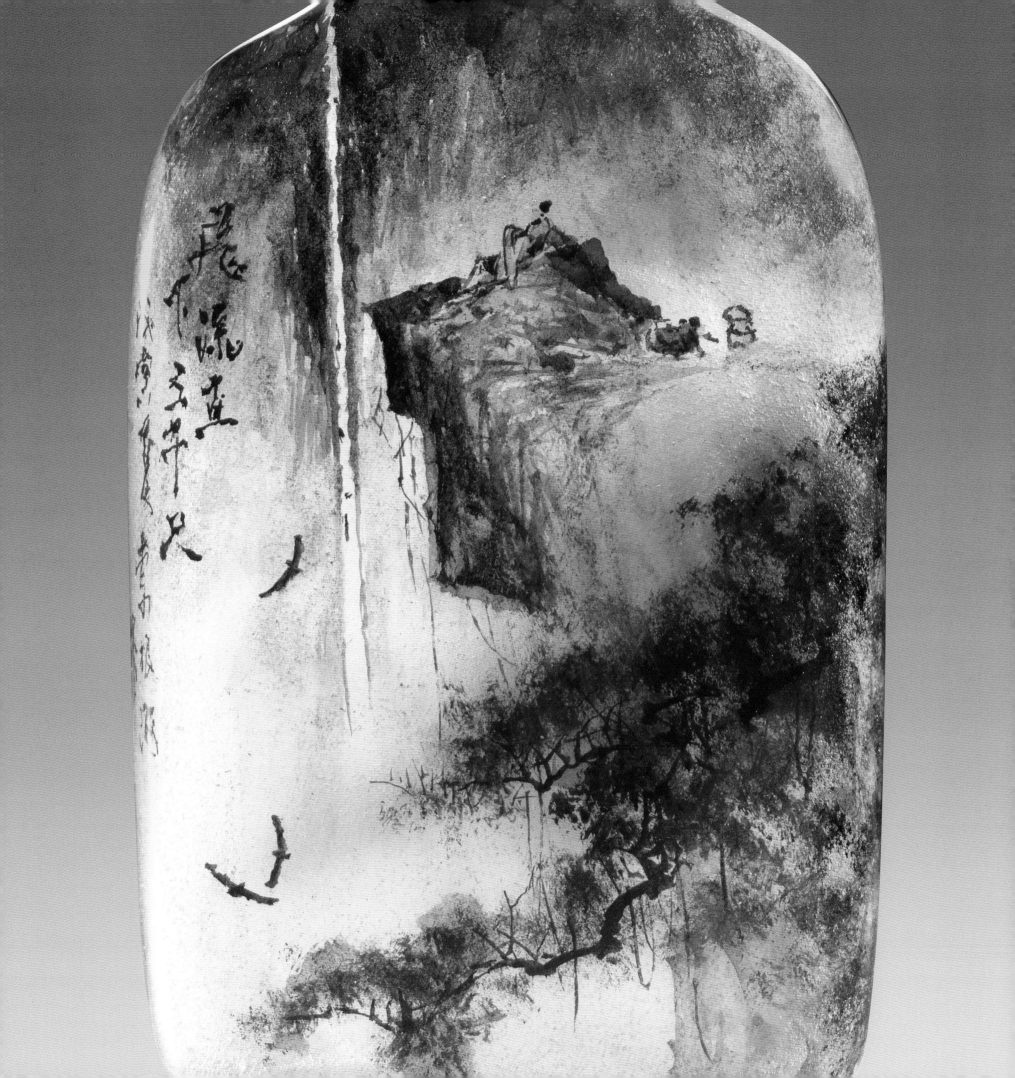

7. 读

高 7 厘米　腹宽 5.5 厘米

玻璃

款识："读。戊寅三月一石索振海作。"

此为同类题材中的精品，墨色晕染的树海，巨岩上的骚人墨客，对着远山深涧，吟诗作对，发思古幽情。笔意洒脱，浓淡恰到好处，背面所绘深林书屋，岂不是《陋室铭》中谈笑有鸿儒、来往无白丁的情境吗！

7. Study

Height 7 cm　Width 5.5 cm

Glass

Marks: "Study. Yi Shi Suo Zhenhai painted in March of the year of WuWu."

This bottle is representative of its kind. It depicts trees painted with a blurred ink effect as well as poets on a giant rock facing waterfalls and mountains in the distance, all touched with handsome brush works and the image on the other face of the bottle shows a scholar's study located deep in a forest. This is the scene described in the famous "Shabby House Poem (LouShiMin)"—Renowned scholars chatting and laughing in a room without common folks bothering them.

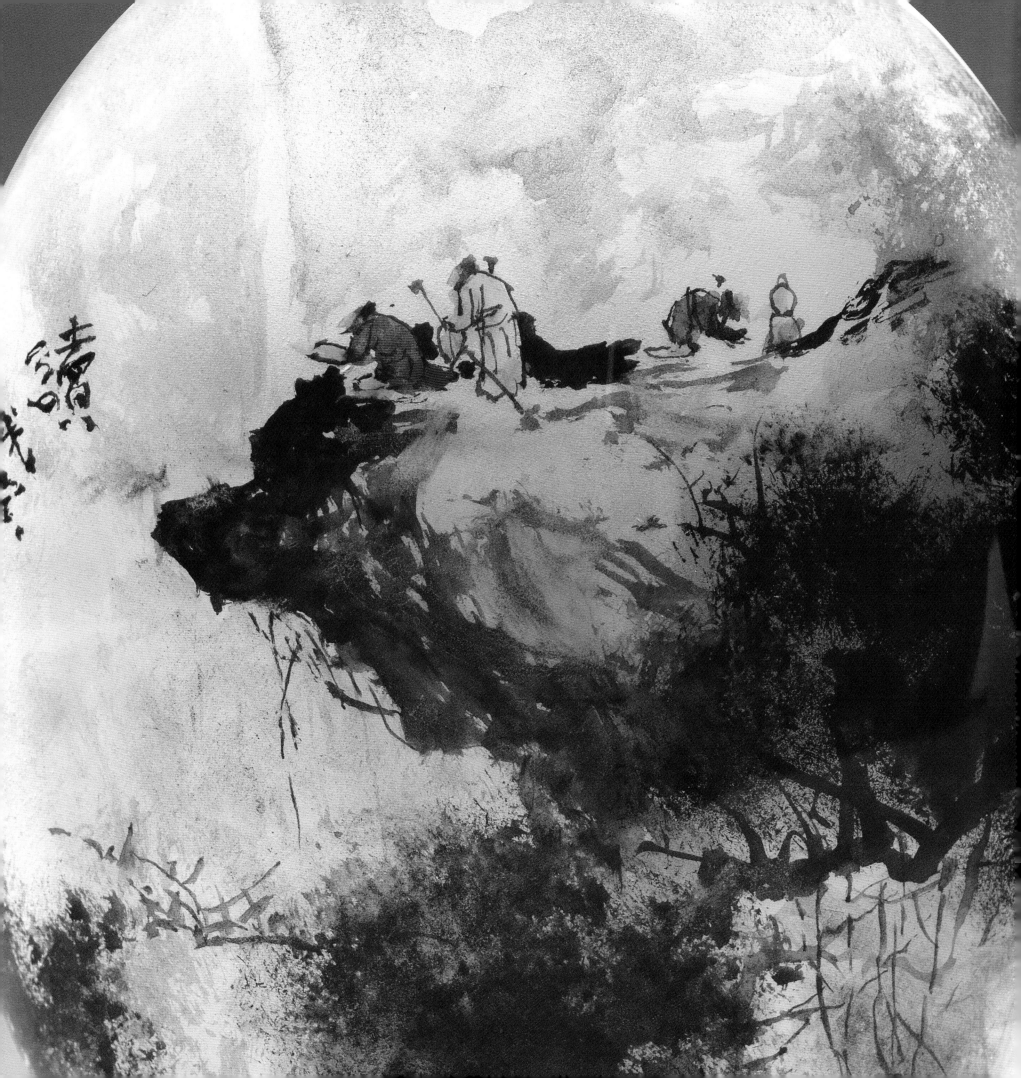

8. 居山图

高 5.9 厘米　腹宽 3.6 厘米

玻璃

款识："居山图。戊寅三月索振海一石作。"

此壶颇有宋代文人画之风致，典雅不铺张，秀丽不繁琐，构图匀称，设色简约，清新自然，虽是古画笔意，在内画不常见此高水平之传统山水画作；一则内画沿袭历史尚短，一则有深厚文人画功底之内画家有限，纵观其作品，堪称"内画文人画代表画家"。

8. Mountain Dwelling

Height 5.9 cm　Width 3.6 cm

Glass

Marks: "Mountain Dwelling. Suo Zhenhai Yi Shi painted in March of the year of WuYin."

This work was influenced by the Song Dynasty Scholar painting style—elegant yet subtle, gracious yet uncomplicated. The layout is balanced, color selection is simple, refreshing and effortless. Although this bottle is meant to be more like a Chinese traditional painting, it is quite rare that a traditional landscape painting of such high standards be demonstrated by an inner painting artist because the history of inner painting is relatively short and fine traditional scholar inner painting artists are so few. Judging by Suo Zhenhai's impeccable technique and the breathtaking results of his gift and skills, he definitely deserves the title, "The Inner Painting Scholar Painting Representative Artist."

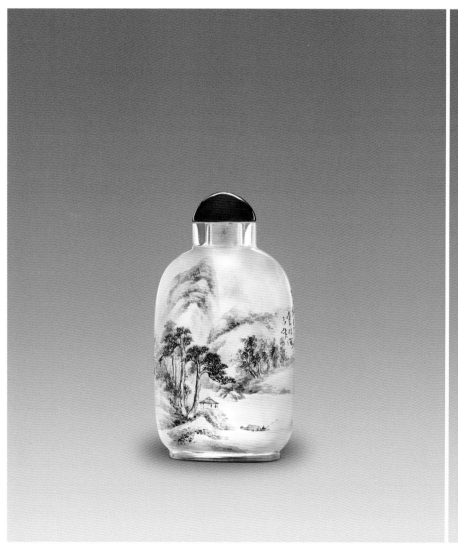
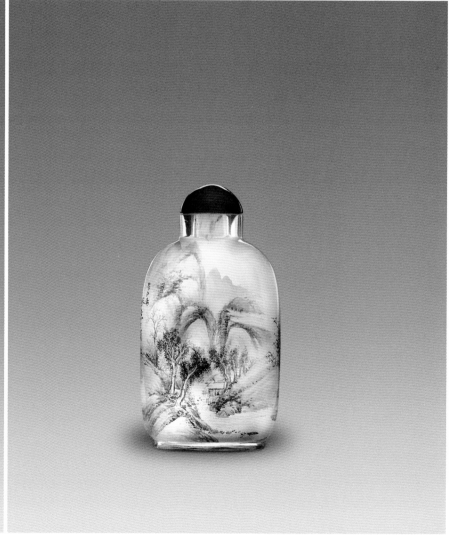

9. 松岭探幽

高 6.7 厘米　腹宽 4.7 厘米

玻璃

款识："甲辰夏月索振海一石仿作。"

此壶为按比例缩小的仿古山水画。画中近处的人与驴却是如此渺小，可以想象原来远处的崇山峻岭是多么的崇伟；壶的另一面为劲风杨柳，路人拉驴，骑驴人寸步难行撑伞顶风行走，再有行船人勉力逆行的景象，画中细节皆清楚交代，气韵生动。

9. Pine Cliff Excursion

Height 6.7 cm　Width 4.7 cm

Glass

Marks: "Suo Zhenhai Yi Shi imitated in a summer month of the year of JiaChen."

This work was imitating and resizing old landscape pictures. The person and donkey close by are so tiny; in perspective, the cliffs and mountains far away are meaningfully high and grand. On the other side, the details of willows swung by strong wind, the pedestrian pulling the donkey with both hands, the donkey rider moving inch by inch and the pedestrian holding an umbrella against the wind are all carefully taken care of and summed up to be lively and moving.

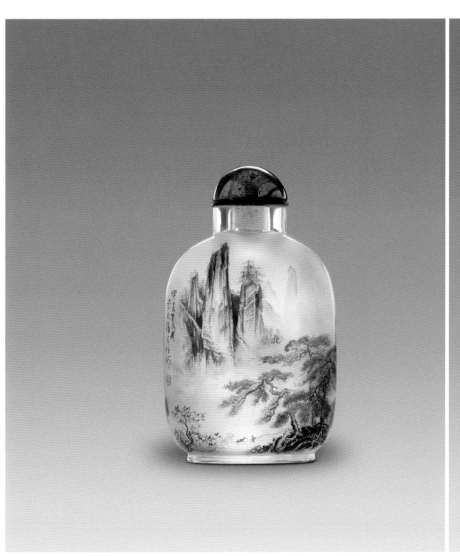
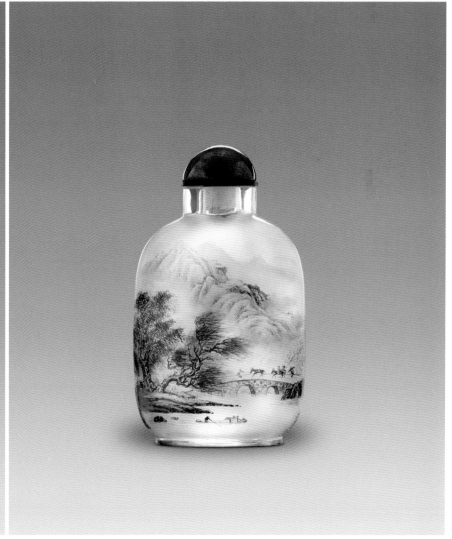

10. 晚霞满天

高 6.3 厘米　腹宽 5.8 厘米

树脂

款识："戊寅三月一石作。"

此壶材质成色特殊，壶带宝石透明橘红色，衬出晚霞般的色泽。无论山屋读卷鸿儒，或是船夫撑杆离坞，皆有晚霞彩满天、山色随人归的情趣，别有一番风情。作者采用此种特殊材质内画，只此一件。

10. Red Dusk

Height 6.3 cm　Width 5.8 cm

Resin

　　Marks: "Yi Shi painted in March of the year of WuYin."

　　The material of this bottle has a unique color—the orange-red shade of transparent jewelry which shines dust-like coloration. No matter what the scenes are, the scholar studying in the mountain cabin or the boater pushing the pole away from the port, they all have the dusk color. This is the only work of the artist that is done in this special material.

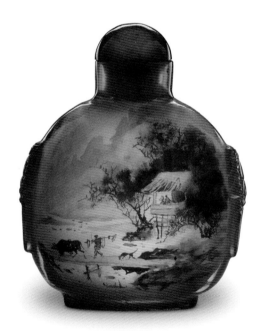 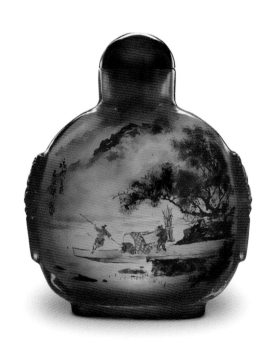

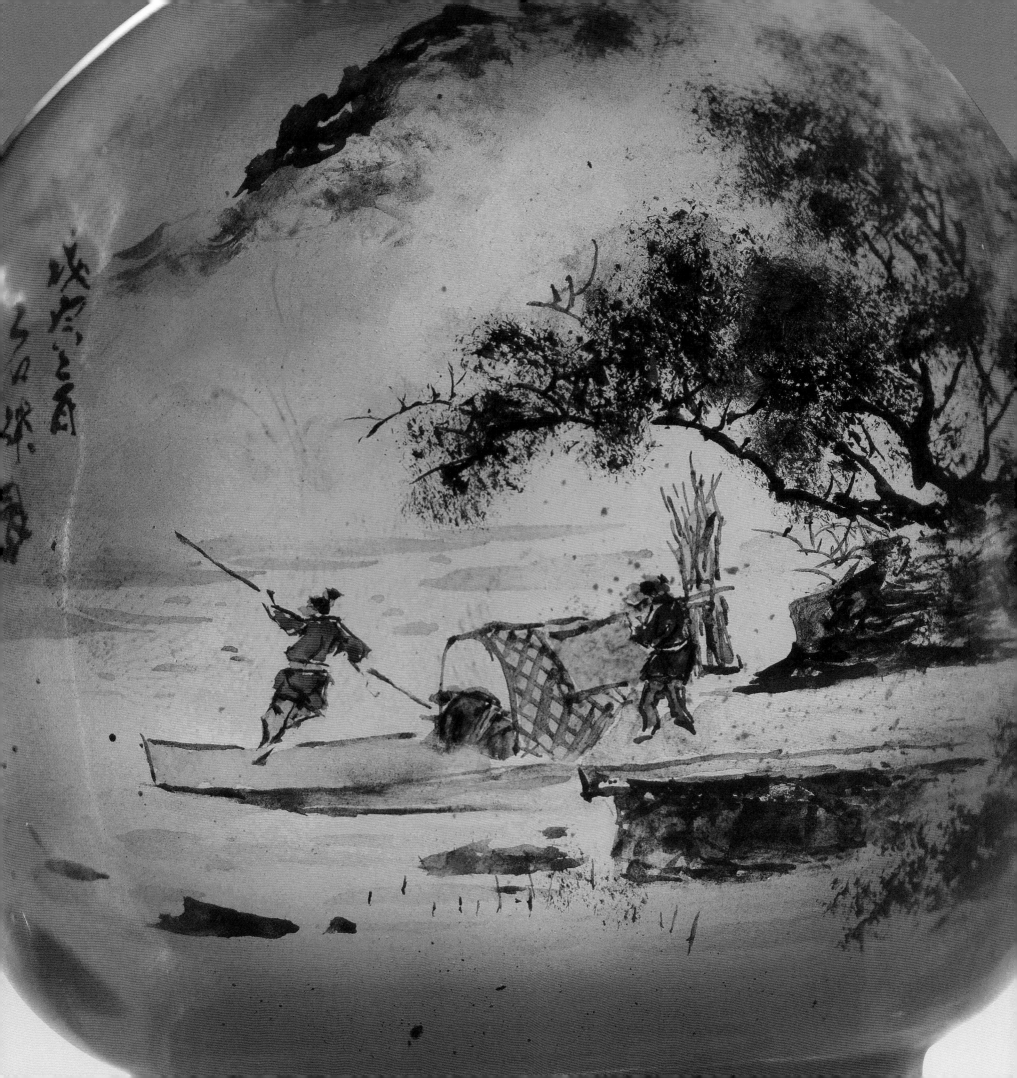

11. 访友

高 7.2 厘米　腹宽 5.6 厘米

玻璃

款识："访友。癸未索振海一石作。"

此壶不同于其他访友壶，是其即兴佳作。画面山涧云雾缭绕，远山瀑布，小桥流水，樵夫家犬引路至友宅。虽居乡间茅舍，仿佛人间仙境，意境幽远，不可言喻。

11. Visiting a Friend

Height 7.2 cm　Width 5.6 cm

Glass

Marks: "Visiting a Friend. Suo Zhenhai Yi Shi painted in the year of GuiWei."

The artist has some other works of the same title. This one is different from the others in that it is an impromptu piece—cloud and fog surrounding the mountain creek, waterfalls and a mountain range far away, a bridge over water, a woodsman's dog leading his master to a friend's house. In spite of the humble house, all these images combine to create a heavenly scene, speechlessly deep and handsome.

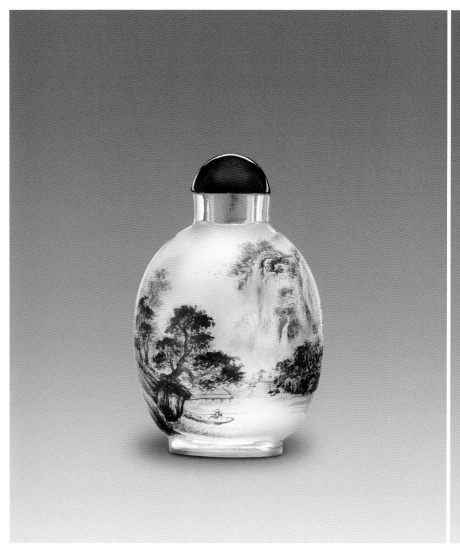 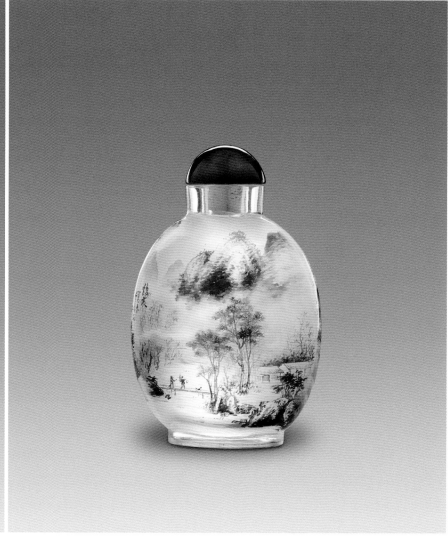

12. 雪月

高 7.1 厘米　腹宽 5 厘米
玻璃

款识："雪月。甲子冬月一石索振海仿作。"

绘雪景要达到用色简约，层层迭色，不乱有序，虽壶中满画，却有雪夜空旷凄迷之感，此乃仿古之作，但正如所有优秀画家临摹一样，不仅像，往往有新精神。

此画古意盎然，以内画重现，不失其气势，反见其构图严谨，容整图于壶，度衡比例，取景裁冗，恰到好处，宛如重新创作。

12. Snow Moon

Height 7.1 cm Width 5 cm
Glass

Marks: "Snow Moon. Yi Shi Suo Zhenhai imitated in a winter month of the year of JiaZi."

Painting snow scenery requires a selection of simple colors, and the ability to arrange the different layers of coloring in the right sequence. Although the inside of the bottle is fully painted, the viewer still feels the emptiness and sadness of a snowy night. This is an imitation of an old work; however, like all excellent imitation works, the original piece and the imitation are not exactly the same and the imitation is instilled with a new and distinct sprit. This work is full of traditional accents that are presented through these inner paintings which show the carefully restructured outlay—putting the entire picture into the bottle with appropriate resizing and cutting like a new creation.

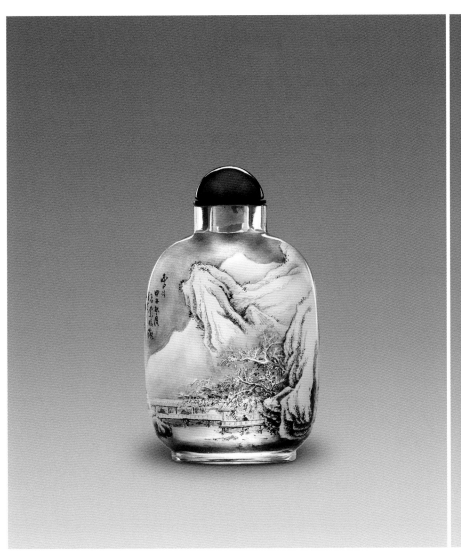

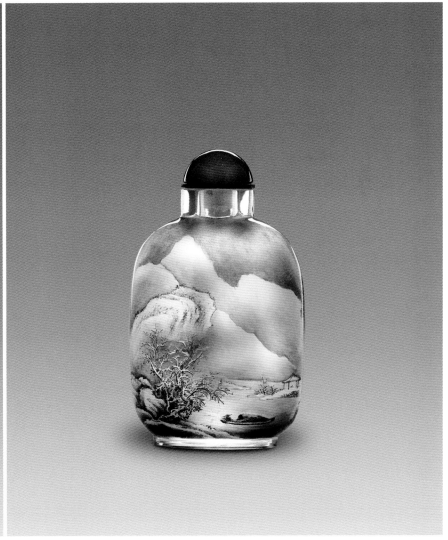

13. 平沙落雁

高 6.2 厘米　腹宽 6 厘米

玻璃

　　款识："平沙落雁。甲申冬月十一月下
浣一石索振海作于津古城三一房舍。"

　　此壶画面绘晚霞满天，千百飞雁落雁，或
成列，或孤单，时高时低；有遨翔天际，有戏水
浅滩；岸边观雁，一望无际，天远景深，抒发心
志，遗世独立，画足以言志，但又意犹未尽。

　　画面以类似广角镜头拉长拉远，心想落
雁平沙入镜，细细笔触，点活雁飞雁落，分出
由近至远多层次空间，平远空旷，营造出凄凄
然的氛围，是掌握意境之精品。类似作品共
两件，弥觉珍贵。

13. Wild Geese Landing on the Sandy Shore

Height 6.2 cm　Width 6 cm

Glass

　　Marks: "Wild Geese Landing on the Sandy Shore. Yi Shi Suo Zhenhai painted at Three One House of Jing Old Town in late winter November of the year of JiaShen."

　　Dusk colors the entire sky; hundreds and thousands of wild geese flying in the sky or landing on the beach, in a queue or alone, high or low, A spectator observes the wild geese from the shore, against the backdrop of a limitless sky, gazing off into the distant horizon in deep contemplation, liberating his mind,. The pictures can speak to his mind but it does not seem to be enough.

　　In this bottle the artist employs techniques such as the wide-angle lens taking a long and far shot, thinking and taking the scene of wild geese landing on flat sands; his precise brush strokes give life to the flying and landing geese as well as enable the viewer to discern between the different layers of spaces from the near to the far. This is an exquisite work of artistic conception, one of the mere two works of its kind by the artist, making it an exceptionally valuable piece.

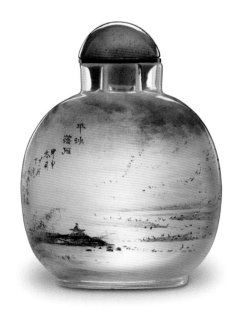 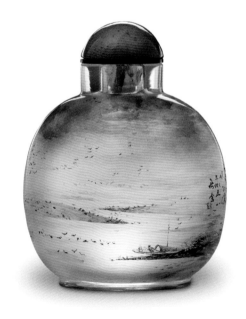

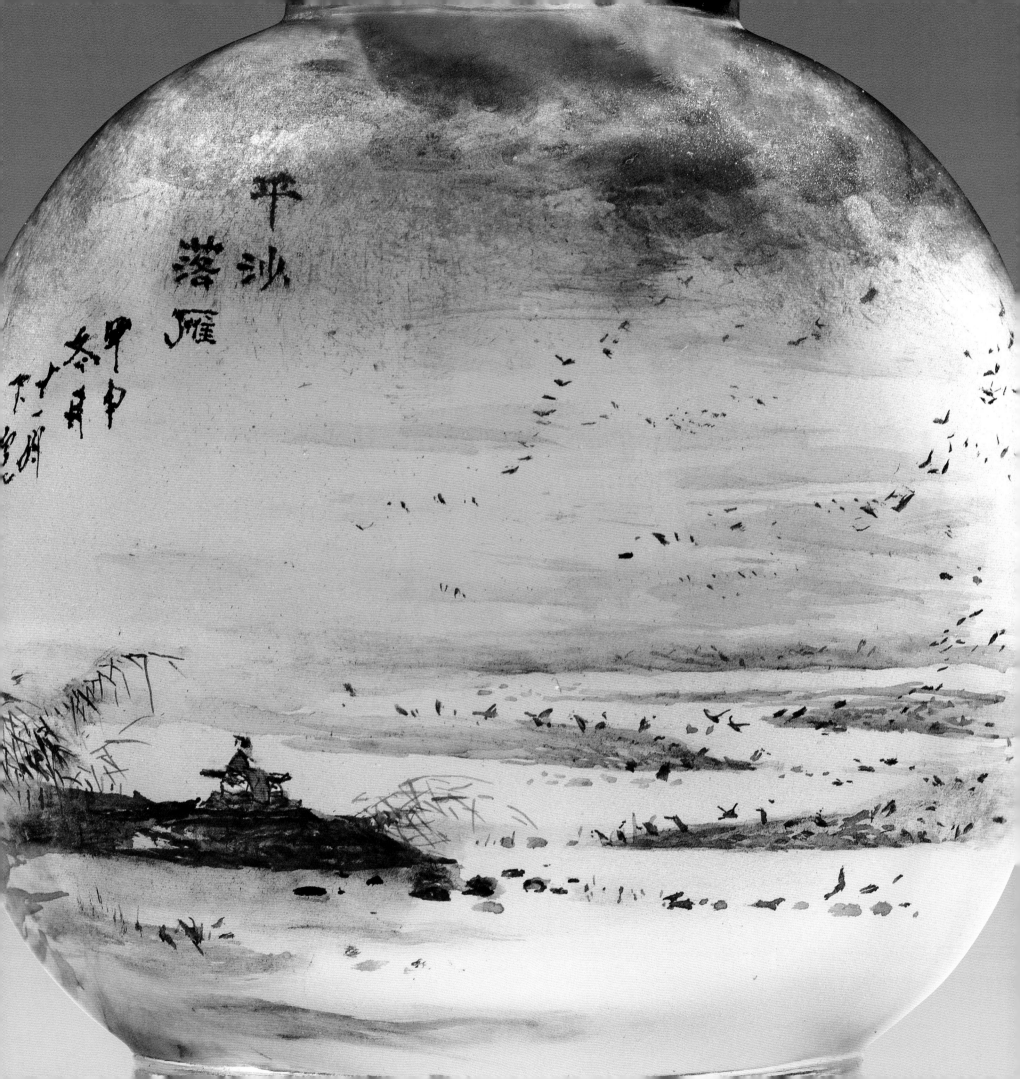

14. 风雪夜归人

高 5.8 厘米　腹宽 3.7 厘米

玻璃

　　款识："日暮苍山远，天寒白屋贫，柴门闻犬吠，风雪夜归人。乙酉年一石作。"

　　把此唐诗作画，说明作者描绘诗境，入木三分，是不可多得的创作绝品。

　　壶另一面款识（楷书）："日暮苍山远，天寒白屋贫，柴门闻犬吠，风雪夜归人。唐刘长卿逢雪宿芙蓉山主人。乙酉年初春三月索振海一石作。"

14. A Man Returns Home in a Blizzard

Height 5.8 cm　Width 3.7 cm

Glass

Marks: "At sunset the dark mountains and skyline are far off in the distance. From the shabby wooden door of the white house, the dog's bark is heard as the man comes back home on a windy, snowy night. Yi Shi painted in the year of YiYou."

The artist turns this Tang dynasty poem into a picture which demonstrates the artist's ability to picture a poem lively and this is an exclusive creative piece.

The marks were written with regular scripts on the other side: "At sunset the dark mountains and skyline are far off in the distance. From the shabby wooden door of the white house, the dog's bark is heard as the man comes back home on a windy, snowy night. Staying at Peony Mountain Host's in a Snowy Night by Liu Zhangqing of Tang Dynasty. Yi Shi painted in spring early March of the year of YiYou."

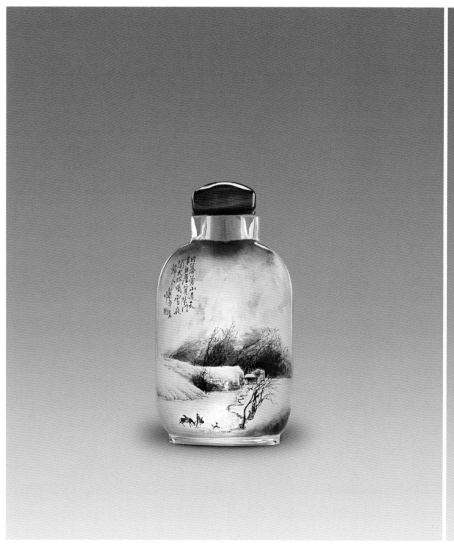
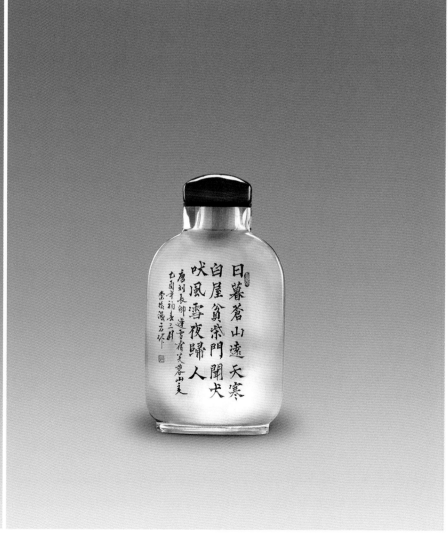

15. 山林亭阁

高 6.2 厘米　腹宽 6.2 厘米

玻璃

款识："甲午索振海一石作。"

壶正面亭阁风景设色只用几种颜色，却产生西方水彩风景画的效果。一抹淡橙带出晚霞满天和谧静的氛围；另一面的山林雪夜，用的也是西画的笔触，透视表现由近处深色林中溪带至远山，层次丰富。

此作品再次展现作者多方位的艺术才华。同类题材内画作品只有两件。

15. Pagoda in a Mountain Forest

Height 6.2 cm　Width 6.2 cm

Glass

Marks: "Suo Zhenhai Yi Shi painted in the year of JiaWu."

The pagoda scene depicted in this inner painting only uses a few colors. It is a piece reminiscent of western water color landscapes—particularly in the brushes of light orange that emphasize the colors of dusk and create a tranquil atmosphere. The snowy mountain forest scene on the opposite side of the bottle also demonstrates western techniques and varying depths; the dark colored creek in the foreground and leads to the mountains in the distance, layer by layer.

This work again shows the artist's versatility in technique. He has only one other work of the same subject matter.

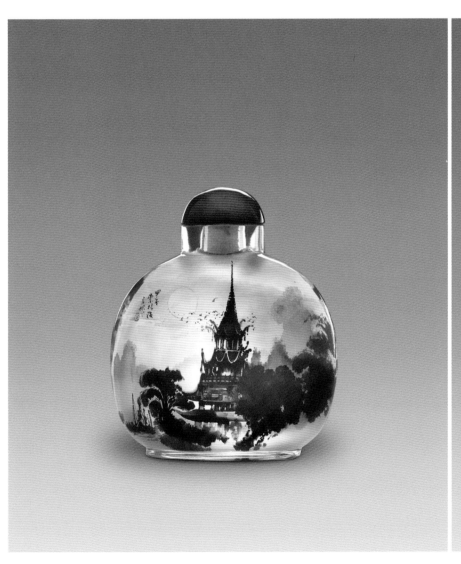
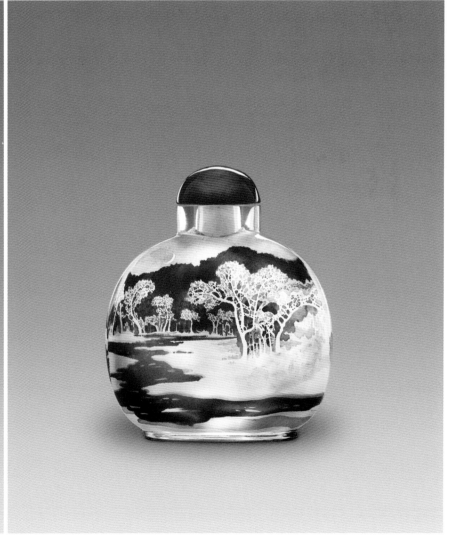

16. 山溪待渡

高 5.1 厘米　腹宽 2.4 厘米

无色水晶

款识："戊寅三月索振海一石作。"

在小尺寸鼻烟壶画山水，难度更高些。须考虑如何在极小的空间，营造出水墨山水的气势和壮丽，笔墨的细致要求，更不在话下。此壶不但作到了，其中的水墨晕染，出神入化，点上生动的人物，精妙高超，无与伦比，是不可多得的作品。

16. Mountain Stream Expecting the Arrival of a Boat

Height 5.1 cm　Width 2.4 cm

Rock Crystal

Marks: "Suo Zhenhai Yi Shi painted in March of the year of WuYin."

While it is difficult to paint anything within inches of space, it is probably most difficult to paint landscapes in a tiny snuff bottle. The artist must create the grandeur of water ink landscapes in a very limited amount of space. The amount of detail and precision necessary to paint an outstanding inner painting landscape is incredible; however, the artist was able to achieve this level of artistic performance in this piece. The water ink dyeing effects employed in this bottle are superb and the lively painted human characters are simply exquisite. Needless to say, this bottle is an extraordinary piece of work.

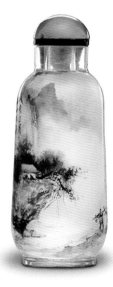
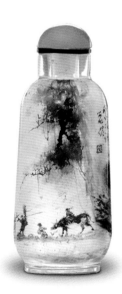

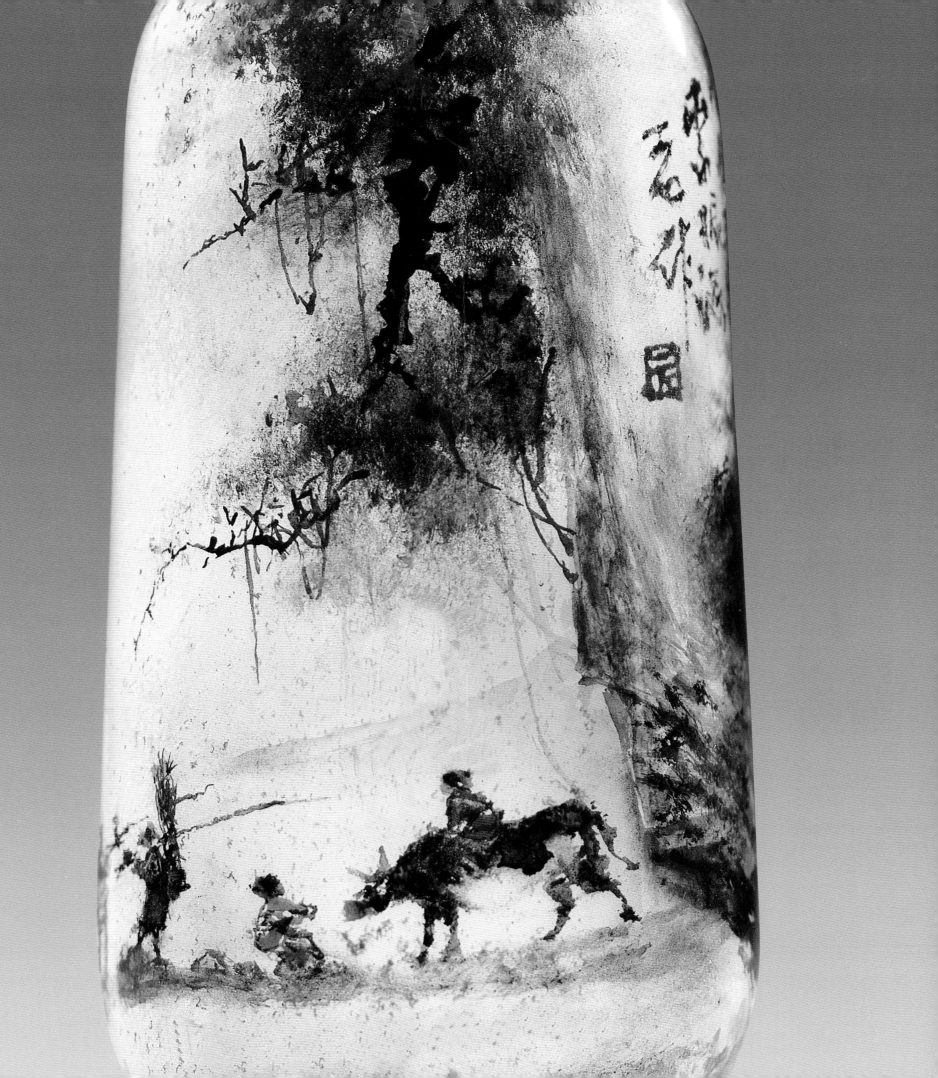

17. 雪月寒林

高 7.3 厘米　腹宽 4.8 厘米

玻璃

　　款识："戊辰索振海一石作。"

　　壶面满满的庞然大树，虽不特意营造触目惊心的感觉，却有肃然起敬的悸动。不似传统国画艺术的阐述方式，略带西画突出夸张的取景，写实中带水墨写意；壶另一面绘月夜雪景，也是西画的笔触和情趣。

　　此类作品虽非作者熟悉的山水题材和笔法，却产生了不凡的视觉效果。亦是作者尝试性的孤品。

17. Snow Moon
 in the Freezing Woods

Height 7.3 cm　Width 4.8 cm

Glass

　　Marks: "Suo Zhenhai Yi Shi painted in the year of WuChen."

　　The large and majestic tree fully occupies the surface of the bottle. The artist may not have intended to evoke feelings of awe in the viewer, but that is exactly what those who lay eyes on this bottle feel. Unlike traditional Chinese art forms, this piece includes elements of western painting styles: bold and exaggerated artistic statements, as well as techniques similar to western realism combined with touches of Chinese water ink style. The opposite side of the bottle depicts a snow scene on a moon-lit night that is also reminiscent of western painting techniques and interests.

　　Despite the fact that the subject matters of these two inner paintings are not created using techniques the artist is familiar with, he still successfully creates extraordinary visual effects. This bottle also happens to be the artist's exclusive experimental piece on this subject.

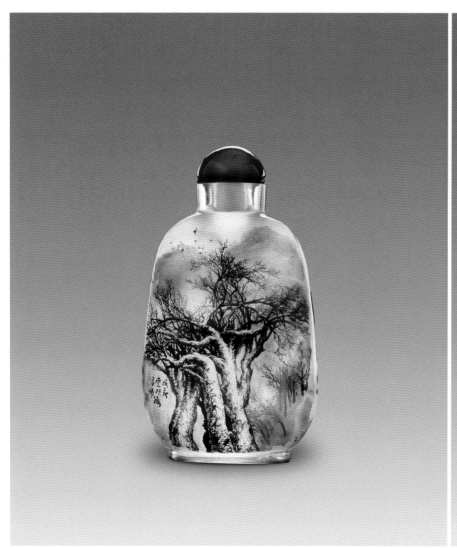
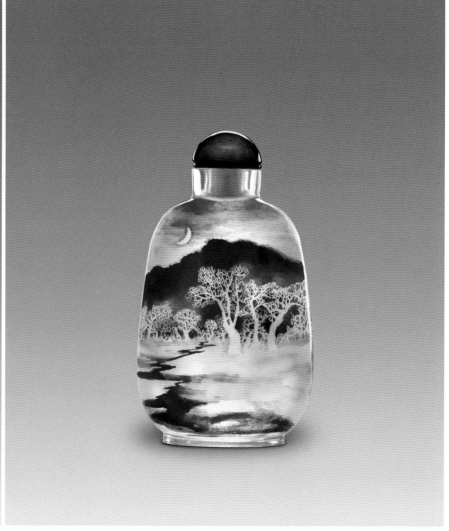

18. 冬

高 6.8 厘米　腹宽 5.3 厘米

玻璃

款识："冬。索一石作。"

作者时以冬景为题作内画山水，唯此壶特殊，亦是独一无二的作品。取景冰雪寒钓，寒天旱地冰撬，皆少人尝试之题材。

此壶生动刻画了古时深冬民间的户外生活，白色雪景用色收发自如，层次丰富有变化，亦是难得佳作。

18. Winter

Height 6.8 cm　Width 5.3 cm

Glass

Marks: "Winter. Suo Yi Shi painted."

Occasionally, the artist would paint unusual scenes from winter such as ones of fishermen ice fishing or people riding snow sleighs; such subject matters are seldom used in traditional Chinese paintings. This bottle is an exclusive piece on winter.

This bottle vividly pictures various outdoor activities enjoyed by the common people during wintertime. The artist demonstrates complete mastery of the coloring technique for snow scenes; evident in the balanced and effective use of different shades of black and white in the painting.

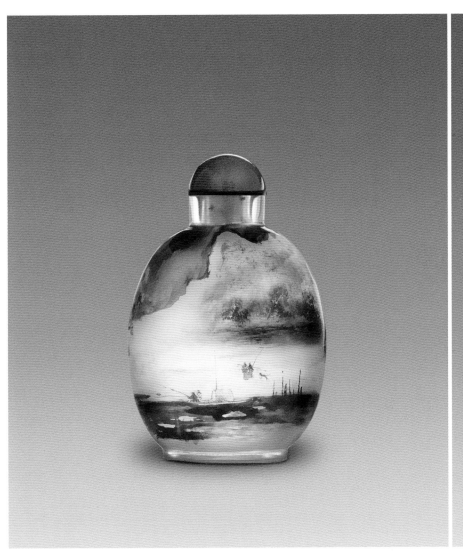
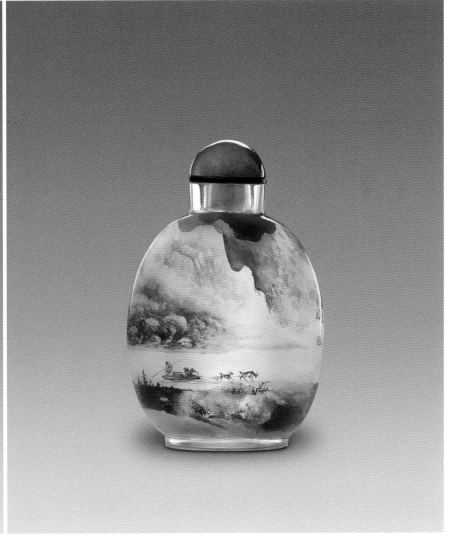

19. 山水渔家

高 6.4 厘米　腹宽 6 厘米

玻璃

　　此壶内画设色淡雅清丽，有如雨过天青，画中构图田园生活，傍山陋室，平溪渡舟，恬静幽远。观此壶者，向往遗世独立、与世无争的心境，油然心生。

19. Fisherman and Landscape

Height 6.4 cm　Width 6 cm

Glass

　　The inner paintings in the bottle display elegant and simple colors that are appropriate for the natural beauty of the scenes they depict, such as the blue sky after rain. These paintings picture life in the countryside: a humble home next to a mountain, tranquil and idyllic. Those who lay eyes on this bottle might contemplate what it must feel like to be alone and completely serene.

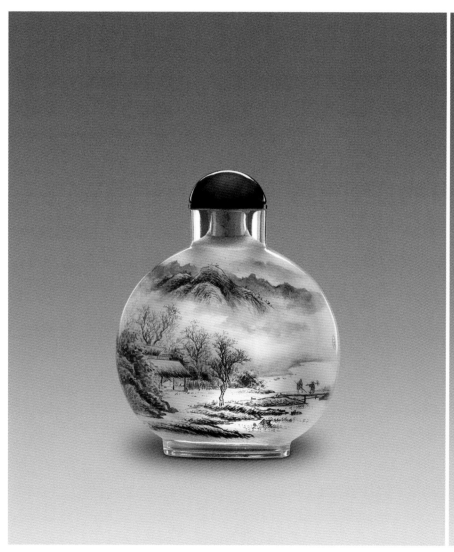

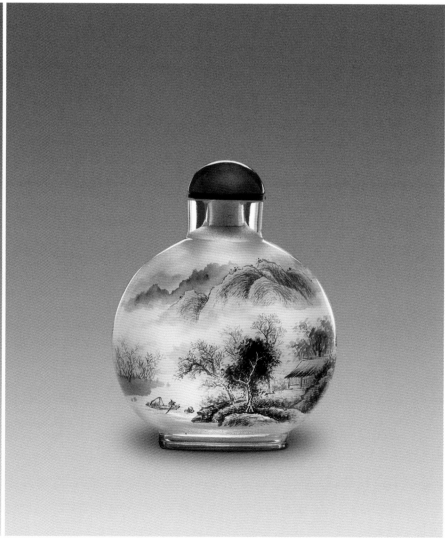

20. 丛林密雪

高 7.2 厘米　腹宽 4.5 厘米

玻璃

款识："戊午索振海一石作。"

壶两面绘山林雪景，笔意细致，景深有层次，颇有西方写实趣味；虽只用了不同深度的黑白两色，勾勒出丰富雪林和山中溪流，点点白雪，好像雪正飘着，再次展现了作者多方面的艺术才华。由于作者一般少作此类作品，此为仅见孤品。

20. Heavy Snow in a Thick Forest

Height 7.2 cm　Width 4.5 cm

Glass

Marks: "Suo Zhenhai Yi Shi painted in the year of WuWu."

The snowy mountain scenes depicted on the two sides of this bottle contain intricate details and layers that are suggestive of western realism. These two inner paintings only use shades of black and white to outline the snowy forest and creek in the mountains; the white dots of snow resemble falling snow flakes. Once again, these paintings demonstrate the artist's versatility. Because the artist seldom chose to paint on this subject matter, this piece is the only one of its kind.

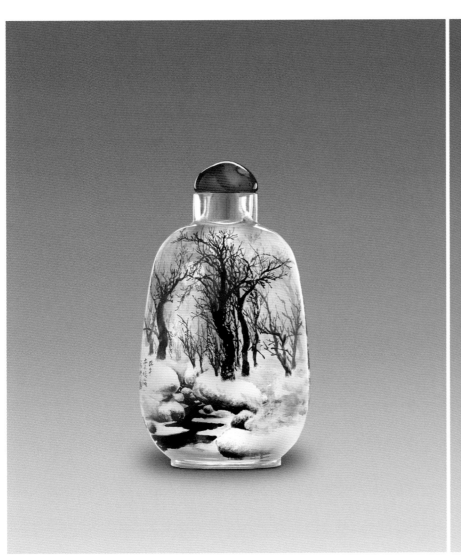
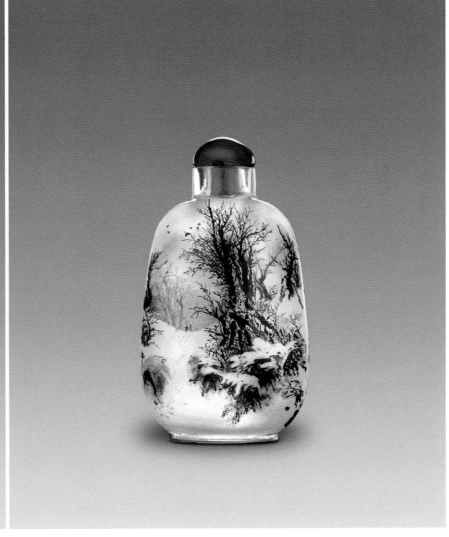

21. 四季山水 （一组四个）

高 7.2 厘米　腹宽 5.2 厘米

玻璃

春壶款识："丁丑春月索振海一石作"；

夏壶款识："丁丑夏索振海一石作"；

秋壶款识："丁丑秋八月索振海一石作"；

冬壶款识："丁丑冬月索振海一石作。"

一样的山水题材，不一样的心境，相同的艺术家，也会有不同的诠释。

这组山水壶着墨于较宽壶面，而其一向因势取材，不拘一体，心中山水无尽，拈来自然精妙；八帧壶面山水，帧帧卓绝，俊秀典雅，极具文人色彩，实属精妙山水内画作品。作者创作整组四季山水极少见，由于胸有成竹，即兴挥洒成画，画稿亦少重复。

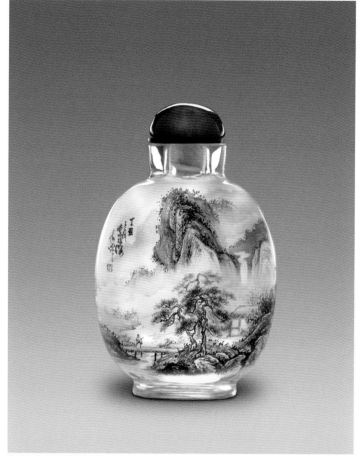

21. Landscapes in Four Seasons

(A Set of Four Bottles)

Height 7.2 cm　Width 5.2 cm

Glass

Spring bottle marks: "Suo Zhenhai Yi Shi painted in a spring month of the year of DingChou;"

Summer bottle marks: "Suo Zhenhai Yi Shi painted in summer of the year of DingChou;"

Autumn bottle marks: "Suo Zhenhai Yi Shi painted in autumn August of the year of DingChou;"

Winter bottle marks: "Suo Zhenhai Yi Shi painted in a winter month of the year of DingChou."

When the artist paints the same landscape subject matter more than once, he interprets the scene differently each time depending on his mindset.

The bottles in this set have wider surfaces. The artist was skilled at making the most of his materials. He never employed a fixed formula, but rather had an incredible feel for painting landscapes; all his creative genius came to him naturally. The eight paintings in this set depict landscapes during the four seasons; they are all elegant and outstanding pieces, rich in the traditional scholarly style and truly exquisite inner painting masterpieces. The artist's complete set of the four seasons' landscapes is quite rare due to the fact that the artist seldom duplicates his work and another complete set would be difficult to come by.

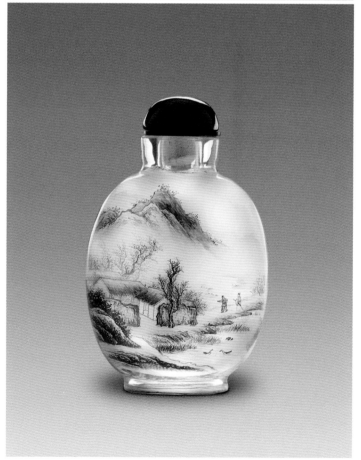

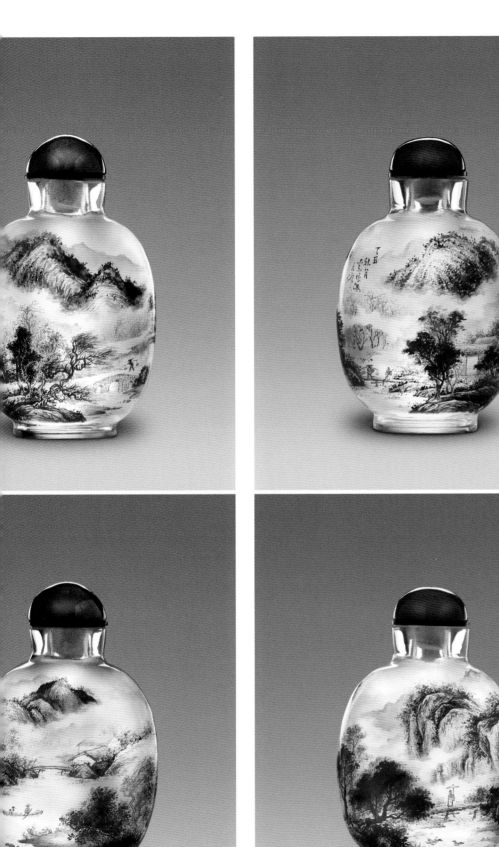
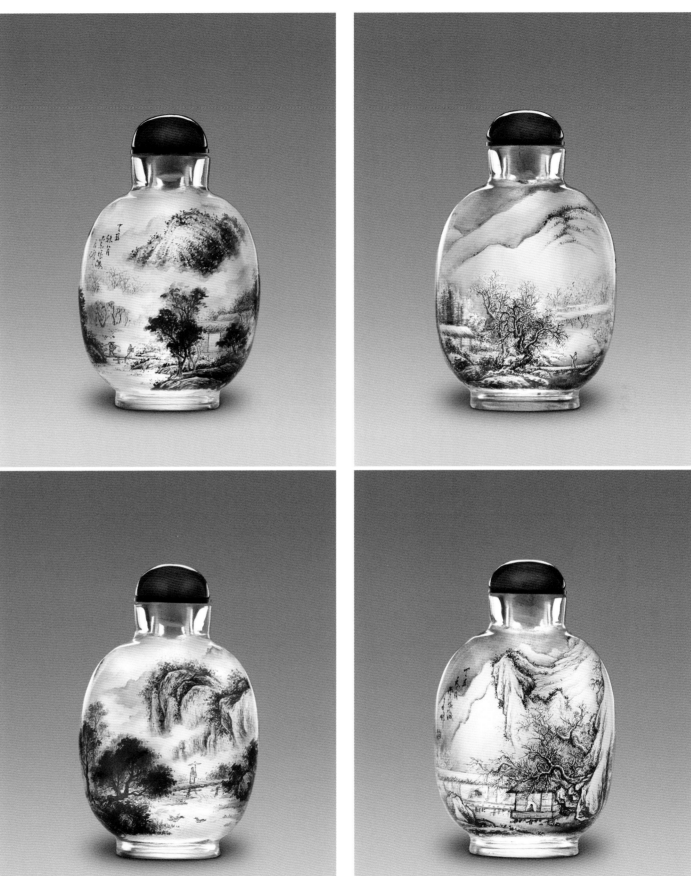

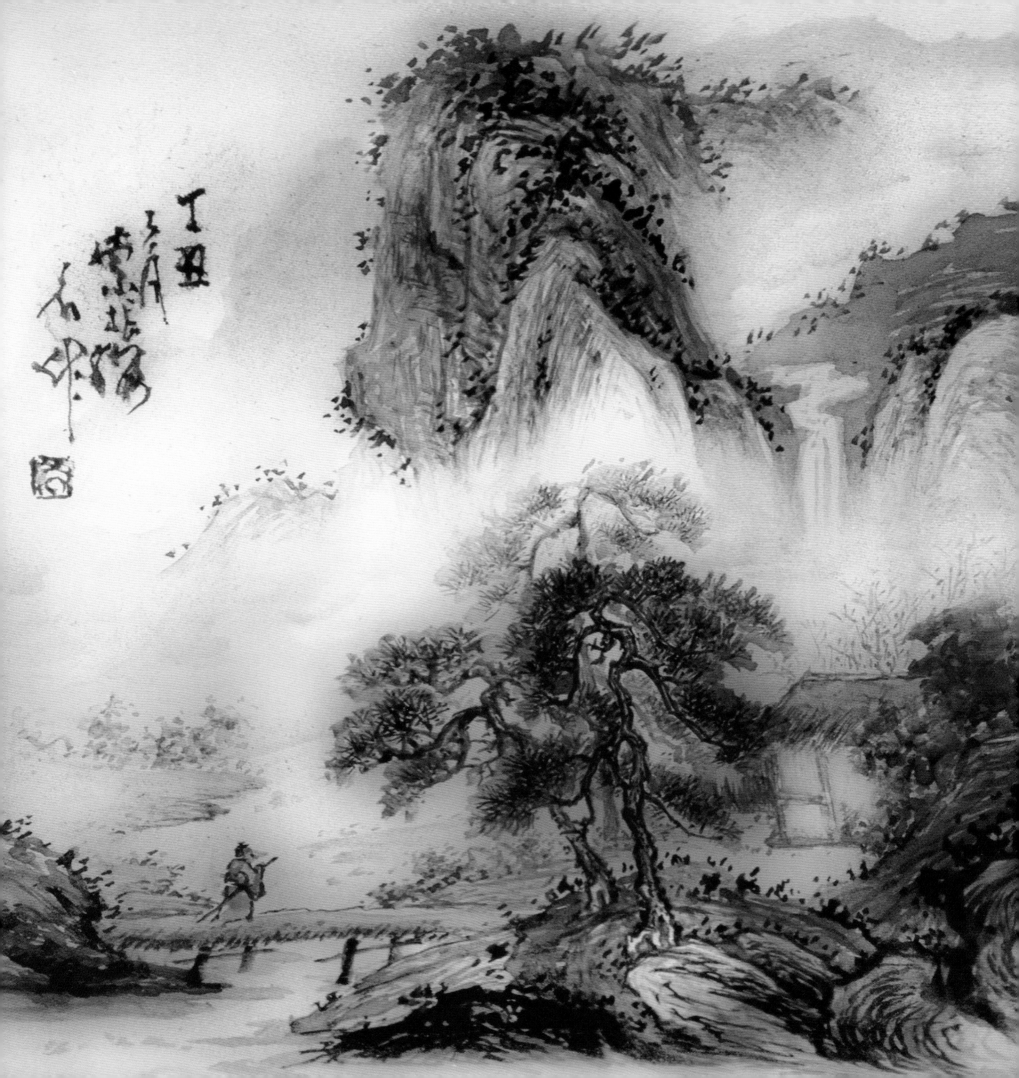

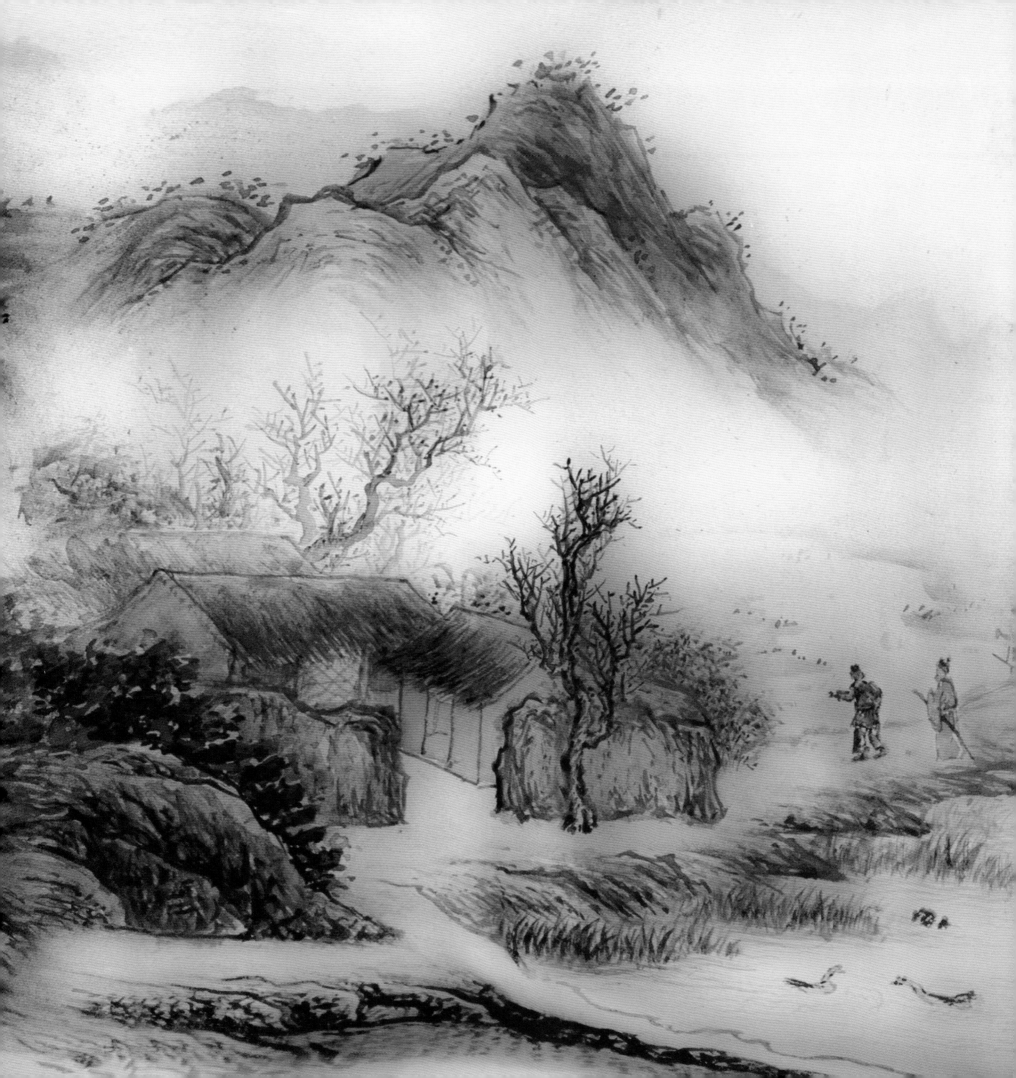

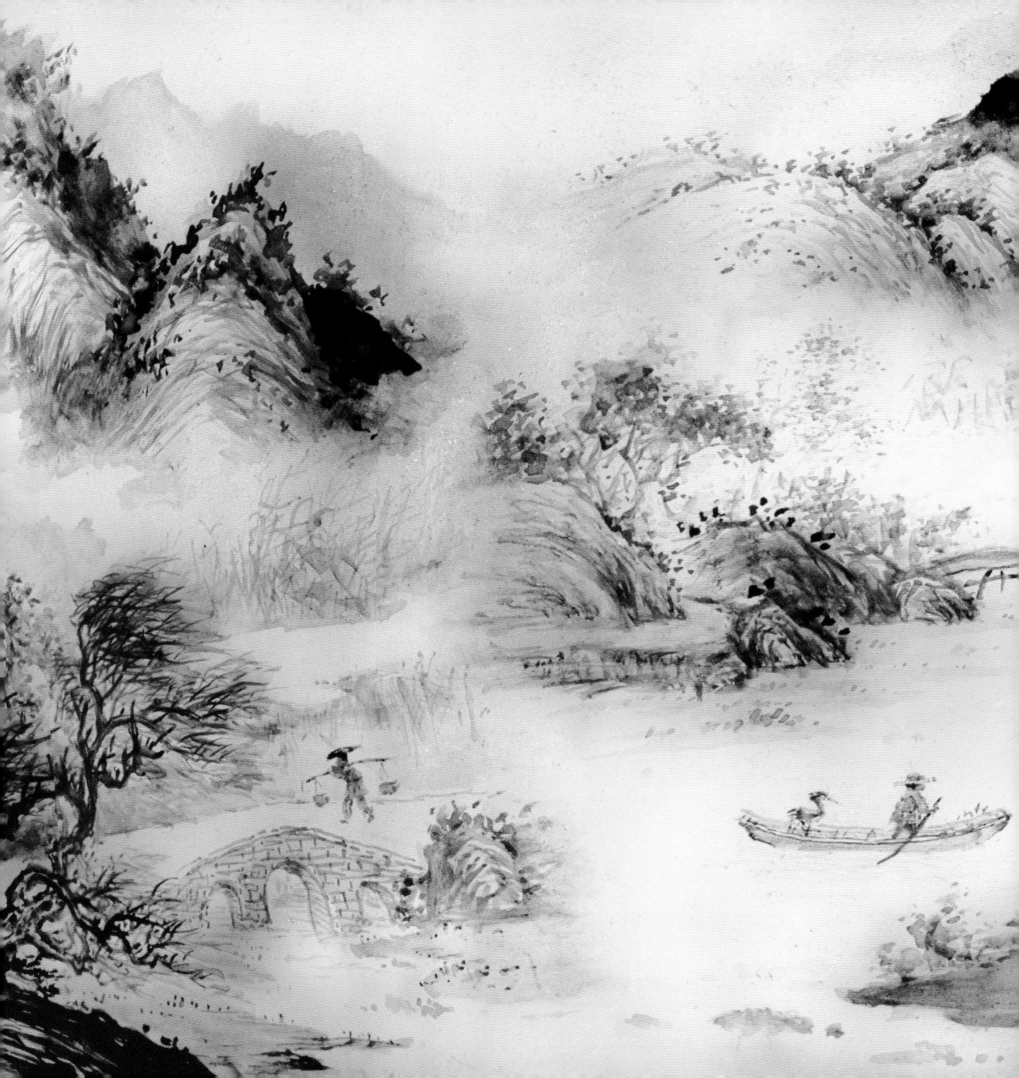

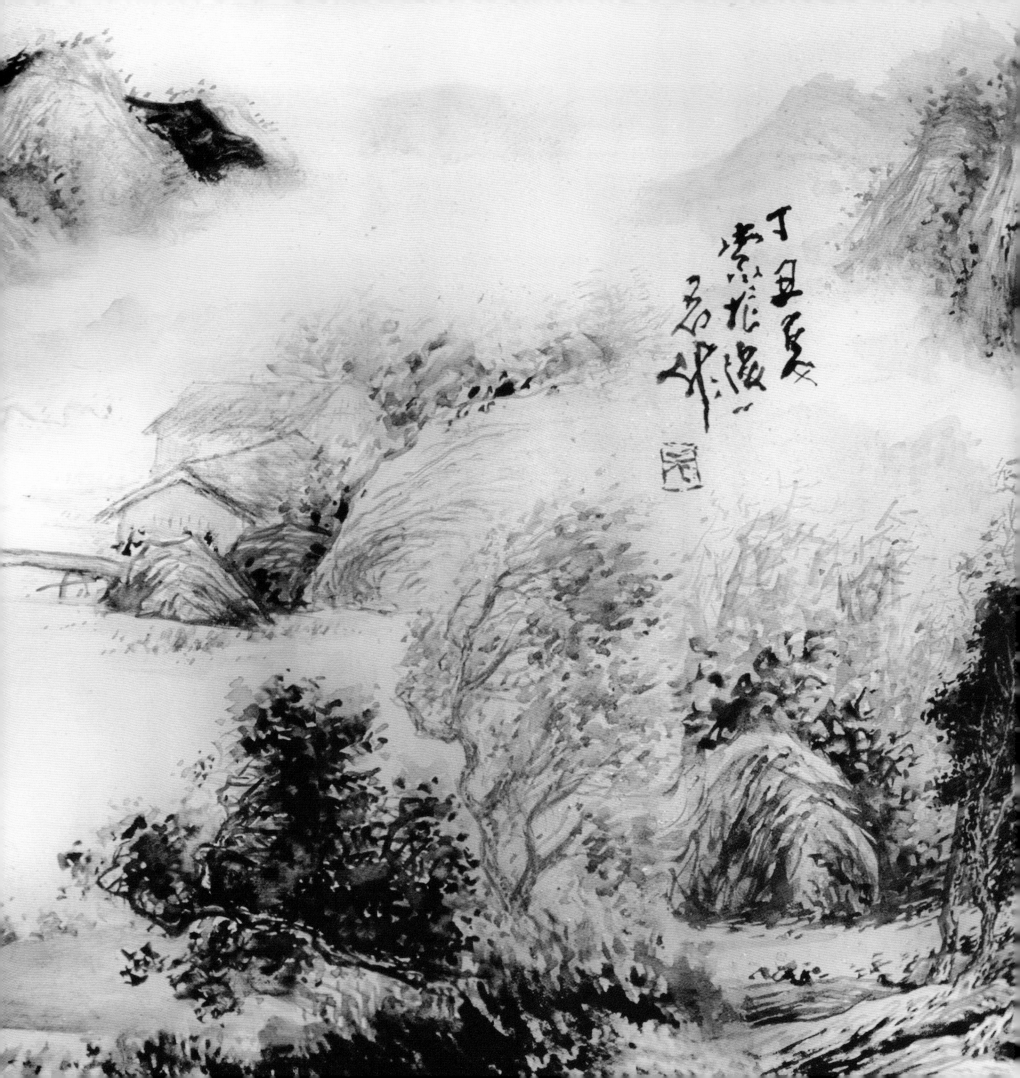

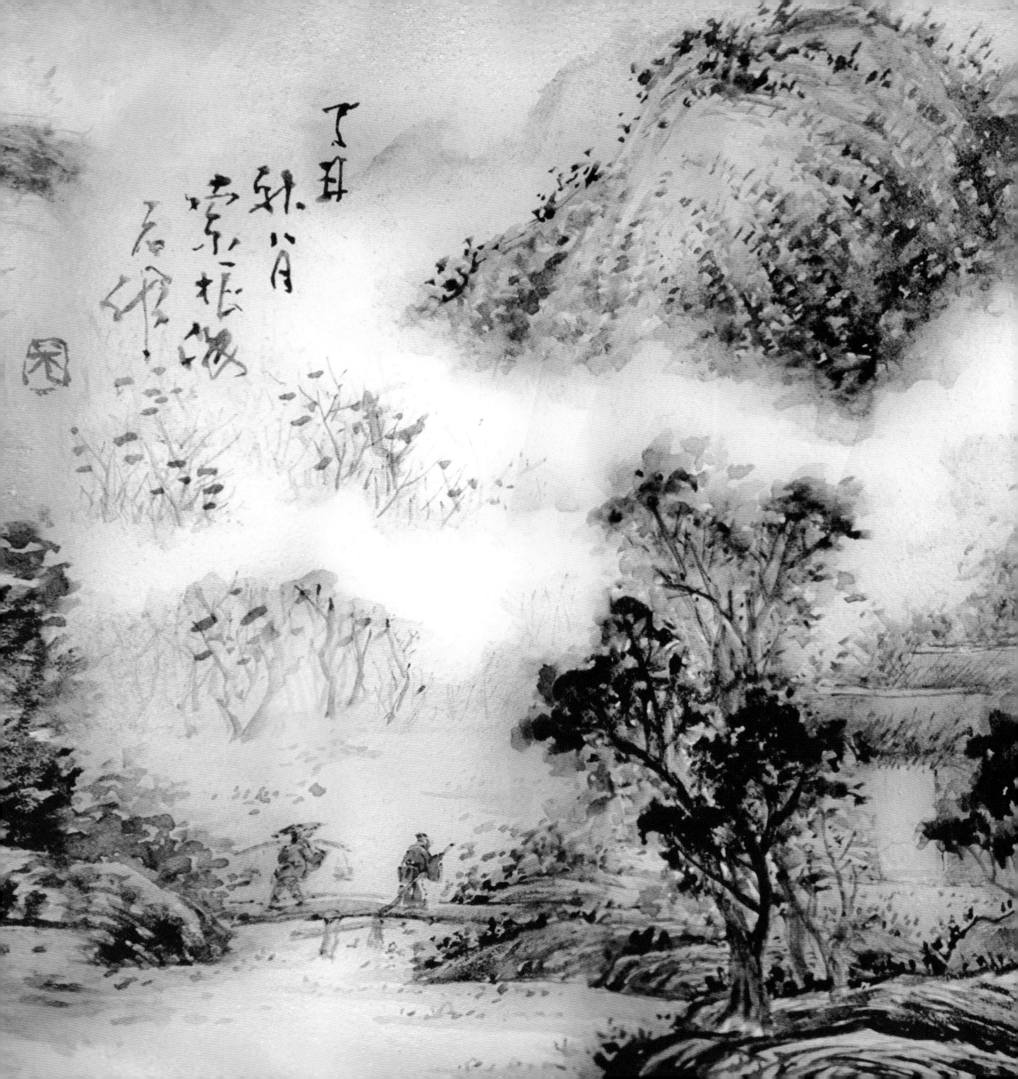

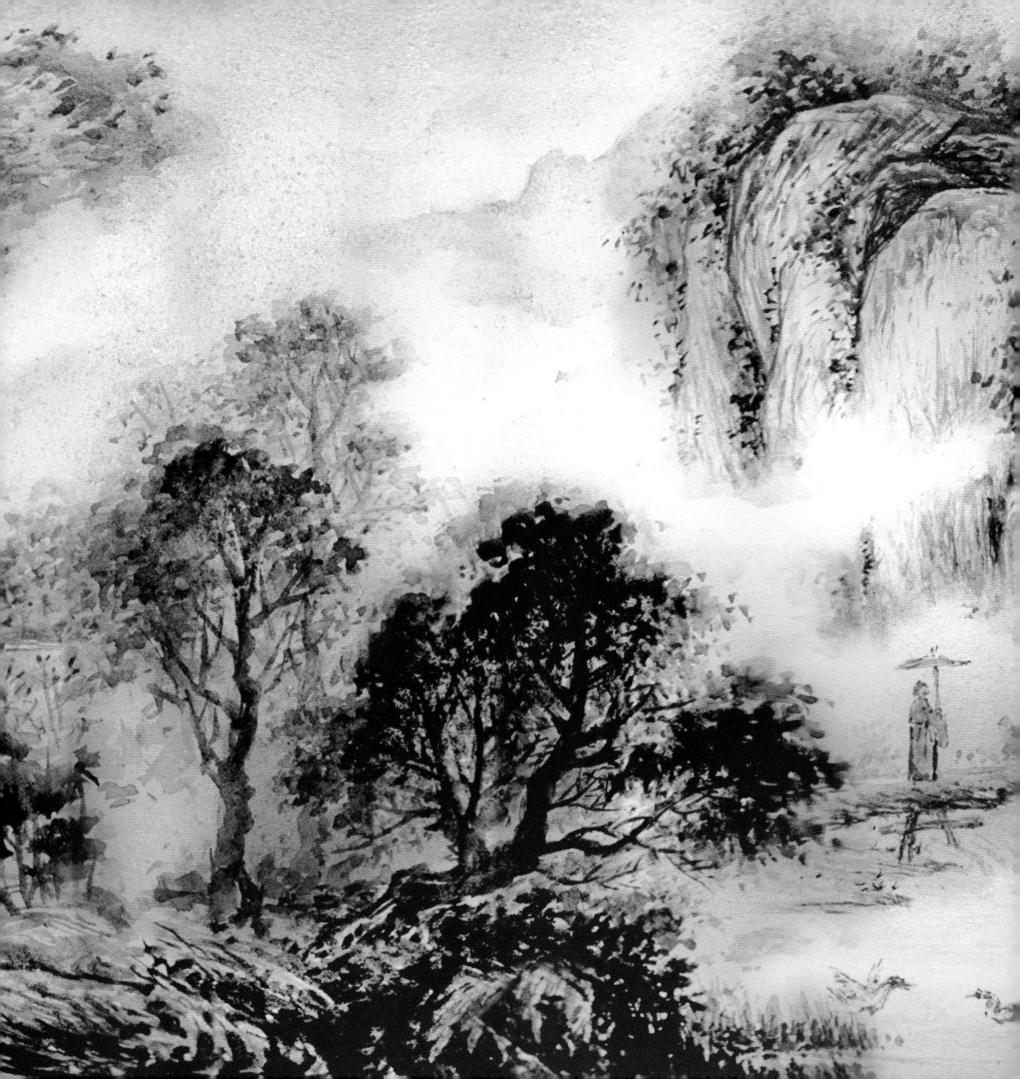

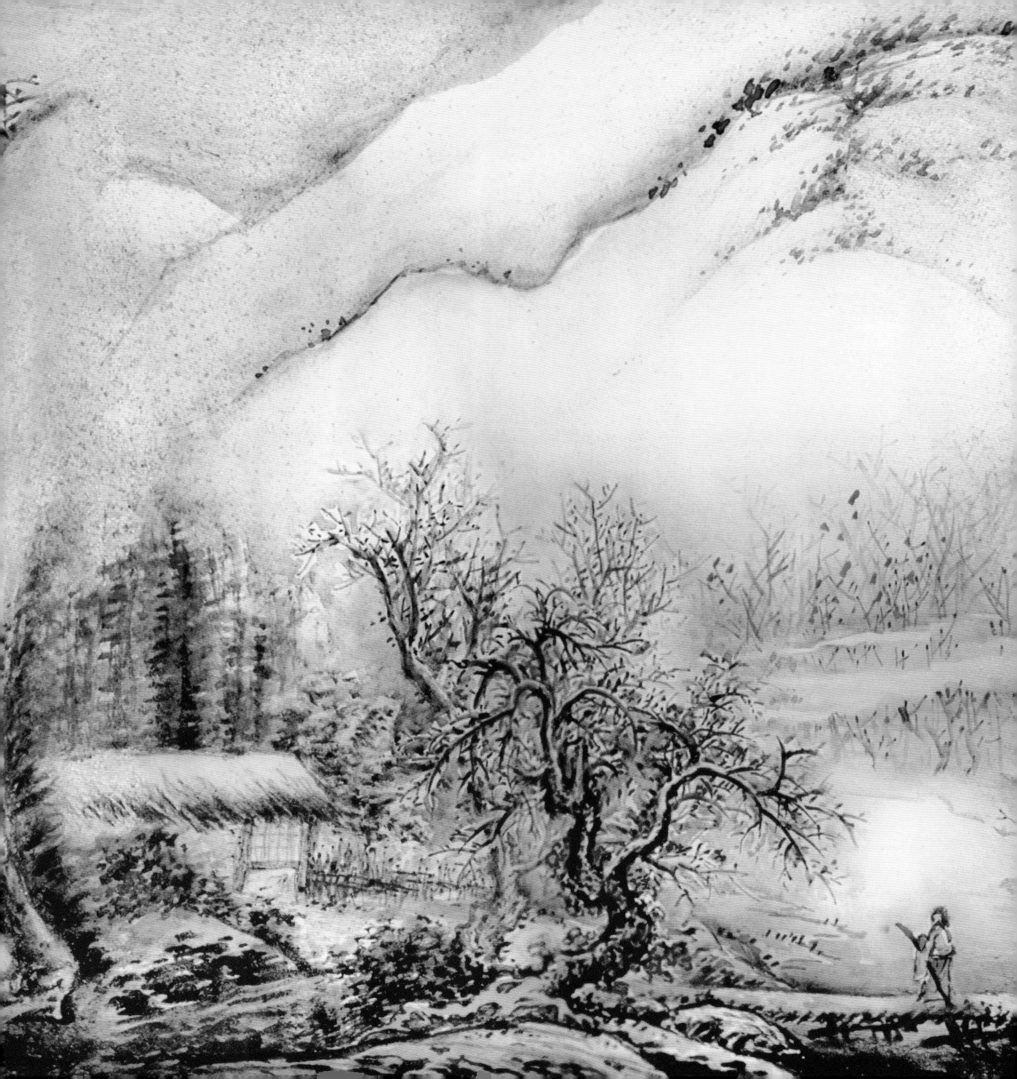

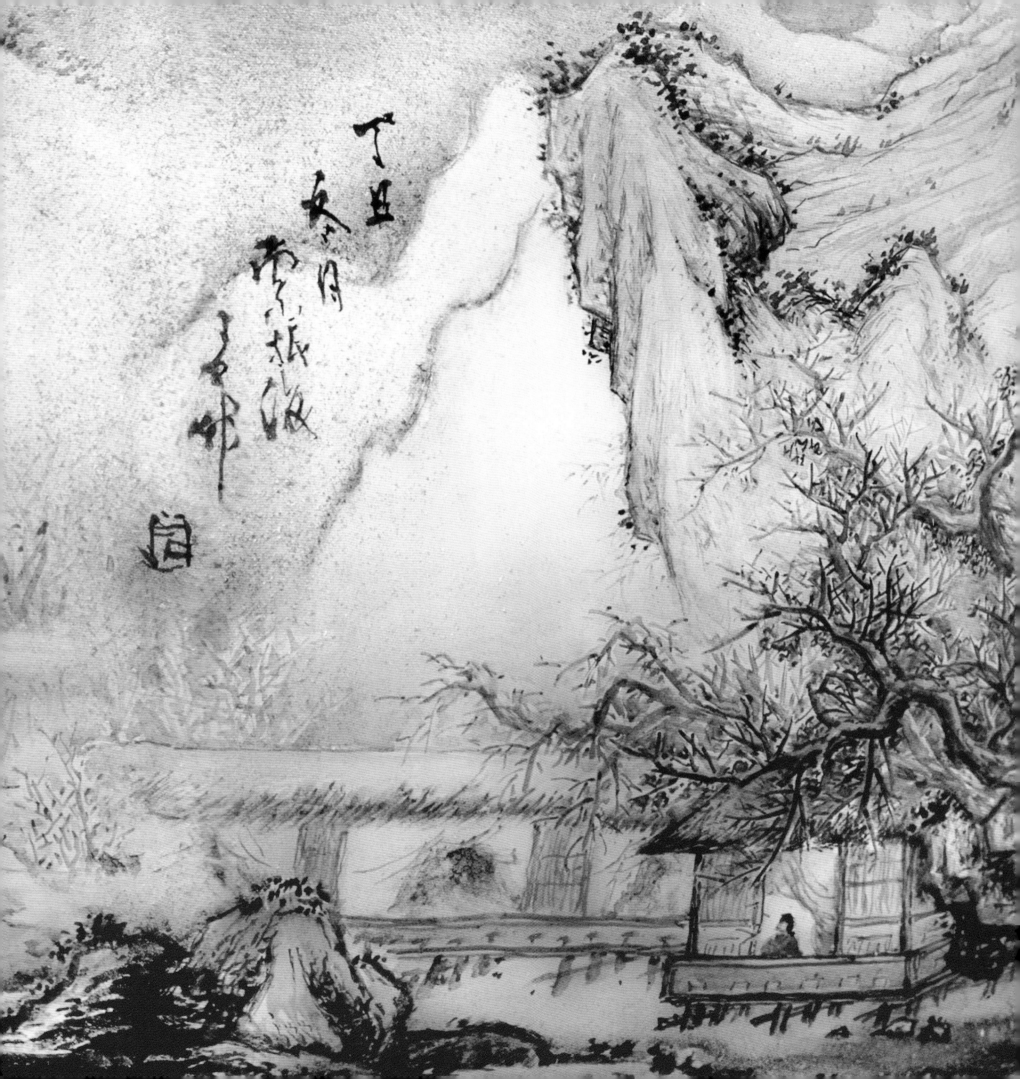

22. 寨外

高 7.3 厘米　腹宽 4.7 厘米

玻璃

　　款识："寨外。癸酉冬月一石振海作。"

　　此壶大片天空中有泼墨的精彩效果。壶中倒钩笔点彩相对较大水墨渲染容易，若非对笔法、水墨和壶面淡水效果掌握精准，泼墨画面则无法收发自如，加上细笔点线构图，湖中舟岸边人，驮夫渡桥赴山寨，犹如画龙点睛，合并完整的体现了泼墨山水绮丽俊秀，浑然天成。

22. Outside a Stockade

Height 7.3 cm　Width 4.7 cm

Glass

　　Marks: "Outside a Stockade. Yi Shi Zhenhai painted in a winter month of the year of GuiYou."

　　The painted sky depicted in this bottle is created using splashing ink techniques. Relatively speaking, using a hook-shaped brush to carefully dot paint the sky would be much easier than using the splash ink technique. If the artist does not demonstrate complete mastery of painting techniques and a thorough understanding of water and the bottle's water absorption effects, attempting the splashing ink technique would be a mistake and lead to artistic disaster. In this piece the artist uses detailed brushstrokes to paint dots and lines that craft the boat in the lake, the man on the shore, and the porter crossing a bridge. These precise brushstrokes add a magical touch to the painting, complimenting and completing the larger landscape created using splash ink effects; this is a unique and handsome piece of work.

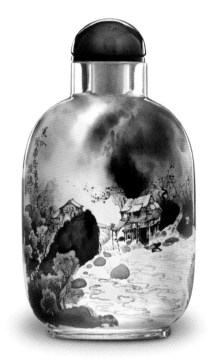

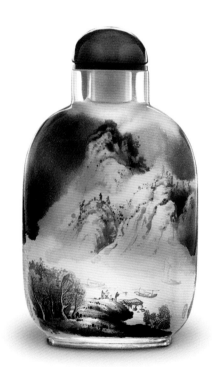

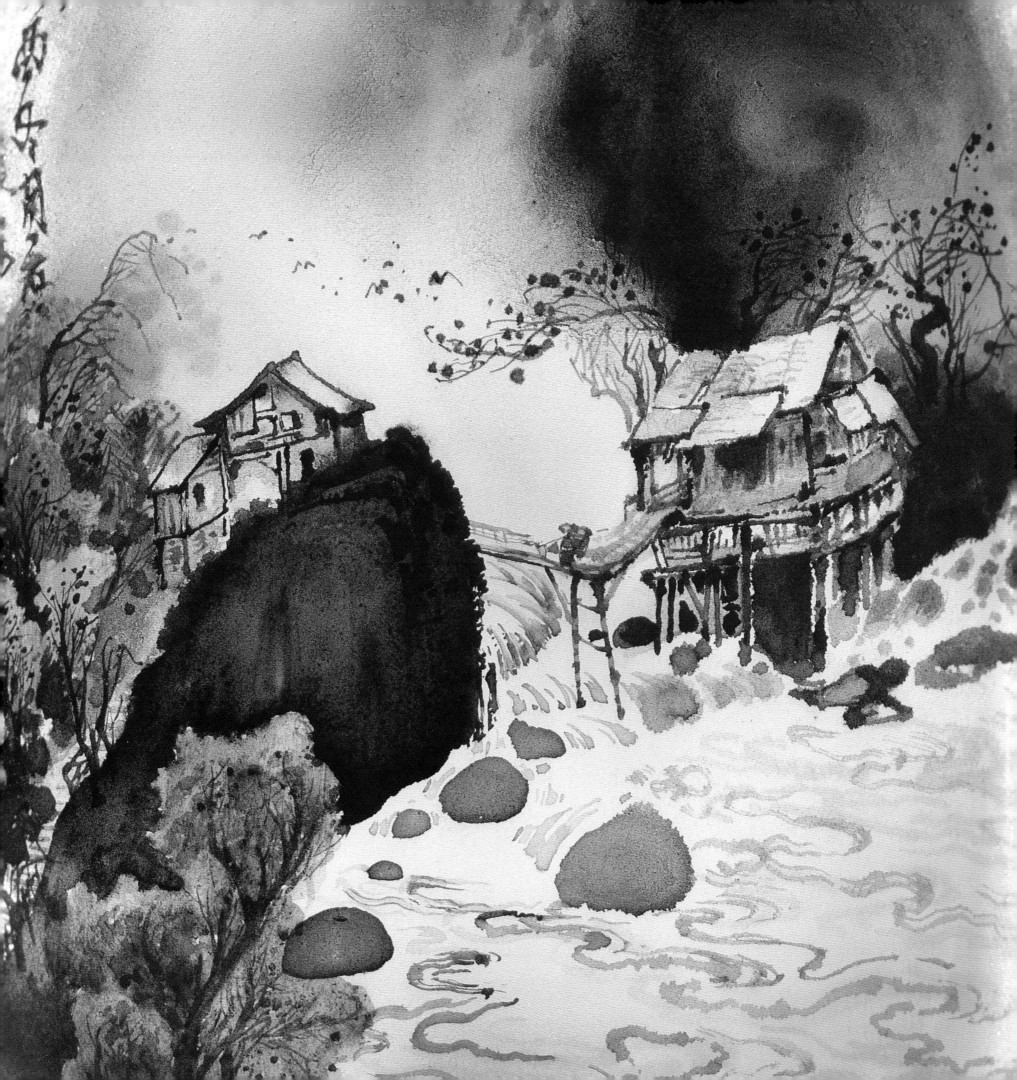

23. 雪山访友

高8厘米　腹宽8厘米

玻璃

　　款识："雪山访友。甲申三月中浣一石索振海作。"

　　雪山夜景常考验画家对黑白墨色的把握，属山水画中高难度之作。过分强调雪白，则失夜之美，墨过深，则易失皑皑白雪在夜里幽幽之魅力，浓淡失度，就马上显得生硬匠气。

　　此作品黑白色度的层次丰富，既多变化又收发自如，反映出作者见习水墨大家李可染画意，练就此方面之感悟力和功夫。细细把玩欣赏，直是欲罢不能。

23. Visiting a Friend in the Snowy Mountains

Height 8 cm　Width 8 cm

Glass

Marks: "Visiting a Friend in the Snowy Mountains. Yi Shi Suo Zhenhai painted in mid March of the year of JiaShen."

A night scene of snowy mountains poses a challenge to the artist's ability to balance the use of black and white. Too much white would cause the painting to lose the beautiful essence of the night and too much black would diminish the charming, magical whiteness of snow in the darkness. Without a balance of darkness and light, the resulting painting would be stiff and unimaginative.

This piece is rich in layers of both black and white; the two colors alternate, mingle, and mix but at all times there is a good balance. This balance reflects the artist's familiarly with water ink master Li Keran's techniques and styles. One can't help but fall in love with this piece upon close observation of its details.

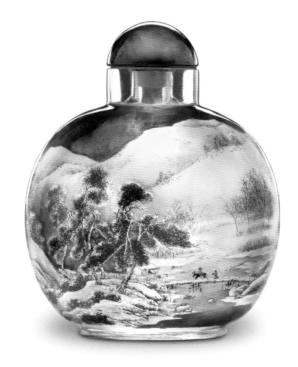
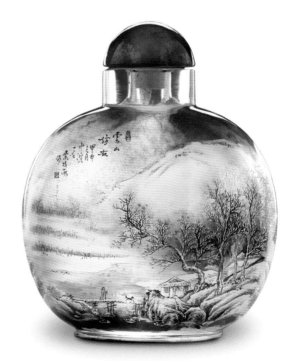

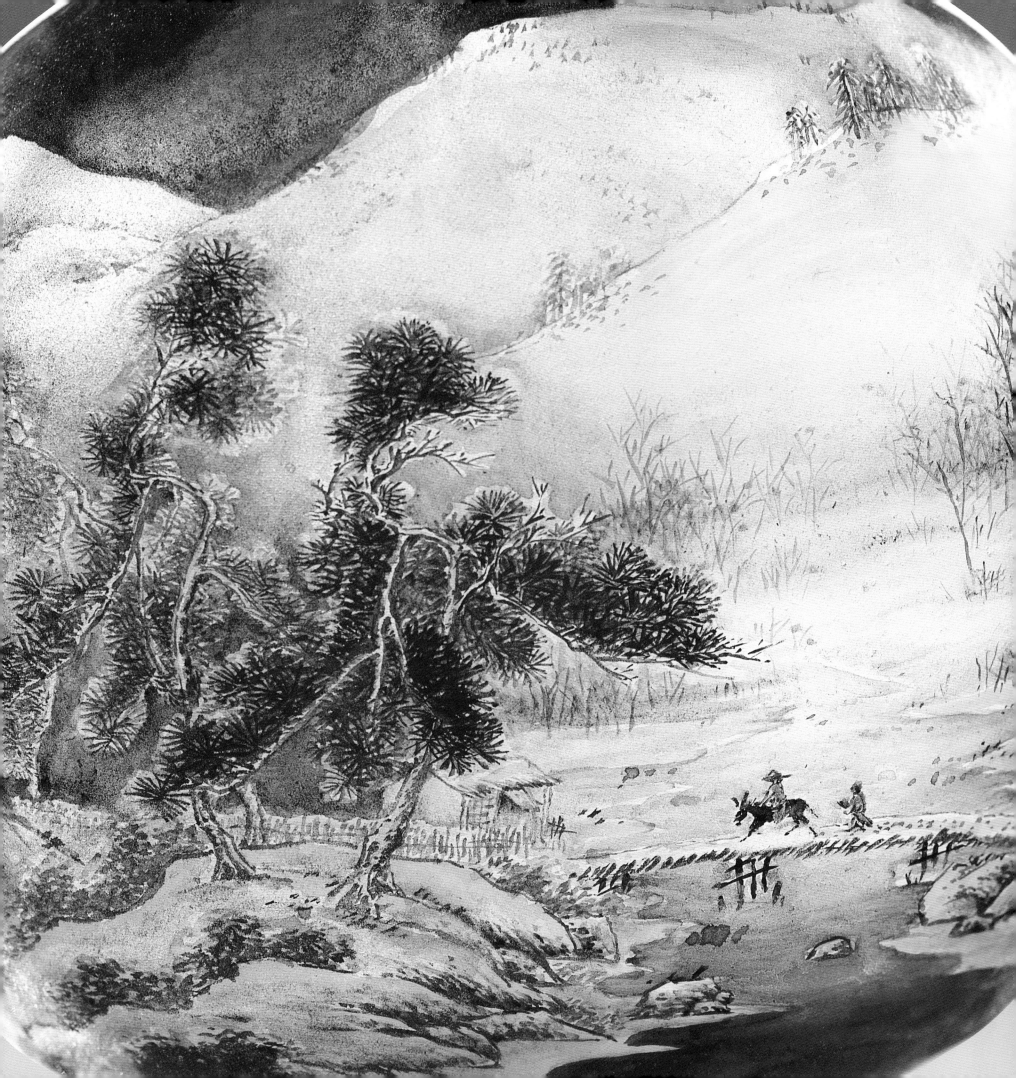

24. 大漠走骑

高 5.2 厘米　腹宽 4.5 厘米

玛瑙

款识："戊午三月索振海一石作。"

此玛瑙壶下半部有似土质沉淀，作者以其作为天成地势，一侧为天宽地广，一行人赶路，犬奔于前，驴和挑夫负重滞后，寥寥数笔刷染远云，由近土质结晶地势、赶路人、再至远空云堆，层次特别分明；另一侧则巧藉陡峭的土质结晶，依山势画就登山访友。

此天然玛瑙内画壶，是精品，更是绝品。

24. Rider in the Desert

Height 5.2 cm　Width 4.5 cm

Agate

Marks: "Suo Zhenhai Yi Shi painted in March of the year of Wuwu."

There are natural crystal marks near the bottom of this agate bottle. The artist used this natural element of the bottle in his painting. The agate marks became the earthy ground. The painting also shows high skies and spacious lands with a group of travelers led by a dog and a porter and donkey falling behind. The earthy land in the foreground, the clouds in the distance and the group of travelers in between form several distinct layers within the painting. On the other side of the bottle, the steep earthy agate marks are used as mountain stones placed in a painting of a mountain climber visiting a friend.

The paintings in this natural agate bottle are outstanding and exclusive pieces of work.

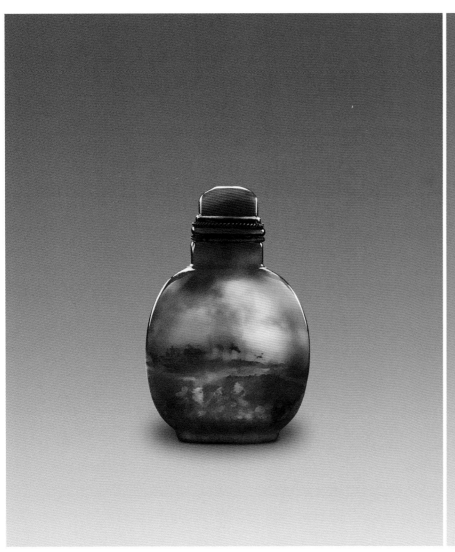
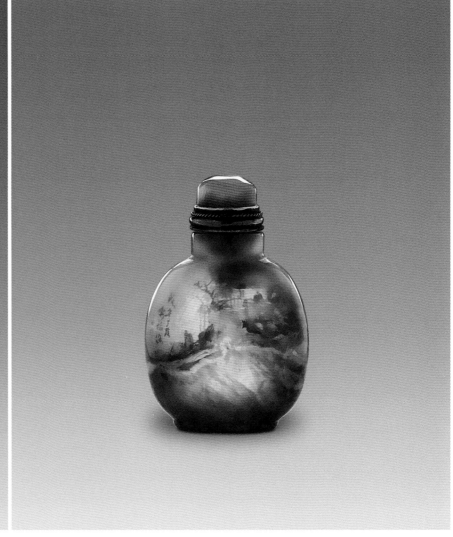

25. 残雪

高 6.2 厘米　腹宽 5.6 厘米

玛瑙

　　款识："残雪。二月索振海一石作。"

　　此壶之天然玛瑙材质白中透残黄，两侧雕有兽首环，既有古意，又有残雪沧凉的茫然效果。作者巧思善加利用，表达了残雪夜故人归和雪夜凄谅的景致，造就了此独一无二的绝品。

25. Lingering Snow

Height 6.2 cm　Width 5.6 cm

Agate

　　Marks: "Lingering Snow. Suo Zhenhai Yi Shi painted in February."

　　The natural white color of this agate bottle is meshed with hints of yellow; these colors combined with the animal head ring carvings give the bottle and aged appearance. The artist was extremely creative and made the most of the natural appearance of the bottle he was working with. The whiteness of the bottle creates an empty, cold feeling similar to what one might feel when standing in snow; this is appropriate considering the artist chose to paint scenes of a pedestrian returning home on a snowy night. This is an exclusive and unique piece of work that demonstrates the artist's incredible ability to fully utilize the material of the bottle.

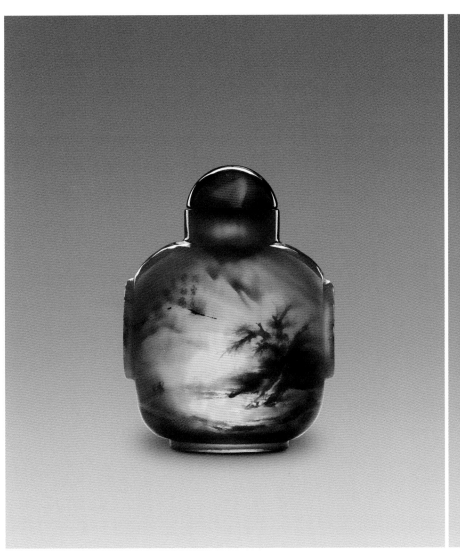

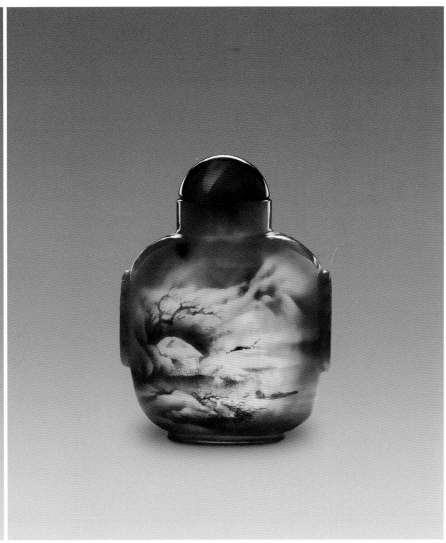

26. 秋山访友

高 5.8 厘米　腹宽 5 厘米

玛瑙

　　款识："秋山访友。戊寅三月索振海一石作。"

　　此玛瑙壶边侧和底侧有深褐色结晶，所以作者巧色天工充分利用，成了奇岩嶙峋，景深又一景，渡桥访友，又见山瀑直泻；借着玛瑙原色的层次感，四周树荫、路人、走驴，若隐若现。对应玛瑙深褐色奇石，巧妙的选择了代表秋天山景的褐色，染遍山谷，透着光瞧有如立体山水画；另一侧玛瑙深褐色结晶后，又见巨岩伸展访客小憩，后又见飞瀑悬空而下，景深由近而远，着实精彩。

26. Visiting a Friend in the Autumn Mountain

Height 5.8 cm　Width 5 cm

Agate

　　Marks: "Visiting a Friend in the Autumn Mountains. Suo Zhenhai Yi Shi painted in March of the year of WuYin."

　　The rim and bottle of this agate bottle are dark brown in color; the artist made the most of them and included them in the backdrop as uniquely shaped rocks. The artist layered one scene behind another—the scene in the foreground shows an individual crossing the bridge to visit a friend and the scene in the background shows mountain waterfalls rushing into the body of water below. Using the natural shades and textures of the agate bottle the artist crafted images of shadows cast by trees, pedestrians, and donkeys walking on a path. To complement the dark brown rock marks on the agate bottle, the artist cleverly chose to paint the entire valley using different shades of brown seen during the autumn season. These colors along with the layered texture of the agate combine to create a seemingly three dimensional landscape. On the other side of the bottle, behind the dark brown crystal block of the agate bottle, there is a gigantic rock where travelers rest and a beautiful waterfall in the background. The sense of layers and depth in this inner painting makes it an outstanding piece overall.

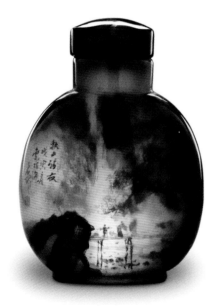
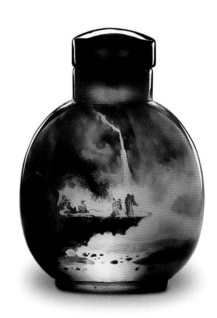

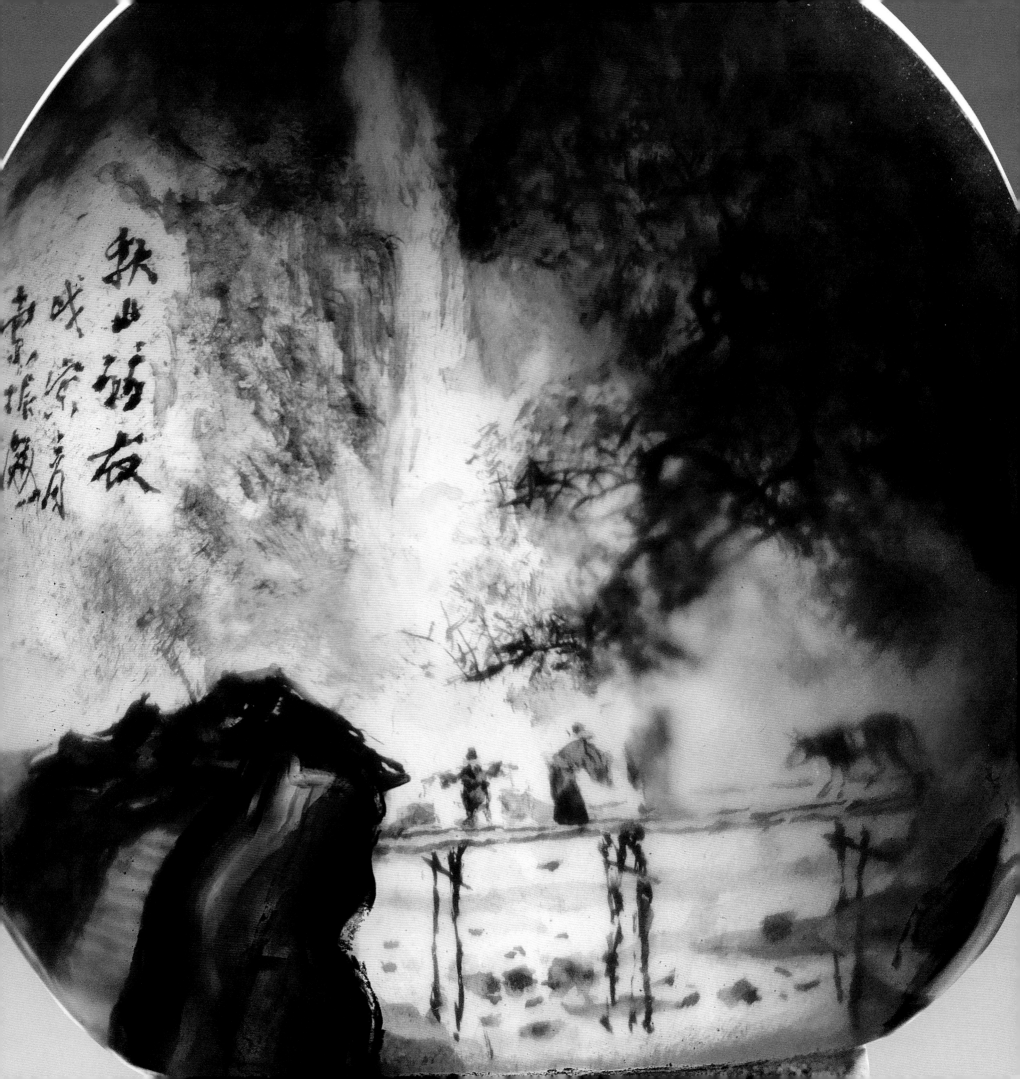

27. 诗中画

高 7 厘米　腹宽 3.6 厘米
玻璃

　　款识："一夜北风起，万里彤云厚，长空雪乱飞，改尽江山旧，迎面观太虚，疑是玉龙斗，纷纷鳞甲飞，顷刻遍宇宙，骑驴过小桥，独叹梅花瘦。一石作。"

　　另一侧款识："日暮苍山远，天寒白屋贫，柴门闻犬吠，风雪夜归人。索振海一石作。"

　　此壶两侧的山水人物各是表现一首诗的情境画，作者吃透诗意，完全忠于原诗境，诗中有画，画中有诗；作者以艺术感性去了解这两首五言诗，再以画笔重现情境。

　　壶正面画的原为踏雪寻梅典故。老者骑驴，小童尾随，踏雪痕尚新，不远梅花开。按此骑驴者为诸葛亮岳丈黄承彦。这首诗描述刘备二次拜访诸葛亮不遇，黄承彦正驱驴而返、吟唱此诗之情景。

27. Painted Poems

Height 7 cm　Width 3.6 cm
Glass

One side marks: "One night, while the north wind blows, thick, red clouds stretch tens of thousands of miles. Snowflakes fly in the spacious sky and the appearance of the old country is changed. Facing an imaginative existence, wondering whether there are jade dragons fighting with each other causing scales to fly across the universe in a few moments. Riding the donkey across the little bridge and sighing over the flowering plum blossoms. Yi Shi painted."

The other side marks: "At sunset the dark mountains and skyline are far off in the distance. From the shabby wooden door of the white house, the dog's bark is heard as the man comes back home on a windy, snowy night. Tang Dynasty's Liu Zhangqing's poem, Staying at Peony Mountain on a Snowy Night. "

The pictures on the two sides of this bottle are landscape and figure drawings of two poems. The artist interpreted the connotation of the poet's words and tried to keep with the true meaning of the poem-beautiful images can be found in the poem and there is poetry in the beautifully painted images as well. The artist uses his artistic perception to understand the five-character phase poems and recreate the poetic stories within his drawings.

One is derived from the idiom "Searching for Plum Blossoms in Snow." An elder rides a donkey across the bridge with a student following behind him, the footprints on snow are still fresh and there are plum blossoms flowering not far away. The donkey rider is, Zhu Geliang's father-in-law, Huang Chengyan. This poem portrays Liu Bei paying Zhu Geliang a second visit and missing him; Huang Chengyan is shown returning on a donkey's back while singing this poem.

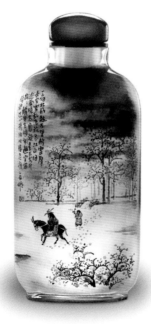

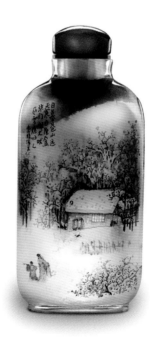

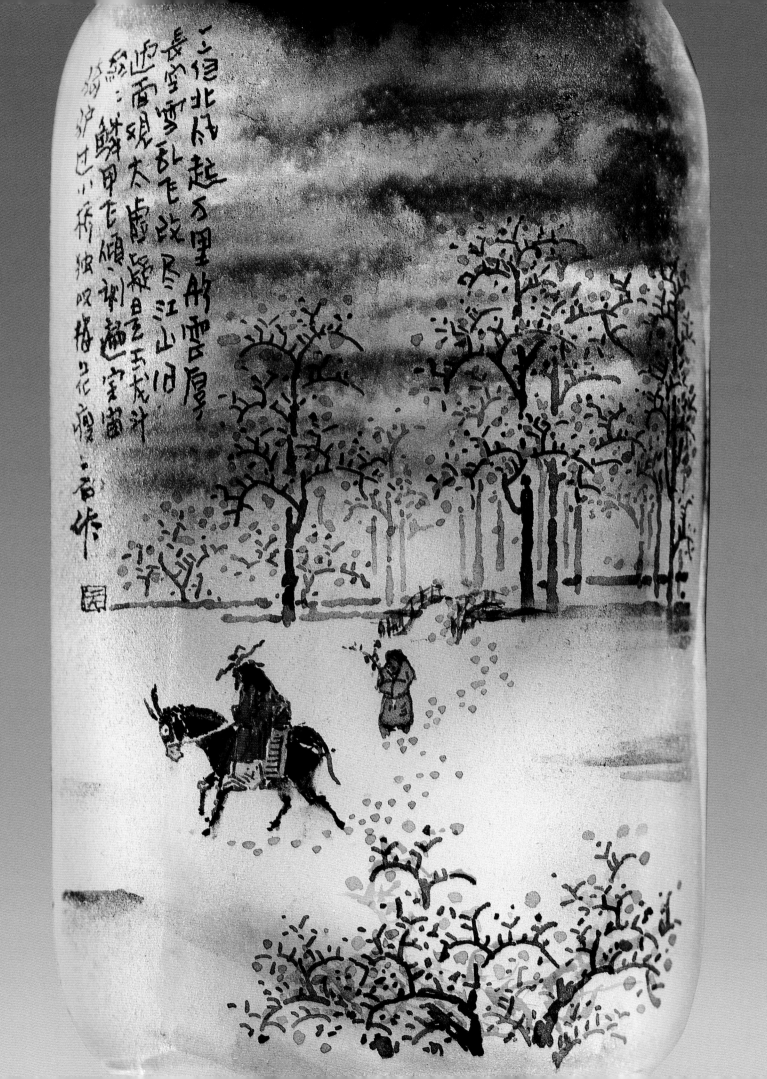

28. 风雨图

<u>高 5.2 厘米　腹宽 4.5 厘米</u>

<u>发丝茶晶</u>

款识："风雨图。壬辰三月一石索振海作于津南古城。"

此壶再次证明了作者的生花妙笔、巧夺天工，着眼于天然发丝、游若飘飘细雨的质感。而壶中心原有之矿石粒，作就渔翁垂钓、忽遭天雨、匆忙走避之状；壶另一侧风中蓑笠翁独钓山水的景致，就材施色，才华无限。此乃精美绝品，千载难逢。

28. Rain and Wind

<u>Height 5.2 cm　Width 4.5 cm</u>

<u>Tea-Colored Quartz Rutilated</u>

Marks: "Rain and Wind. Yi Shi Suo Zhenhai painted at the south of Jing Old Town in March of the year of RenChen."

This work further demonstrates the artist's magical brush strokes and ingenious techniques. He took the natural fuzzy appearance of the bottle's surface to create a rainy scene. The crystal rock in the center of the bottle is the place where the fishermen was sitting before the rain came pouring down. The other side of the bottle depicts a fisherman alone in the landscape, a fishing rod in one hand and a rain jacket on his back. With high quality materials, the artist is able to produce a masterpiece with his phenomenal skill. This work is an exquisite and rare piece.

29. 清明上河图

高 7.5 厘米　腹宽 5.8 厘米

发晶

款识："清明上河图。时在丁亥索一丁作。"

如何将闻名中外的长卷清明上河图浓缩特写于一小壶中，索老提供了答案。由透视技巧配合壶的尺寸和弧度，妥善安排了由近至远、丰富饱满的宋朝河岸虹桥的景象。人物景色繁多而不杂乱，笔笔细腻填充成完整绮丽的画面，远近有致，再衬以茶底色，更增添了古意。

此壶整体展现了大师级的创作风范。由于作者一般不作此类画，此作品亦成其孤品。

29. Scroll Painting of the Upper River during the Qing Ming Festival

Height 7.5 cm Width 5.8 cm

Quartz Rutilated

Marks: "Scroll Painting of the Upper River during the Qing Ming Festival. Suo Yi Shi painted in the year of DingHai. "

Is it possible to condense the world famous long scroll of the Picture of Upper River during the Qing Ming Festival into a small bottle? The artist proved that is, using perspective techniques along with careful measurement and observation of the bottle. The artist paid particular attention to depth in the painting, and he was able to recreate a rich and interesting scene straight out of the Song dynasty river market. There were many figures to include but the result was not chaotic; stroke by stroke, detail by detail, the artist painted the entire bottle with gorgeous pictures of perfect proportions on a tea-color (provides aged appearance) background.

The resulting piece shows mastery in artistic creativity and skill. Because the artist seldom touched on subjects of this nature, this work is the only one of its kind.

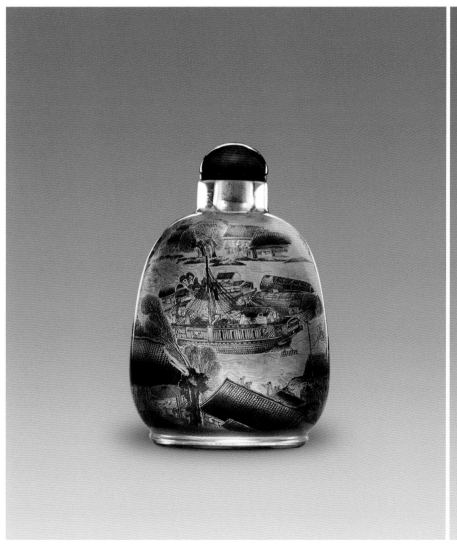
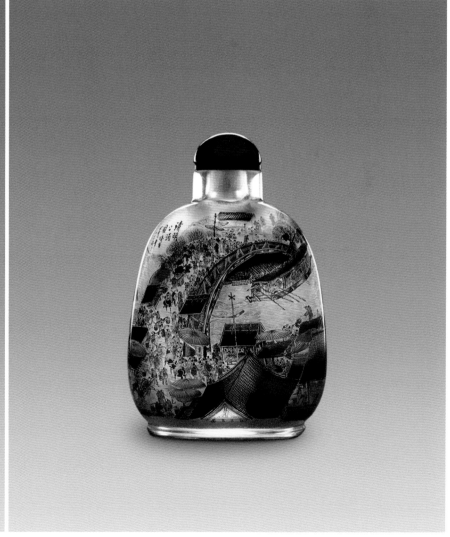

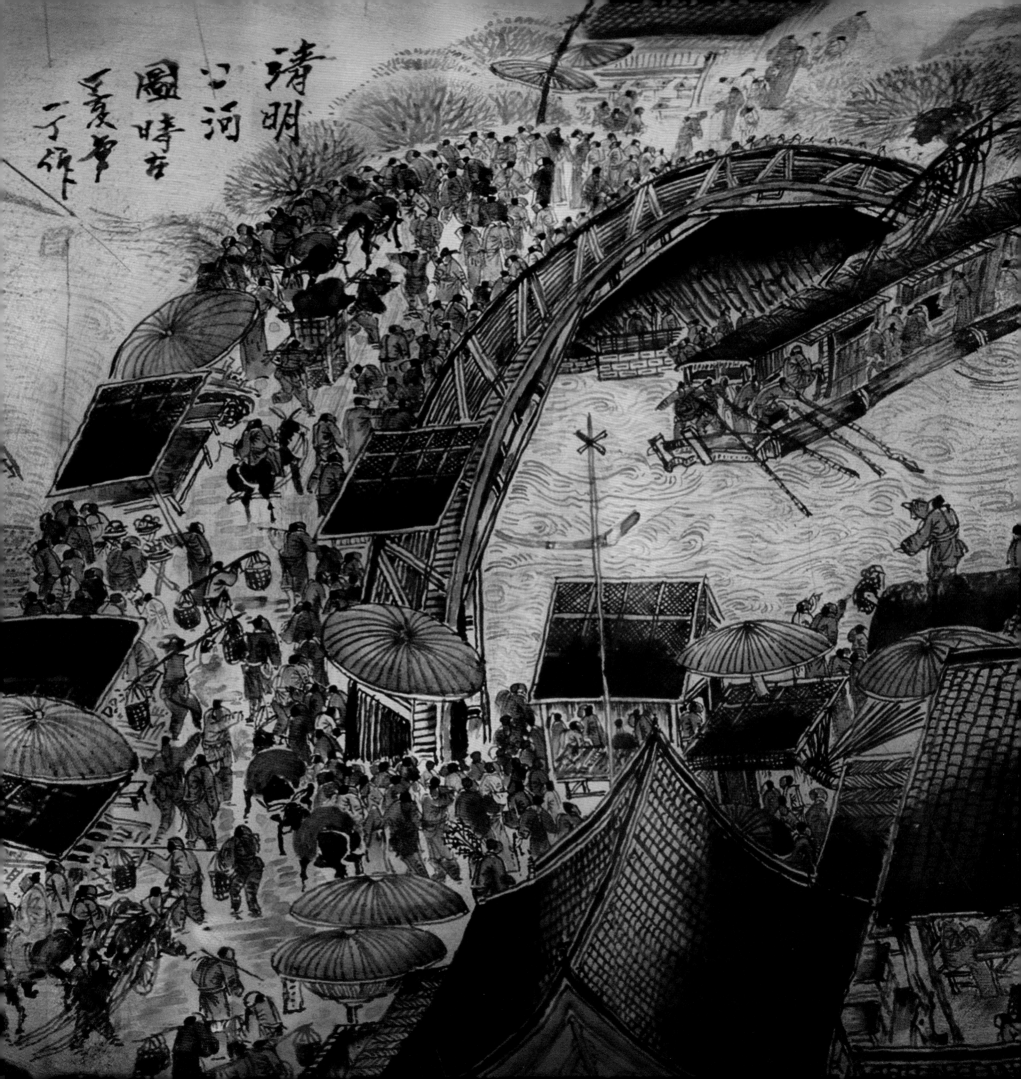

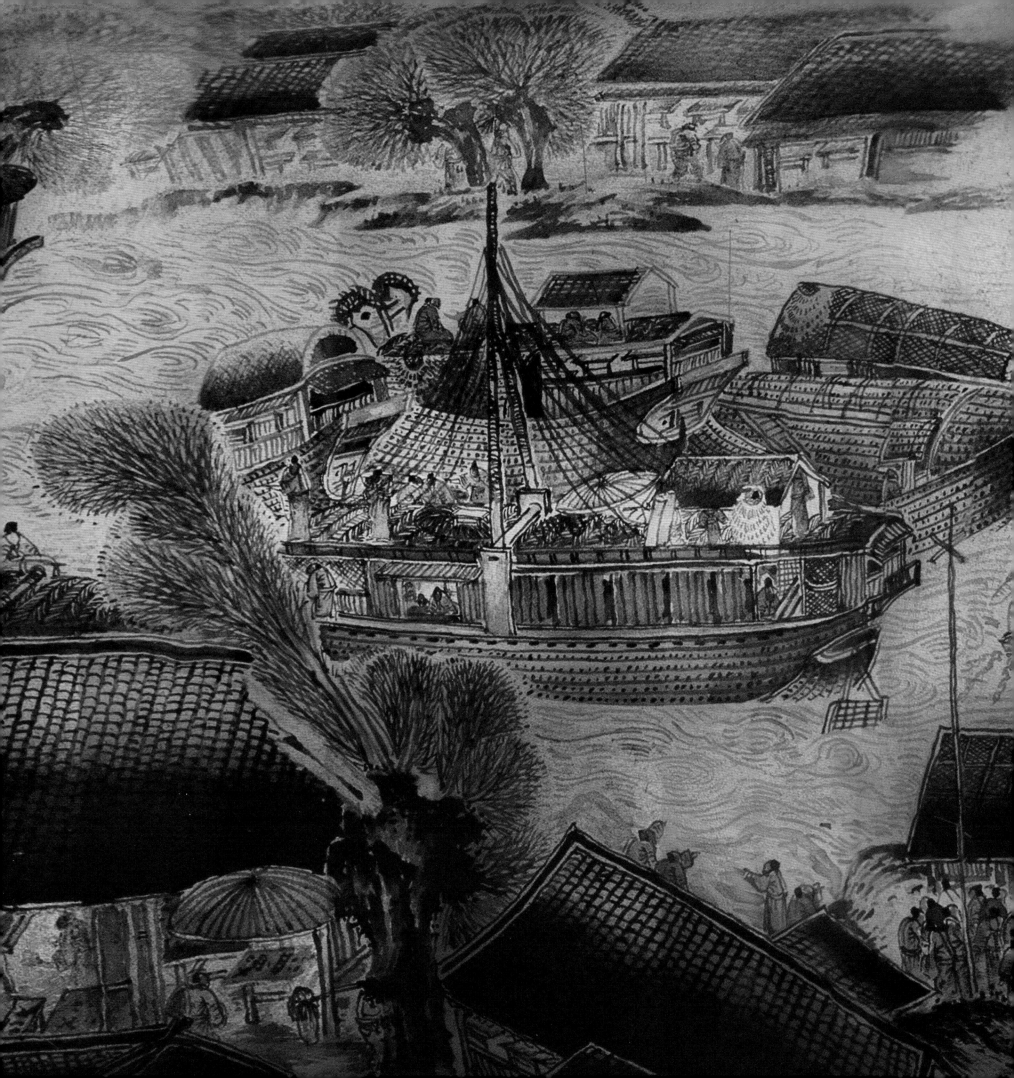

30. 米芾拜石

高 4.8 厘米　腹宽 3.2 厘米

玻璃

　　由山水构图更能看出索振海的文人画造诣深，由水墨晕染效果更能了解他绝妙的笔法和技术，在小小方寸天地间，生花妙笔，展现米芾拜石的神韵和王羲之观鹅的意境。

30. Mi Fu Worshipping Stones

Height 4.8 cm　Width 3.2 cm

Glass

　　One can see the artist's sophisticated scholarly painting style from the way he organizes his landscape paintings. One can understand his extraordinary talent and skill with the brush by observing the water ink dyeing effects in this painting. Within inches of space, he demonstrates delicate brushwork that is able to convey the spirit of Mi Fu's worship of stone and Wang Xizhi's concentration during his observation of geese.

 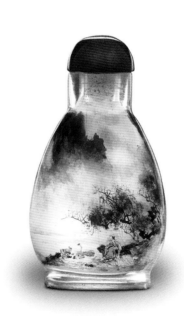

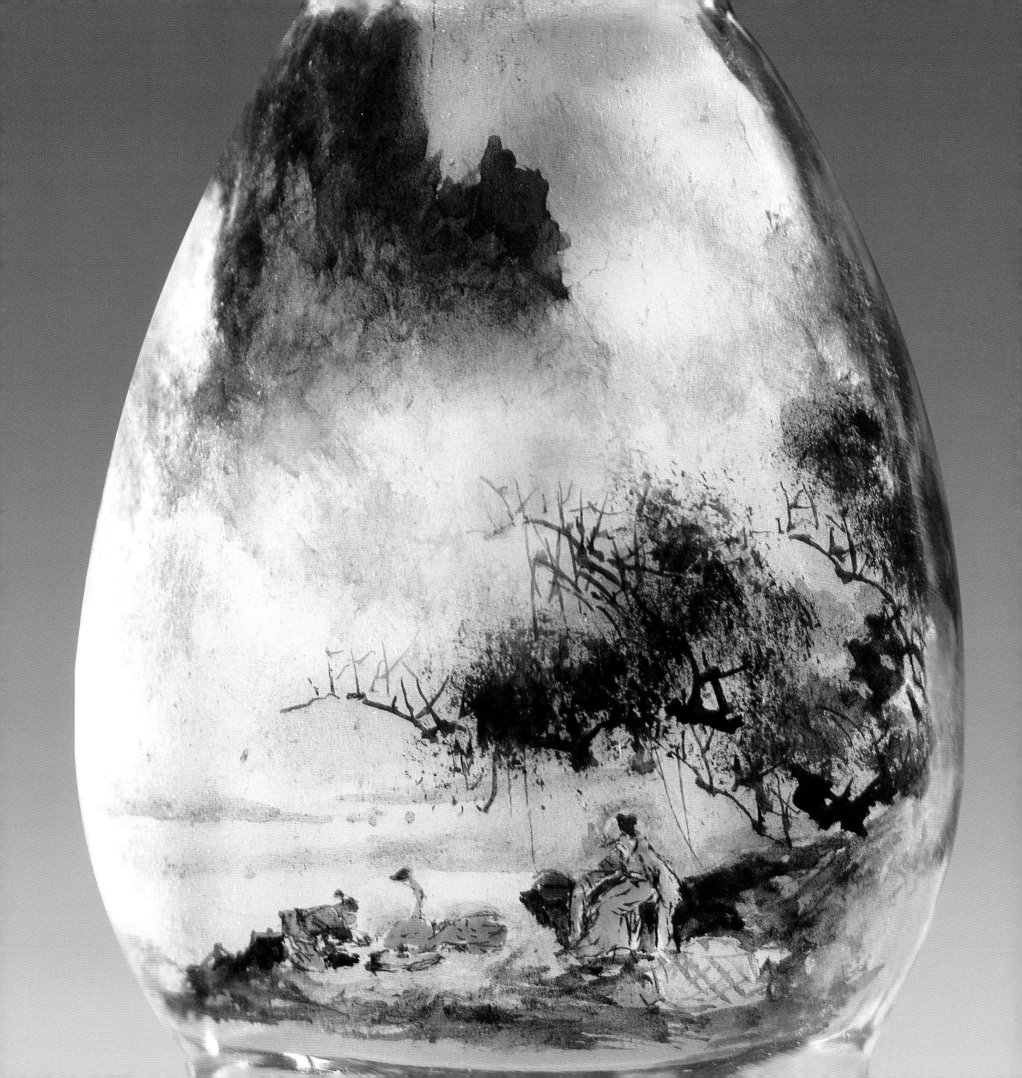

31. 山远志清

高 7.5 厘米　腹宽 6.3 厘米

玻璃

　　款识："戊午三月下浣索振海作于俏厅。"

　　此壶两侧带兽首环。呈现作者固有的水平，下笔轻重虚实，完美结合的构图安排，正足以区分"俗众"及"高雅"。笔墨之外，意境引人入胜，留给观赏者的综合印象是"俊秀高雅，清新脱俗"。

31. Ambitions Inspired by Distant Mountains

Height 7.5 cm　Width 6.3 cm

Glass

　　Marks: "Suo Zhenhai painted at Qiao Room in late March of the year of WuWu."

　　Two sides of this bottle have animal head carvings. This bottle demonstrates the artist's consistent standard of work with precise brushstrokes and beautiful layouts which are the factors which distinguish the "high class" artwork from that which is "common". Besides the brushwork, the images are thought-provoking and the viewers' overall impression is that this is an elegant, refreshing, and overall extraordinary piece.

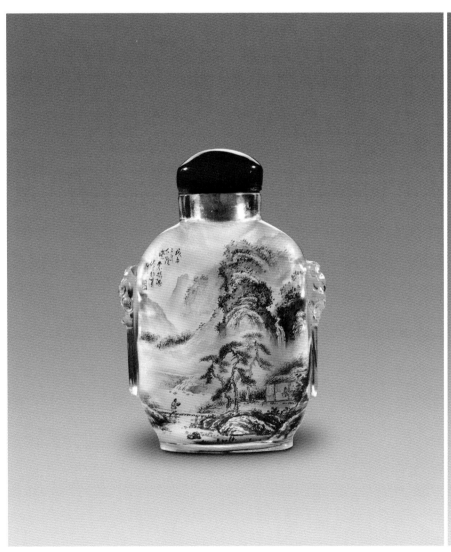
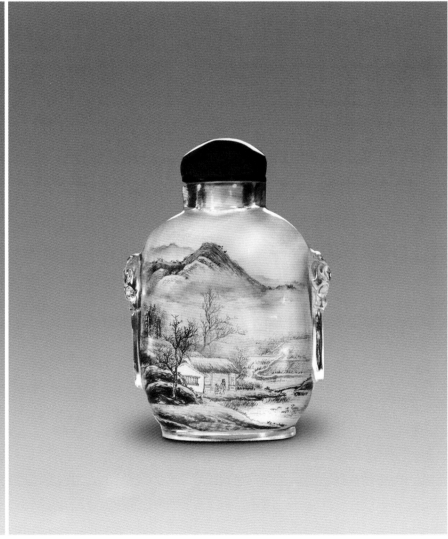

32. 云山胜境

<u>高 5.7 厘米　腹宽 5 厘米</u>

<u>发晶</u>

款识："羌笛何须怨杨柳，春风不度玉门关。癸未年仲春于南窗下索振海一石作。"

另一面款识："一石作。"

此壶为作者山水精彩孤品。云中巨峰矗立，山亭深藏，远空飞鸟，近山人烟；方寸之间，竟能由近至远，景深诸多层次，更显云山胜境的壮丽；壶另一侧莲塘孤舟采藕，壶面大部分留白，点缀莲花，背景渐渐没入晚霞，意境幽远。

32. Paradise of Cloudy Mountains

<u>Height 5.7 cm　Width 5 cm</u>

<u>Quartz Rutilated</u>

Marks: "The willow melody played on a Tartar flute laments the delay of spring. But the spring breeze, in fact, never blows past the Jade Gate. Suo Zhenhai painted at the south window in mid spring of the year of GuiWei."

The other side marks: "Yi Shi painted."

This bottle is one of the artist's more outstanding and exclusive pieces. The high mountains pierce through the clouds and the pagoda becomes barely visible. The sky stretches as far as the eye can see, making the birds flying in the sky seem closer. Within inches of space, the artist portrays the depths of the painting so clearly, so that which is located in the background is easily distinguishable from that which is found in the foreground; this creates a beautiful cloudy mountain scenery. The other side of the bottle pictures lotus roots being harvested by a single boat in the lotus pond. Most of the picture is either blank or dotted by lotus flowers; the scenery suggests a hint of dusk settling in. The artistic message of this piece is deep and thought-provoking.

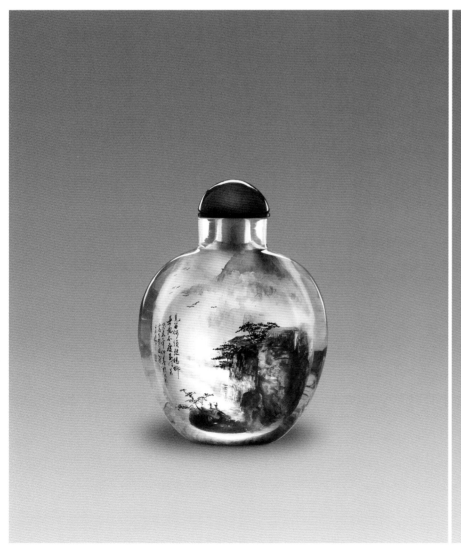

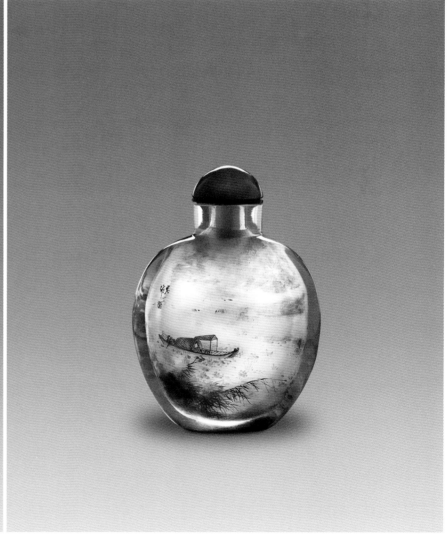

33. 渔樵耕读 （一组四个）

高 7.5 厘米　腹宽 5.7 厘米

玻璃

渔壶款识："渔。戊午三月上浣一石索振海作于古城"；

樵壶款识："樵。一石索振海作于津师古城正房舍"；

耕壶款识："耕。戊午夏月一石索振海作于津南古城"；

读壶款识："读。戊午秋八月一石索振海作。"

市面有见此题材之壶，或成套，或不成套，唯作者亲力亲为之作，皆随兴之作，很少完全重复。

此组壶乃一时之选，作者精彩力作，以其独特擅长之水墨晕染，点彩成画，气韵天成，流畅生动，其虽常谦称师法古今人，实精彩笔墨独树一格，难能可及，可谓"索氏神奇内画山水"的经典之作。

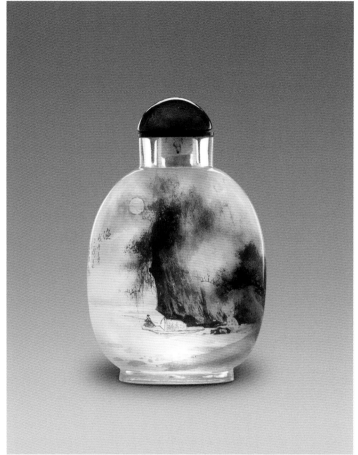

33. Fishing; Woodcutting; Farming; Studying

(A Set of Four Bottles)

Height 7.5 cm　Width 5.8 cm

Glass

Fishing Bottle's marks: "Fishing. Yi Shi Suo Zhenhai painted at the south of Jing Old Town in early March of the year of WuWu,"

Woodcutting Bottle's marks: "Woodcutting. Yi Shi Suo Zhenhai painted at the front house of Jing Old Town,"

Farming Bottle's marks: "Farming. Yi Shi Suo Zhenhai painted at the south of Jing Old Town in summer month of the year of WuWu,"

Studying Bottle's marks: "Studying. Yi Shi Suo Zhenhai painted in autumn August of the year of WuWu."

There are series or parts of this series on the market; as long as the ones painted by the artist himself are often improvised and seldom completely repeated works.

This particular series is the most selective of its kind; it also happens to be the artist's personal favorite. Using his unique water ink dyeing technique and detailed brushstrokes, the artist produces paintings which are one of a kind. The modest artist explains that he drew inspiration from and imitated both past and contemporary artists; however, the truth is, his water ink styles are his own, and they do not resemble those of anyone else. In fact, the level of technique his paintings demonstrate is hard for others to emulate. This series is a representative work of "Suo's magic touch in the creation of inner painting landscapes."

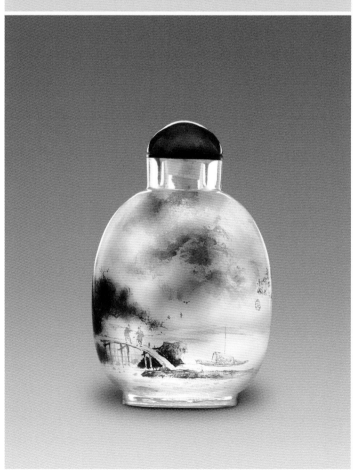

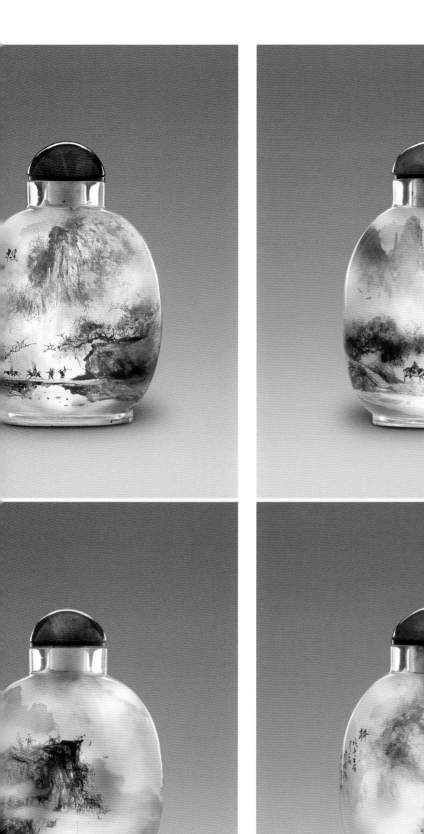
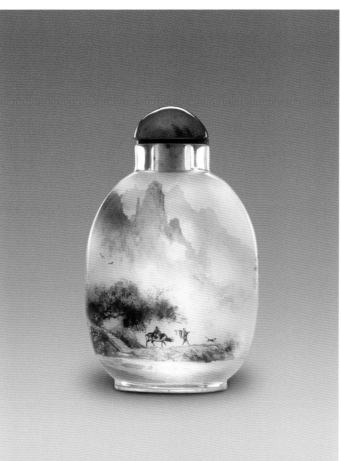
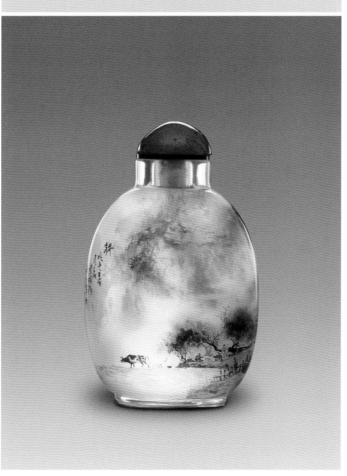
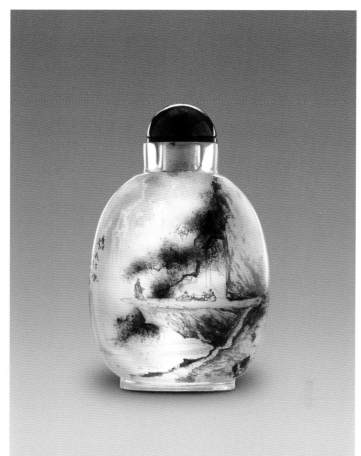
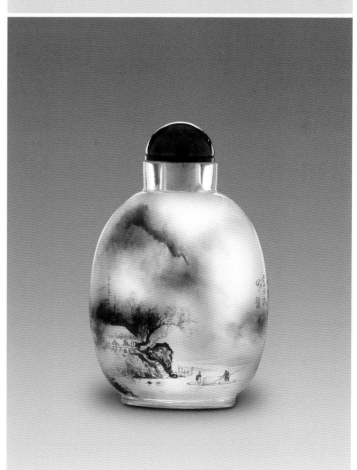

34. 秋江放艇

高 7.5 厘米　腹宽 3.6 厘米

玻璃

款识："一石作。"

壶一侧画的是初秋景色，大地绿意渐褪，将迎岁晚；另一侧画的是深秋萧瑟，江上过舟了无痕，很容易感受到山河凋零的气象，画面带有浓浓的文人风。

34. Boating in the Autumn River

Height 7.5 cm　Width 3.6 cm

Glass

Marks: "Yi Shi painted."

On one side, the picture is an early autumn scene; the shades of green in nature subside to make way for the end of the year and the coming of cold seasons; on the other side, the picture depicts a scene in late autumn, in which nature is slowly withering. The boat travels down the river leaving no trace of having been there. The viewers of this piece are aware of the withering feel brought by seasonal changes. These paintings demonstrate the traditional Chinese scholar painting style.

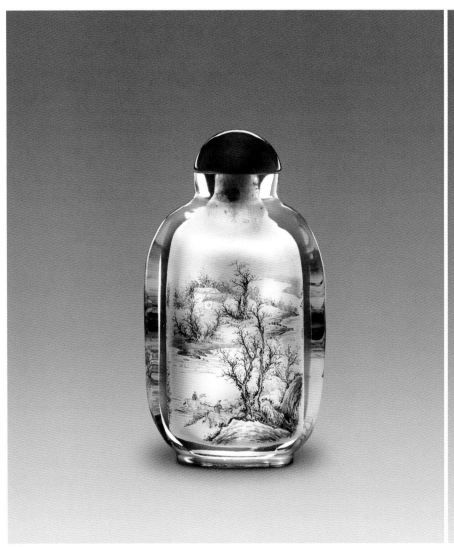

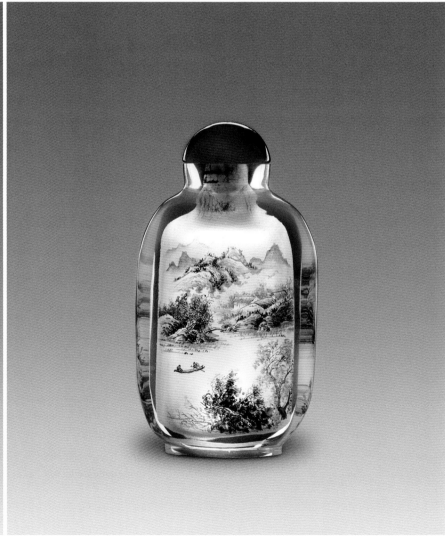

35. 云山访友

高 12.9 厘米　腹宽 8.5 厘米

玻璃

　　壶两侧雕有兽首环。洗练的国画笔触，超俗的山水笔墨和精准掌握壶面比例构图，反映了作者一生追求"养我胸中元气，壮我情怀笔墨"的精神世界。

　　作者画内画是胸有成竹，挥洒成画，尤其画山水，绝非拘泥于一笔一点的重复或相似，更像是自然流露出心中山水和胸中情怀。此壶是作者较大尺寸的山水内画，也是此类壶代表作。

35. Visiting a Friend at Yun Mountain

Height 12.9 cm　Width 8.5 cm

Glass

　　Both sides of the bottle have animal head ring carvings. The refined traditional Chinese painting techniques, outstanding water ink landscape designs, and precise layout of this bottle reflect the artist's lifetime pursuit of "cultivating the energy in his heart and empowering his brush strokes in his mind."

　　Inner painting is a difficult craft, but the artist is able to complete his pieces with relative ease because the art comes naturally to him; this is particularly true about his landscape inner paintings. Not a single stroke is repeated or similar to another, yet the artwork possesses a natural flow of feelings and emotions that comes from his heart. This bottle is one of the artist's larger-sized inside-painted bottles; it is a representative piece.

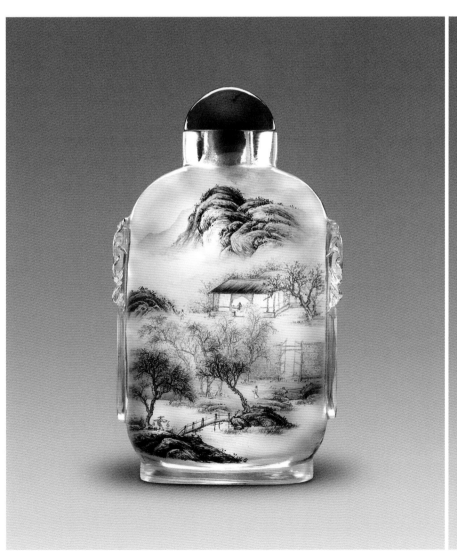
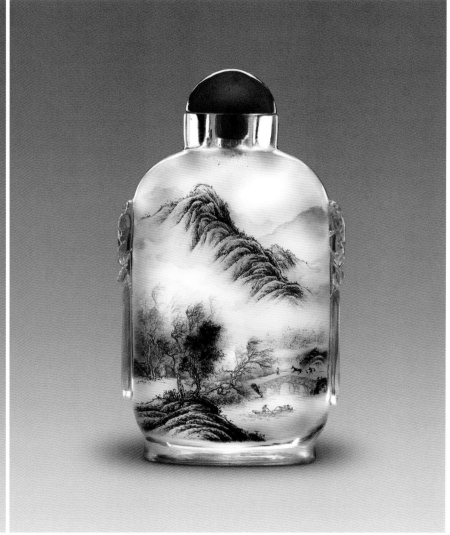

36. 云山雨意

高 7 厘米　腹宽 4.8 厘米

玻璃

　　款识："戊午三月下浣一石索振海仿作。"

　　虽不清楚作者仿的是何人的画作，但将原山水云雾缭绕的景致，以左右反画搬移到壶内方寸之间，是极需笔墨功力的。

　　此壶两面画如行云流水，流畅不生涩，桥上赶路人和躲雨挑夫、奔犬，体现出整个风雨欲来的生动。

36. Cloudy Mountains before the Rain

Height 7 cm　Width 4.8 cm

Glass

Marks: "Yi Shi Suo Zhenhai imitated in late March of the year of WuWu."

It is not clear as to who the artist of the original work is, but the inside painting artist certainly did a good job of imitating the landscape—a scene of hills wreathed in mist. The artist uses the inverted painting style to create this piece; with so little space to work with, the artist must be just as skilled as he is talented with the brush. The paintings on the two sides of the bottle are outstanding works of art; all the distinct images fit together flawlessly. The scene foreshadows a storm as people and a dog are shown trying to elude the rain.

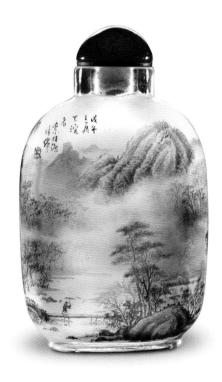
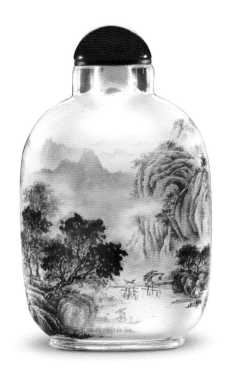

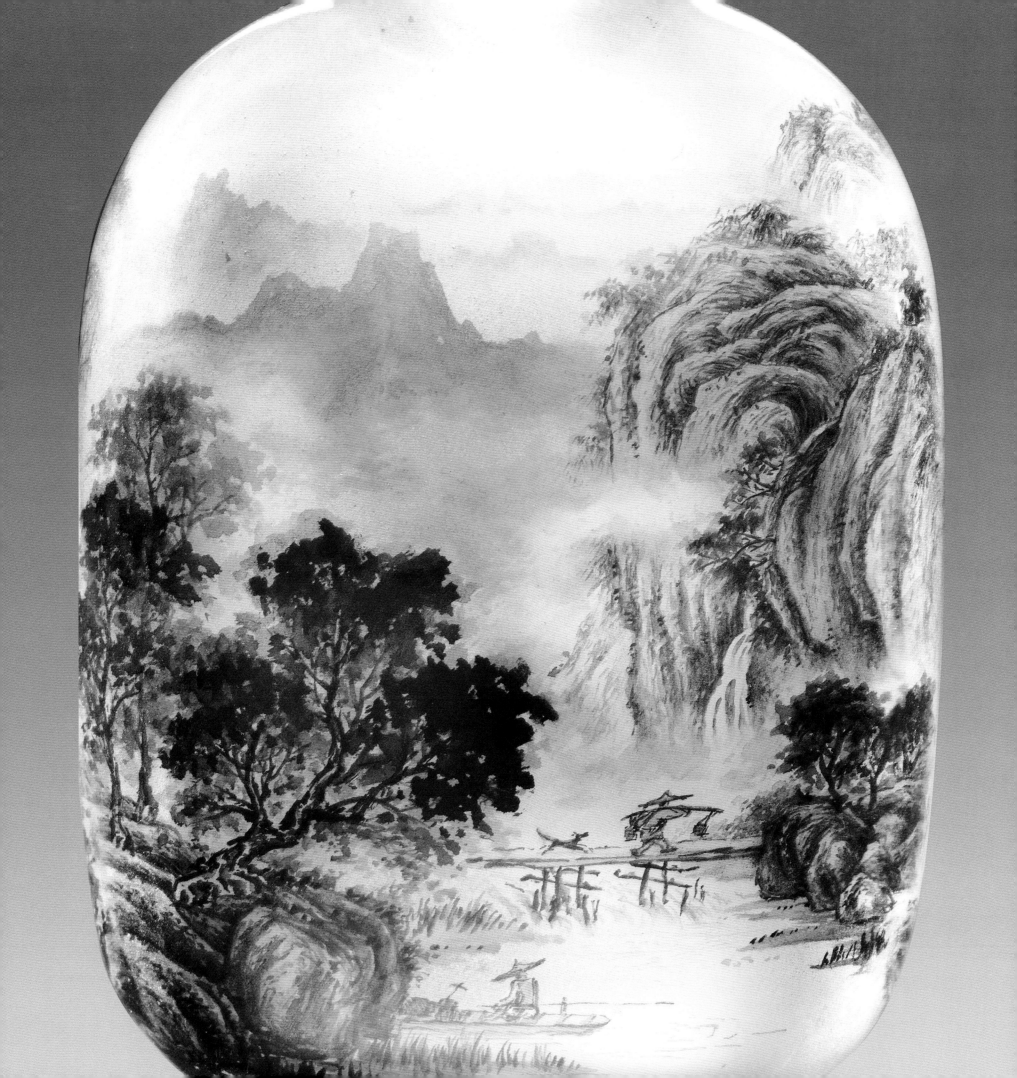

37. 风雨云月 （一组四个）

高 6.7 厘米　腹宽 3 厘米

玻璃

风壶款识："风。戊午夏一石索振海作"；

雨壶款识："雨。戊午秋八月一石索振海作"；

云壶款识："云。戊午冬月索振海一石作"；

月壶款识："月。天晴、水静、月近人。戊午三月索振海。"

内画倒钩笔经小洞反方向在磨砂壶面不见笔尖的条件下作画，堪称鬼斧神工。画工描内画已属不易，遑论同条件下加上壶面不渗水，再想达到水墨晕染的绝佳效果，更是难上加难。不但水墨的拿捏要准，笔意的随心所欲，还要深厚的国画底子，与众不同的山水情怀，才能完成此组壶的惊人之作。

四壶八景，若是外画，已是精彩绝伦，更不用说在内画极有限的条件下完成，真有如神来一笔，若再细观其人物，虽微小却个个生动到位；帧帧山水，构图卓绝，笔墨超凡，云山、雷雨、疾风、明月，都在印证着作者"神奇山水妙法自然"的功力。由于作者生前只曾画过两套，皆收录于此，而此组壶型比较精美，尤其珍贵。

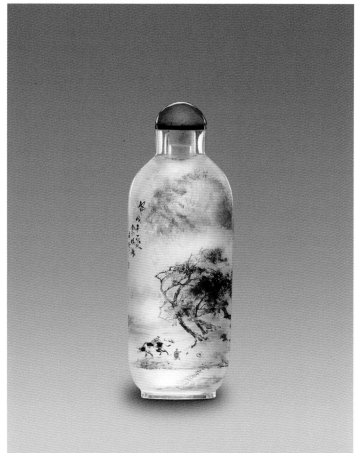

37. Wind; Rain; Clouds; Moon
(A Set of Four Bottles)

Height 6.7 cm　Width 3 cm

Glass

Wind Bottle's marks: "Wind. Yi Shi Suo Zhenhai painted in summer of the year of WuWu;"

Rain Bottle's marks: "Rain. Yi Shi Suo Zhenhai painted in autumn August of the year of WuWu;"

Cloud Bottle's marks: "Cloud. Suo Zhenhai Yi Shi painted in winter month of the year of WuWu;"

Moon Bottle's marks: "Moon. Clear sky, water still and moon close to men. Suo Zhenhai, March of the year of WuWu."

It is incredible that inner painting artists are able to create masterpieces using hook-shaped pens; they are required to paint in the opposite direction through a tiny opening at the top of the bottle on a matte glass surface. In addition to these challenges, the artist cannot even see the tip of his own brush when painting the inside of the bottle. Needless to say, producing detailed inner paintings is no easy task; under the above painting conditions, the artist must also paint on a surface that does not absorb water,

making it difficult to perfect water ink dyeing effects. This set of bottles requires not only a perfect mixture of water and ink and excellent brush technique, but a solid understanding of traditional Chinese painting and an extraordinary feel for landscapes as well.

There are four bottles and eight paintings in this set; each bottle is an exceptional piece of work even by normal painting standards, much less as a snuff bottle inner painting. If you look closely at the figures in the paintings, they are all tiny but very lifelike. Each painting is crafted by the magical touch of the artists brush according to a well thought layout. The clouds, mountains, thunder, rain, wind, and moon all reflect the artist's intent to reflect the concept of "Magical Landscapes Painted According to Nature". The artist only painted two sets on this subject matter and both series are included in this book. The bottles in this series are particularly sophisticated and precious.

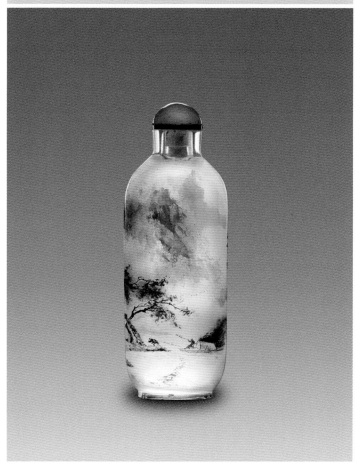

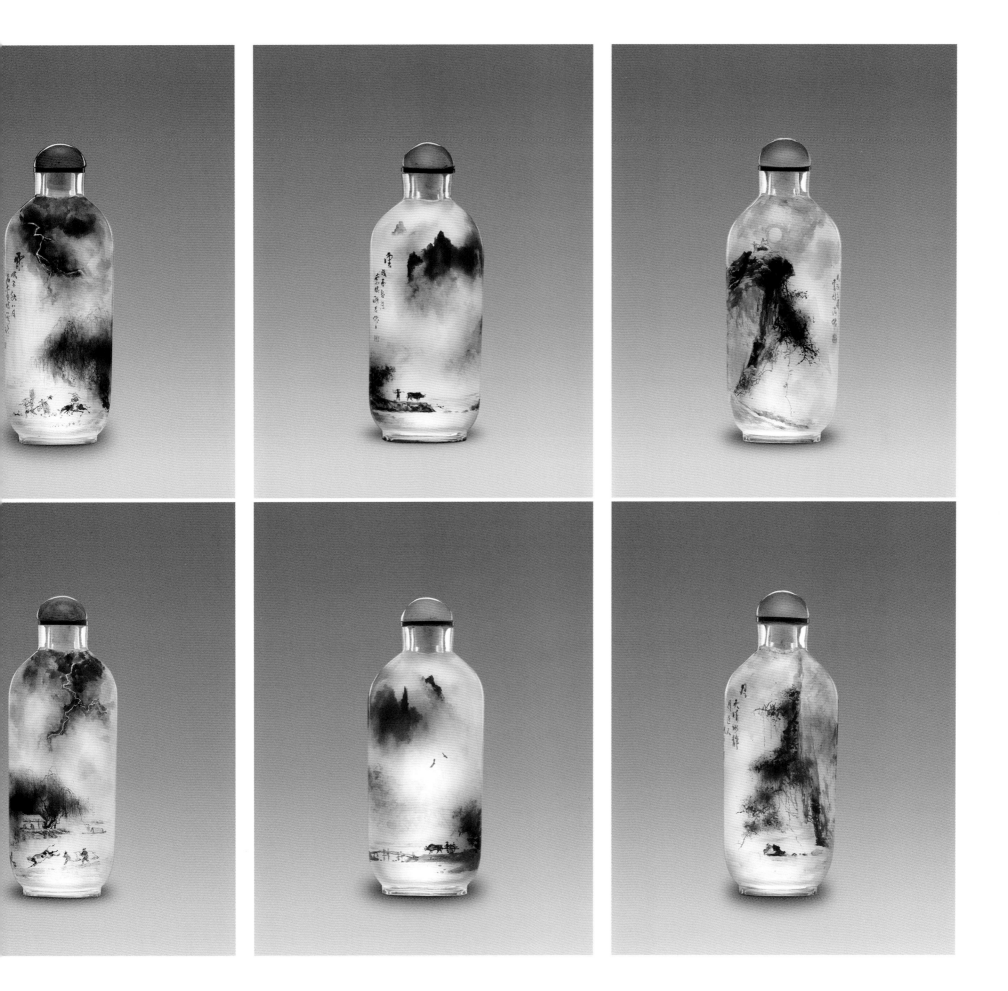

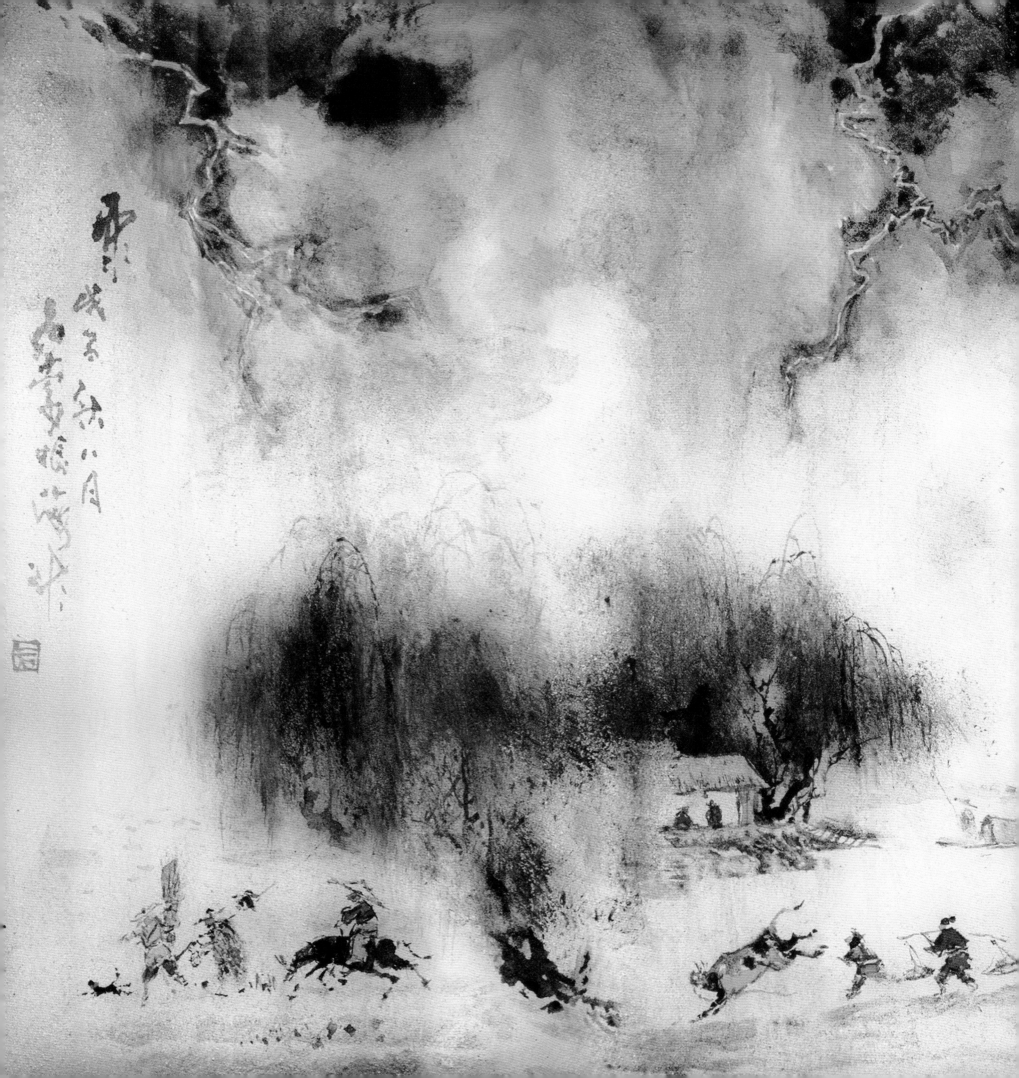

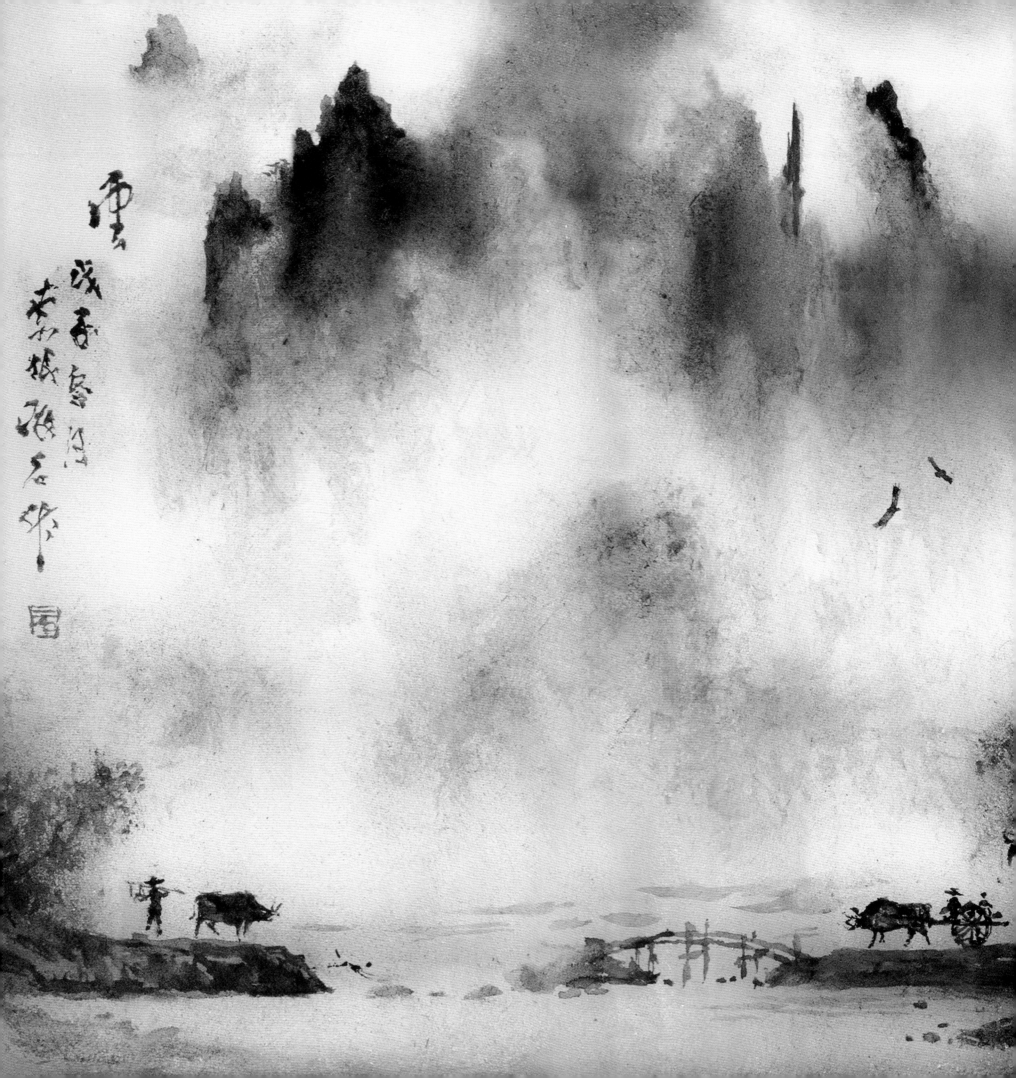

38. 风雨云月 （一组四个）

高 7 厘米　腹宽 5 厘米

玻璃

　　风壶款识："风。辛己八月中浣一石索振海作于津门"；

　　雨壶款识："雨。辛己八月中浣一石索振海作于津门"；

　　云壶款识："云。辛己秋八月下浣一石索振海作于津南"；

　　月壶款识："月。辛己秋一石索振海作于津南。"

　　风壶两侧画面仿佛连贯展现出风吹、天青、树摆、牧童追帽、渔夫抓竿等生动流畅

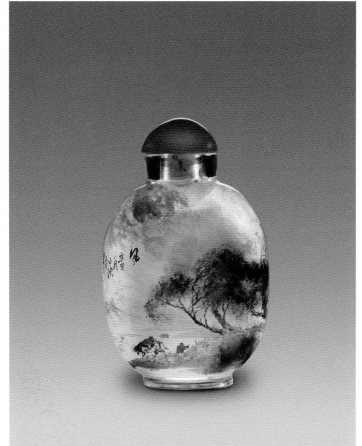

的情景。雨壶两侧雷电交加，天色阴霾，没带雨衣雨具的农民仓惶奔走，犬奔，牛狂，仿佛被雷声惊吓，雨景生动活现。云壶云海迷漫，山头隐现，大树稼汉耕牛，都以暗墨描绘，与淡墨形成对比，颇有诗意。月壶水中追月，高岭探月，意显月不孤单，不但有文人雅士附庸风雅，还有山川美景为伴。

　　作者能以生花妙笔，绘出画面的脉动和活力，绝非一般画家可及。其作品可远观，亦可就近细细品味，实一流画家之作。

38. Wind; Rain; Clouds; Moon
(A Set of Four Bottles)

Height 7 cm　Width 5 cm

Glass

　　Wind bottle marks: "Wind. Yi Shi Suo Zhenhai painted at Jing Gate in mid August of the year of XinJi;"

　　Rain bottle marks: "Rain. Yi Shi Suo Zhenhai painted at Jing Gate in mid August of the year of XinJi;"

　　Cloud bottle marks: "Cloud. Yi Shi Suo Zhenhai painted at the south of Jing in autumn late August of the year of XinJi;"

　　Moon bottle marks: "Moon. Yi Shi Suo Zhenhai painted at the south of Jing in the autumn of the year of XinJi."

　　The paintings on the Wind bottle depict trees swaying in the wind, a young shepherd chasing his hat, and a fisherman with his fishing rod. The pictures on the Rain bottle show vivid scenes of thunder and lightning in the dark gloomy sky, people without umbrellas or raincoats running

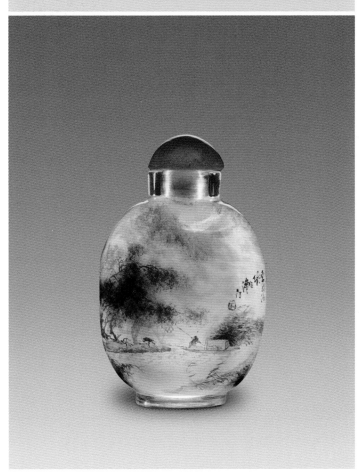

around in a panic, dogs and cattle terrified by the crack of thunder. The paintings on the Cloud bottle show a mass of hazy clouds standing in contrast to dark colored mountain tops looming over farmers and cows grazing near big trees. The paintings on the Moon bottle show a scholar reaching towards the moon's reflection in water, and a scholar reaching the moon on a high cliff, reflecting the idea that the moon is not alone because there are poets and scholars striving to understand her; furthermore, the majestic mountains are always there to keep her company.

　　The artist uses his magical brushwork to convey the spirit and energy within these paintings. His work can be viewed both from a distance and up close-the effect might be different, but the great impression the viewer is left with is the same. This is a set of truly remarkable pieces.

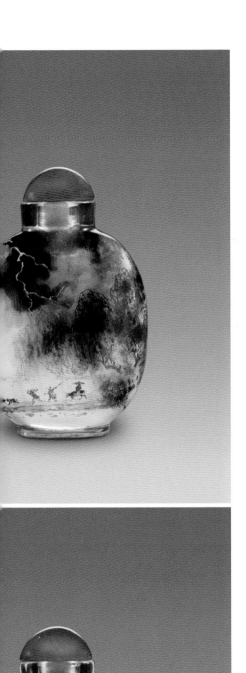

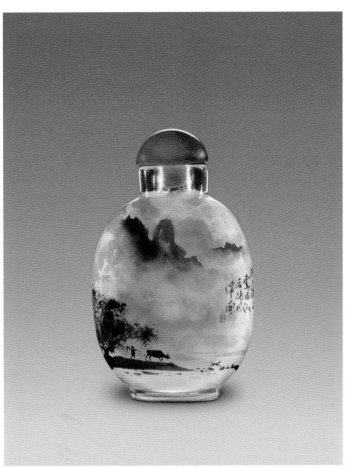

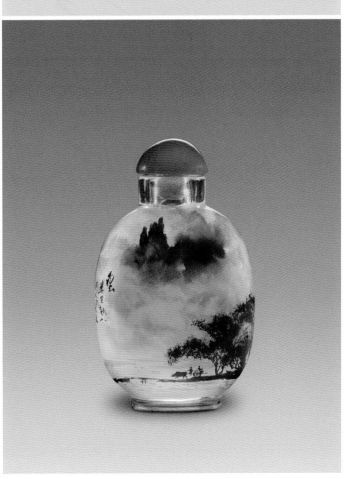

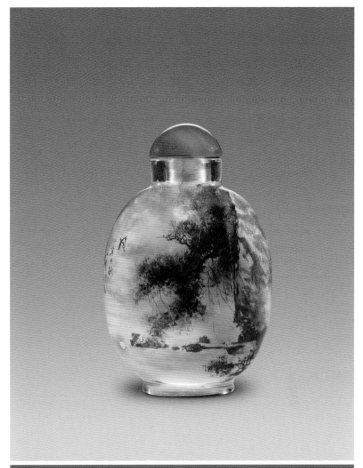

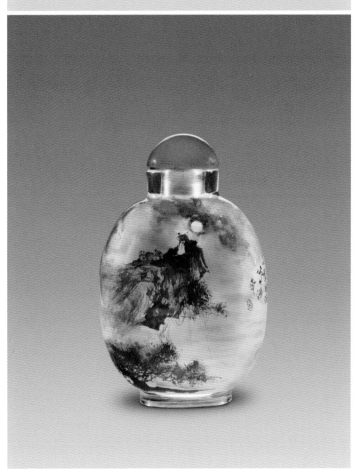

39. 论古访友

高 6.6 厘米　腹宽 10.7 厘米

玻璃

款识："论古。乙卯三月下浣一石作。"

另一面款识："访友。一石作。"

作者内画屏作品极其稀少，且件件孤品，故而件件珍贵。内画扇屏的倒钩笔作画角度与内画壶不仅有所不同，扇画面由窄至宽，构图得有所偏重取舍，上沿得以尽情发挥，展现山水宽阔壮丽，下沿得以收敛取景，充分拿捏尺度，完美利用整个扇面布局，呈现神奇山水风貌。

内画屏比鼻烟壶左右相反的画法更难，由于只能从屏下方的小孔伸笔作画，所以不但左右相反，而且必须上下颠倒的作画，堪称绝技。

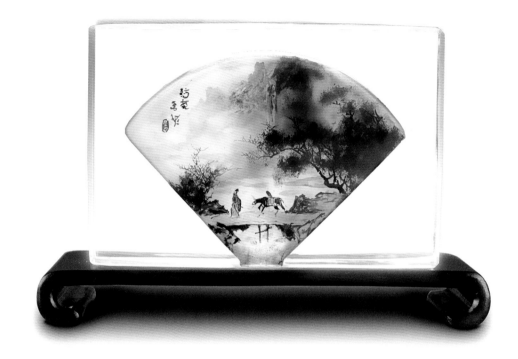

39. Discussing the Past;
Visiting a Friend

Height 6.6 cm　Width 10.7 cm

Glass

Marks: "Discussing the Past. Yi Shi painted."

The other side marks: "Visiting a friend, Yi Shi painted in late March of the year of YiMou."

Inner painting screens by this artist are rare and almost every single one of them is considered an exclusive piece. Painting the interior of a screen requires the artist to use the hook-shaped pens to paint at angles different from those used when painting snuff bottles. This is because screens are fan-shaped on the inside, starting narrow at the base and broadening near the top of the screen. The layout of each screen painting must be planned carefully to fit the fan-shaped space; near the top of the screen the wider space can accommodate a larger landscape scene, while the narrower base can only fit a smaller scene. The artist was very aware of these measurement requirements as he painted this piece, and as a result he produced a very well planned and excellently painted landscape.

Painting the interior of screens is, in some ways, harder than painting in snuff bottles because bottle painting only requires that the artist paint left to right in the opposite direction, whereas screen painting requires that the artist paint both left to right and upside down.

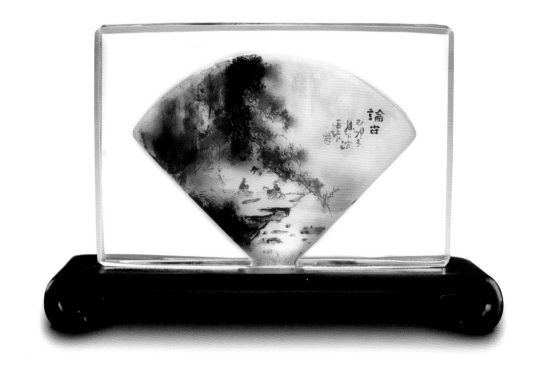

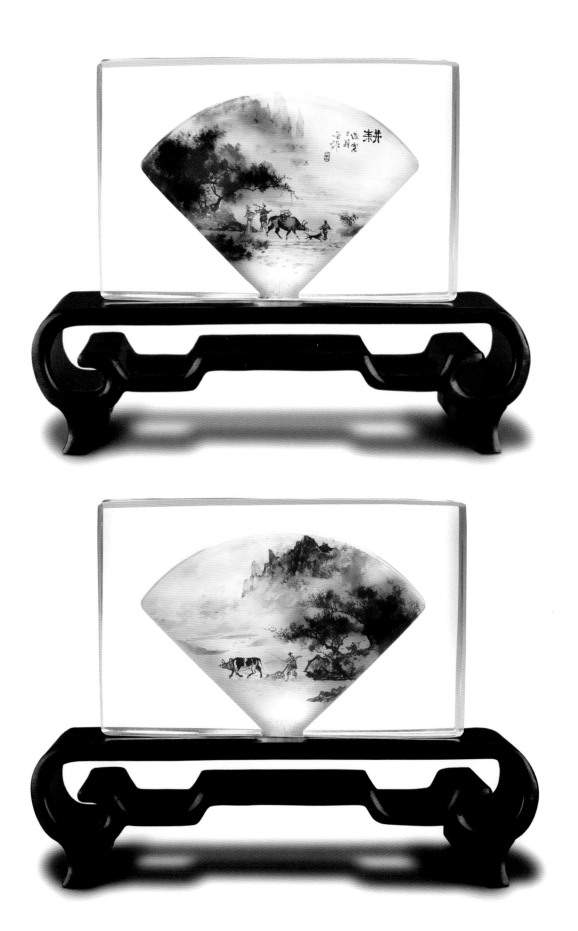

40．耕

高 6.6 厘米　腹宽 10.7 厘米

玻璃

　　款识："耕。戊寅三月一石作。"

　　相对内画壶而言，扇面屏允许较近距离的人物特写，也更容易欣赏到作者刻画人物的生动笔触。笔意随性老练，不但笔到意到，还意犹未尽，十分精彩。此件亦是孤品。

40. Farming

Height 6.6 cm　Width 10.7 cm

Glass

　　Marks: "Farming. Yi Shi painted in March of the year of Wu Yin."

　　Relatively speaking, it is slightly easier to paint a close up human figure in a screen than in a bottle; the screen allows a better view of the vivid brushstrokes the artist uses to paint the figure. His precise brushstrokes are the result of years of practice; they always come out the way he intends for them to. This screen is a remarkable and exclusive piece.

41. 春

高 6.9 厘米　腹宽 10.9 厘米

玻璃

　　款识："春。一石作。"

　　满谷春桃绽放，不同于作者其他春主题的山水作品，桃红春色渲染着较大范围的画面。由于扇面展开给于的色彩空间较充分，无庸过分担心桃色抢画面，所以作者大胆的用足了桃花红。本扇屏是件精品，也是绝品。

41. Spring

Height 6.9 cm　Width 10.9 cm

Glass

　　Marks: "Spring. Yi Shi painted."

　　This screnn pictures spring plum flowers blooming all over a valley; it is slightly different from the artist's other spring subject inner paintings. Plum red is the dominant color in this painting. The fan shape of the screen provides more space for the artist to paint; therefore, he is able to employ the plum color without fear of the bold color overriding the entire painting. This is a fine and exclusive piece of inner painting art.

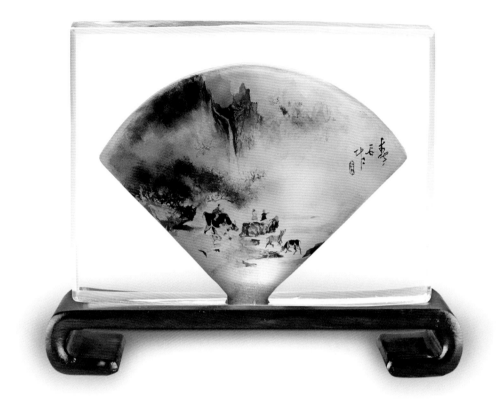

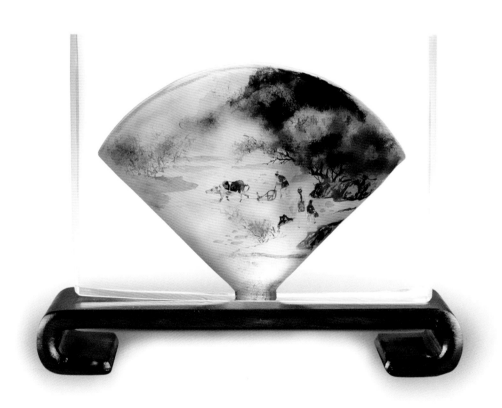

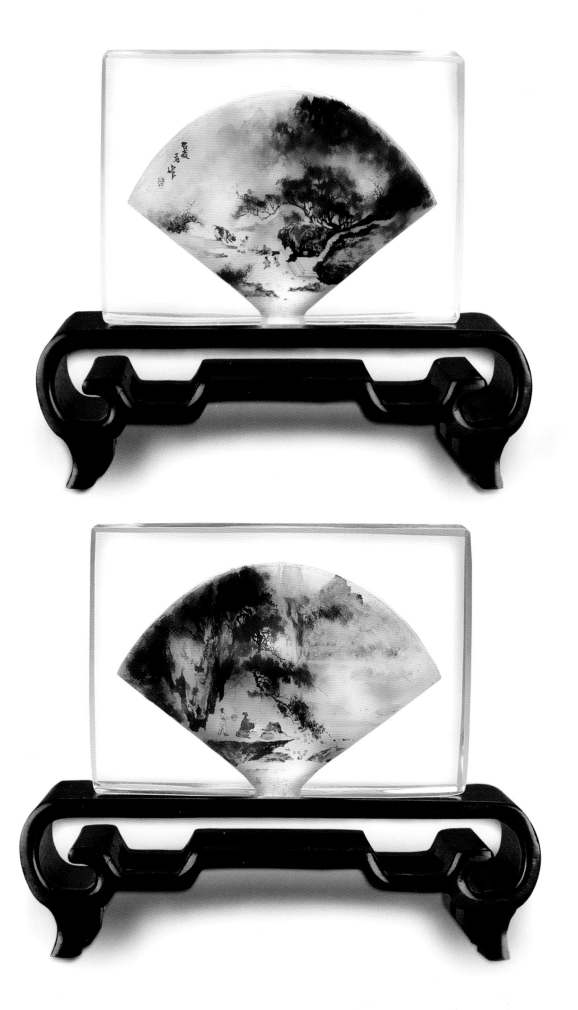

42. 夏

<u>高 7 厘米　腹宽 11 厘米</u>

<u>玻璃</u>

　　款识："夏。一石。"

　　仲夏牧童戏水，绿夏深山书童摇扇清读，峰峦叠翠，暑中求凉。扇面给与较多自由空间的发挥，所以此扇屏构图于其鼻烟壶内画中未见有相同者，且是内画屏孤品。

42. Summer

<u>Height 6.6 cm　Width 10.7 cm</u>

<u>Glass</u>

　　Marks: "Summer. Yi Shi."

This bottle shows a mid-summer scene; a young shepherd boy is wading into the water to play and cool down. Deep in the mountains, under the green shade, another boy is holding a fan as he studies; the only human character in the painting seems to command the peaks and hills, the majestic landscape he is surrounded by. The fan shaped space provides more room for developing different layouts; the layout in this screen is unique to this piece, making this an exclusive piece of work by the artist.

43. 大山水

高 9.9 厘米　腹宽 17.1 厘米

玻璃

　　这是作者生前唯一创作的大山水屏。终于能无拘无束的在大范围空间挥洒胸中五壑，气势不凡；画面散发出其神奇山水一贯的俊秀气质，远山近水层次分明，水墨晕染浓淡有致，整体呈现出壮丽不俗的风雅，气韵生动，堪为作者山水内画巅峰之作。

43. Grand Landscape

Height 9.9 cm　Width 17.1 cm

Glass

　　This is the only large landscape screen painting the artist painted in his lifetime. With the relatively larger painting space available in screens, the artist could finally express the landscapes he had in his mind free of restriction. This piece demonstrates extraordinary momentum and the final product is a magical landscape, handsome and elegant in nature. Distant mountains in the background and a body of water in the foreground create distinct layers within the painting. This effect is primarily created through a water-ink dyeing technique. This is one of the artist's best landscape inner painting pieces.

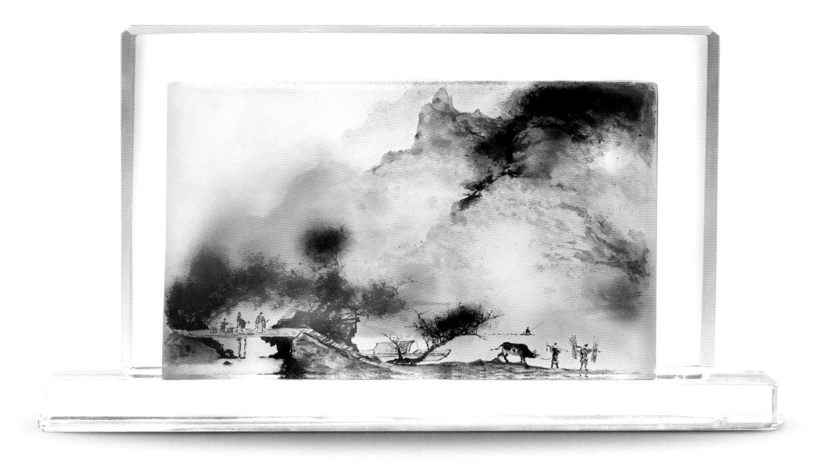

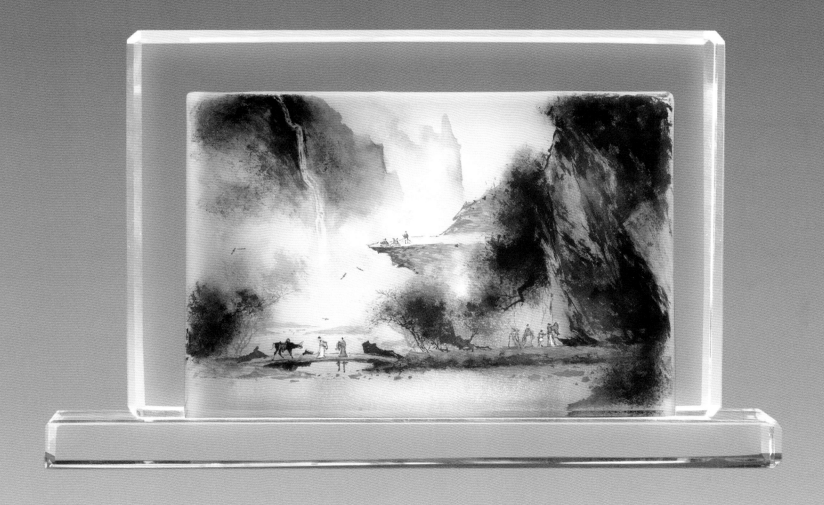

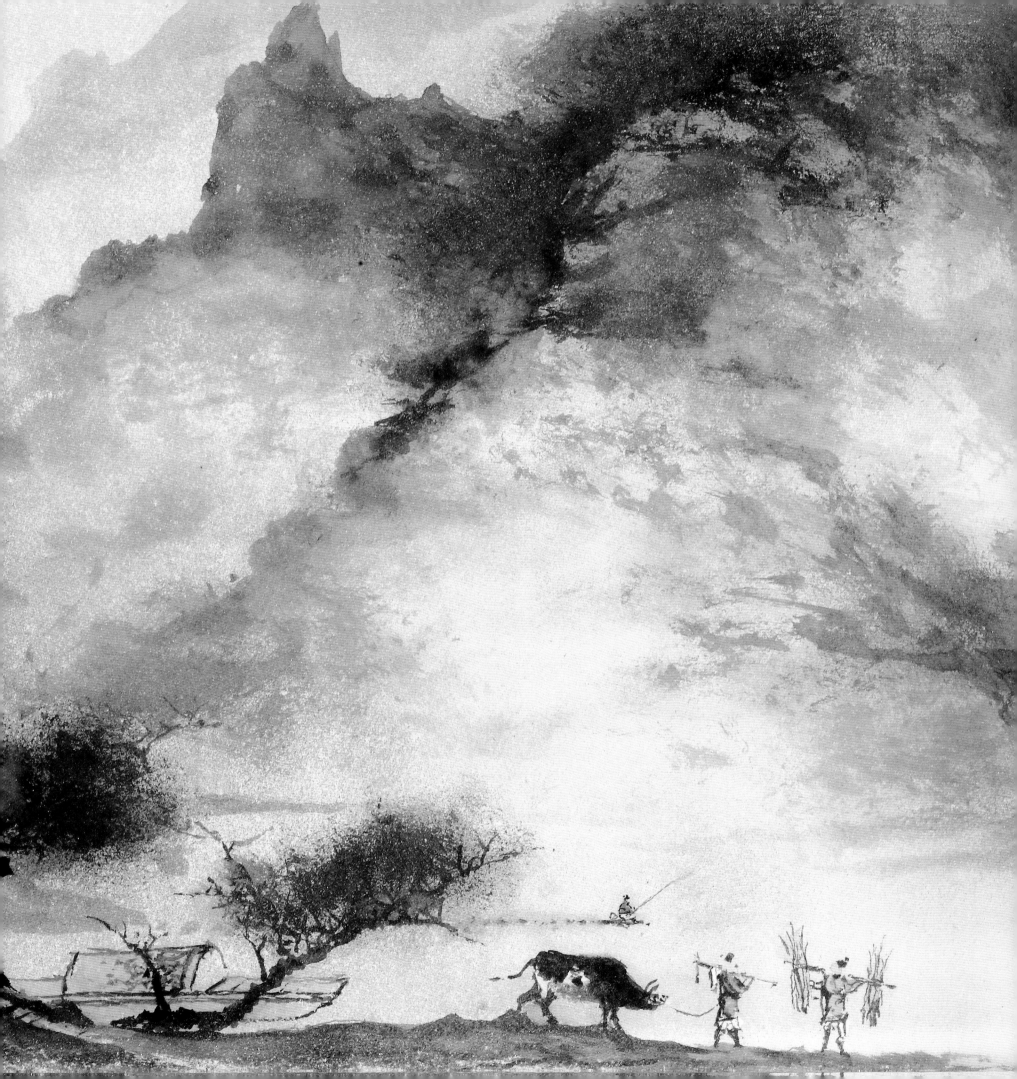

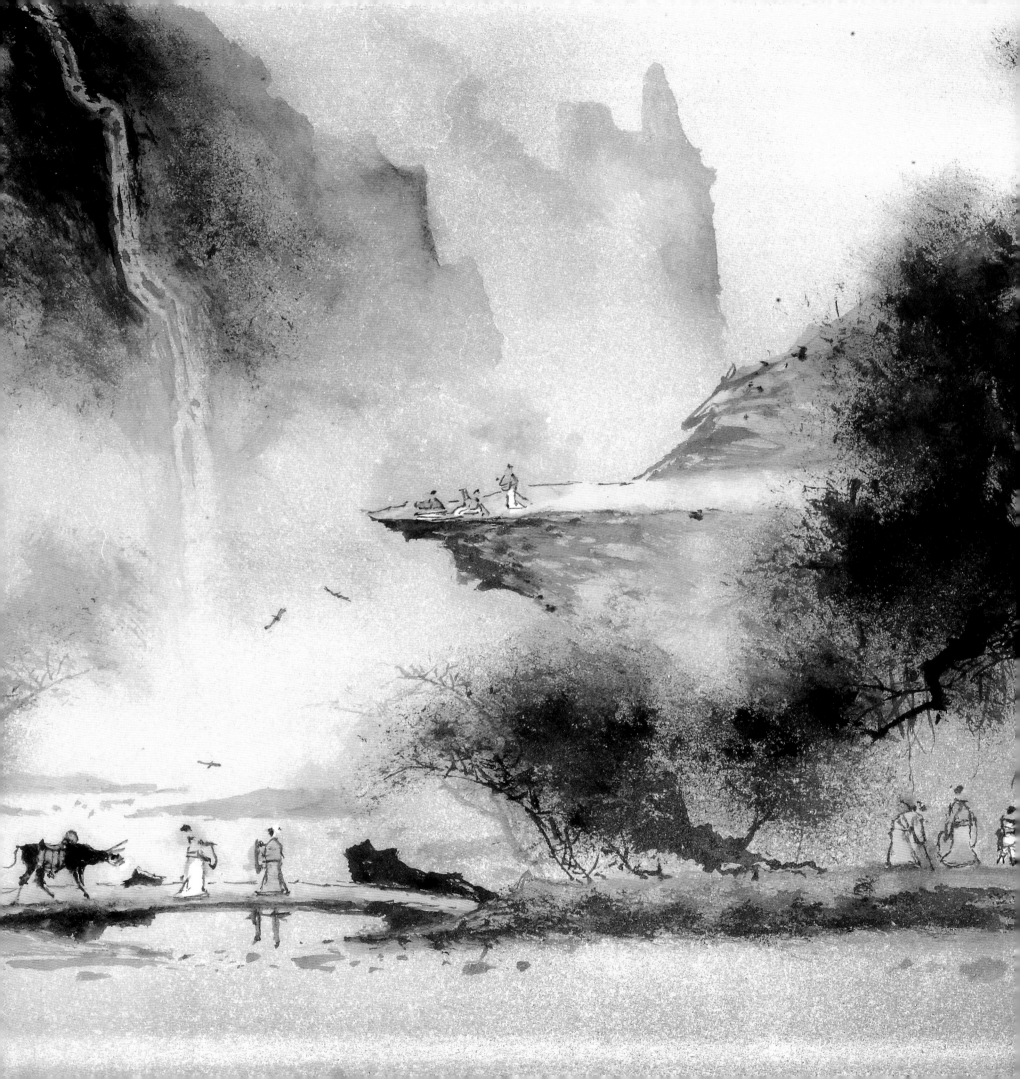

花 鸟

Birds and Flowers

44. 鹭鸶晓月

<u>高 5.6 厘米　腹宽 4 厘米</u>

<u>玻璃</u>

款识："摹清人笔法，多年愧未能似。庚辰三月索振海作。"

另一面款识："师古人师造化。庚辰一石作。"

壶一面绘鹭鸶孤立坳石，湖边芦草，湖中明月倒影，营造出恬静古趣、幽然深邃的意境；壶另一面绘枯树栖息双鹊，相偎相依，构图清丽简洁，饶有情趣。壶体两边侧雕有兽面环。

此壶茶色背景是由王习三先生亲笔代为添加的。

44. Egret Acquainting itself with the Moon

<u>Height 5.6 cm　Width 4 cm</u>

<u>Glass</u>

Marks: "Modeled after the brushwork of Qing Dynasty artists. However, the imitation does not do the original justice. Suo Zhenhai painted in March of the year of GengChen."

The other side marks: "Learned from nature and from the past. Yi Shi painted in the year of GengChen."

One side of the bottle pictures a lone egret standing on an awkwardly shaped rock with the reed flourishing around the lake and the reflection of the moon on the lake's surface. This wondrous scene builds a sense of tranquil elegance. The other side of the bottle pictures a dry tree supporting two magpies leaning against each other, painted simply and beautifully. Two edges of the bottle have animal head carvings.

The tea colored background was added by Mr. Wang Xisan.

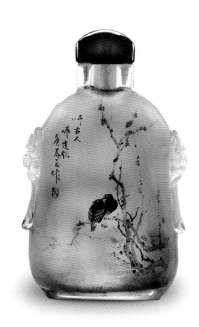

45. 双雀

高 9 厘米　腹宽 4.5 厘米

玻璃

　　此壶绘雀鸟形体动作生活有力，炯炯有神，无论写花写鸟，用笔老练，不容迟疑，设色构图，笔到意到，笔尽意未尽。观者若一时失神，会以为欣赏的是外画，因其绝非如一般内画战战兢兢一笔一笔的照着描画，而是作者 40 多年纯熟国画底子的展现。

　　此壶为索老提供给学生的范本。

45. Twin Sparrows

Height 9 cm　Width 4.5 cm

Glass

　　This bottle portrays a group of lively, spirited sparrows; their bright, piercing eyes are the most noticeable feature of this inner painting. The flowers and the birds are painted with swift and skillful brushstrokes; the layout and colors used in this piece are an incredible expression of the artist's creative genius and allows one to see straight into the artist's mind. The birds are painted so vividly, one might forget that one is wondering at an inside-painted work. The artist does not paint the birds using conventional stroke by stroke inside-painting imitation methods. This piece demonstrates the artist's forty years of experience in traditional Chinese painting.

　　This bottle is a master sample for students to learn from.

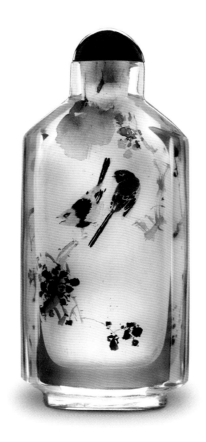
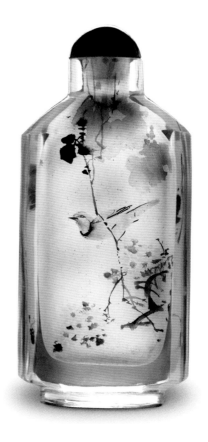

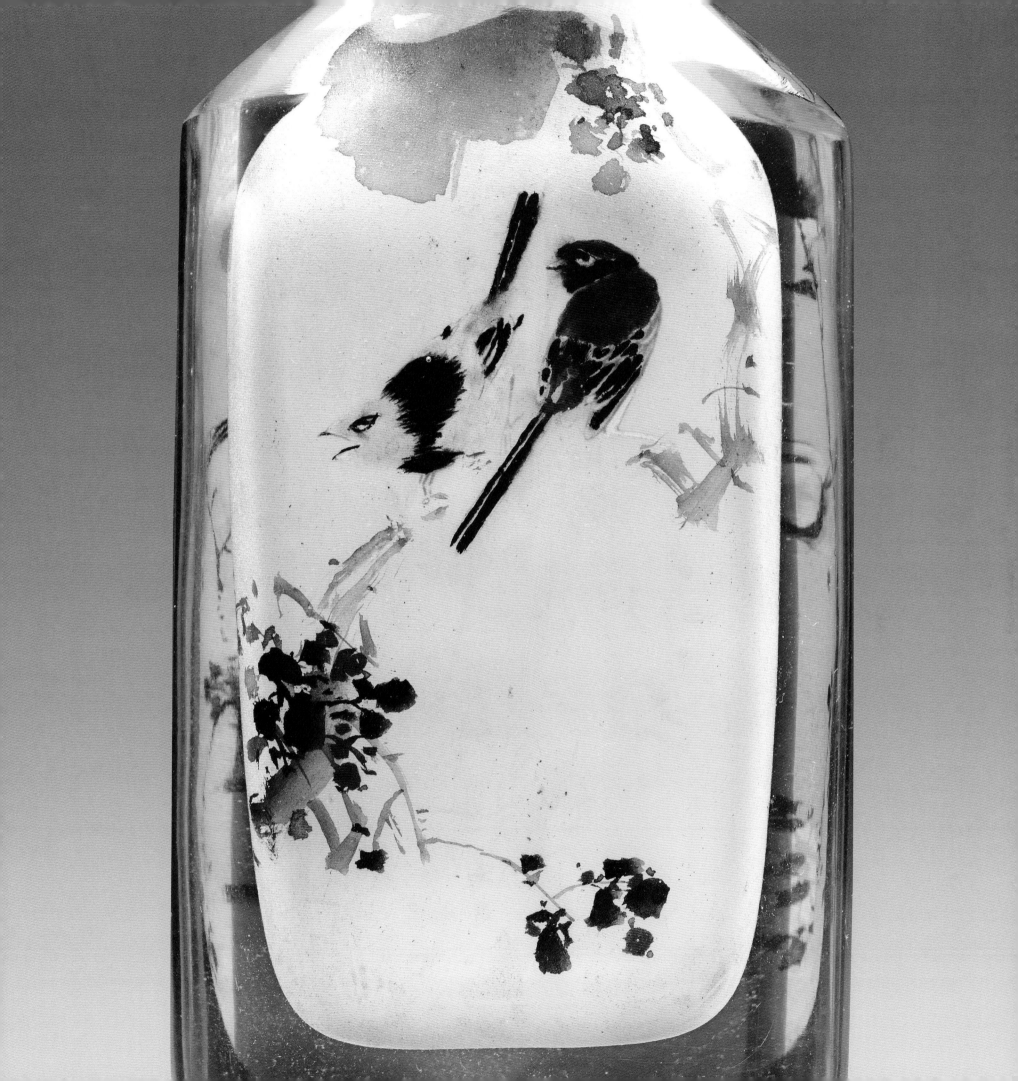

46. 林间翠鸟

高 5.7 厘米　腹宽 3.6 厘米

玻璃

款识："师古人师造化师今人，四十年愧未能似。乙卯三月。"

另一面款识："下浣一石索振海作于津南古城三房舍。"

画面写意林间翠鸟和荷塘鹭鸶，是笔墨润色、挥洒自如的力作。鸟禽的神态自若，神气活现，和素雅清静的氛围融成一片，不唐突，不耀目，却有一份气定神闲的优雅，颇富文人画风的气质。此题材为作者孤品。

46. Kingfisher in the Woods

Height 5.7 cm　Width 3.6 cm

Glass

Marks: "Learned from the ancient, from nature and from the contemporary; ashamed that after forty years one still cannot paint well. March of the year of Yi Mao."

The other side marks: "Yi Shi Suo Zhenhai painted at the third house of the south of Jing Old Town in late March."

These free style inner paintings of a kingfisher in the woods and an egret in the lotus pond are painted in black ink and colors. The birds are painted simply but elegantly to appear calm and relaxed, proud and mighty. The image of the birds creates a sense of tranquility, giving the inner painting a rich scholarly feel. This is the artist's exclusive piece of this subject.

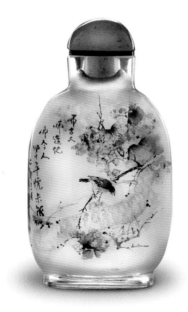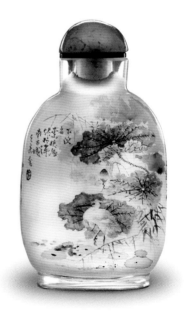

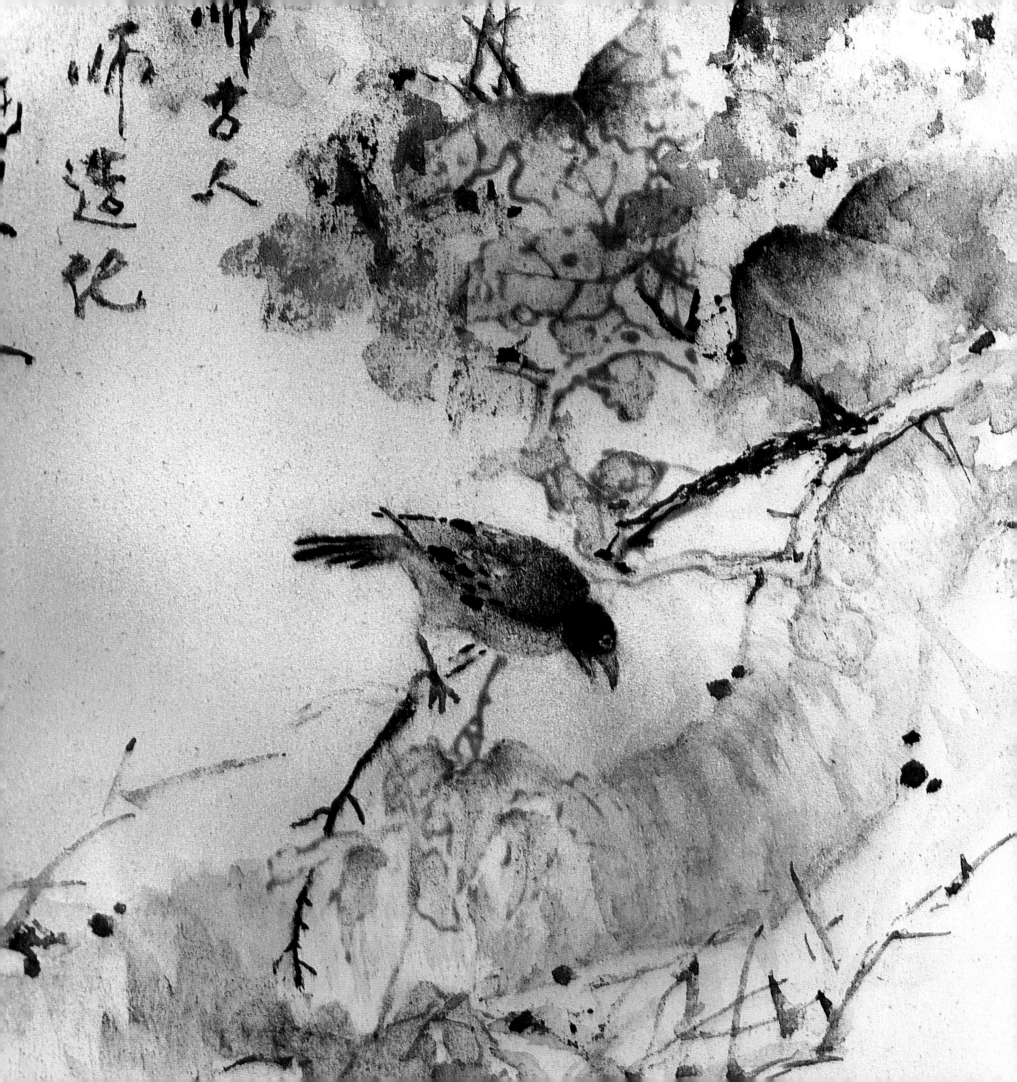

47. 初春戏雀

高 6.2 厘米　腹宽 3.2 厘米

玻璃

　　款识："戊寅索振海一石作。"

　　作者的禽鸟之作，有略带现代元素创意者，也有典雅古意者。如此壶，看似古画，其实为其仿古风展露文人气质之作，承袭国画传统的精髓，用内画的技巧，再现文人花鸟画之风华。

47. Playful Sparrows in Early Spring

Height 6.2 cm　Width 3.2 cm

Glass

Marks: "Suo Zhenhai Yi Shi painted in the year of Wu Yin."

The artist has employed both contemporary creative elements and elegant ancient styles in his paintings of birds. This bottle has the appearance of an antique painting and is, in fact, painted in a scholarly style reminiscent of that which was prevalent in the past. He employed the most sophisticated traditional Chinese painting techniques and his inner painting talent to convey the scholarly beauty of this flower and birds scene.

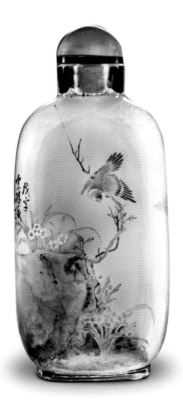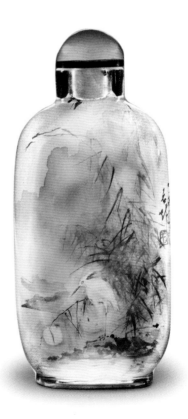

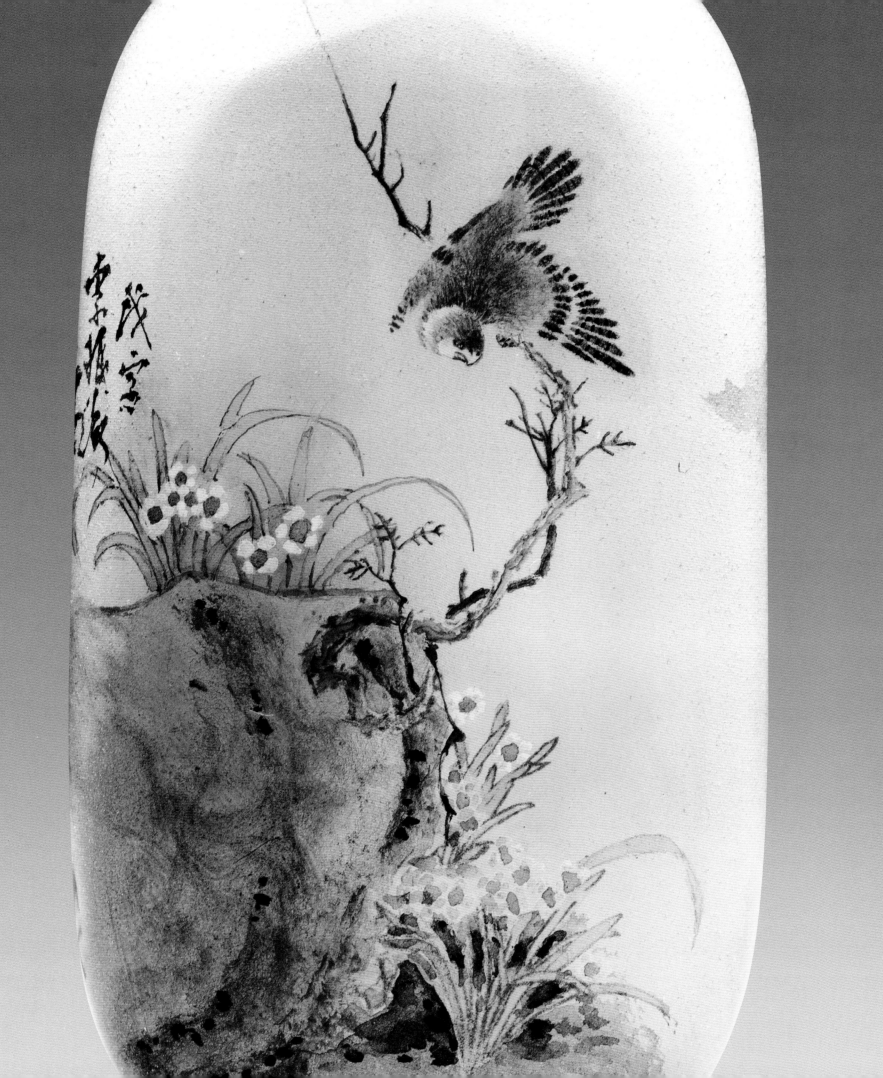

48. 雉鸡

高 7.2 厘米　腹宽 4.7 厘米
玻璃

　　此壶绘鸟姿态卓越，用色绝妙，好似跳出水墨写意的山石花草背景，令人爱不释手。

　　此为学徒习作范本，唯作者亲笔之作，才能充分展现其精气神。

48. Pheasant

Height 7.2 cm　Width 4.7 cm
Glass

　　This bottle pictures birds with style and class. The colors the artist chose to use go well together, making it seem as if the birds are about to jump out from the water-ink painted background. The viewer will undoubtedly be fascinated by such a sight.

　　This is a master sample for the artist's students to learn from. Only a work done by the master artist himself reveals the true spirit of this art.

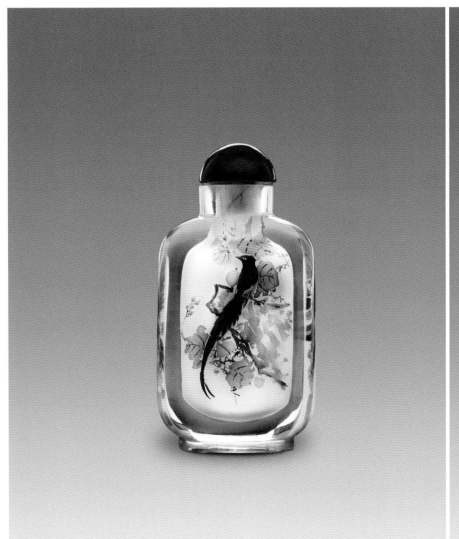
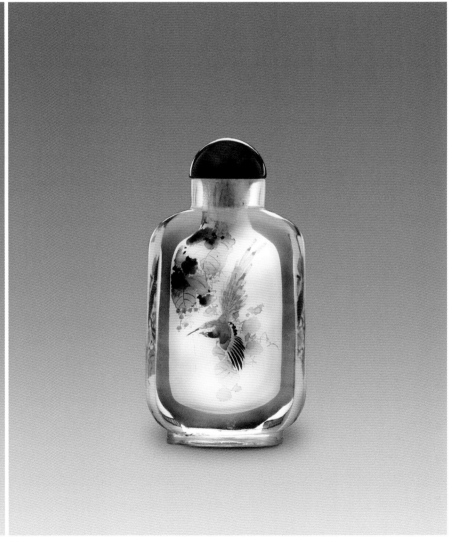

49. 雪

高 7.2 厘米　腹宽 5.1 厘米

玻璃

　　款识："雪。庚辰索振海作。"

　　清代扬州画家边寿民善绘芦雁题材，此壶虽非仿作，却已具边寿民画雁水平。尤其深雪芦苇，色彩层次极为丰富，人难所及，实属绝妙力作。

49. Snow

Height 7.2 cm　Width 5.1 cm

Glass

　　Marks: "Snow.　Suo Zhenhai painted in the year of GengChen."

　　The Yangzhou artist, Bian Shoumin, from the Qing dynasty was exceptional at painting wild geese. This painting is not an imitation, but it possesses qualities similar to that of Bian Shoumin's paintings: the colorfully painted reeds in the deep snow in particular are especially similar to Bian Shoumin's style of painting. This inner painting is well beyond the works of many others in terms of sophistication and quality; it truly is an incredible piece.

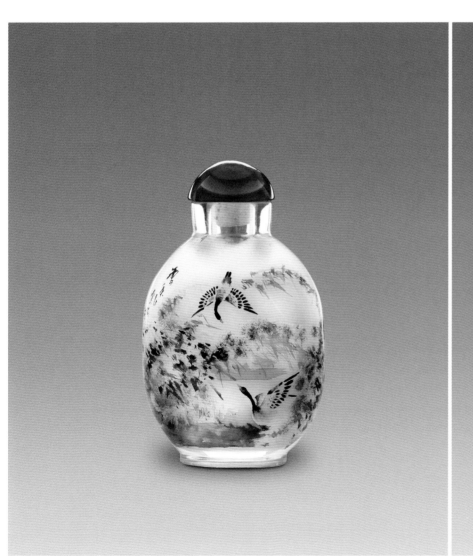

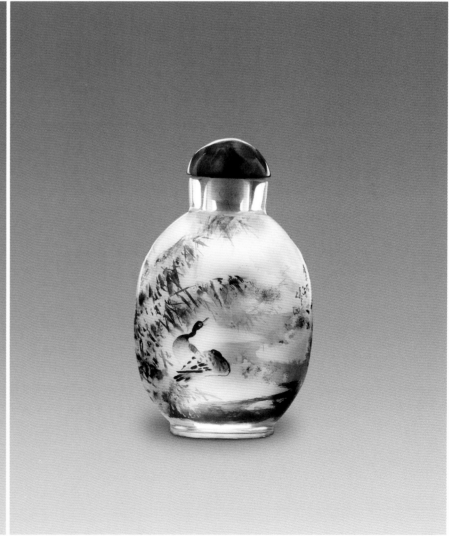

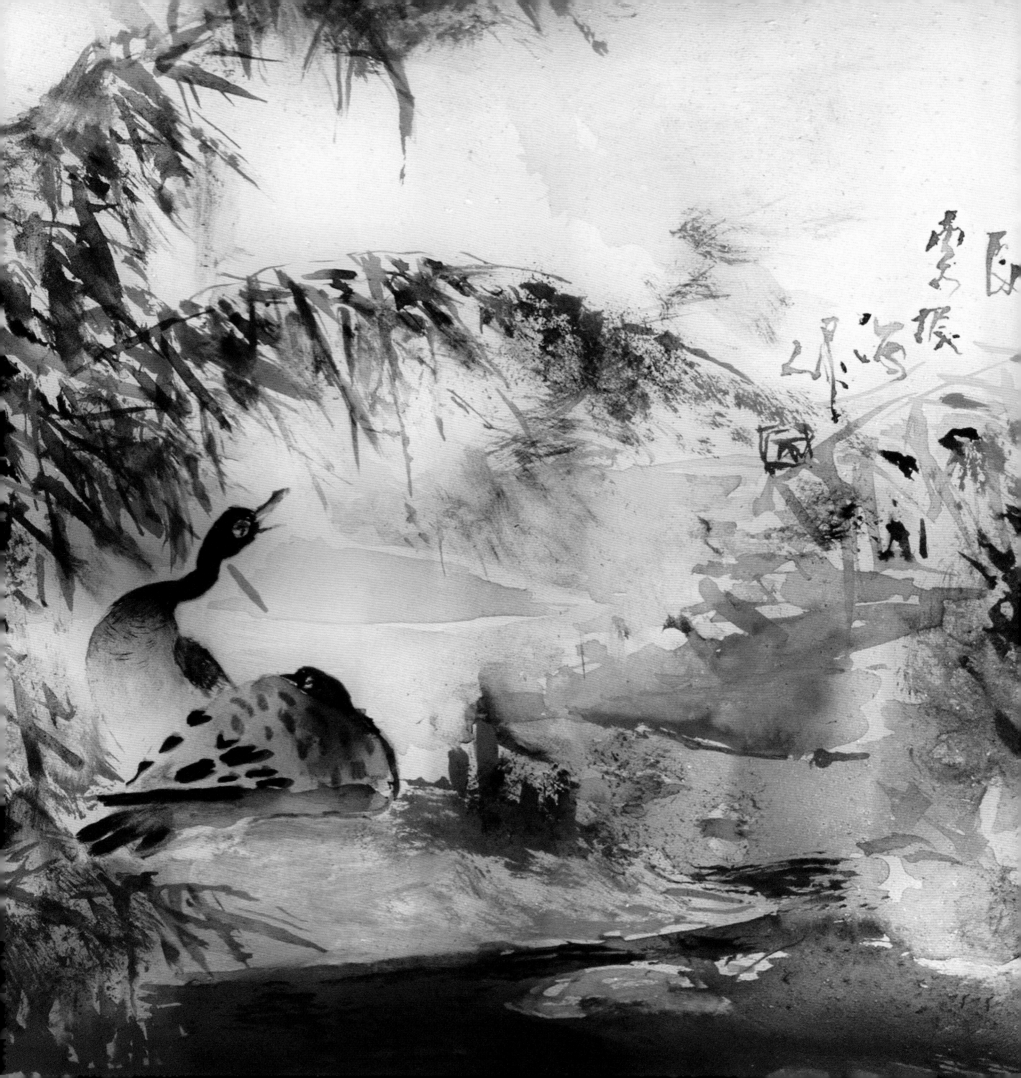

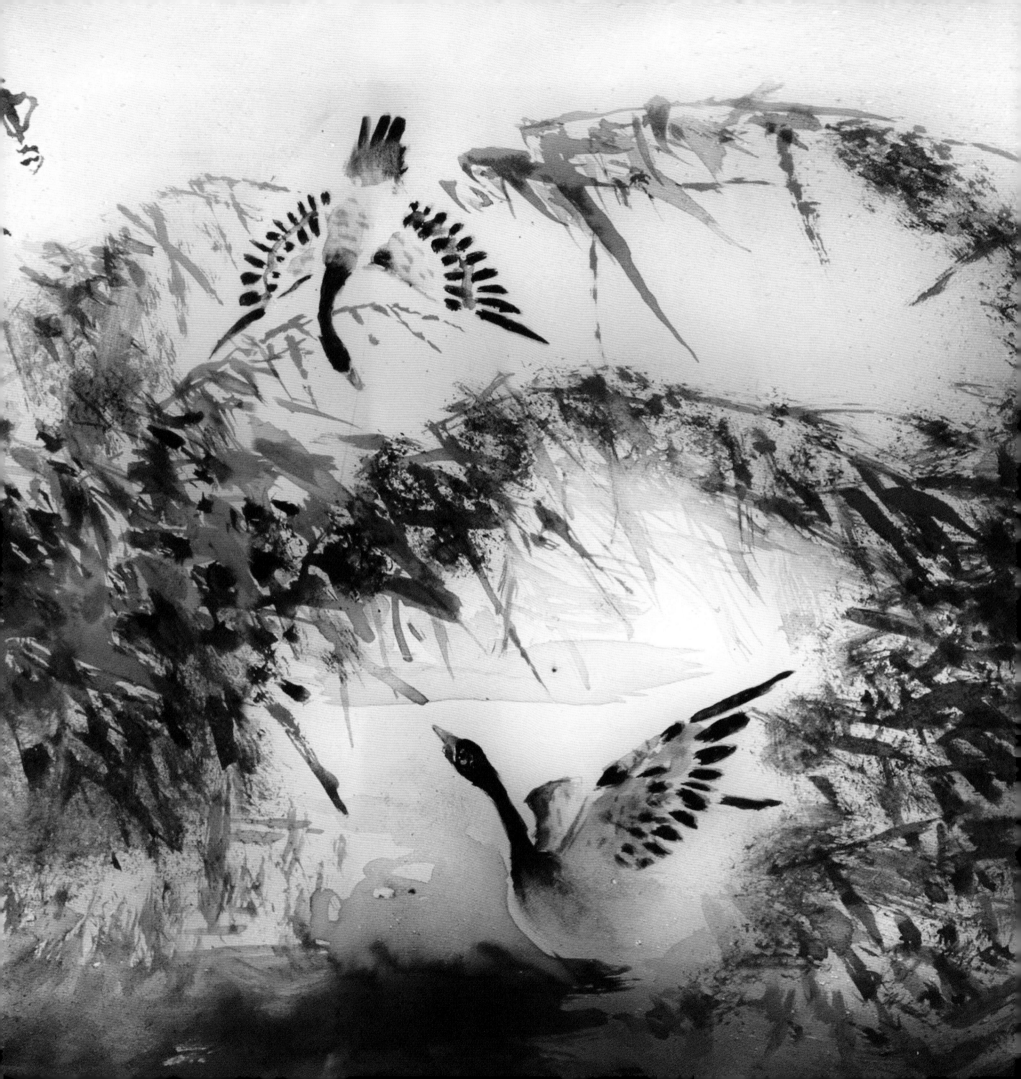

50. 风雨月雪 （一组四个）

高 7 厘米　腹宽 2.8 厘米

玻璃

风壶款识："风。戊午三月索振海一石作"；

雨壶款识："雨。戊午夏月一石索振海作"；

月壶款识："月。戊午秋八月一石索振海作"；

雪壶款识："雪。戊午冬十一月一石索振海作。"

以雁为主体形象，贯穿四种天象和季节，流畅完美的表达了雁的动态。仔细琢磨欣赏这八帧雁景图，可再次体现作者作画贯有的元素——神奇笔墨，妙法自然。

50. Wind; Rain; Moon; Snow

(A Set of Four Bottles)

Height 7 cm　Width 2.8 cm

Glass

Wind bottle marks: "Wind. Suo Zhenhai Yi Shi painted in March of the year of WuWu;"

Rain bottle marks: "Rain. Yi Shi Suo Zhenhai painted in a summer month of the year of WuWu;"

Moon bottle marks: "Moon. Yi Shi Suo Zhenhai painted in autumn August of the year of WuWu;"

Snow bottle marks: "Snow. Yi Shi Suo Zhenhai painted in winter November of the year of WuWu."

This set uses wild geese as the subject matter in four seasonal scenes; the movements of the wild geese as well as their resting positions are beautifully and elegantly portrayed. If one carefully studies these eight paintings of wild geese, one will find elements common throughout many of his inner paintings—magical brushstrokes that mimic nature's beauty.

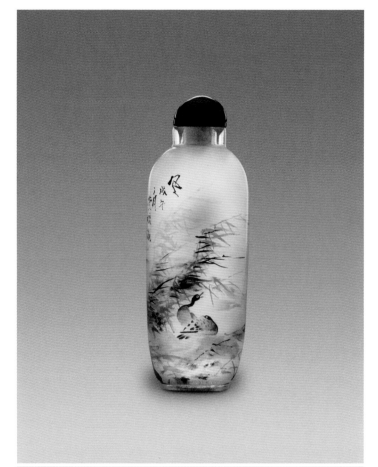

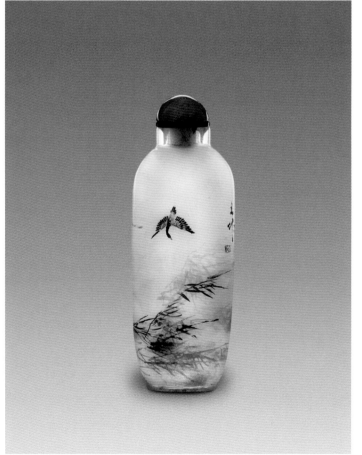

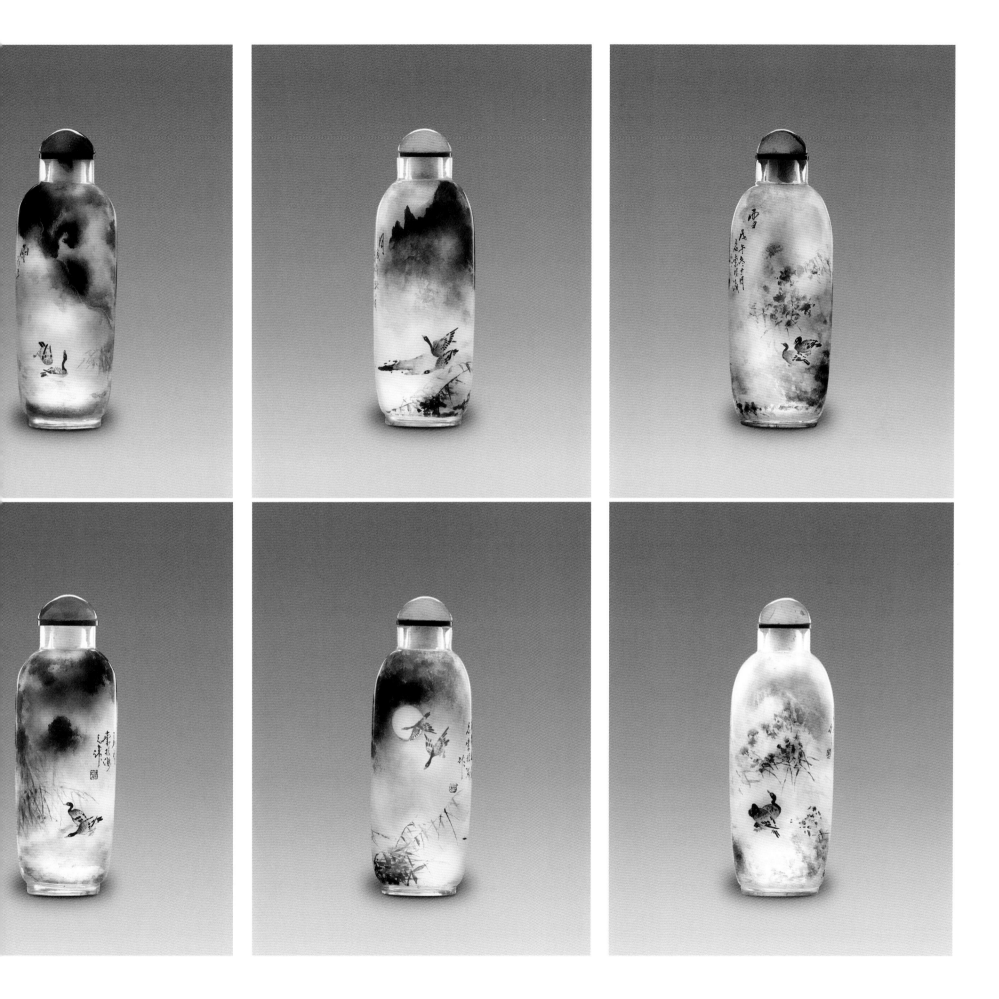

51. 荷塘戏蟹

高 5.8 厘米　腹宽 3.7 厘米

玻璃

　　款识："索一石作。"

　　此壶水墨晕染层次，可谓发挥得淋漓尽致。成功的水墨运用，渲染出画面的湿润感；再加上巧墨着色的螃蟹，宛然欲活，横行于湿漉漉的大荷叶之间。此件作品也是作者精彩孤品。

51. Playful Crabs in a Lotus Pond

Height 5.8 cm　Width 3.7 cm

Glass

　　Marks: "Suo Yi Shi painted."

　　The layers of water-ink dye are executed perfectly in this bottle. The water-ink images cover the entire bottle which is effective in creating a watery background that the viewer can almost reach out and touch. The subtle ink-colored crabs are detailed and lifelike, scuttling across the large lotus leaves. This is a superb and exclusive work.

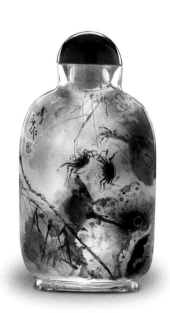
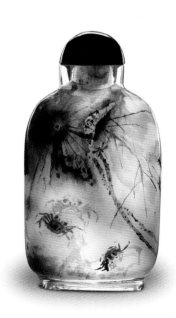

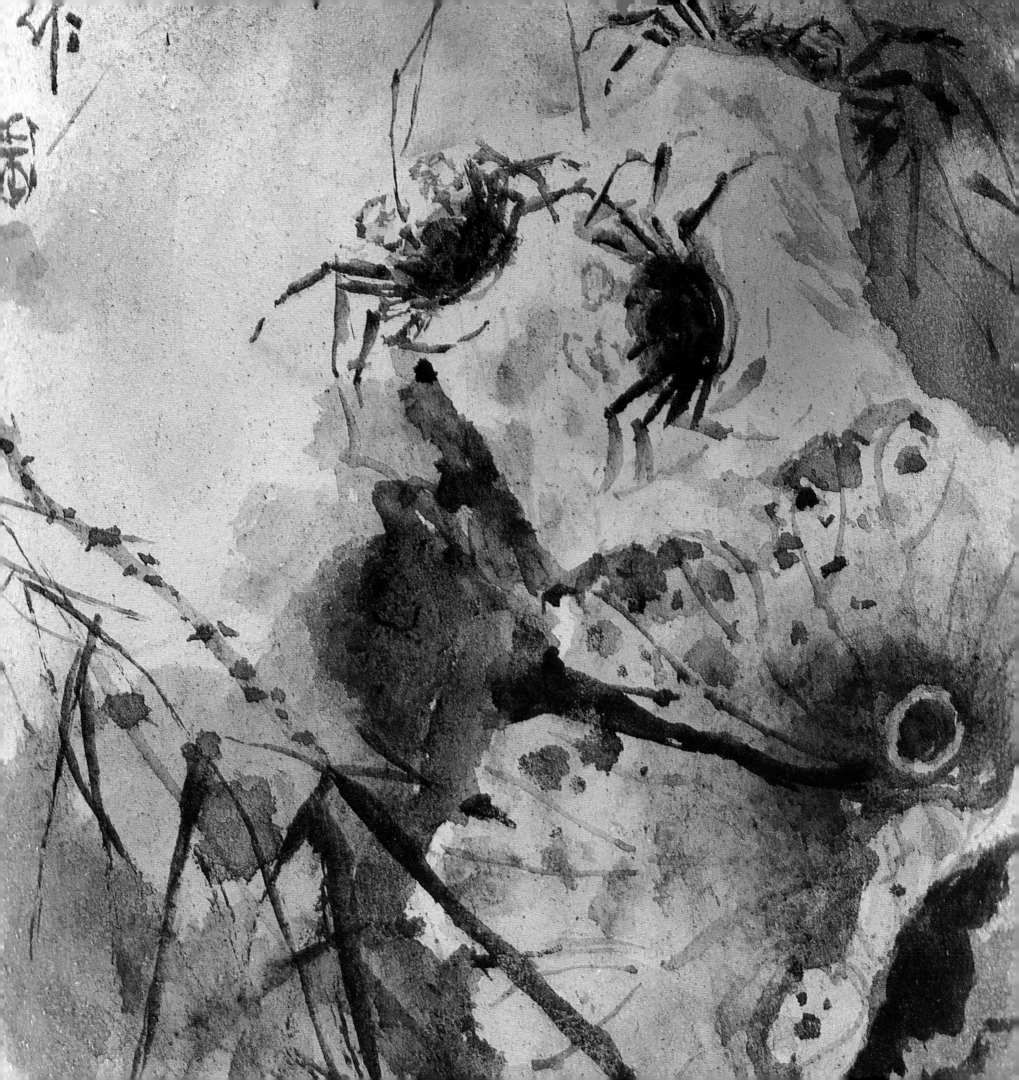

52. 游

高 6.5 厘米　腹宽 2.7 厘米

发晶

款识："甲申冬十一月索振海一石作。"

此壶造型设计充分利用其茶色和由底部浑厚向上渐疏的金发丝，配上作者巧夺天工的妙笔；仅五尾游鱼，或低或高，或仰或俯，若隐若现，栩栩如生，宛如真的鱼儿在水中游，实属极品绝妙壶，空前绝后。

52. Swimming

Height 6.5 cm　Width 2.7 cm

Tea-Colored Quartz Rutilated

Marks: "Suo Zhenhai Yi Shi painted in winter November of the year of JiaShen."

This bottle's design makes the most of its natural tea color and the golden hairy texture that is visible on the surface of the bottle, thicker at the bottom and thinner at the bottle neck. The detailed depictions of the five fish are painted by the artist's magical brushstrokes. The painting is so realistic one can almost see movement in the images; the five fish swim above and below each other, partly hidden and partly visible. This is truly an unprecedented masterpiece.

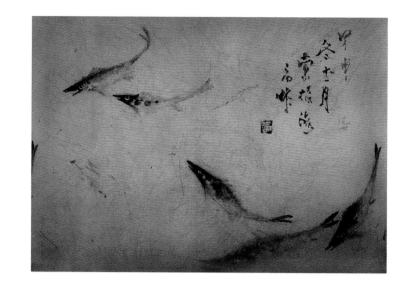

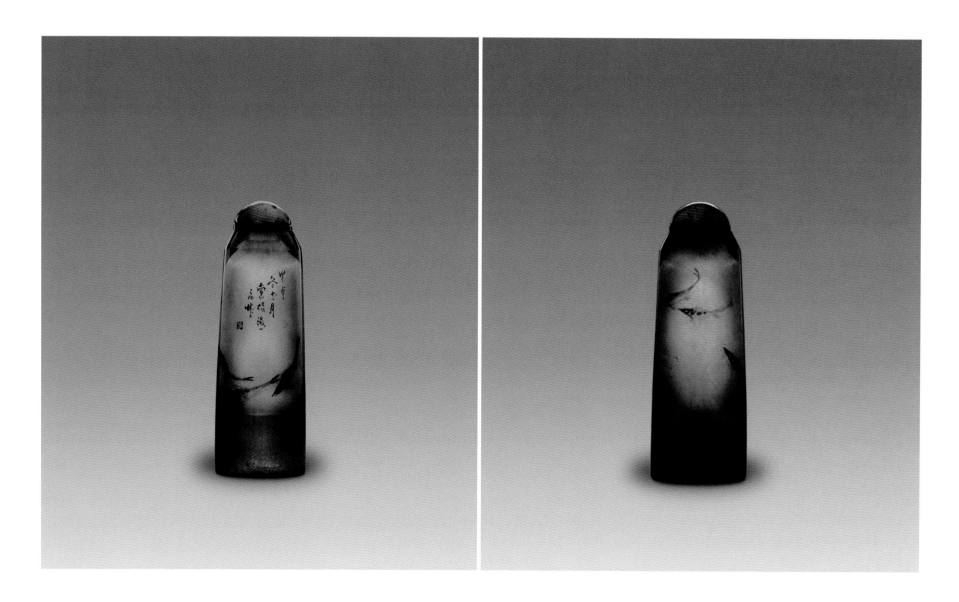

53. 荷塘戏蛙

高 7 厘米　腹宽 5.2 厘米

玻璃

　　款识："庚辰夏七月下浣索振海一石作。"

　　壶一面绘的青蛙，盯着眼前的红蜻蜓，蓄势待发；一旁载浮载沉的同伴，也虎视眈眈，在写意的水墨荷塘中跃出彩色的青蛙小虫；另一面绘三只青蛙错落有致，上者正观望着冉冉上升的蜘蛛。两面构图，巧妙生动，妙趣横生。此作品为仅有的两件作品之一。

53. Playful Frogs in a Lotus Pond

Height 7 cm　Width 5.2 cm

Glass

　　Marks: "Suo Zhenhai Yi Shi painted in summer late July of the year of GengChen."

　　One side of the bottle pictures a frog eyeing a red dragonfly, positioning itself to capture a delicious meal. Another frog nearby also stares at the insect with hungry eyes. Insects and colored frogs are pictured coming out from the water-ink painted lotus pond background. The other side depicts three frogs in picturesque disorder, with the one closest to the top eyeing a crawling spider. The layouts of the two pictures are lively and appealing. This work is one of the two pieces the artist painted on this subject matter.

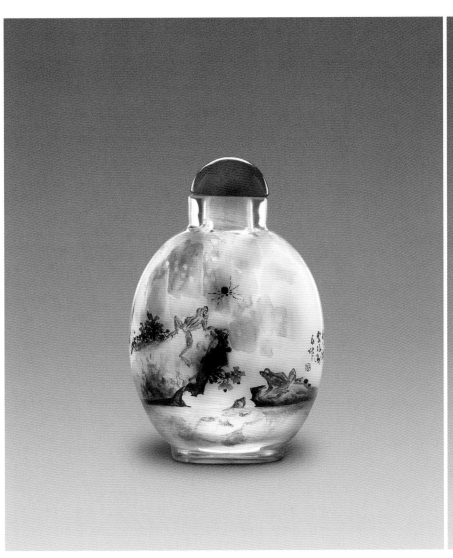

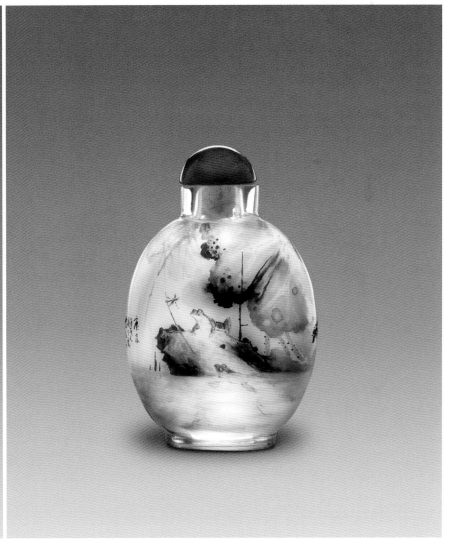

54. 田园野趣（对壶）

高 4.8 厘米　腹宽 3.6 厘米

玻璃

　　在此对精巧小壶内，生动的螳螂和天牛，仿佛由竹节中、红头菜上，峥嵘出头，是注目的焦点，也是牵动画面的灵魂；蝉伏孤枝，蚱蜢倒挂黄花，虻蜂围绕，静中有动，营造出画面张力，是小品中的不凡作品。

54. Playful Insects in a Garden
(A Set of Two Bottles)

Height 4.8 cm　Width 3.6 cm

Glass

　　These realistic paintings of insects are painted in a pair of slender bottles. The mantis and longicorn beetles seem to be break free from the bamboo and red beet backgrounds they are painted in the bamboo and red beet, causing them to stand out as the focal points of the artwork. There are cicadas laying on a lone piece of tree branch, and a grasshopper is hanging under a yellow flower surrounded by a swarm of bees. Subtle movements are evident even in the subjects which appear to be still in the artwork; only a true master of inner painting would be able to paint such extraordinary pieces.

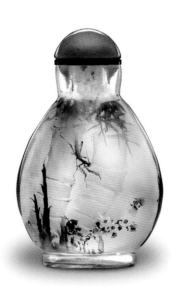 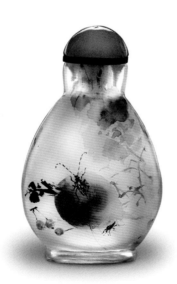

55. 吉祥富贵

高 10.2 厘米　腹宽 6.8 厘米

玻璃

款识："戊午三月一石作。"

壶中绘的鸡给人第一印象是神气活现，鲜活的色彩和生动的形态。虽是内画，却气势逼人，构图不俗，有着欣赏外画大家作品同样的感动。以外画的标准来看内画，其实是要求更高，由于内画种种的限制条件，而看作者内画却常不知觉的会当外画来欣赏，全因为它们极美。

55. Honor and Good Fortune

Height 10.2 cm　Width 6.8 cm

Glass

Marks: "Yi Shi painted in March of the year of WuWu."

The first quality of this piece of artwork that grabs the viewer's attention is the high and mighty appearance of the chickens. The lively colors and vivid poses of the birds create a sense of aggression similar to that of chickens that are the subjects of paintings done on canvas. Judging inner paintings by the same standards as one would paintings on canvas is highly demanding, due to the fact that inner painting artists are subject to so many additional restrictions that traditional artists are unaware of. Appreciation of the artist's inner paintings often time will have the same appreciation of the outside painting; it is that they are just that great.

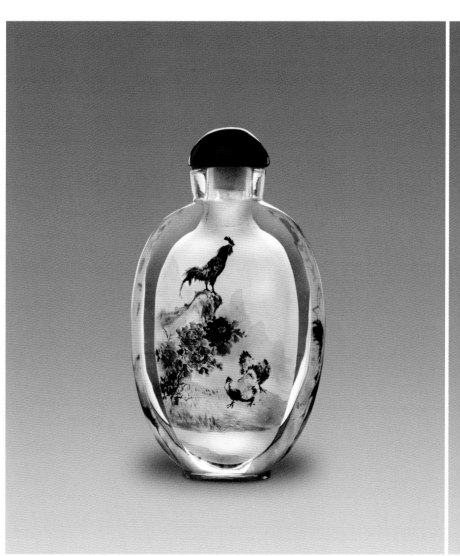
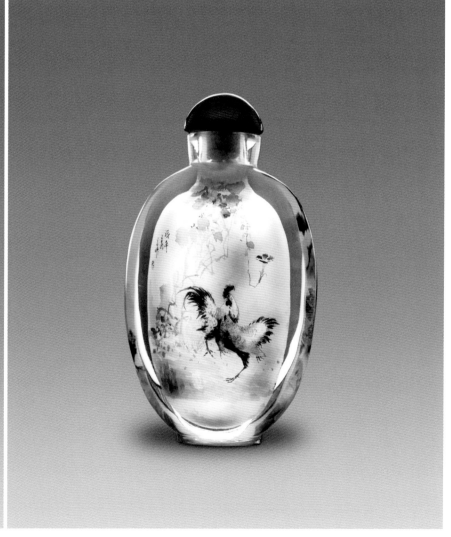

56. 雅房闲赋

高 7 厘米　腹宽 3.5 厘米

玻璃

款识："师古人师造化，习近人习今人习白石老人，四十年愧未能似。甲申年索振海一石作。"

作者擅工笔虫草，精气神颇有白石老人笔意，虽非写实，却像活物；壶两面背景雅致简淡，更能衬托出小虫的生动。

56. Resting in an Elegant Study Room

Height 7 cm　Width 3.5 cm

Glass

Marks: "Learned from the past and from nature, from the present and from Bai Shi Old Man; ashamed that after forty years one still cannot paint the way Bai Shi Old Man did. Suo Zhenhai Yi Shi painted in the year of JiaShen."

The artist is very skilled at painting insects and plants with fine brushstrokes. His artwork possesses the spirit of Bai Shi Old Man's paintings. This painting is not a work of realism, but the insects portrayed in the artwork are still extremely lifelike. The backgrounds of both sides of the bottle are simple and elegant, which greatly enhances the liveliness of the insects in the paintings.

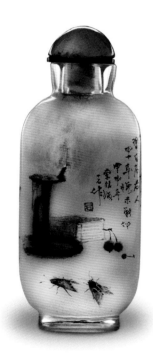
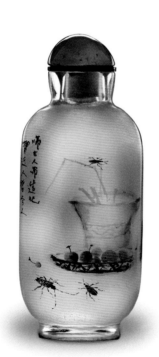
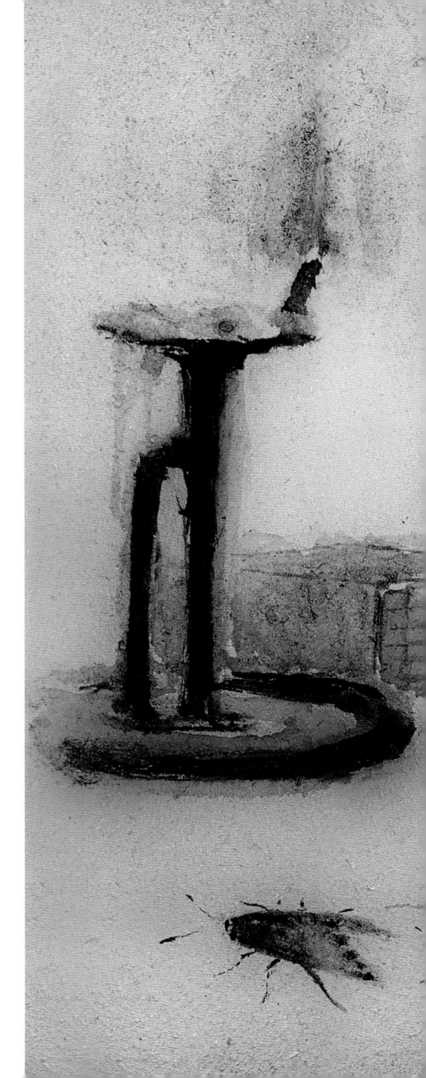

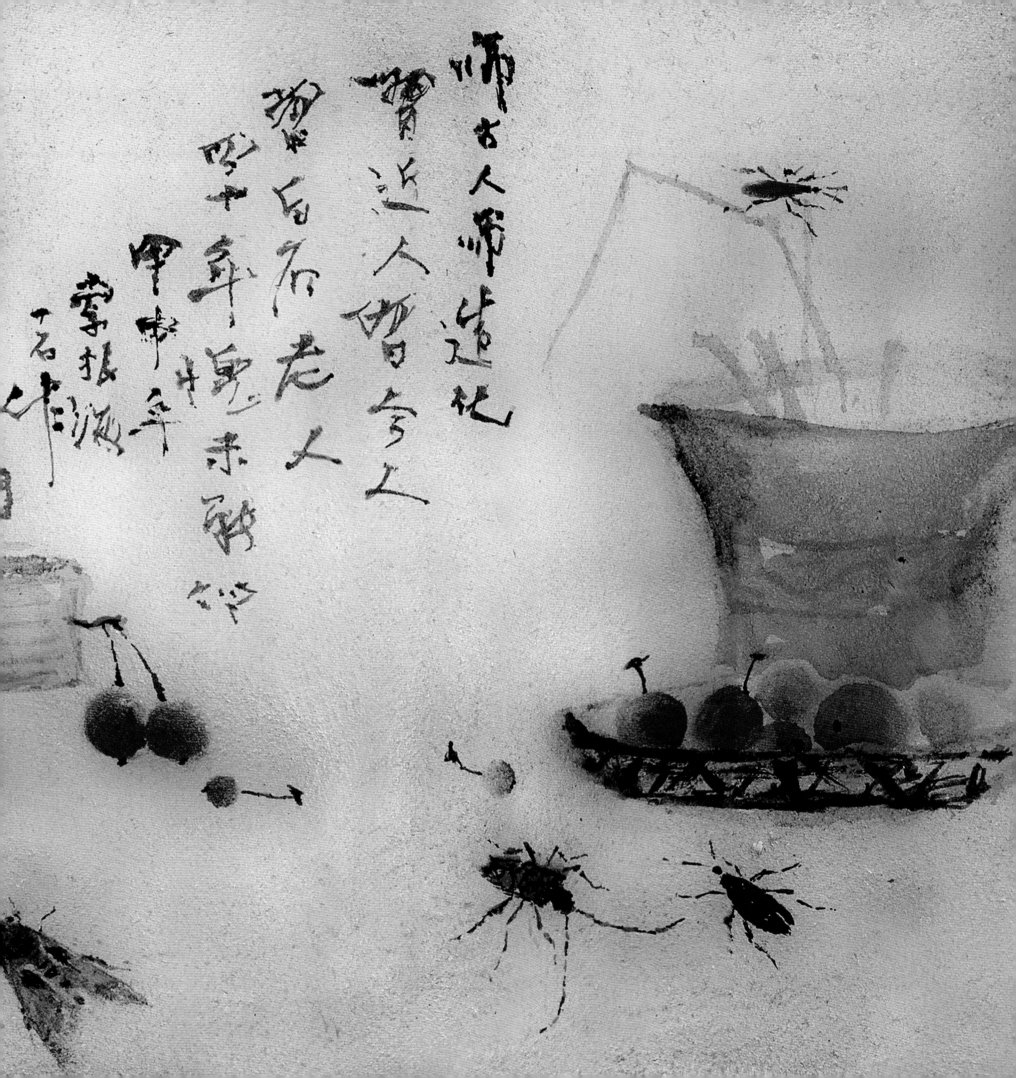

57. 草间虫（对壶）

高 11.8 厘米　腹宽 4.2 厘米

玻璃

款识：“甲子三月一石作。”

　　盈握此二壶仿佛天牛和螳螂就快爬到手，不但栩栩如生，还神气活现；其间穿插流窜的虹蜂，搭配写意花草，立体感十足，生动逼真。

57. Insects in a Meadow

(A Set of Two Bottles)

Height 11.8 cm　Width 4.2 cm

Glass

　　Marks: "Yi Shi painted in March of the year of JiaZi."

　　When one holds these two bottles in one's hands, it feels as if the longicorn beetle and the mantis are about to crawl out of the bottle and into one's palms. The insects are painted so vividly and so lifelike-- standing proud and mighty in the paintings. The flying wasps along with the flowers and plants painted with free brushstrokes make the layers of this inner painting distinct and three dimensional.

58. 草田蜻蜓

高 7 厘米　腹宽 4.5 厘米

玻璃

款识："习白石老人，四十年愧未能似。壬午索振海一石作。"

抓住蜻蜓停停飞飞一刹那的神态并不容易，写意的背景又浓淡恰到好处，以免画面失去焦点。

此壶即充分掌握到这些要点。此件作品是作者虫草类内画唯一的蜻蜓主题之作。

58. Dragonflies in a Meadow

Height 7 cm　Width 4.5 cm

Glass

Marks: "Learned from Bai Shi Old Man; ashamed that after forty years one still cannot paint the way Bai Shi Old Man did. Suo Zhenhai Yi Shi painted in the year of RenWu."

Painting a dragonfly that is perched and still is already a difficult task, let alone trying to paint and capture moments when it is in-flight. The free style painting of the background needs to be appropriate and precise; otherwise, the focus of the picture will be lost.

All the details of this bottle are carefully executed. This work is the artist's only dragonfly inner painting among his insect and plant pieces.

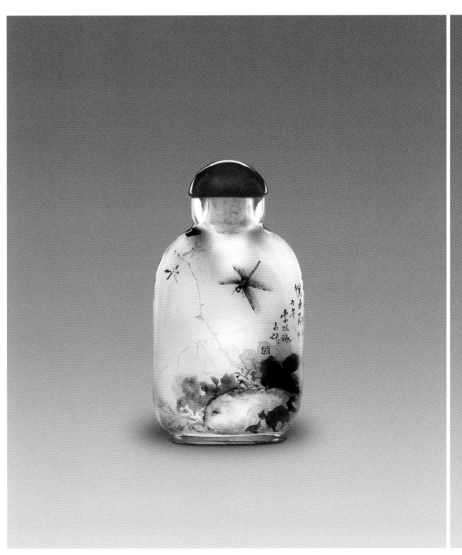

59. 闲趣

<u>高 4.5 厘米　腹宽 4 厘米</u>

<u>玻璃</u>

　　款识："习白石老人，四十年愧未能似。甲申冬月索振海作。"

　　另一面款识："一石作。"

　　作者习齐老画烛火、茶壶等家常器皿和昔家中常见小虫、褐天蛾，小蛾匍伏，天牛滞留，取其动中有静、静中有动的家闲趣味。虽是小品，但欲仿大师笔意，无相当功力，恐画虎类犬。作者再显示其不凡的国画功夫，才能小画大师风，耐人寻味，且雅俗共赏。

59. Casual Fun

<u>Height 4.5 cm　Width 4 cm</u>

<u>Glass</u>

　　Marks: "Learned from Bai Shi Old Man; ashamed that after forty years one still cannot paint the way Bai Shi Old Man did. Suo Zhenhai painted in a winter month of the year of JiaShen;"

　　The other side marks: "Yi Shi painted."

　　The inner paintings of this bottle are based on Master Qi Bai Shi's painting of candle fire, tea pot, ordinary household utensils, and insects often seen in the house in the olden days such as brown moths and longicom beetles; it highlights the household normal interests of stillness in movements and movements in stillness. It might be a smaller piece but it was painted according to the brushwork of a master Chinese painting artist. If the snuff bottle artist did not have sufficient skills in traditional Chinese painting, this piece would not have turned out well. The snuff bottle artist once again demonstrates his extraordinary Chinese painting skills. This bottle demonstrates mastery of traditional Chinese painting in a relatively small painting and is worthy of praise.

60. 虫趣

高 4.2 厘米　腹宽 4.2 厘米

玻璃

　　此小壶虫草作品是精采小世界。由于空间紧凑，显得内容更生动；螳斗蜂，天牛攀瓜篮，占据画中心和大部分画面，观者立即被动态印象捉住眼神，实为小内画壶中大作品。

60. Playful Insects

Height 4.2 cm　Width 4.2 cm

Glass

　　This artwork portrays small insects and plants and is a true wonder in the art world. The limited space available for the artist to paint in, in fact helps the painted images come to life. The depictions of a mantis gallantly fighting a bee and a longicom beetle crawling its way up a squash basket takes up most of the available space; the viewer's attention is immediately directed towards these impressions of movement. This is truly an inner painting master piece.

61. 虫草

高 6.5 厘米　腹宽 2 厘米

玻璃

　　款识："习白石老人，四十年愧未能似。甲申八月索振海一石作。"

　　在此特别细长壶里创作，画面的构图和题材，都是挑战。作者发挥壶型的优势，绘以竹上螳螂和瓜草蟋蟀，虫草巧小俏丽，壶身纤细，相得益彰。

61. Insects and Plants

Height 6.5 cm　Width 2 cm

Glass

　　Marks: "Learned from the Bai Shi Old Man; ashamed that after forty years one still cannot paint the way Bai Shi Old Man did. Suo Zhenhai Yi Shi painted in August of the year of JiaShen."

　　It is a challenge to paint in such a slender bottle in terms of deciding layout and the subject matter of the painting. The artist uses the bottle's shape to paint a mantis clinging on to a bamboo stick and crickets resting next to a squash. The insects and plants are painted as tiny figures which is appropriate considering the size and shape of the small and slender bottle.

62. 石趣

高 7 厘米　腹宽 6 厘米

玛瑙

　　款识："甲寅夏月索振海一石作。"

　　此天然玛瑙壶的纹路残色，是难得的幽幽灰茶底色，其中掺杂有不规则的深褐花纹和灰白点线，正好给作者创作石中虫草提供了条件。或增色成石，或顺灰白纹理加轮廓成石，壶表残色辉映着壶内的色彩，使得崎石变得更立体、更有层次。尤其若是透光欣赏，螳螂宛如藏身石缝，蚱蜢、虹蜂像在不同的画面上，犹如三度空间的作品。

62. Insects in the Cracks of Stones

Height 7 cm　Width 6 cm

Agate

　　Marks: "Suo Zhenhai Yi Shi painted in a summer month of the year of JiaYin."

　　The natural agate marks on this bottle are an unusual deep tea brown color mixed with irregular dark brown patterns and grey-white dots and lines. The natural color of the bottle inspired the artist to paint a scene of insects and plants beside stones. The artist darkens the colors of the stones and adds other grey-white dots and lines to resemble rocks and pebbles. The surface colors reflect the colors inside of the bottle to create a three dimensional effect that greatly enhances the painted images. When one holds the bottle up to the light, the mantis looks as if it is hidden behind the cracks of the stone, and the grasshopper and bee seem to be on different layers within a single painting.

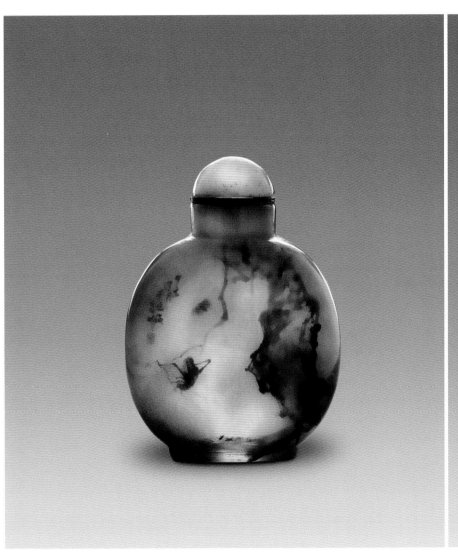
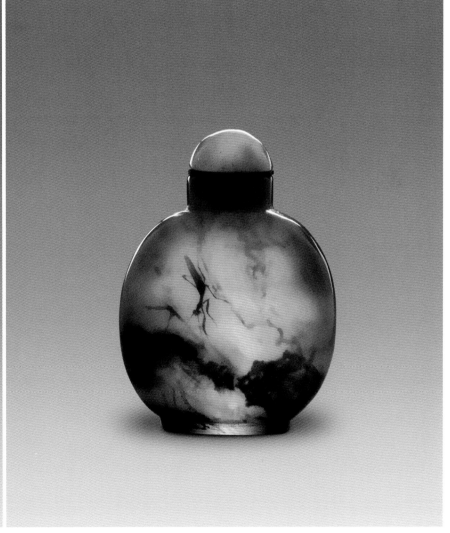

63. 夏荷

高 5.8 厘米　腹宽 5.2 厘米

玛瑙

　　款识："乙酉年索振海一石作。"

　　此壶为天然玛瑙残色，图案有如枯萎荷叶，作者善加利用；构图荷池景观，间插荷枝残叶，夏荷绽放争艳，天然残荷色如上天巧妙泼墨，凡透光欣赏者，无不惊叹其巧夺天工。

63. Summer Lotus

Height 5.8 cm　Width 5.2 cm

Agate

　　Marks: "Suo Zhenhai Yi Shi painted in the year of YiYou."

　　This bottle is the natural color of agate, whose marks resemble that of withering lotus leaves. The artist utilizes this feature of the bottle to paint a lotus pond with blossoming flowers, lotus stems and withering leaves. The natural color of the bottle gives off a shine similar to that of splashed ink. Those who admire this bottle against the light will be amazed by the ingenious design of the piece.

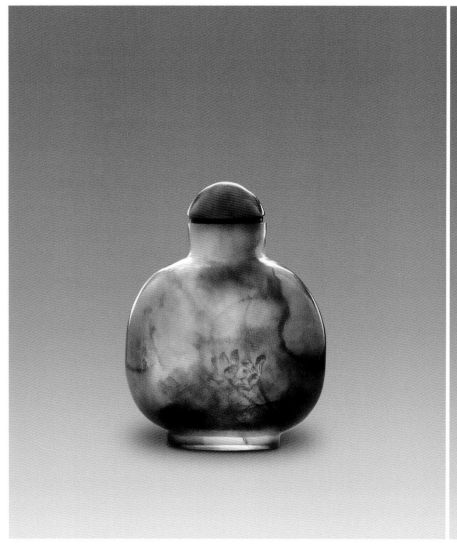 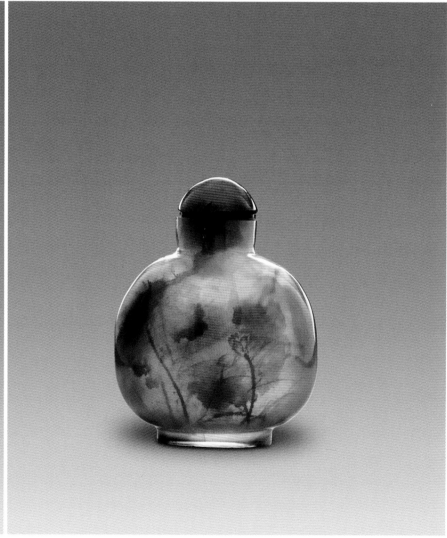

64. 长夏清趣

高 6.6 厘米　腹宽 5.5 厘米

玛瑙

款识："乙酉长夏索振海一石作。"

作者借着两侧玛瑙纹里的不同，一侧纹里有如湖里芦草漂浮，便画了鱼乐图，另一侧纹路更似枝干横生，适合游走小虫，遂添红叶山石，因材成画。

64. Relaxing during a Long Summer

Height 6.6 cm　Width 5.5 cm

Agate

Marks: "Suo Zhenhai Yi Shi painted in the long summer of the year of YiYou."

The artist uses the naturally occurring marks of agate on the two sides of the bottle as a part of his inner paintings—on one side, the marks resemble reeds floating in the lake. Paintings of fish are added to complement the reeds. The agate marks on the other side of the bottle resemble a pile of twigs: a suitable place for insects to thrive in. The artist also adds red leaves and mountain rocks in this painting to enhance the overall appearance of the artwork. He utilizes the natural appearance of the bottle material to create a unique masterpiece.

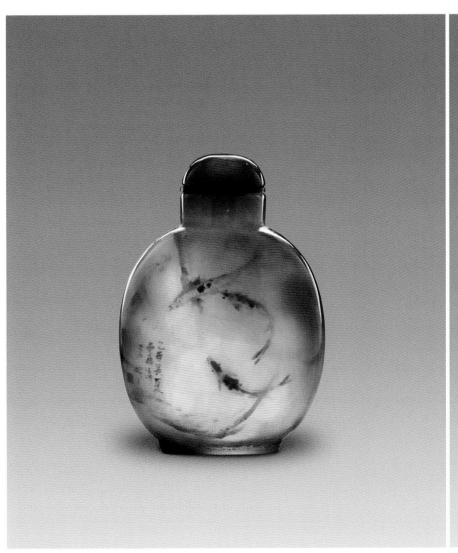
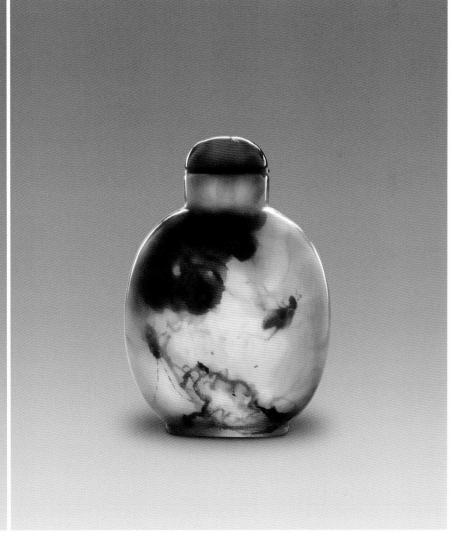

65. 草间虫趣 （一组四个）

高 6.8 厘米　腹宽 3 厘米

玻璃

　　款识："习白石老人，四十年愧未能似。甲申索振海一石作"；

　　款识："习白石老人，四十年愧未能似。甲申三月索振海一石作"；

　　款识："习白石老人，四十年愧未能似。甲申索振海一石作"；

　　款识："习白石老人，四十年愧未能似。甲申冬月索振海作。"

　　此组壶乃作者虫草经典代表作，世面较常见此类形作品，壶形材料多为普通，且多不成套。此套壶墨笔流畅，虫草生动，为作者特别用心之作。作者希望能完整、较好的保存，堪称留世精品之作。

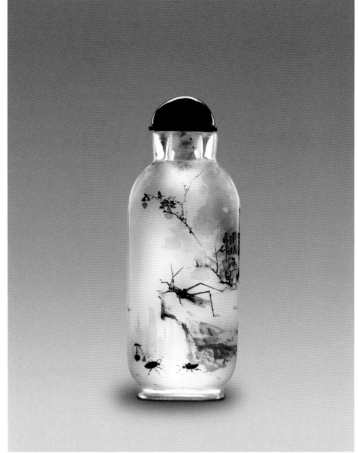

65. Insects among Plants

(A Set of Four Bottles)

Height 6.8 cm　Width 3 cm

Glass

　　Marks: "Learned from Bai Shi Old Man; ashamed that after forty years one still cannot paint the way Bai Shi Old Man did. Suo Zhenhai Yi Shi painted in the year of JiaShen;"

　　Marks: "Learned from Bai Shi Old Man; ashamed that after forty years one still cannot paint the way Bai Shi Old Man did. Suo Zhenhai Yi Shi painted in March of the year of Jiashen;"

　　Marks: "Learned from Bai Shi Old Man; ashamed that after forty years one still cannot paint the way Bai Shi Old Man did. Suo Zhenhai Yi Shi painted in the year of JiaShen;"

　　Marks: "Learned from Bai Shi Old Man; ashamed that after forty years one still cannot paint the way Bai Shi Old Man did. Suo Zhenhai painted in a winter month of the year of JiaShen."

　　This series is the artist's representative work in inner paintings that portray insects and plants. The artist has more individual pieces of this kind which are mostly ordinary bottles and not in a complete set. This series was painted by the artist with special care; the insects and plants are extremely lifelike and the brushwork is superb. The artist himself expressed his desire to ensure that this set is well preserved; it truly is an exquisite set of inside painted snuff bottles that should be shared with the world.

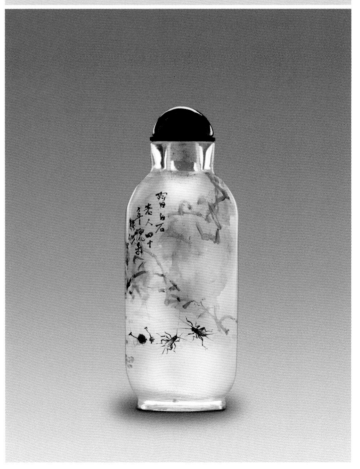

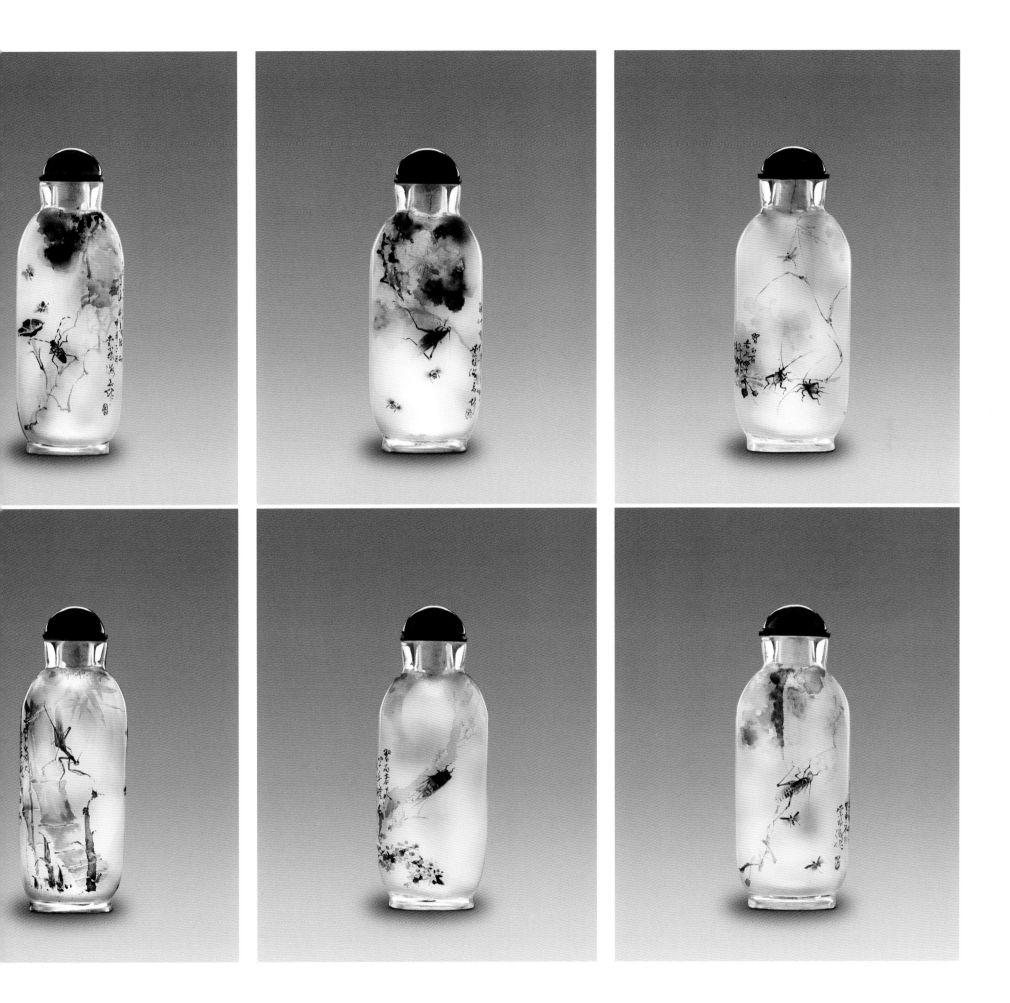

66. 动中取静

高 6.6 厘米　腹宽 2.8 厘米

无色水晶

款识："戊寅三月索振海一石作。"

此壶天然水晶于壶尾有天然斜断层，亦成内画壶整体效果之元素。作者画虫草，与其说仿白石老人画，不如说效法他的画风和笔意。烛火前的飞蛾和小虫，匍匐前行，画里静中有动，动中有静；壶另一侧小小空间里绘有蝴蝶、蟋蟀、蚱蜢和小蜂，虽取大众民俗题材，仍带有作者画作固有的朴雅文人气质。

66. Stillness in Movement

Height 6.6 cm　Width 2.8 cm

Rock Crystal

Marks: "Suo Zhenhai Yi Shi painted in March of the year of WuYin."

This crystal bottle has a natural fault at the bottom, which becomes an interesting element in the overall appearance of the bottle. The artist painted insects and plants; he imitated Bai Shi Old Man's painting style and brushwork rather than his paintings. The moth and small insects are shown crawling before the candle fire. In this painting, one can find stillness in that which is moving and movement in that which is still. On the other side of the bottle, a butterfly, a cricket, a grasshopper, and a small bee all fit onto the limited space available. Plants and insects are common subject matters in folk art, but this bottle is unique in that it demonstrates the artist's simple, elegant, scholarly painting style.

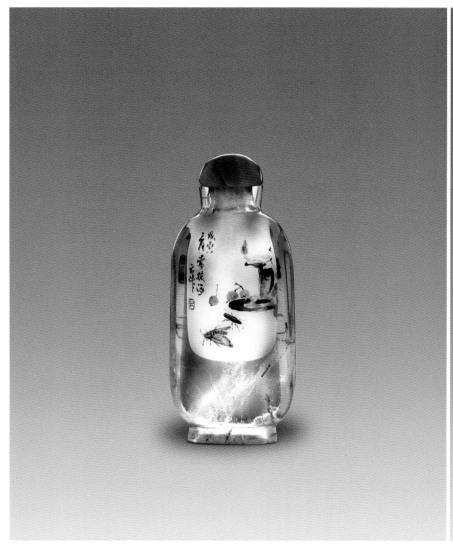
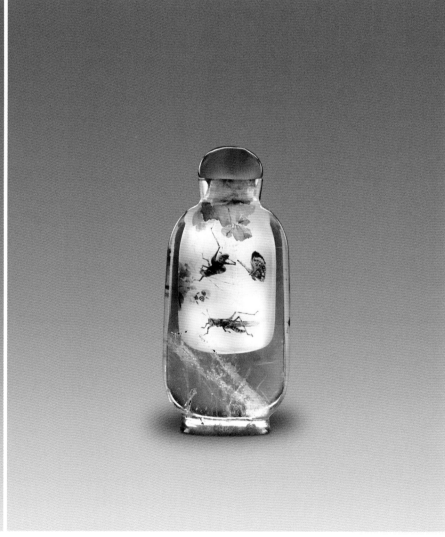

67. 草间偷活（对壶）

高 7.5 厘米　腹宽 4.5 厘米

玻璃

　　款识："甲子一石作。"

　　另一面款识："一石作。"

　　此组壶堪为作者虫草内画的一时之作。螳螂、蚱蜢的精气神足，天牛、蟋蟀的蠢蠢欲动，令人百看不厌；壶型款式为内容小、壶面偏厚，壶面的光辉折射，使壶中形象更清晰可见，益显壶内虫草的鲜活生动，栩栩如生。

67. Thriving among the Plants
(A Set of Two Bottles)

Height 7.5 cm　Width 4.5 cm

Glass

　　Marks: "Yi Shi painted in the year of JiaZi."

　　Marks: "Yi Shi painted."

　　This set contains a series of extraordinary insect and plant inner painting pieces. The mantis and grasshoppers are full of vigor and spirit; the longicorn beetle and crickets look like they are ready to cause trouble. Viewers will never be tired of admiring this series. The bottles have thicker surfaces and narrower interiors. The thicker Glass surface refracts the light, making the images in the bottles look clearer and more illuminated—perfect for showing the liveliness of the insects and plants.

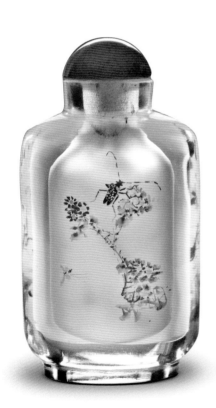

68. 四君子

高 10.8 厘米　腹宽 6.8 厘米

玻璃

　　款识："戊辰夏月一石作。"

　　作者将梅兰竹菊四君子共融于一壶中，精彩布局，浓淡相间，笔笔生动。而自然中此四种植物无法并存，但在文人画中都代表君子。此画实中有虚，虚中有实，文人画意，不言而喻，为作者此类代表作。

68. Four Gentlemen

Height 10.8 cm　Width 6.8 cm

Glass

　　Marks: "Yi Shi painted in a summer month of the year of WuChen."

　　The artist's layout design and his mixing of light and dark colors help to produce an excellent piece of work. This bottle depicts plum flowers, orchids, bamboos, and chrysanthemums with every detail brought to life by precise brushstrokes. In nature, the four plants shown in this painting cannot coexist; however, they all represent the qualities of a gentleman in Chinese scholarly painting.

Thus, this image portrays abstract concepts and abstract expression in that the four plants are painted together. But at the same time, there is an element of natural harmony present in the image in that the four plants are unified through the connotations they carry. This is the artist's representative work of this subject.

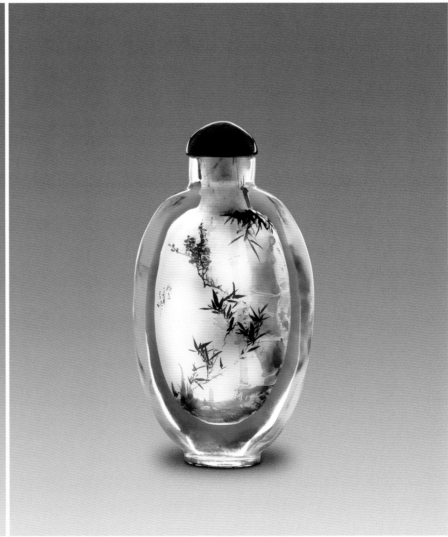

69. 戏虾

高 6.3 厘米　腹宽 4.7 厘米

玻璃

款识："习白石老人，四十年愧未能似。壬午夏月一石作。"

此壶造型呈中空蛋形，作者选择追着蛋形壶面，巧妙地以寥寥数笔绘出三尾姿态各异的河虾，淡墨以求河虾壳薄色清的质感，一气呵成，以求生活鲜跳的力度，颇具白石老人风范，是作者随笔小品。作者此类作品极少。

69. Playful Shrimps

Height 6.3 cm　Width 4.7 cm

Glass

Marks: "Learned from Bai Shi Old Man; ashamed that after forty years one still cannot paint the way Bai Shi Old Man did. Yi Shi painted in a summer month of the year of RenWu."

This bottle is shaped like a hollow egg, and the artist utilizes this unique feature of the bottle to paint three river shrimps of different shapes and sizes. He uses diluted ink to depict the river shrimps' clear shell. The artist uses swift brushstrokes to bring the shrimps to life with movement. This piece employs the Bai Shi Old Man style. It is an impromptu piece, making it extremely rare.

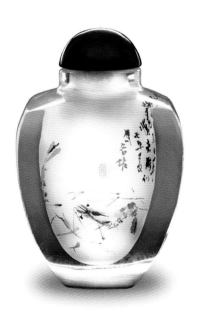
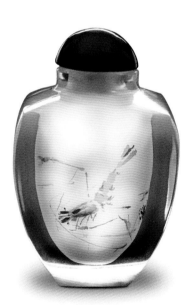
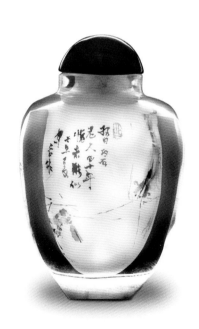
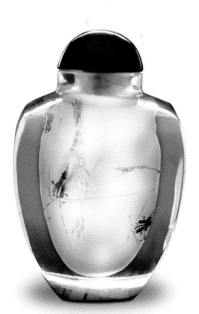

70. 梅兰竹菊 （一组四个）

高 6.3 厘米　腹宽 4.9 厘米

玻璃

款识："一石作。"

此组壶型特别，淡雅细致，壶中水墨写意花草，更显素净清丽。

梅树绽放，浓纤合度，疏落有致，墨影衬前花，显得层次丰富，生意盎然。

兰草淡彩有如素颜美人，婀娜多姿，草草数笔，却是内画难处，意到笔到，不容迟疑，不容重描。

竹壶有如作者随兴之作，不特别讲究笔法，而是追求整体雨后竹林的清丽，潇洒自然，风雨过后，竹叶垂乱，景深处淡墨竹又显得水淋淋，雨后春笋展现了初萌的生命力。

菊壶快笔成画，纷而不乱，画面张力更是收发自如，有如瞬间完成，却不失文人画的素雅风情。

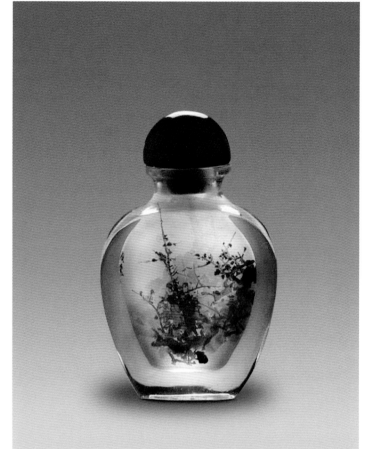

70. Plum Flower, Orchid, Bamboo, Chrysanthemum

(A Set of Four Bottles)

Height 6.3 cm　Width 4.9 cm

Glass

Marks: "Yi Shi painted."

This series is special, refined, and elegant; the water-ink flowers and plants in the bottles are more simple and elegant when painted in this free style of painting

The plum flower tree blossoms are scattered randomly throughout. The flowers in the foreground are painted against an ink shadow backdrop, which enhances the overall effect of the inner painting.

The orchid's light colors are beautiful, natural, and organic. There are only a few strokes in each painting and which is what makes inner painting so difficult—an artist is sometimes only allowed a few brushstrokes and there is no room for hesitation or mistakes.

The bamboo bottle is an example of improvised work; it does not stress the artist's brushwork. The artist's aim is to depict the natural beauty of a bamboo forest after a cleansing rainstorm. After the rain falls and the wind blows, the scattered bamboo leaves and bamboo shoots are given an artistic watery effect. New life and energy emerge from the bamboo shoots after the rainstorm.

The bottle picturing chrysanthemum flowers is painted with swift brushstrokes, each stroke made with expert precision; not a single stroke is too faded, and not a single stroke is too bold. It almost seems as if the artist completed this piece within a few seconds, but even so, it possesses the qualities of traditional scholarly painting.

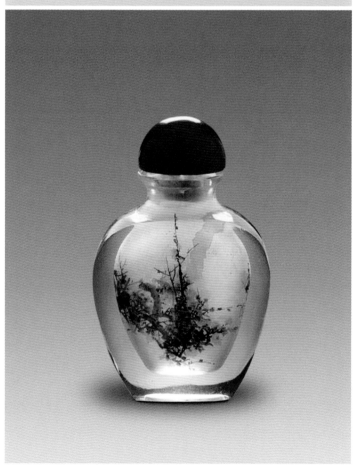

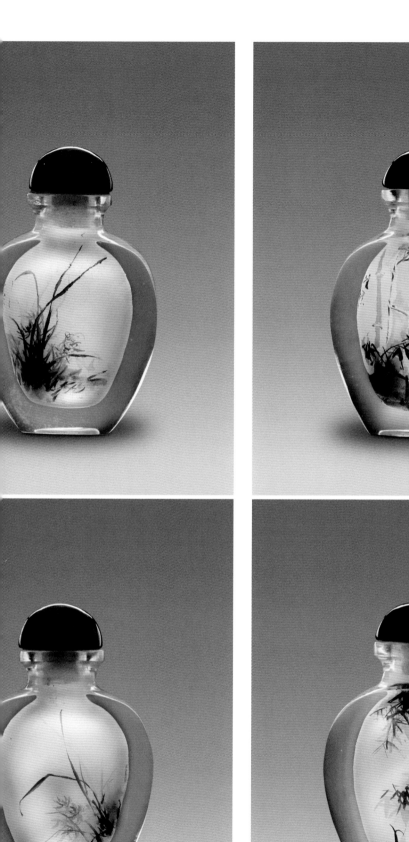
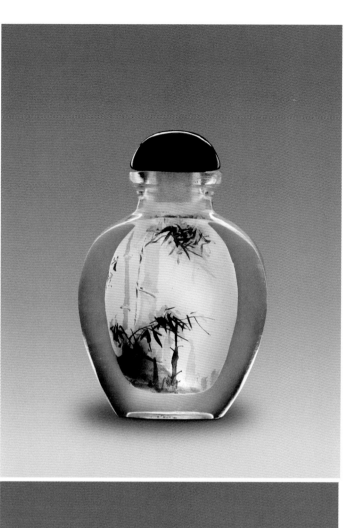
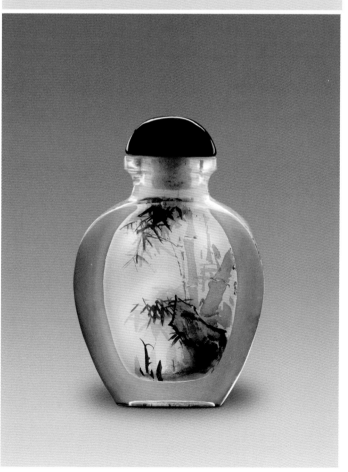
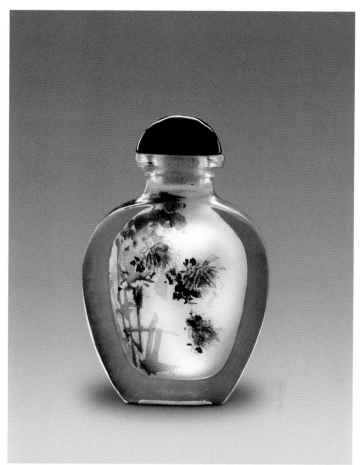
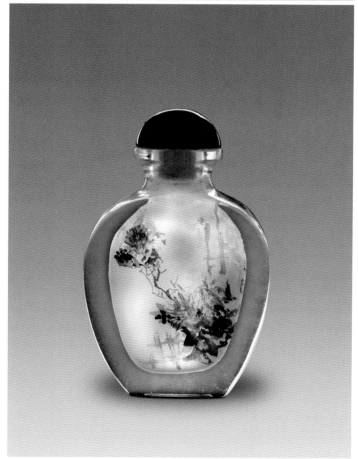

71. 草间野趣 （一组四个）

高 7.2 厘米　腹宽 5.2 厘米

玻璃

款识："习白石老人。四十年愧未能似。时在甲申秋索振海作"；

款识："习白石老人。四十年愧未能似。时在甲申秋索振海作"；

款识："师古人习今人。丁丑三月一石索振海作"；

款识："师古人习今人。甲申三月索振海一石作。"

此组壶是作者精选其最经典虫草题材的代表作。壶内画帧帧精彩，虫草生动逼真，背景丰富多层次变化，堪称巅峰之作。鲜白色牵牛花衬托着青绿色的螳螂，神采奕奕，昂首投足，以及壶背面紧抓着花枝茎的天牛，马上吸引住观者的视线，不经意地即被它们的细腻生动所感动。

另一壶，秋蝉栖息相对虻蜂飞扰，螳螂衬着黄花而水墨渲染的层次感，则更显细腻。

另一壶，两蚱蜢缠绕着番红花茎，生气蓬勃，相应壶背面的两蟋蟀仿佛针锋相对，蓄势待发。

另一壶，竹节虫伫足观望，甲虫逼近，牵牛蔓棚伸出一组顽强牵牛花，对应两将对决的蟋蟀，隐隐透露着作者不服输的精神。

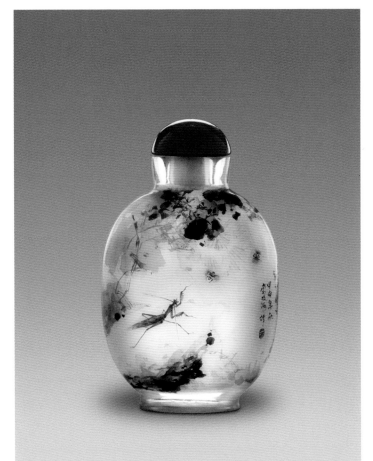

71. Insects Thriving among Plants

(A Set of Four Bottles)

Height 7.2 cm　Width 5.2 cm

Glass

Marks: "Learned from Bai Shi Old Man; ashamed that after forty years one still cannot paint the way Bai Shi Old Man did. Suo Zhenhai painted in the autumn of the year of JiaShen;"

Marks: "Learned from Bai Shi Old Man; ashamed that after forty years one still cannot paint the way Bai Shi Old Man did. Suo Zhenhai painted in the autumn of the year of JiaShen;"

Marks: "Learned from the ancient and from the contemporary. Yi Shi Suo Zhenhai painted in March of the year of DingChou;"

Marks: "Learned from the ancient and from the contemporary. Suo Zhenhai Yi Shi painted in March of the year of JiaShen."

This series is the artist's personal favorite and is also representative work among his classic insect and plant pieces. Each picture shown in these bottles is superbly painted; the insects and plants are lifelike and vivid; the backgrounds are deep and richly shaded. They are truly all master pieces. The refreshing white morning glories complement the green mantis, a spirited and proud creature. On the other side of the bottle, the longicorn beetle hangs tightly onto the stem of the flower. The vivid details of these paintings immediately catch one's eyes.

One side of the other bottle, a resting cicada is surrounded by a swarm of busy bees; the other side of the bottle depicts a mantis camouflaged in a yellow flower.

In a third bottle, two grasshoppers tackle the saffron twigs vigorously; on the other side, two crickets are posed for take-off.

In the fourth bottle, a stick insect pauses and stares at an approaching beetle; there is a pair of morning glories poking out from behind a fence. Nearby, two crickets engage in an epic fight, reflecting the artist's own unwillingness to be defeated by the obstacles and challenges he faced.

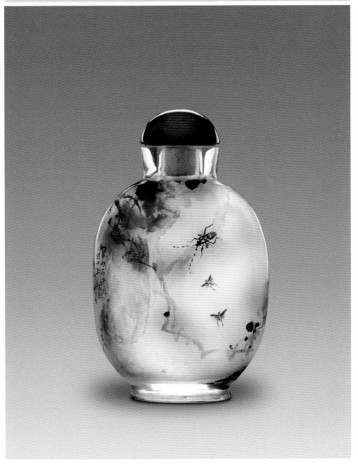

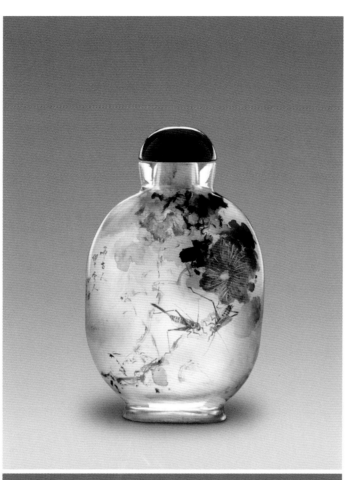

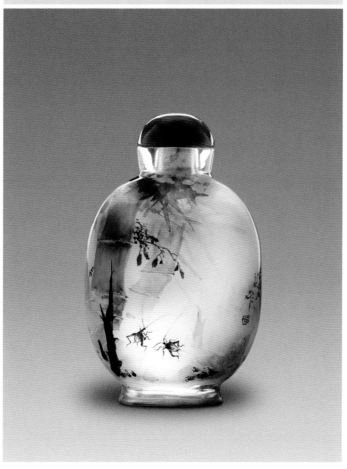

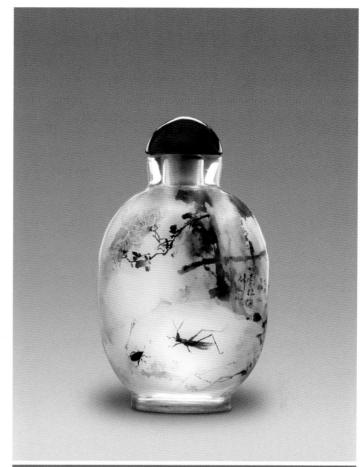

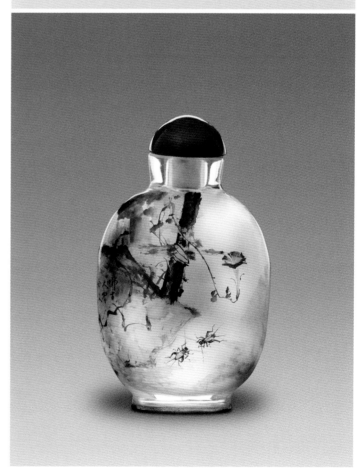

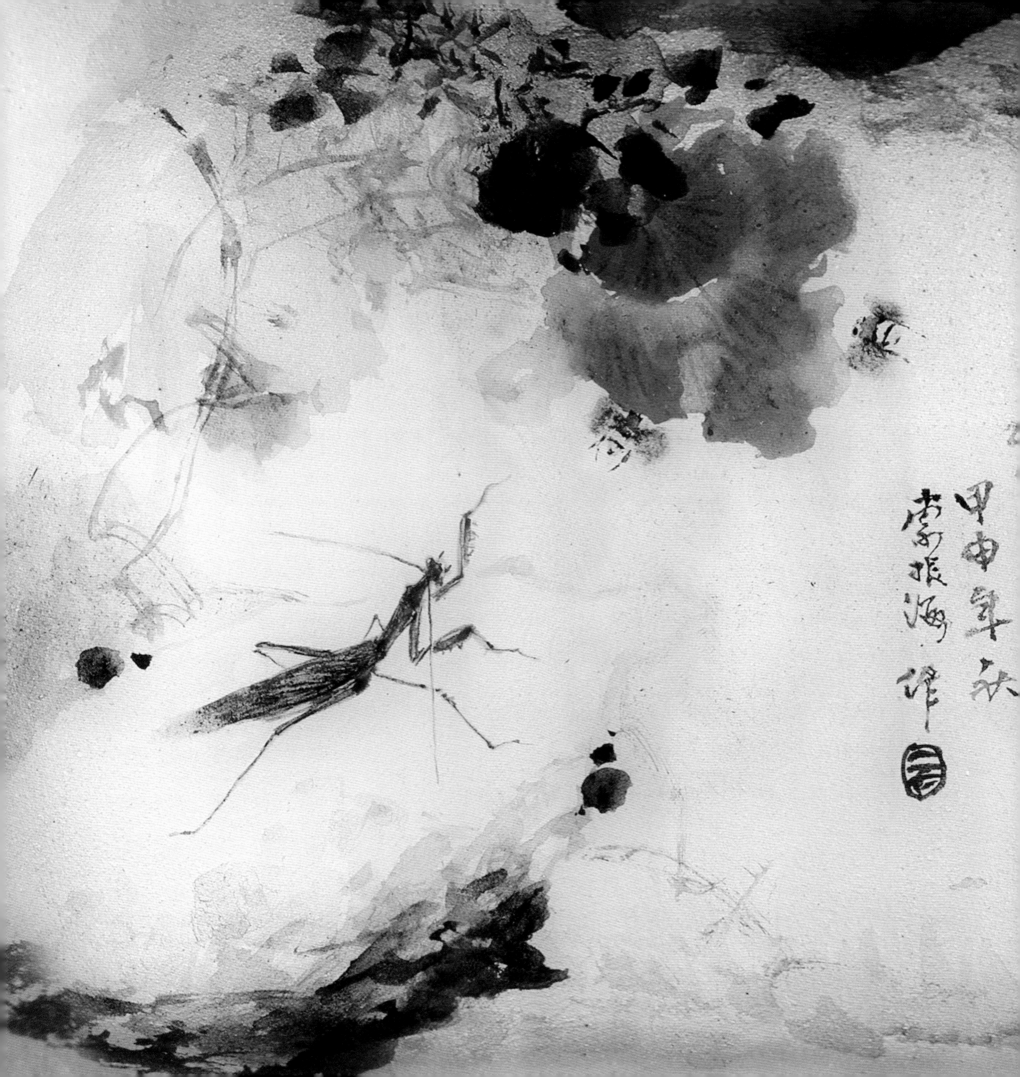

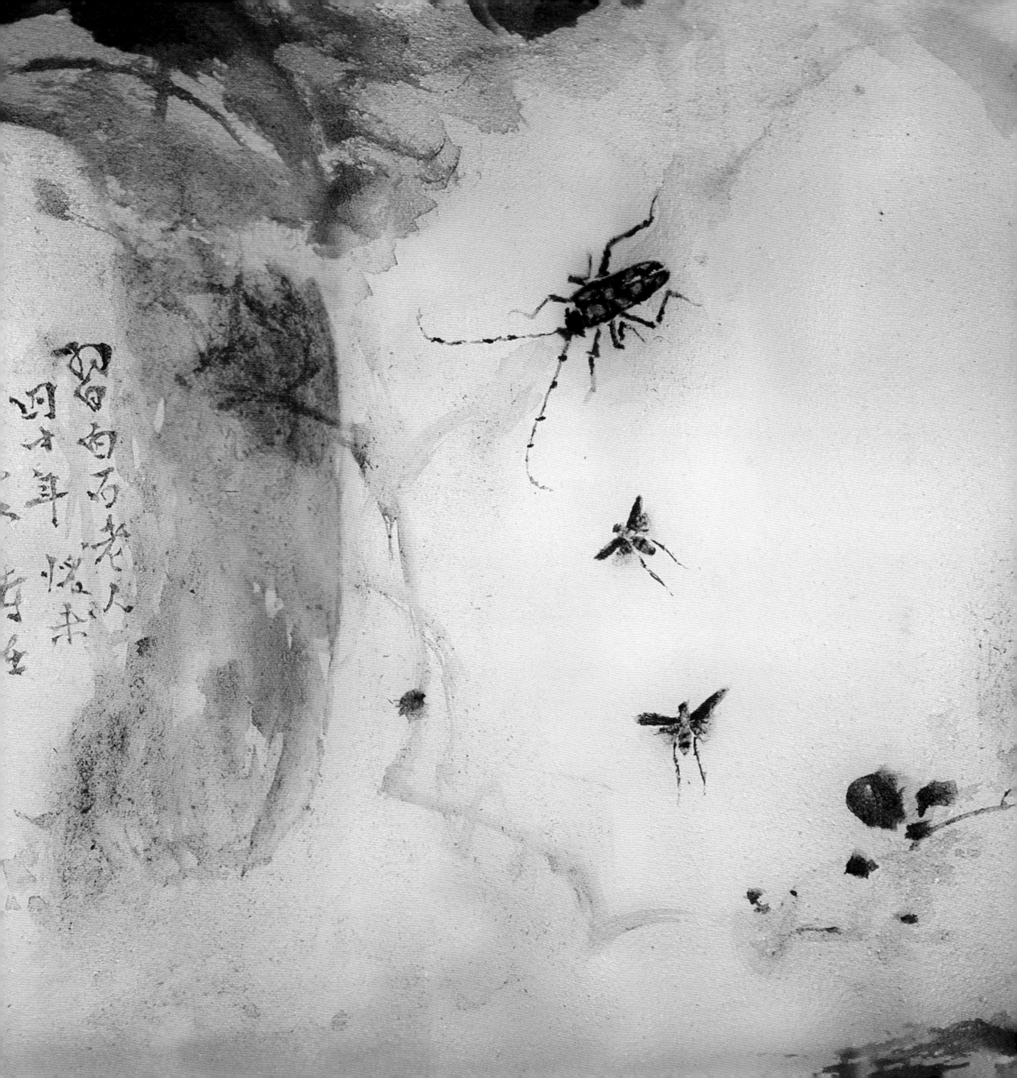

72. 虫草

高 7.1 厘米　腹宽 11 厘米

玻璃

　　款识："戊寅一石作。"

　　扇面屏的空间较窄壶面有向横发挥的余
地，可丰富虫草的数量，尤其绘出数虫横爬或
斜飞的情景。由于作者虫草屏风作品仅有此
件，再想到内画屏作画完全是上下左右颠倒
着画，着实珍贵。

72. Insects and Plants

Height 7.1 cm　Width 11 cm

Glass

　　Marks: "Yi Shi painted in the year of WuYin."

　　The fan shape interior of this glass screen lends
itself to a more flexible canvas for the artist to work
with. The fan space has a narrow opening that broadens
into a wider open space near the top of the screen. The
wider part of the fan shape interior can accommodate
a large number of insects and furthermore allow the
artist ample room to depict insects which are crawling
and flying sideways. This is the artist's only insect and
plant screen, which makes it particularly valuable.

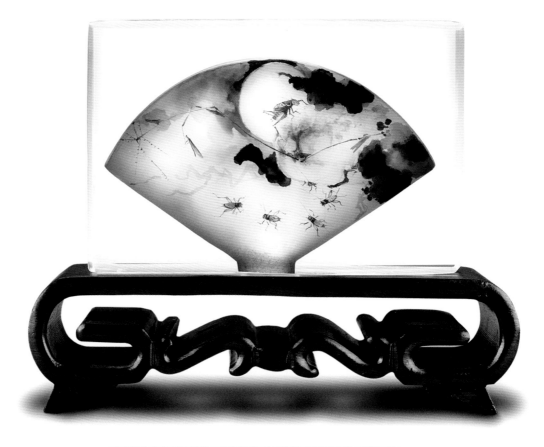

73. 山雉

<u>高 6.6 厘米　腹宽 10.9 厘米</u>

<u>玻璃</u>

款识："一石作于津南。"

作者虽有相似鸟主题的内画壶作品，但扇面屏作品显得更大器醒目。由于此件鸟扇面亦为孤品，颇为难得。

73. Pheasant

<u>Height 6.6 cm　Width 10.9 cm</u>

<u>Glass</u>

Marks: "Yi Shi painted at the south of Jing."

The artist has other similar works in which the primary subject is birds; but the fan-shaped interior lends itself to a more flexible canvas for the artist to work with. With more space to paint the background, the artist is able to place the bird in a majestic setting. This is an exclusive and very special piece.

人物　People

74. 清江渔隐

高 7.3 厘米　腹宽 4.8 厘米

玻璃

款识："戊辰夏月一石索振海作。"

壶一面绘溪边孤舟竹林深处，老翁微酣意不在渔，独钓山水，犹有未尽。作者用精湛的笔法，在不渗水的壶内壁画出竹林远近的水墨渲染效果，又突出写意人物的肢体面部语言，勾勒出与世疏离、时不我予的诗人情怀，意境颇耐人寻味。

壶另一面绘书生忽闻松尖随风悉悉索索作声，陷入沉思，忘了一旁听候指示的书童。作者用随风起舞的帽带表现风动，书生手执文卷摒胸，体现出若有所思的神情；笔墨浓淡有致的多层次展现风中松摆的恍惚，扛书望着主人的书童屈身前倾以示待命，传神的布置了这幅生动的互动情境。壶体两边侧雕有兽面环。作者人物画作品稀少，同一题材很少重复，最多二三件。

74. Hidden Fisherman in a Clear Stream

Height 7.3 cm　Width 4.8 cm

Glass

Marks: "Yi Shi Suo Zhenhai painted in a summer month of the year of WuChen."

The lone boat is on a creek deep inside the bamboo forest. The old fisherman is a little drunk, but this does not stop him from fishing; the old man fishes alone on his boat in the dead of silence. The artist was very skilled with his brush, painting the depth of the bamboo forest with dyeing effects on the inside surface of the bottle; he painted the facial expression and the body language of the character to try to convey a soft and transient atmosphere—creating a thoughtful and deeply intriguing scene.

The other side of the bottle pictures a scholar's reaction to an abrupt noise made by the tips of pine tree branches. The scholar enters into a state of deep meditation, and he forgets all about his servant who is standing nearby. The artist painted the tassel erect in the air to show that the wind is blowing. The artist also painted the scholar holding the scroll close to his chest to show that he is in deep thought. The ink used to paint this landscape is alternatively dilute and concentrated to produce different shades that contribute to a layered effect. This technique creates the effect of pine tree branches moving in the wind. A servant is shown bending forward awaiting his master's instruction; the subtle moods and movements of the characters in the pictures are conveyed vividly. This bottle has two animal head ring carvings on its narrow sides. The artist seldom includes people in his inner paintings. Pieces in which people are the main subject are rare; there are at most two or three pieces of the same subject.

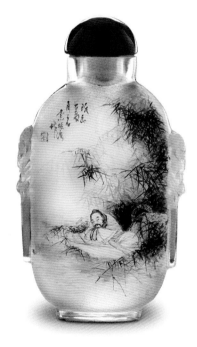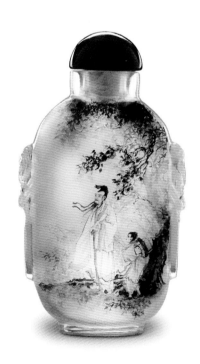

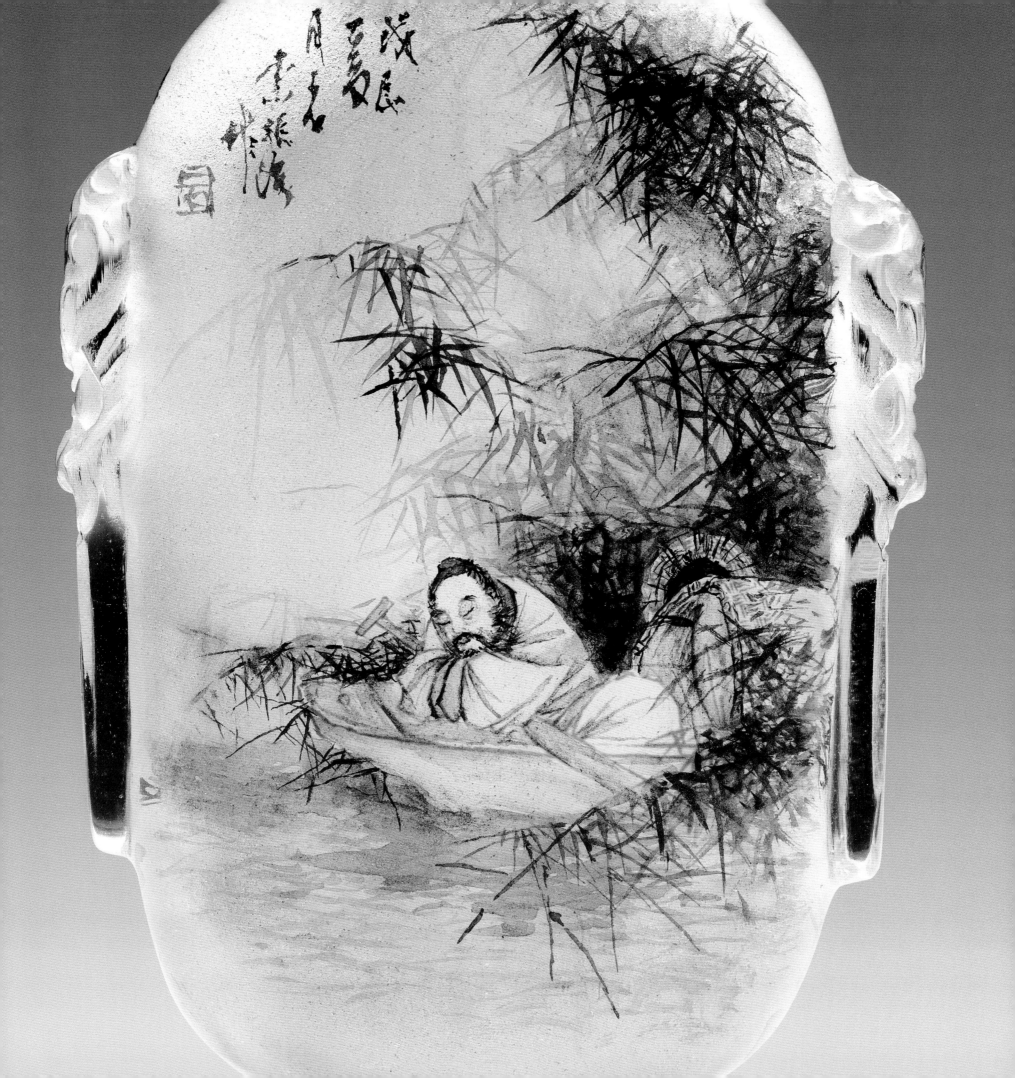

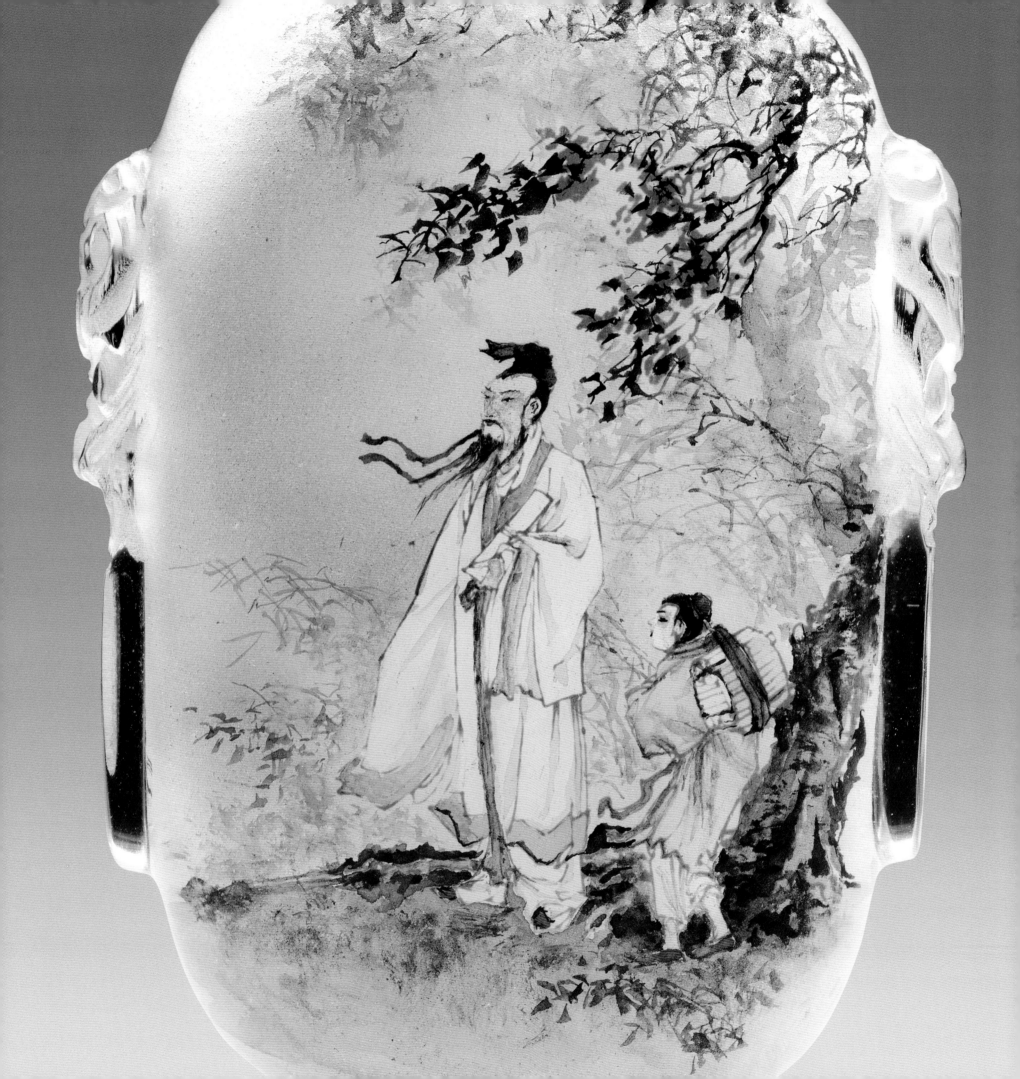

75. 竹林高卧

高 5.5 厘米　腹宽 4.2 厘米

玻璃

款识："师古人习今人习近人师造化。甲子冬月索振海作。"

此壶绘士人敞开衣襟露胸膛，靠书横臂卧林荫；另一面则绘借林中操琴以明志，潇洒不羁，遗世忘我，是一种境界，也是一种抒发；感叹时不我予，不如归隐山林，寄情山水。但倘若真能忘情，又何须离群索居，乃画中有话，有所语，有所不语，是情境画精品。虽是情境画，但又处处细节清晰，意境不凡，但画面布局清新雅致不繁琐，是作者极具深度的作品。

75. Resting in the Bamboo Forest

Height 5.5 cm　Width 4.2 cm

Glass

Marks: "Learning from the ancient, the recent, the contemporary and the nature. Suo Zhenhai painted in a winter month of the year of JiaZi."

This bottle shows a scholar stripping off his robe to reveal his chest; he is leaning against a pile of books while his arm lies in the shadow of a tree. The other side of the bottle pictures a scholar playing the lute in the woods, losing himself in his own music. The painting conveys the character's frame of mind: one of dejection as he sighs with the thought that time is running out. The scholar would rather hide in the woods and immerse himself in nature than confront his duties to the country. However, one might then question: If the scholar can forgo his duties, is there still a need to live removed from society? These are paintings with subtle meanings—some are more obvious while some are more obscure. Although they are just pictures with contexts, they are both paintings that have been carefully thought through.—this is truly a master piece.

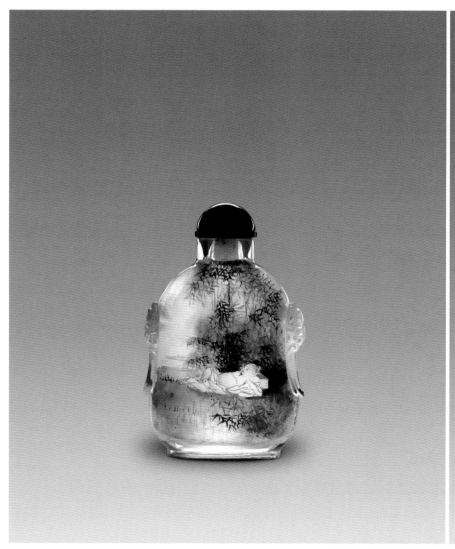
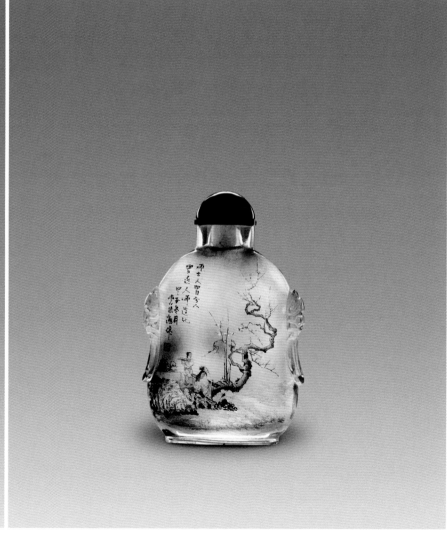

76．竹林七贤

高 7.5 厘米　腹宽 4.8 厘米

玻璃

　　款识："竹林七贤。岁在丁丑年一石作。"

　　另一面款识："一石作。"

　　竹林七贤是国画经常引据的历史人物画题材，七贤的互动关系着画面的协调和整体感。内画受限于壶面，如何在很窄的画面成功的安置七位贤者，和贤者们的面部表情及肢体语言，极为关键。

　　作者以极其精湛的艺术语言，经其巧思，完整的呈现出作者对此题材的诠释。仔细揣摩画中人物，虽欲寄情山水，或对弈，或讪谈，或赏书卷，或阅山水，但脸上表情、身体语言，在不经意间流露出忧心国事的纷乱心境，可谓成功表现作者心之所欲，臻"笔有尽，意无穷"之境界，显见笔者功力不凡。此壶是作者此题材中唯一作品。

76. Seven Solons in a Bamboo Forest

Height 7.5 cm　Width 4.8 cm

Glass

　　Marks: "Seven solons in bamboo forest. Yi Shi painted in the year of DingChou."

　　Marks: "Yi Shi painted."

　　The Seven Solons in a bamboo forest is a historical subject in traditional Chinese painting. The interactions amongst the seven solons create the picture's balance and overall feeling. Inner paintings are confined by the bottle's limited painting space, so it is crucial that the artist utilizes the space given to portray the painted subjects; which in this case, is the seven solons. Incorporating facial expressions and the body language of the solons poses an even tougher challenge for the artist.

　　Through ingenious designs, the artist conveys meaning beyond what is perceived by the eye. If one were to study the figures in the picture closely, one will notice that they are all either immersed in the natural landscape, playing chess, conversing, studying from a scroll, or marveling at the majestic mountains and tranquil waters. Their facial expressions and body language show the concerns they each have for the welfare of their country. The artist is successful in demonstrating that while his brushstrokes may have ceased, the story he is trying to tell continues to develop in the minds of those who observe this piece. Only artists with the most extraordinary skills are able to achieve this. This is the artist's only work pertaining to this subject.

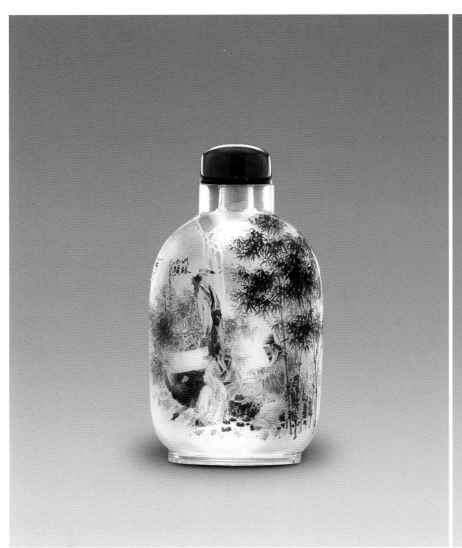

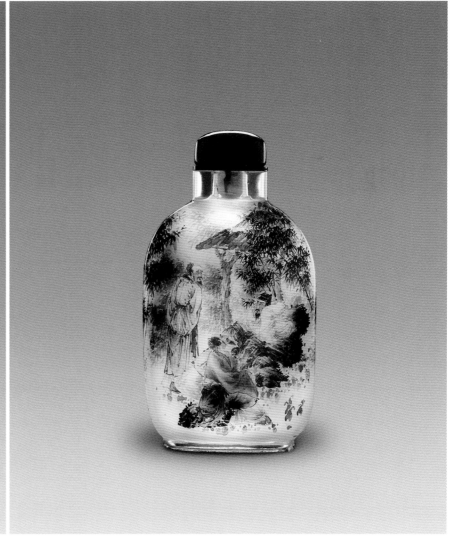

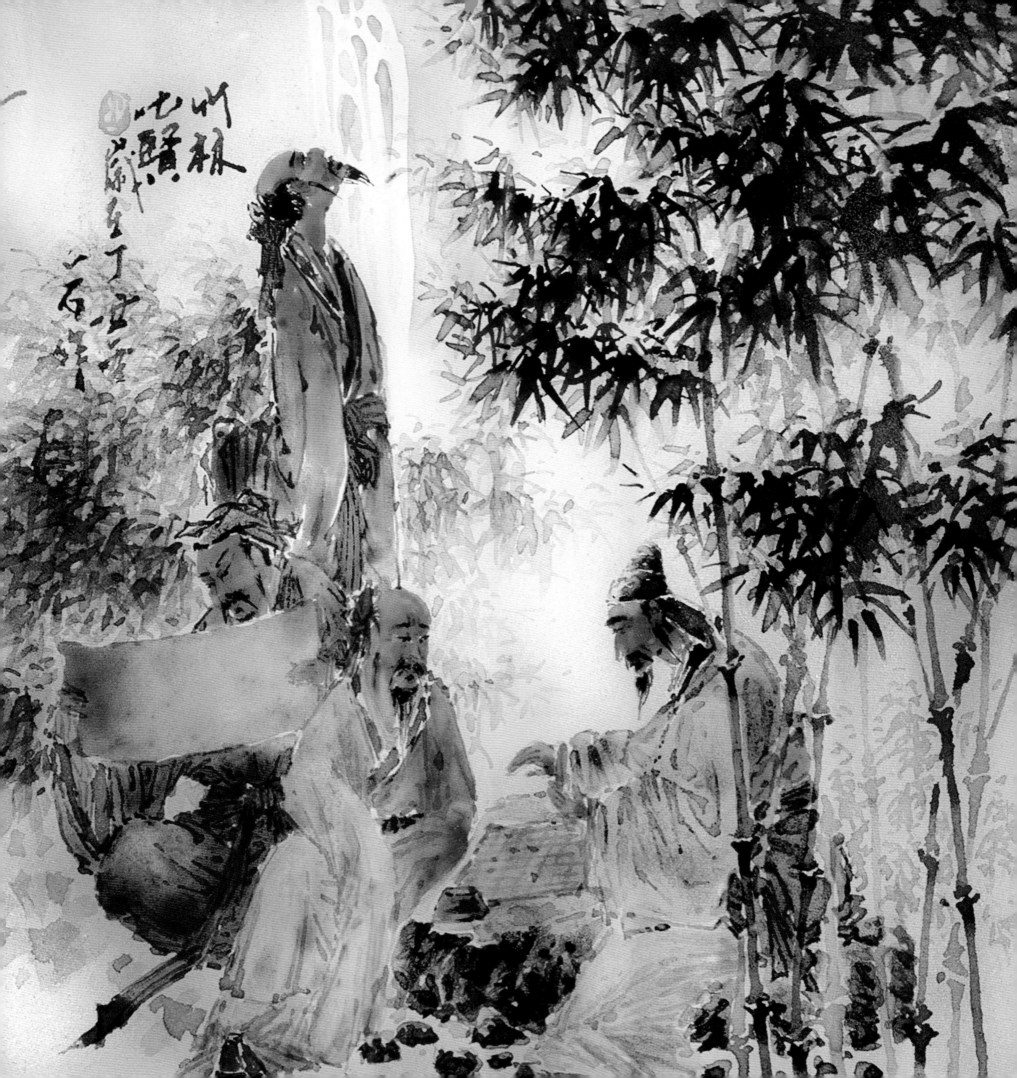

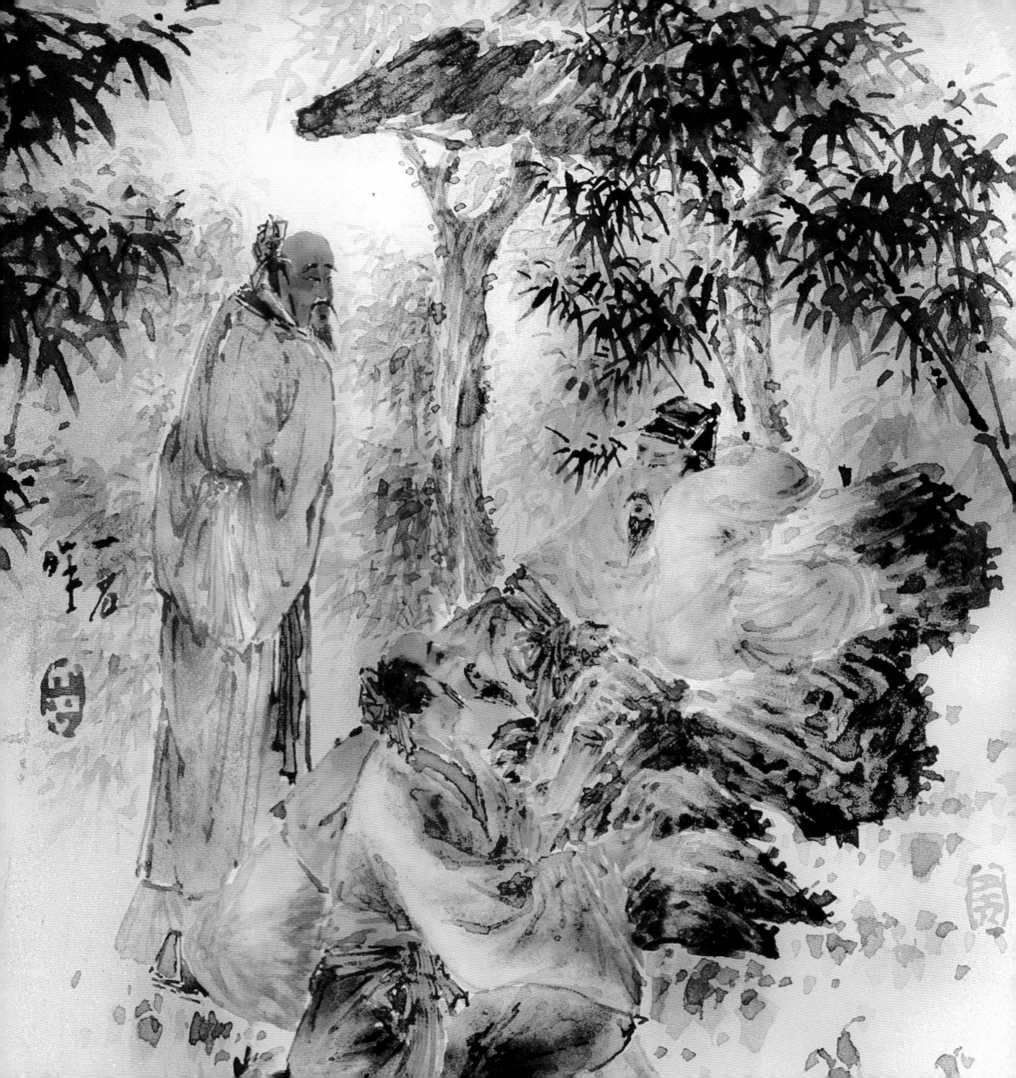

77. 老叟

高 8 厘米　腹宽 3.5 厘米

玻璃

款识："癸酉秋月一石振海作。"

壶一面绘的老叟，虽以写意笔法绘成，但面貌历尽沧桑，倚杖老态龙钟，令人凄然；而壶另一面老翁牵着马由小径走来，一边摇着扇子，仿佛看遍红尘，一副悠然自得的样子。此壶可谓由俩老叟之表像，成功的刻画出两种不同的心境。

此为作者绝品力作，类似题材仅有两件。

77. Old Man

Height 8 cm　Width 3.5 cm

Glass

Marks: "Yi Shi Zhenhai painted in an autumn month of the year of GuiYou."

One side of the bottle portrays an old man done in free style brushworks; his facial expression implies that he has had many experiences in life. The old man's hunched back shows that he has had many years on this earth; he holds a stick in one hand to help reduce the pain he feels with every step he takes. The images are truly disheartening and sorrowful. The other side of the bottle portrays an old man waving a fan in one hand to cool himself down while pulling a horse by its reigns, guiding it through a narrow path. He seems to have lived life to the fullest, as the expression on his face is carefree and content. The artist successfully depicts two different mindsets through the paintings of these old men.

This is one of the artist's best pieces and there are only two pieces of the same subject.

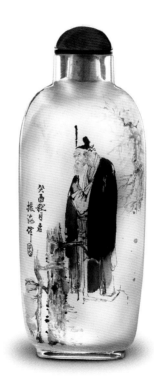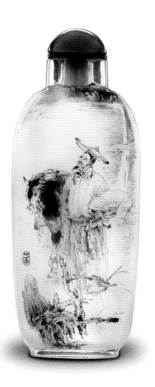

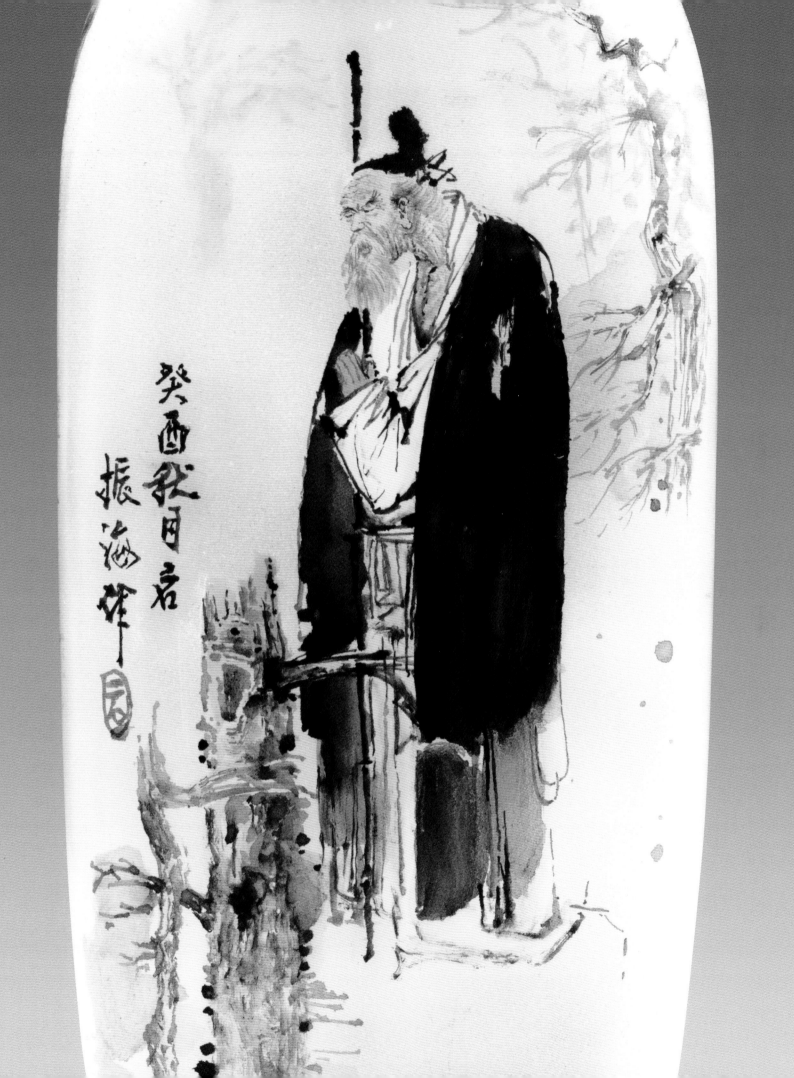

78. 浓荫仕女

<u>高 7.2 厘米　腹宽 3.6 厘米</u>

<u>玻璃</u>

款识："庚子冬月索振海一石作。"

壶中两面绘仕女体态柔美，婀娜多姿，一衬着垂柳，一衬着假山竹林，布局典雅清丽，不失为古典美人的精美佳作。

78. Lady in Heavy Shadows

<u>Height 7.2 cm　Width 3.6 cm</u>

<u>Glass</u>

Marks: "Suo Zhenhai Yi Shi painted in a winter month of the year of GengZi."

Each side of this bottle depicts a beautiful woman figure. One woman is leaning against a willow tree while the other is surrounded by an artificial mountain and bamboo forest scene. The layouts of both these paintings are graceful and elegant; the bottle is a beautiful piece of work.

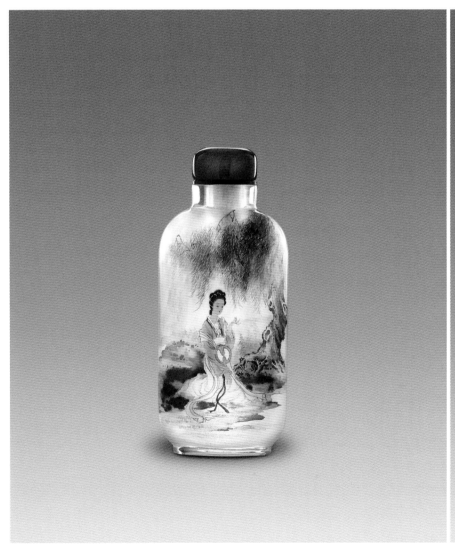
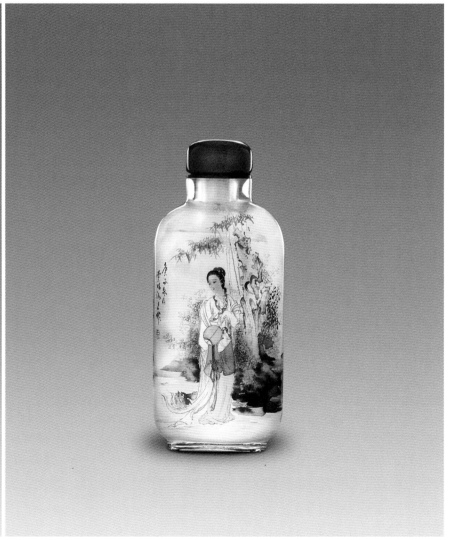

79. 月下倩女

高 5.5 厘米　腹宽 4 厘米

玻璃

款识："辛东□□画于河北古城之拓一斋。"

另一面款识："辛东画堂。"

这是作者的新尝试，画风突变，也是唯一此画风作品。因何原因作此作品已不可考，也未落款作者署名。所绘二女，线条简约随意，着淡彩，轻描淡写，别具风情。

79. Fair Lady under the Moonlight

Height 5.5 cm　Width 4 cm

Glass

Marks: "XinDong -- painted at Tuo Yi Zhai of Hebei Old Town."

The other side marks: "XinDong Painting Hall."

This is an experimental piece. The artist used swifter brush to complete this painting. It is the only one of its kind. The artist left no explanation as to why he completed this work in such a way and why he decided not to sign his name on the piece. The two ladies in the images are painted with simple and casual lines, light colors, and free strokes. This is a special piece among the artist's creations.

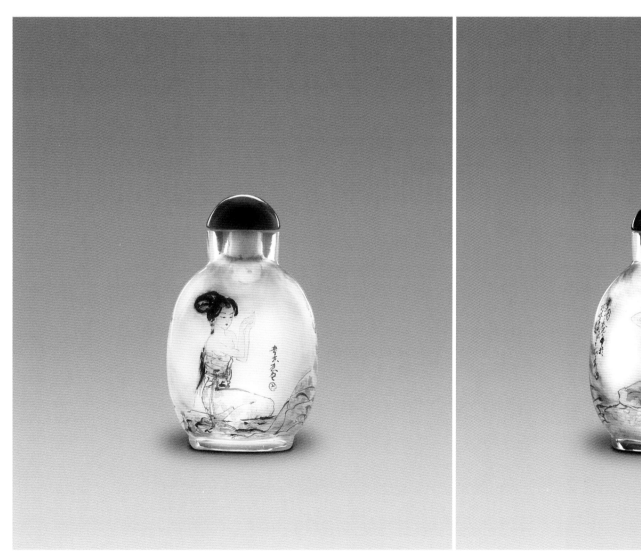
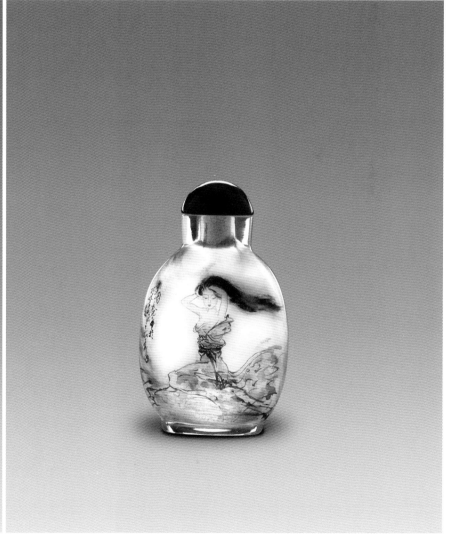

80. 武松打虎

高 8 厘米　腹宽 3 厘米

玻璃

款识："丙辰秋月索振海一石作。"

市面内画多为工笔写实京剧人物画，除非有深厚的国画人物写意功力，在壶中方寸之间，才能悠游自在。在笔尖的迅速流转中，掌握京剧人物的微妙姿态和动作神韵，恐怕只有如索老者才做得到。武松打虎及胡氏失子惊疯的故事是京剧经典名作。

此件原为作者绘成欲供学生习作，唯对学生而言难度过高而作罢，故成稀世唯一珍品。

80. Wu Song Beating a Tiger

Height 8 cm　Width 3 cm

Glass

Marks: "Suo Zhenhai Yi Shi painted in an autumn month of the year of BingChen."

On the market there are many fine detailed Beijing opera figure paintings. Unless the artist has an exceptionally strong foundation in Chinese free style painting techniques, he would not be able to create a masterpiece within the limited space of a snuff bottle using a hooked brush pen. The artist must use the tip of the brush in a very smooth and experienced way, carefree and certain in order to capture the subtle movements and spirit of the figures. It is possible that only someone like Suo can achieve this. The stories of Wu Song beating a tiger and Hu Shi losing a child are well-known Beijing opera classics.

This piece was originally intended to be a learning sample for the master artist's pupils. However, it was realized that the techniques employed were too difficult for the students to replicate. This bottle then became the artist's only piece that dealt with this subject matter.

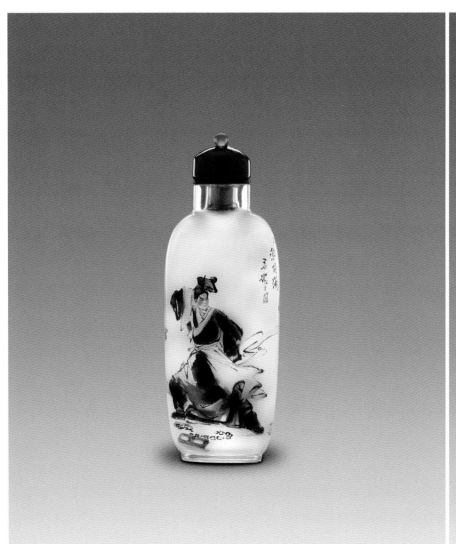

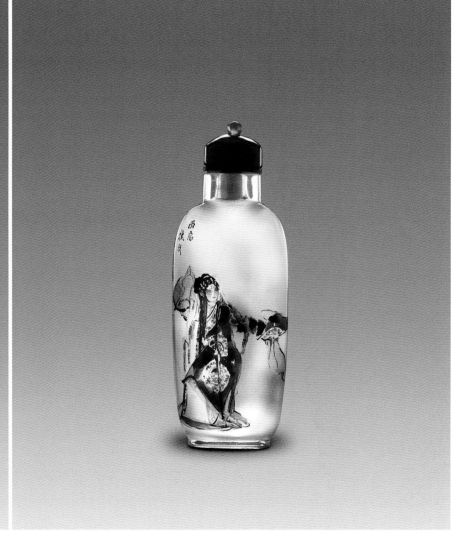

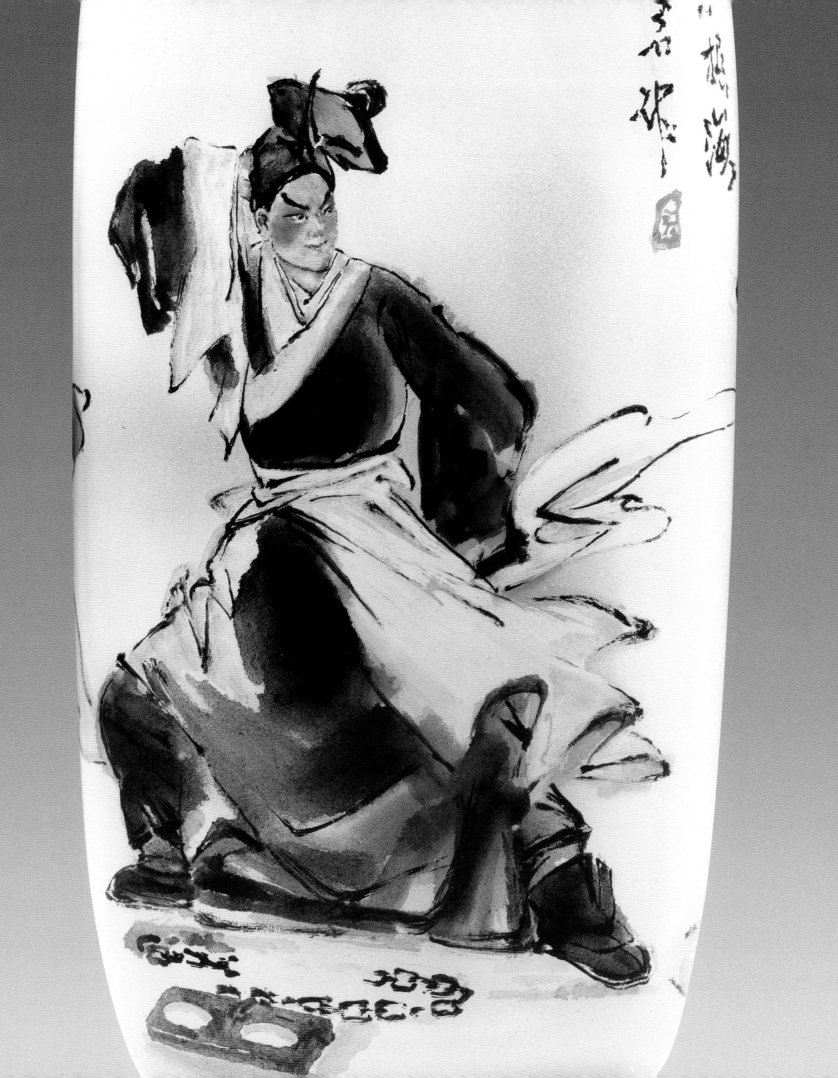

81. 赏菊图

高 5 厘米　腹宽 5 厘米

发晶

款识："戊寅三月一石素振海作。"

另一面款识："赏菊图。"

画中所绘仕女色彩稍重，自成视觉焦点，很容易注意到她华丽裙摆的层层线条，弹琴的优雅姿势，衬托淡雅的背景，自有一份说不出的雍容华贵；背面画中视觉焦点的仕女是处于静态，衬着茂密的菊花，却又是另一份恬静自得的悠哉。本题材内画亦是作者独件孤品。

81. Gazing at Chrysanthemums

Height 5 cm　Width 5 cm

Quartz Rutilated

Marks: "Watching chrysanthemums."

The other side marks: "Yi Shi Suo Zhenhai painted in March of the year of Wu Yin."

This inner painting portrays a lady in the olden days. The image is composed of darker colors and the focus is naturally concentrated on the lady and her splendid multi-layered skirt. Her playful yet graceful gestures create an elegant feel for the entire painting. The visual focus of the inner painting on the other side of the bottle is another lady; she is sitting still against a backdrop of flourishing chrysanthemums, which contributes to a tranquil atmosphere.

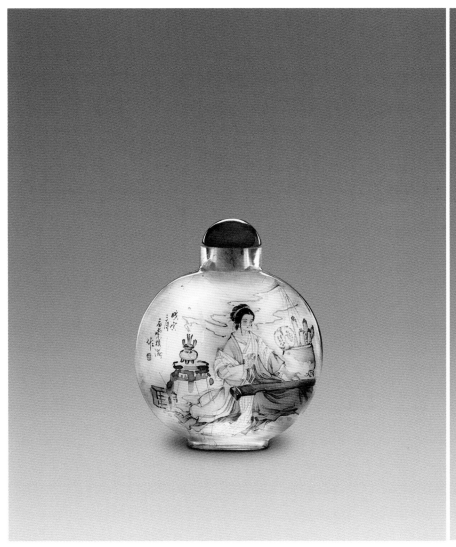
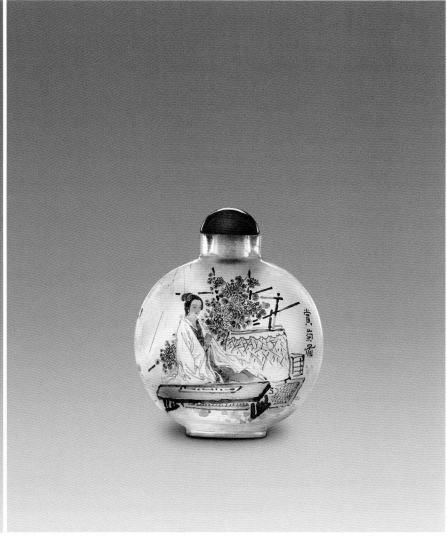

82. 淑女

<u>高 7.5 厘米 　腹宽 6 厘米</u>

<u>玻璃</u>

　　款识："甲申三月下浣索振海一石作。"

　　另一面款识："一石作。"

　　由于重彩讲究颜色的铺陈，相对较着重以色彩的厚实感来吸引观众的感官享受。

　　此壶正反面所绘的淑女，除姿态柔美婉约之外，色彩突出，色调高雅，极易在观者心中留下印象，实属重彩佳作。此作品为作者新尝试，亦是独一无二。

82. Lady

<u>Height 7.5 cm　Width 6 cm</u>

<u>Glass</u>

　　Marks: "Suo Zhenhai Yi Shi painted in late March of the year of JiaShen."

　　The other side marks: "Yi Shi painted."

　　The generous application of color in this piece stresses the show-case of colors as a way of attracting one's gaze.

　　On both sides of the bottle, two ladies are beautifully and elegantly portrayed; the coloration of the artwork is remarkable and aesthetically appealing. This is the only piece that employs the unique style of painting whereby colors are generously applied.

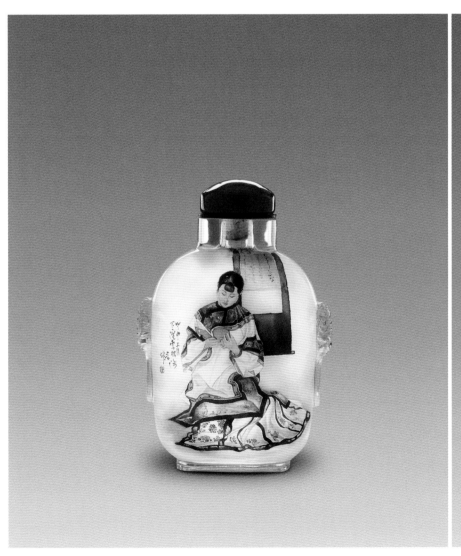

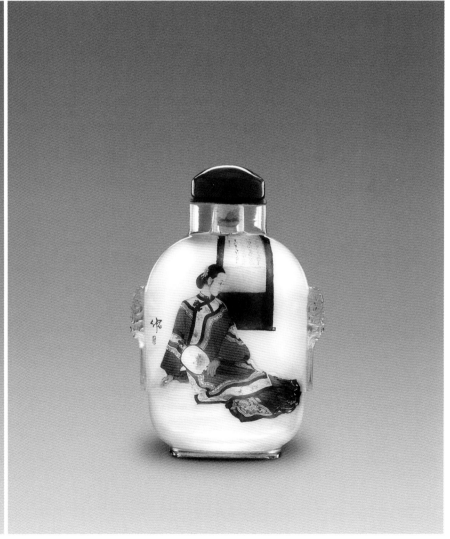

83. 柔风含情

高 6.4 厘米　腹宽 2.1 厘米

玻璃

　　作者借此细长壶设景，表现淑女婉约含蓄，脉脉含情。相对纯以人物为主，此壶为风景人物画，风景元素亦是主角，对照仕女的柔弱是芭蕉的高耸，竹菊倚立阁窗，半身淑女翘首倚望。此壶为此题材唯一作品。

83. Love Carried on a Breeze

Height 6.4 cm　Width 2.1 cm

Glass

　　The artist uses the slender shape of this bottle to enhance the painting it portrays; the ladies' shyness, evident in their tender gazes becomes much more striking. Scenery is an important element in inner painting art, and this painting depicts scenery of people. High above the ladies are banana leaves, bamboos and chrysanthemums framed in an attic window. A lady tilts her head back to marvel at this wondrous sight. This is the artist's only work pertaining to this subject.

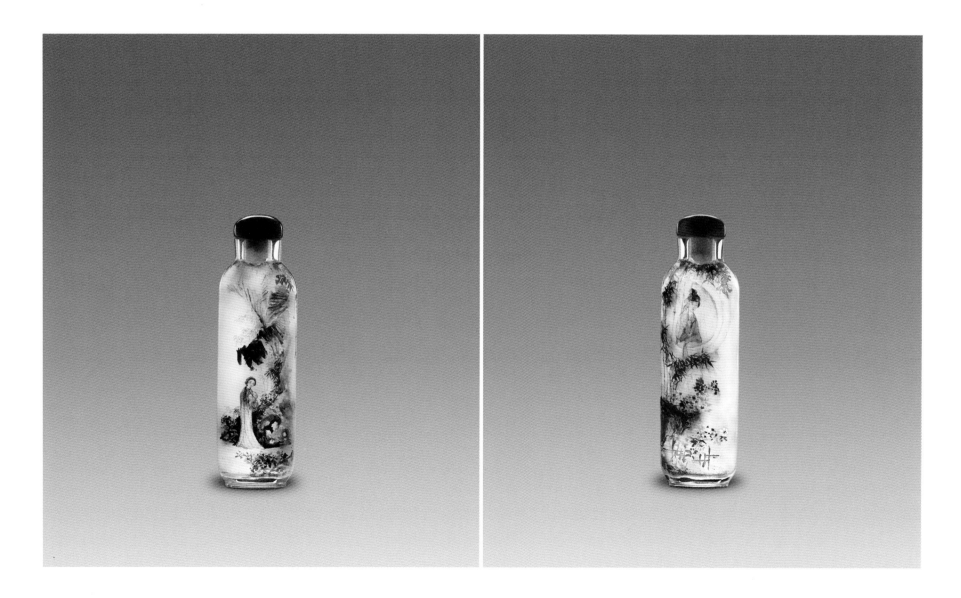

84. 爱鹅图

高 7.9 厘米　腹宽 9.3 厘米

玻璃

　　款识："爱鹅图。戊寅夏月习范先生笔法一石习作。"

　　另一面款识："戊寅一石仿作。"

　　此壶绘羲之爱鹅、牧童牵驴题材，乃习作范曾画。不同于作者自行创作的山水人物画之爱鹅图，不同趣味，不同风格，作者自有分寸，表现合度，皆充分发挥其艺术才华，令见者无不珍惜。此亦为样本孤品，专供学徒习作之用。

84. Loving Geese

Height 7.9 cm　Width 9.3 cm

Glass

　　Marks: "Loving geese picture. Yi Shi practiced and learned from Mr. Fan's brushworks in a summer month of the year of WuYin."

　　The other side marks: "Yi Shi imitated in the year of WuYin."

　　This bottle adopts the subjects of Xi Zhi love Geese and a young shepherd boy pulling a donkey by its reigns. The two inner paintings are derived from Fan Zeng's paintings. The imitations are different from the artist's own people and landscape paintings in that they demonstrate different focuses and styles. People will appreciate this piece when they lay eyes on it. It is an exclusive learning sample for the master artist's students.

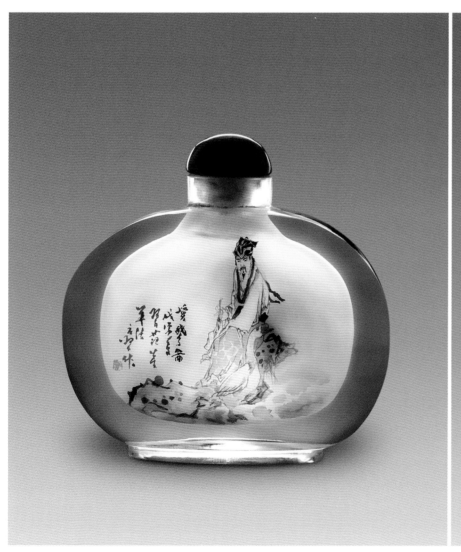

85．老翁骑虎

高 10.8 厘米　腹宽 6.8 厘米

玻璃

款识："甲寅三月仿范曾先生笔意一石仿作。"

另一面款识："一石作。"

此为仿范曾人物画精品，从其画面看虎虎生威，毫发细腻，色泽鲜活，神灵活现，及老者赤足骑虎，悠游无念，神态自若。虽是仿作笔意，却也有自身创作元素，有如翻译文学作品，虽符原意，仍然有译者本身的理解和功力，才有此作品雅而不俗、兼笔墨精彩的成绩。此为作者此题材孤品样本，供学徒习作。

85. Old Man Taming a Tiger

Height 10.8 cm　Width 6.8 cm

Glass

Marks: "Yi Shi imitated Mr. Fan Zeng's brushwork in March of the year of JiaYin."

The other side marks: "Yi Shi signed."

This piece is an imitation of Fan Zeng's original work. The tiger is majestic in appearance, painted with detailed brushstrokes and bright colors; the barefooted old man on the tiger's back exudes a carefree and content attitude. In spite of being an imitation, this piece still contains the master artist's own creative touch. This is an exclusive work and was originally intended to be used as a teaching sample.

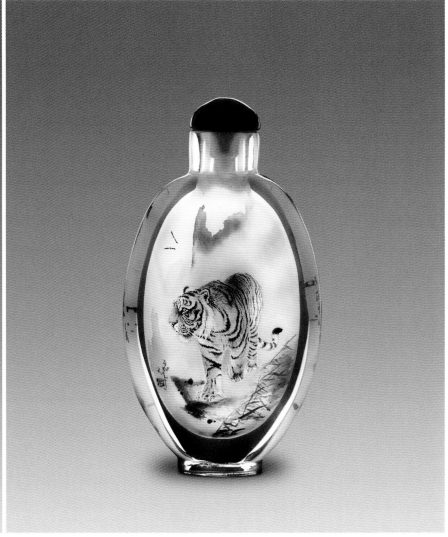

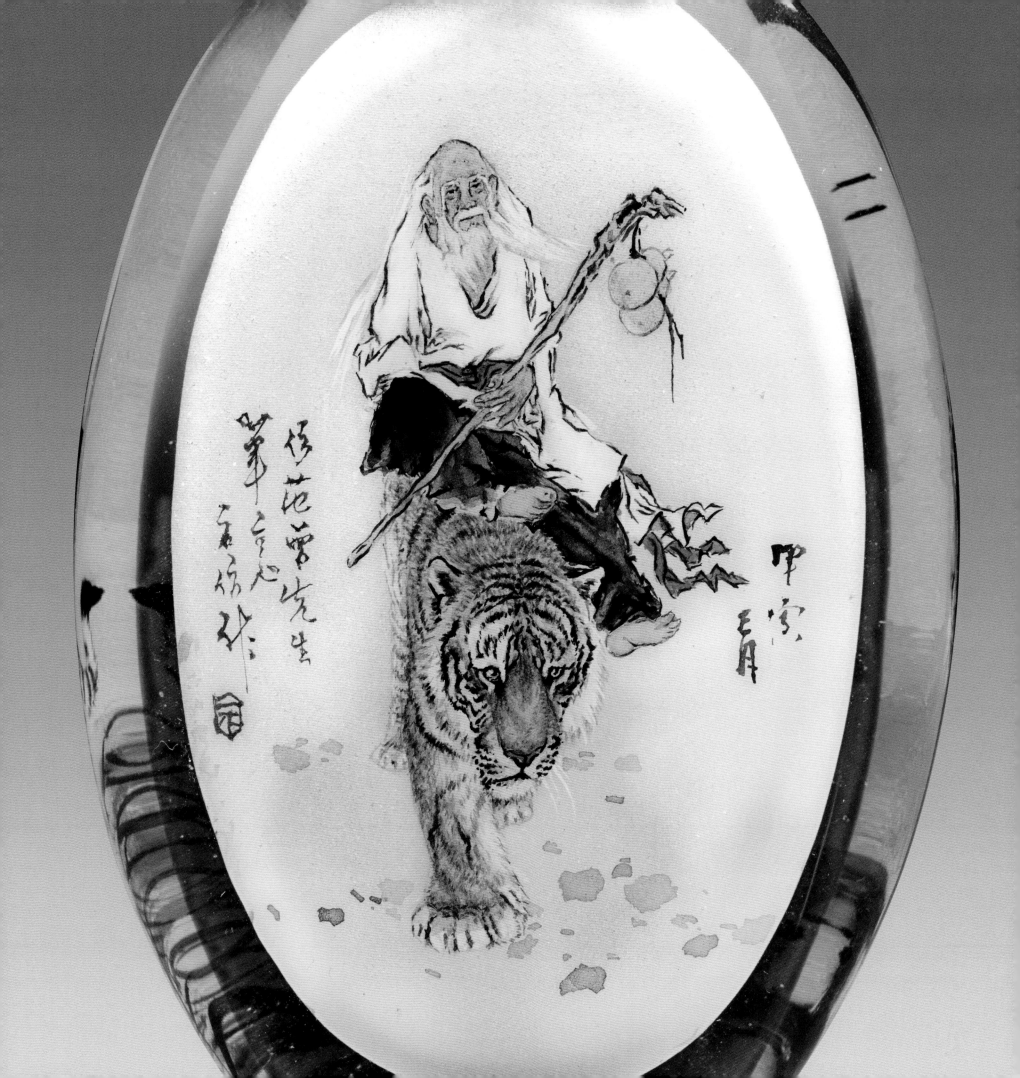

86. 红衣骑士

高 7.9 厘米　腹宽 8.6 厘米
玻璃

款识："仿范曾先生笔法，数年愧未能似。甲申冬月索一石仿作。"

壶两面画望海红衣骑士，赶集老翁童子牵牛，虽仿作笔意，作者熟练笔触和极具深度的艺术认知能力，却使其仿作不匠气亦不生硬，实为佳作。此为样品独件，供学徒习作，惜皆未能似。

86. Rider Dressed in Red

Height 7.9 cm　Width 8.6 cm
Glass

Marks: "Learn from Mr. Fan Zeng's brushworks; feel guilty of not doing a good job. Suo Yi Shi imitated and signed in a winter month of the year of JiaShen."

One side of the bottle shows a man in a red dress riding a horse, while overlooking the ocean. The other side pictures an old man and a boy pulling on the reigns of a cow, slowly making their way to a fair. Although this is an imitation piece, the artist's skilled brush techniques and perceptive artistic eye is evident. This is a well executed pieced of art and is definitely an example of extraordinary craftsmanship. It is a pity that the artist's pupils are unable to replicate the artistry demonstrated in this exclusive learning sample.

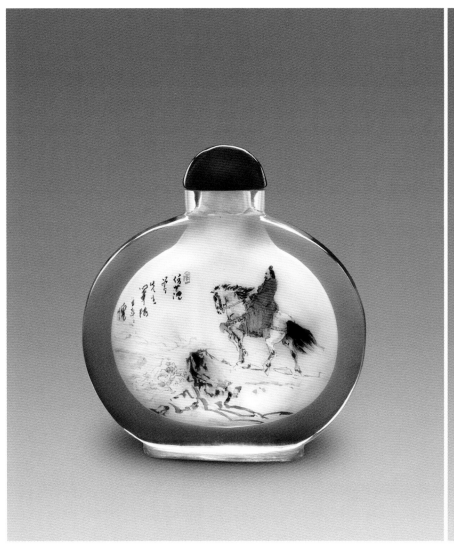
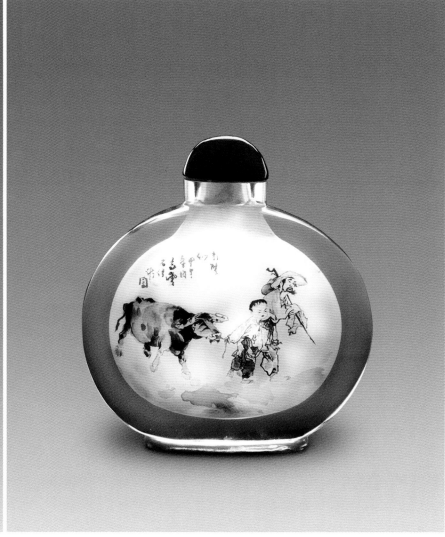

87. 鹤童骑翁

高 6.3 厘米　腹宽 5.8 厘米

玻璃

　　款识："一石仿作。"

　　范曾人物画常为他人临摹题材，但多流于俗套，未得体现原作精神。作者自身文人画涵养甚深，虽是仿作，透过自己笔墨功夫，整体展现文人气息的人物水墨画；无论鹤起童舞，或是童引骑翁，都让观者能欣赏作者精彩笔墨，生动刻画人物和文人素质的风采。此壶为作者留下的样品独件。

87. Boy and Crane; Old Man Riding an Ox

Height 6.3 cm　Width 5.8 cm

Glass

　　Marks: "Yi Shi imitated."

　　Fan Zeng's figure paintings are often the subjects of imitation pieces. However, the imitations are often done through conventional methods; consequently, the spirit that could be found in the original artwork is not present within the imitation. The artist was very good at the scholarly painting style; in spite of being an imitation, the piece he created with ink-colors portrayed the figures with a scholarly essence. Be it a flying crane or a young boy leading an old man, the viewers can see the precise brushwork of the artist and the vivid figures within the painting. This bottle is the only one of this subject matter that was used as a teaching sample.

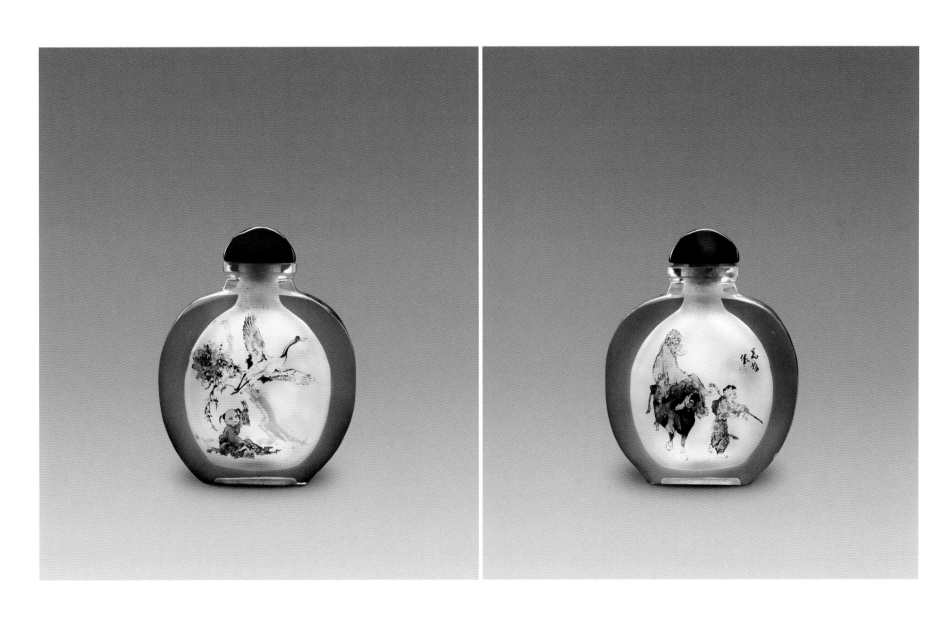

88. 木兰从军

高 8.2 厘米　腹宽 9 厘米

玻璃

　　这是作者留作样品的木兰题材系列壶之一，此题材作品市面并没有。花木兰历史题材为世人熟悉，自然有所期待，以此作画较不易跳出窠臼，所以作者以保守的构图点出主题。图中布局恰如其分，笔法熟练，木兰家居喂鸡，领军花旗军，皆与观画者的期望契合。

　　此壶原备作样本供习作，学徒力未能及而作罢，因而成绝品。

88. Mu Lan Joins the Military

Height 8.2 cm　Width 9 cm

Glass

　　This bottle is part of the Mu Lan series, used as teaching samples by the artist. It is not available on the market. Hua Mu Lan is a well-known historical figure in the Chinese culture; therefore, there are high expectations for works of art that use Mu Lan as the primary subject. The subject matter allows less freedom for novel creation; the artist has chosen a conservative layout to depict the subject matter. The paintings are arranged in a standard way and completed with skilled brushstrokes—the paintings of Mu Lan feeding the chickens and leading the Hua Army both meet audience's expectations.

　　This bottle was originally prepared as a teaching sample for the students; but the students were unsuccessful in imitating it.

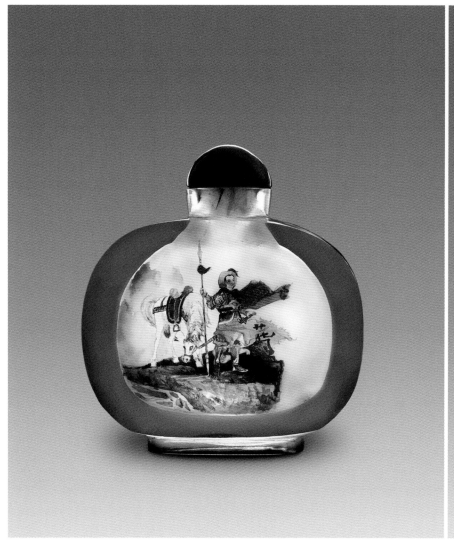
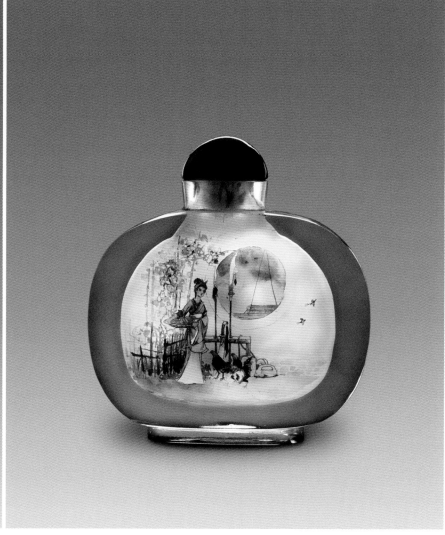

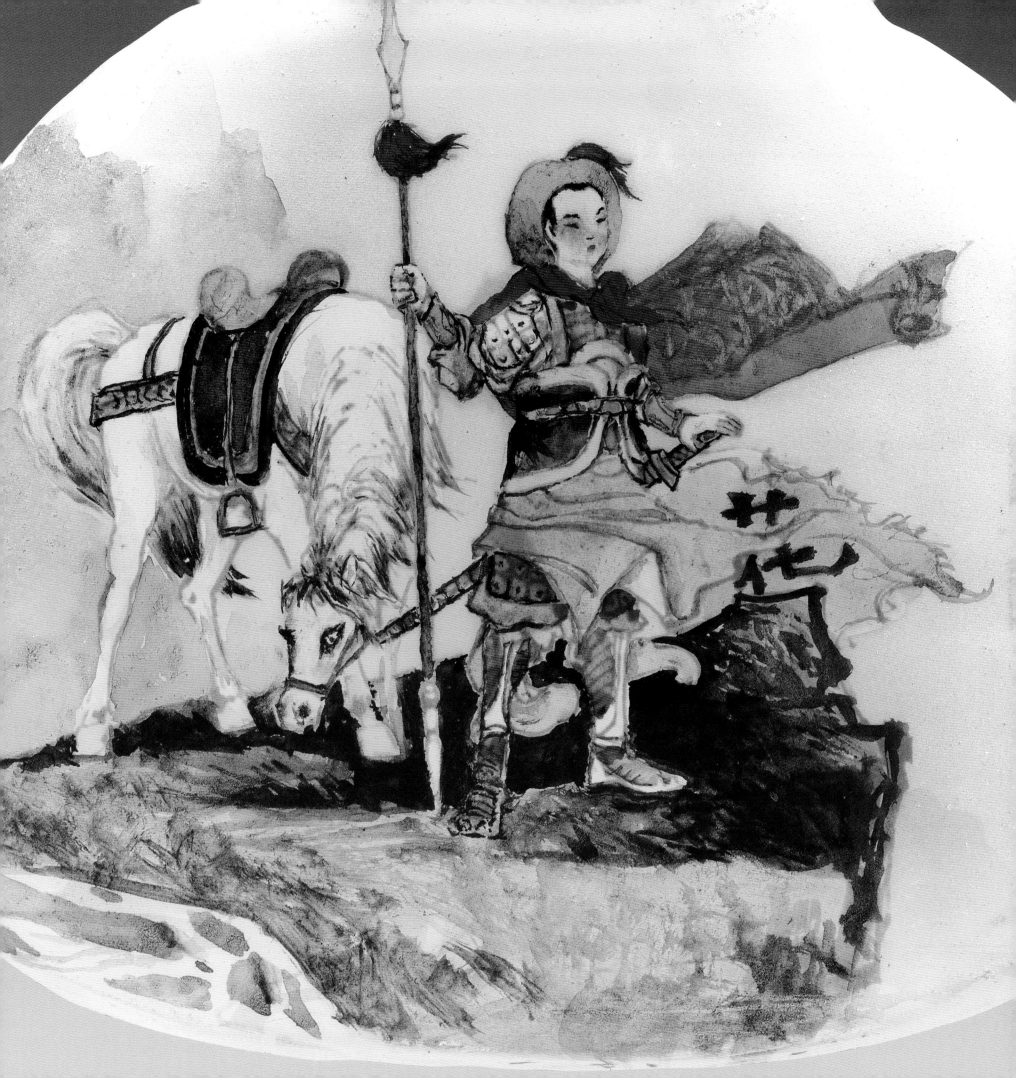

89. 木兰补裘

高 7.7 厘米　腹宽 8.8 厘米

玻璃

这也是作者留作样品的木兰题材系列壶之一。木兰月下缝补，弓箭高挂，蓄势待发；另一面绘木兰勒马眺望神州，一展壮志。构图严谨，亦是历史人物画的佳作。与另一壶同为学徒习作准备，而因后作罢成了孤品。

89. Mu Lan Sewing a Leather Jacket

Height 7.7 cm　Width 8.8 cm

Glass

This is a bottle from the Mu Lan series; the artist used the bottles in this series as teaching samples. Mu Lan is shown to be sewing under the moon, with a bow hung above her, ready for her to pick up should she need it. The picture on the other side of the bottle portrays Mu Lan holding a horse by its reigns, surveying the vast landscape, with thoughts of saving her country crowding her mind. This bottle, along with the other one depicting Mu Lan, was originally prepared for the master artist's students to use as a learning sample. It too is an exclusive piece; the only one of its kind.

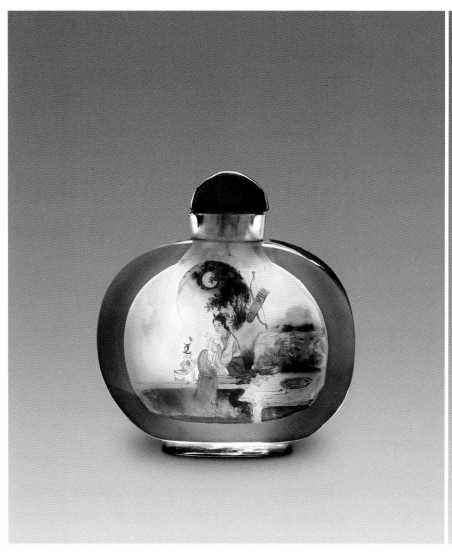
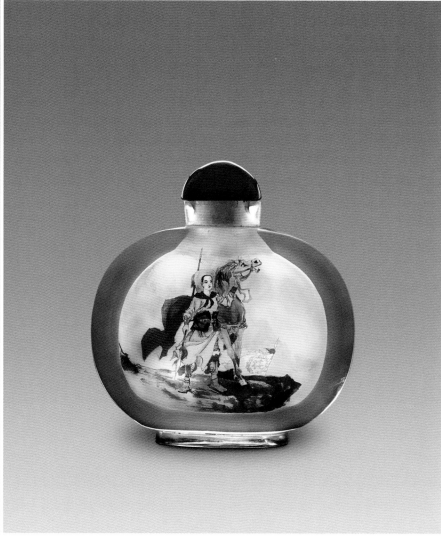

90. 乐在其中

高 7.9 厘米　腹宽 8.9 厘米

玻璃

　　款识："乐在其中。戊寅四月下浣一石作于津南。"

　　另一面款识："一揽乾坤。戊寅三月下浣一石作。"

　　此为较民俗的题材，弥勒佛敞胸露腹，悠哉的抠着耳朵，无忧无虑，状似乐在其中；另一面弥勒佛伸懒腰打哈欠，双手张开，好似抓住天地乾坤。非以神圣不可侵的面貌来画佛，是作者另一种艺术表现。

　　作者原意是将此作为样本供学徒习作，故未有重复未来佛图样的作品。

90. Loving Life

Height 7.9 cm　Width 8.9 cm

Glass

Marks: "Feel Happy in It. Yi Shi signed at the south of Jing in late April of the year of WuYin."

The other side marks:"Hold up the universe. Yi Shi signed in late March of the year of WuYin."

In this piece of folk art, the Mi Le Buddha shows his bare chest and stomach while picking at his ears in a carefree manner, clearly content with his life. On the other side of the bottle, the Mi Le Buddha is yawning with both arms raised above his head, spread far apart from each other, as if he is trying to grasp the universe in his hands. The artist did not paint the Buddha in a majestic light, which is a creative decision that is justified as a form of artistic expression.

This bottle was originally prepared as a teaching sample for the students; there is no other bottle that depicts the Future Buddha in this image.

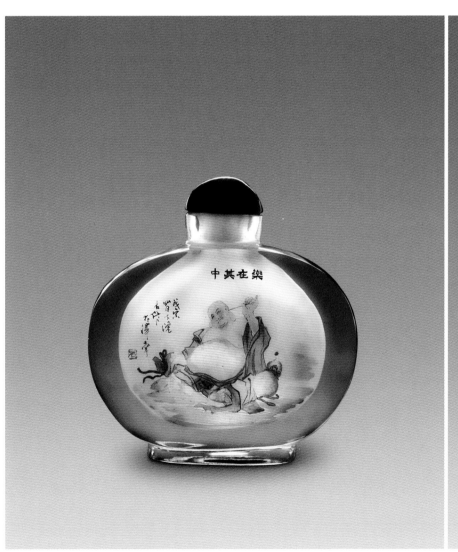

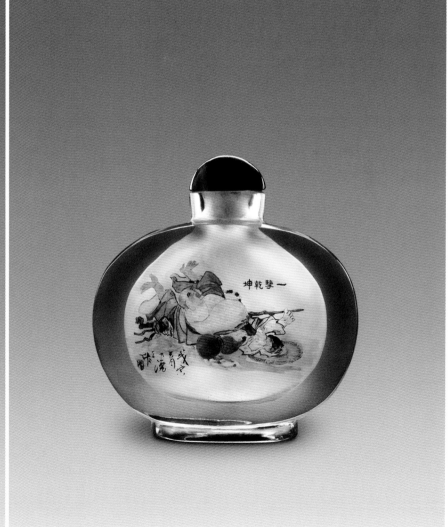

91. 皆大欢喜

高 7.9 厘米　腹宽 8.9 厘米

玻璃

　　款识："皆大欢喜。戊寅一石作。"

　　另一面款识："笑口常开。甲寅三月下浣一石作。"

　　此壶和乐在其中是同类型的作品，也是成功的体现未来佛的度量和风采。虽是想象画，也是自身理想的表征。此壶亦是样本孤件。

91. Happiness All Around

Height 7.9 cm　Width 8.9 cm

Glass

　　Marks: "Everybody is Happy. Yi Shi signed in the year of WuYin,"

　　The other side marks: "Grinning All the Time. Yi Shi signed in late March of the year of JiaYin."

　　This bottle is similar to the bottle titled "Feel Happy in It". The bottle successfully shows the magnanimity of the Future Buddha. It is an imaginative piece. This is an exclusive piece; the only one of its kind.

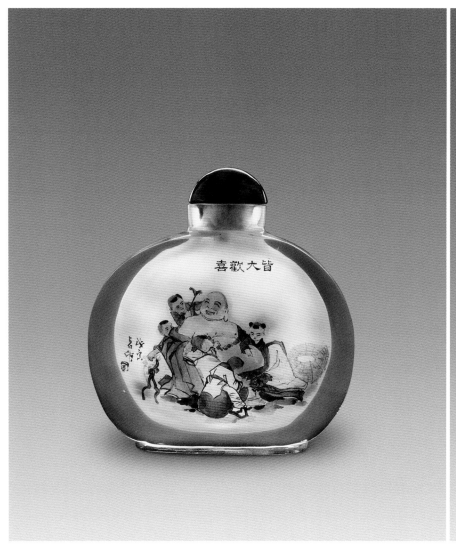

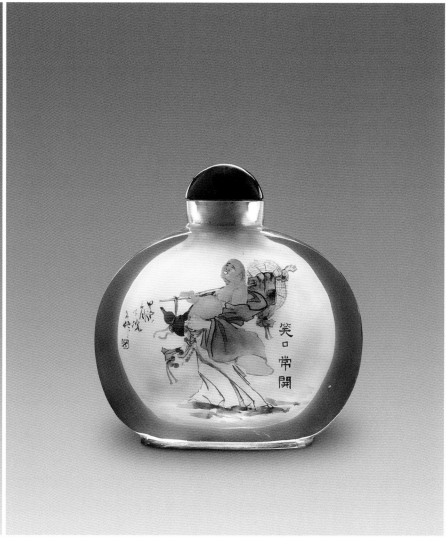

92. 西情

高 8.5 厘米　腹宽 6.8 厘米
玻璃

款识："西情。壬午夏一石作。"

观赏故事人物画，着重画中人物的交互关系和整体故事的叙述能力。作者借将士回身告别，一旁随扈控马待驰，西域侠士豪情斑斑可见；另一面绘喇嘛僧人走访江湖养鹰汉，故事情节仿佛正在展开中。此亦为学生习作准备的孤件样本。

92. Story of the West

Height 8.5 cm　Width 6.8 cm
Glass

Marks: "Story in the West. Yi Shi signed in the year of RenWu."

Inner paintings that tell a story focus heavily on the interactions amongst the figures in the paintings. The artist depicts a rider with his back turned to convey that he is bidding his present company farewell; those who are holding the horses all await the chance to let go. The other side of the bottle portrays a group of lama monks visiting an eagle trainer. The scene seems to be the beginning of a new chapter in this artistic sequel. This is an exclusive teaching sample prepared for student to learn from.

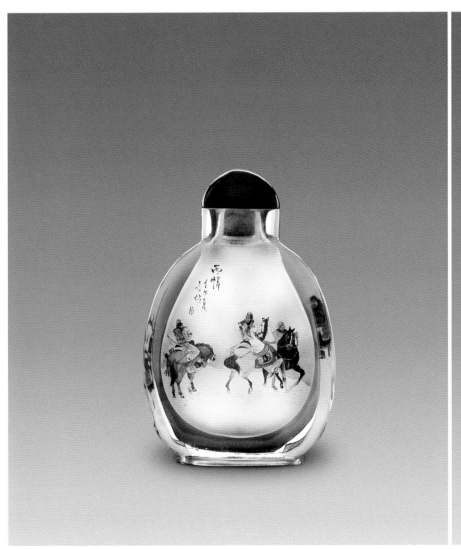

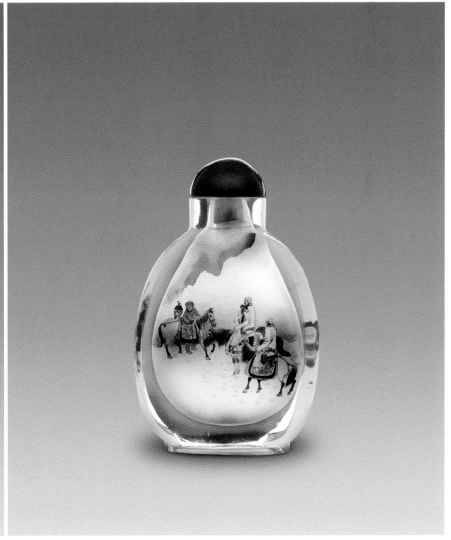

93. 西游记 （一组四个）

高 7.2 厘米　腹宽 5 厘米

玻璃

款识："骗扇。火焰山。一石作"；

"假扇。一石作"；

"闹洞。壬午三月一石作"；

"火焰山借扇。壬午一石作"；

"献扇。一石作"；

"灭火。一石作"；

"斗牛王。一石作"；

"骗扇。一石作"。

此四件壶八面各画有一段西游记故事，帧帧精彩，不落连环画之俗套，创作者自有风格。更像文人写意神仙画，墨中添彩，画中神仙活灵活现，又比一般文人神仙画来得生动有趣，更不同于传统内画风格，将创作生命力和国画笔触，发挥得淋漓尽致，是难得的佳作。此类作品数量极其有限，弥为珍贵。

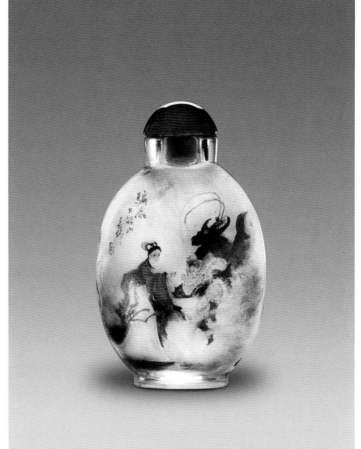

93. Journey to the West

(A Set of Four Bottles)

Height 7.2 cm　Width 5 cm

Glass

Marks: "Stealing the fan at Flare Mountain. Yi Shi signed,"

"Fake fan. Yi Shi signed,"

"Disturbing the cave. Yi Shi signed in March of the year of RenWu,"

"Borrow the fan at Flare Mountain. Yi Shi signed in the year of RenWu,"

"Surrendering the fan. Yi Shi signed,"

"Putting off the fire. Yi Shi signed,"

"Fighting against the Bull King. Yi Shi signed,"

"Stealing the fan. Yi Shi signed."

There are eight "Journey to the West" stories in this four-bottles series.. Each of them is an exquisite piece of work; unlike the conventional images reminiscent of comic strips that are often depicted in artwork portraying the Journey to the West. The artist approaches the depiction of this fairy tale scene in a unique way. He is creative in mixing paint colors with ink to make the characters in the artwork come to life. This technique is different from the usual inner painting style. The artist's creativity stems from merging two different Chinese painting techniques. This series is truly precious as it is remarkable work and is very rare.

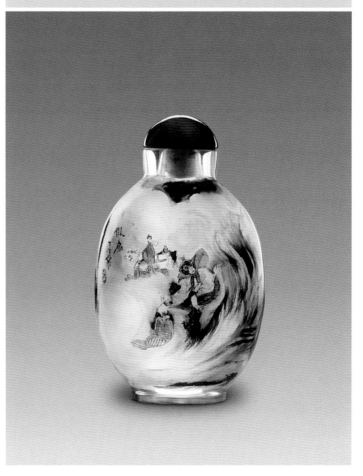

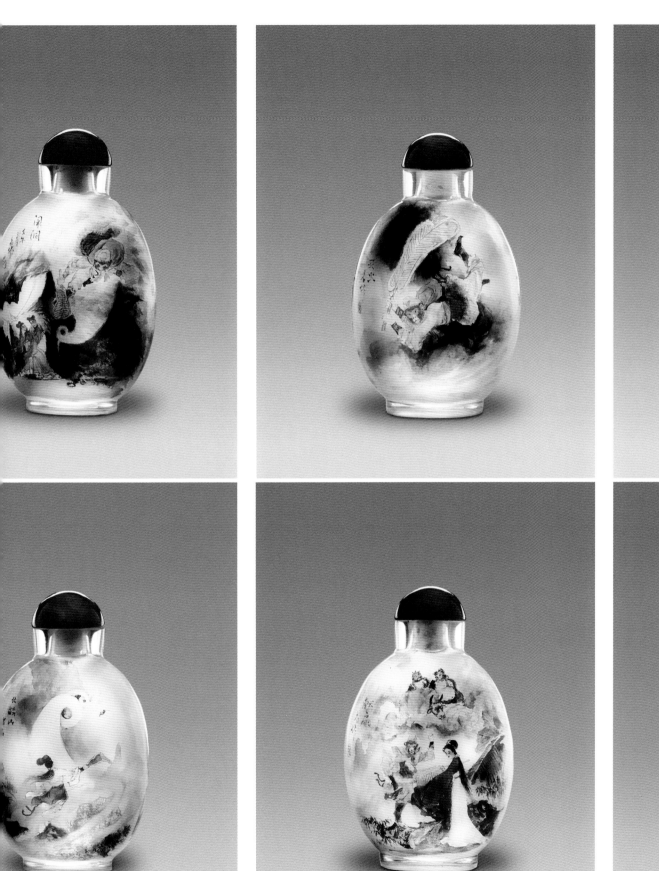
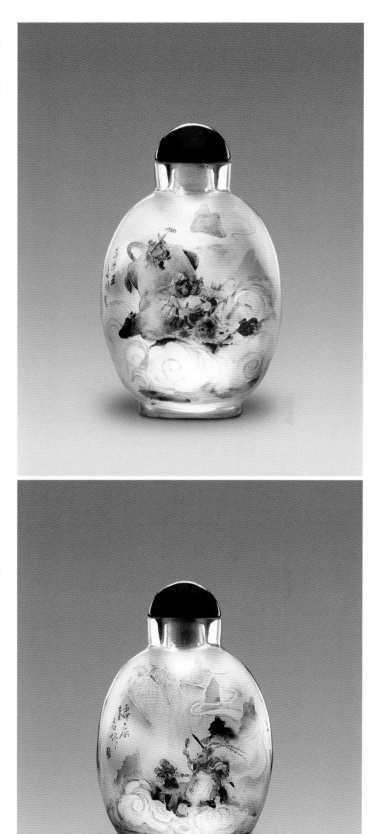

94. 长板坡

高 7.8 厘米　腹宽 8.5 厘米

玻璃

款识: "长板坡。"

另一面款识 "夜战。丙子三月下浣一石索振海作。"

同样是极少的三国演义题材作品, 经作者之妙笔, 赵子龙长板坡大战曹军, 葭萌关前张飞夜战马超, 犹如生动的图中人物用其身体语言, 身历其境的表述故事情节和战场厮杀的激烈。此作品也因学徒习作效果不佳成了绝品样本。

94. Zhang Ban Slope

Height 7.8 cm Width 8.5 cm

Glass

Marks: "Zhang Ban Slope."

The other side marks: "Night Battle. Yi Shi Suo Zhenhai signed in late March of the year of BingZi."

The artist painted very few pieces on the "Romance of the Three Kingdoms"; this bottle being one of the few. The artist's magical brushstrokes allow the body language of the characters portrayed to tell the stories of the battlefield. The inner painting shows Zhao Zilong fighting against Cao Army at Zhang Ban Slope and Zhang Fei battling against Ma Zhao at night in front of the Xia Meng Gate. These images come to life with the artist's brushstrokes and are truly able to convey the intensity of the battles it portrays. This piece was not appropriate for the purpose of a learning sample due to its complexity; it is, however, and exclusive sample of its kind.

95．古城会

高 7.8 厘米　腹宽 8.8 厘米
玻璃

　　款识："古城会。戊午三月一石作。"

　　另一面款识："战吕布，三国人物。戊午一石作。"

　　作者不拘泥于传统摹拟或连环画的俗套，用自己的艺术语言流畅生动的诉说三国人物的故事。跃马奔腾，刀枪交会，画面犹如动画史诗般在你眼前活生生的上演着，关公青龙偃月刀灌顶式的架开蔡阳的大刀，你仿佛感受到现场厮斗的震撼。两幅画虽未忽略细节，但是撼人心弦的是整体画面动感的流畅和穿透力。同类作品很稀少。

95. Meeting in an Old Town

Height 7.8 cm　Width 8.8 cm
Glass

　　Marks:"Meeting in Old Town. Yi Shi signed in March of the year of WuWu."

　　The other side marks: "Fighting Lv Bu, People of the Three Counties. Yi Shi signed in the year of WuWu."

　　The artist was not restricted by existing imitations or comic strips; instead he used his own artistic language to tell the story "Romance of the Three Kingdoms". The horses' in this inner painting are shown galloping and hurdling over swords and knives, creating a truly epic spectacle. The Red-Faced General uses his Dragon Stopping Moon Knife to force fully to push Cai Yang's big knife away . One can practically feel the tremors of the fight when admiring this piece. The two inner paintings are very detailed and precise, the smooth execution of each brushstroke is truly phenomenal. Very few works similar to this one exist in the world.

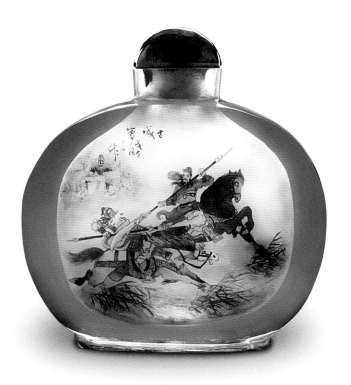 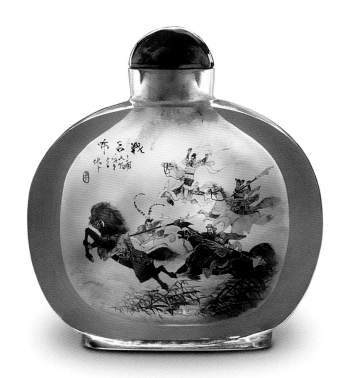

96. 武松

<u>高 8.8 厘米　腹宽 6.6 厘米</u>

<u>玻璃</u>

　　款识："武松。戊午夏一石作。"

　　武松打虎虽常见于连环画，作者在此以写意国画和水墨山水的方式，不落俗套的再现此民间故事，透视景深的远近处理，又是一般国画家常忽视的一环。这里妥善处理，使得山虎从远处奔向坐在巨石上的武松，看起来栩栩如生；另一面画中老虎逼近武松，咆哮跃起，经由远近层次和高超细腻的笔法，也显得活泼生动。此为作者一时兴起之作，后不曾再作，而成遗世精美孤品。

96. Wu Song

<u>Height 8.8 cm　Width 6.6 cm</u>

<u>Glass</u>

　　Marks: "Wu Song. Yi Shi signed in the summer of the year of WuWu."

　　Wu Song, a fictional character, is often seen beating a tiger in comic strips. The artist adopts free style Chinese painting and water-ink landscape painting techniques to show the folklore story in a unique manner, using western perspective techniques which are often neglected by Chinese artists. The artist uses a technique involving depth portrayal to illustrate the tiger running from the mountains in the distance towards Wu Song who sits atop a huge rock. This is an example of the artist's improvised artwork; the only one of its kind.

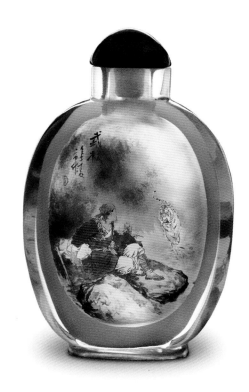
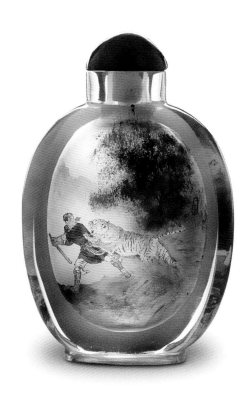

走
兽

Animals

97. 宁拙勿巧

高 7.7 厘米　腹宽 3.3 厘米

玻璃

　　此壶有二团扇书法、一扇面书法及二绘画，共五幅作品。

　　扇面书法"宁拙勿巧"，款识："一丁"；同面图画为猫戏飞虫，款识："一丁"；团扇书法"百折迂回向东去，江飞东流万里长，人今漂泊尚他乡，烟波草色时牵恨，风雨云烟霭苍茫，渔唱菱歌互短长"；款识："壬午夏一丁"。

　　另一面团扇书法"山中无一事，虚坐秋为水，静云彩空众，心正嘉许，山雨无晴天，烟霏朝夕来，摊书向何处"；款识："壬午三月

一丁"；同面图画为猫石图，款识："岁次壬午年夏月于兰亭阁。"

　　通壶典雅秀丽，是作者此类孤品。此壶画面安排按昔日较讲究的鼻烟壶，帧帧仔细着墨，并注重相对关系和最后呈现的整体效果。

97. Mindless over Mischievous

Height 7.7 cm　Width 3.3 cm

Glass

　　This bottle is comprised of five separate works, including two calligraphy pieces and three paintings. The calligraphy reads "Mindless over Mischievous", marks: "Yi Ding." The painting on the same side of the bottle shows a cat toying with a flying insect, marks: "Yi Ding." The calligraphy in the round window reads "Flowing to the east; a river stretches eastward for tens of thousands of miles; the traveler is staying in a foreign town; seeing the waves of green grass makes the traveler sad; wind, rain, and clouds obscure the scene; fishermen sing about water chestnuts;" marks: "Summer of the year of RenWu, Yi Ding."

　　The calligraphy in the other round window (also enlarged on the next page) reads phonetically "shan zhong wu yi shi xu zuo qiu wei shui jing yun cai kong zhong xin zheng jia xu shan yu wu qing tian yan fei zhao xi lai tan shu xiang he chu;" marks: "March of the year of RenWu." The painting on the same side of the bottle is of a cat and a stone, marks: "Summer month of the year of RenWu at LanTing Pagoda."

　　The bottle is elegant and is an exclusive work of its kind. The layout of this bottle is arranged according to the traditional and refined style of snuff bottles from the past; in this piece, the refined appearance is a result of precise coordination of the small windows.

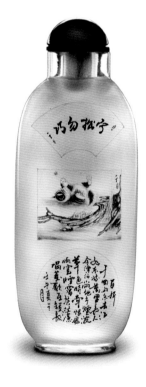
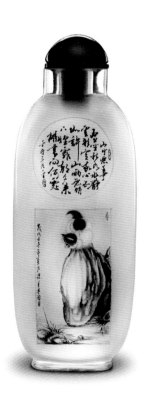

山中無事…静
雪里生新…忘心忘
云形空家心…山雨無晴
如許新霽鶴千朵
八望畫寒…
樓臺畫向何處
壬午三月丁

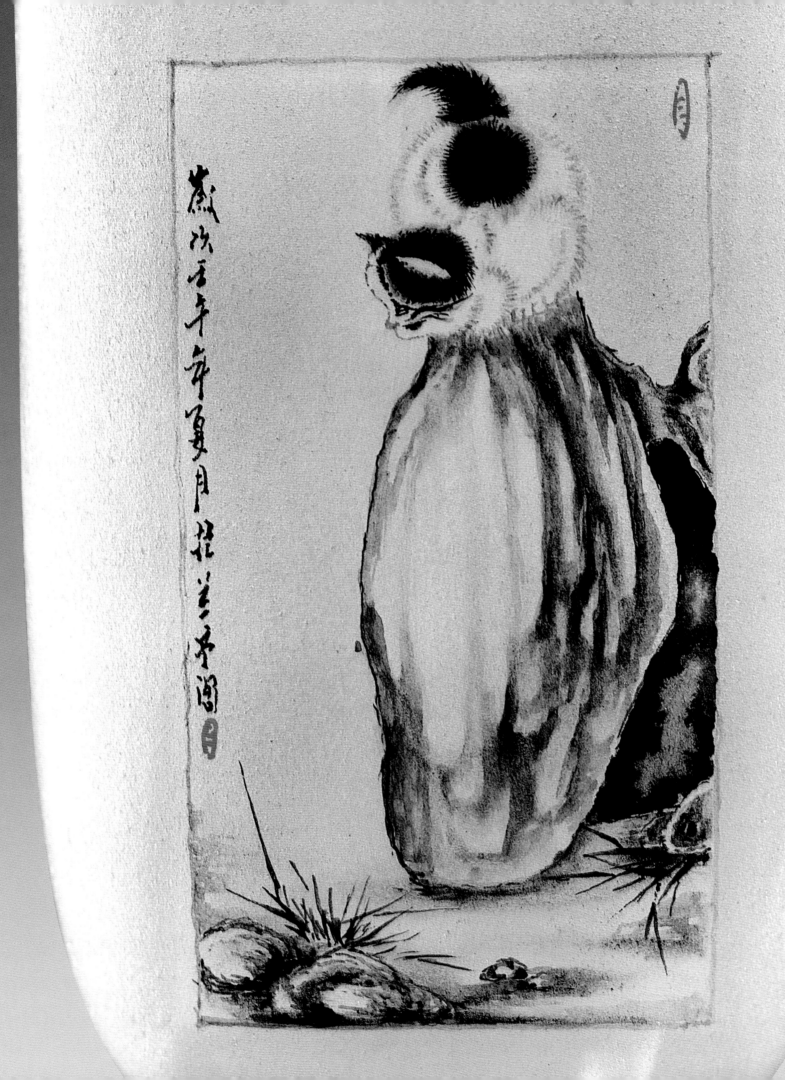

98. 狸奴

高 7 厘米　腹宽 3 厘米

玻璃

　　款识："师造化习古今名人。索振海一石作。"

　　此壶笔法的细腻自不在话下，但是此壶的构图，关键完全是在两面画中猫的神情和身形，猫追虫的专注，牵动着观画者的神经，扣人心弦。

98. Cat

Height 7 cm　Width 3 cm

Glass

　　Marks: "Learned from the natural world and studied the works of both ancient and contemporary masters, Suo Zhenhai Yi Shi painted."

　　The detailed brushwork in this bottle is beyond description; key factors of the layout for this bottle are the cat's appearance and gestures—the cat's concentration while chasing the insect is fascinating and effectively captures the viewer's attention.

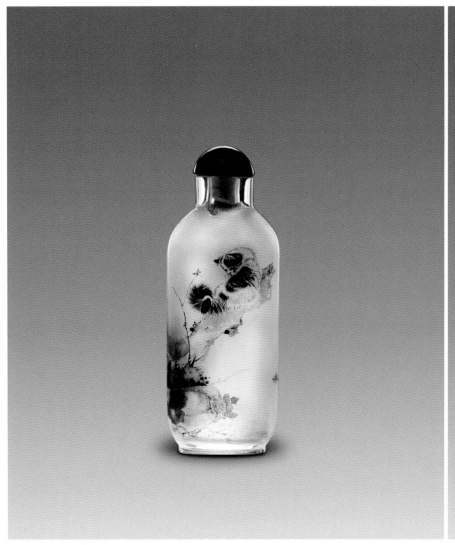

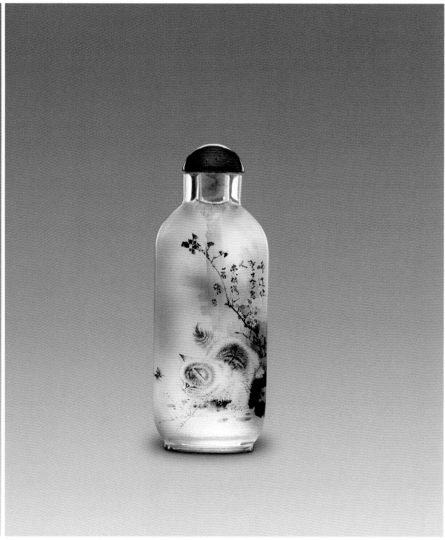

99. 二马

高 5.7 厘米　腹宽 5.5 厘米

玻璃

款识："仿唐人笔法。戊寅三月一石习。"

壶一面仿唐名画韩干牧马图，另一面仿唐人画双驹，皆属临摹上乘之作。此为作者仿作绝妙孤品。

99. Two Horses

Height 5.7 cm　Width 5.5 cm

Glass

Marks: "Imitated brushwork of the Tang Dynasty. Yi Shi imitated in March of the year of WuYin."

On one side of this bottle, the artist imitated a famous painting from the Tang dynasty: "Herding Horses" by Han Gan. The other side of the bottle is an imitation of a painting by an artist from the Tang dynasty. Both imitations are fine works of art and are considered the artist's exclusive and fine pieces on this subject matter.

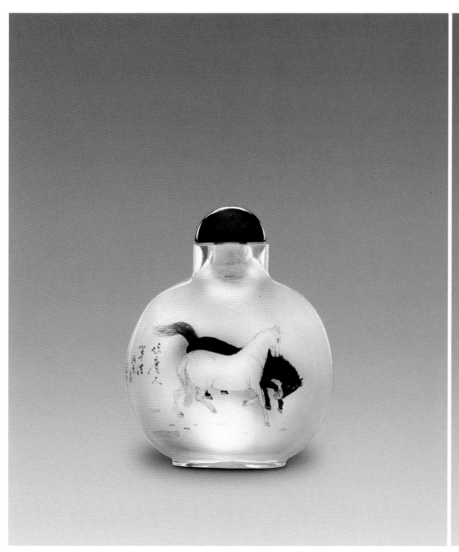

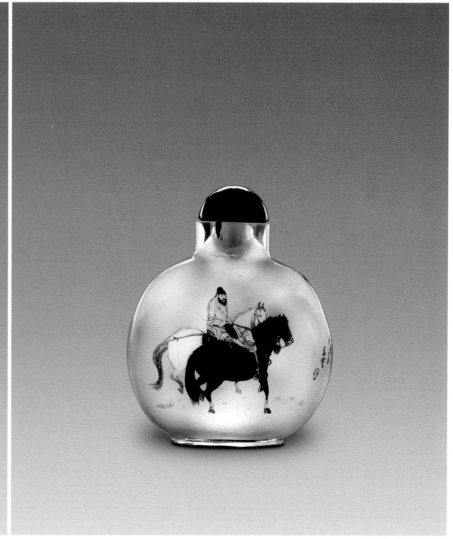

100. 双驹

高 7.2 厘米　腹宽 5.2 厘米

玻璃

款识："习清人笔法。戊午三月一石仿作。"

壶一面两马相依偎低头吃草，另一面两马厮发鬃摩亲昵，皆体态传神，临摹古人笔意到位。作者此题材作品仅有此件。

100. Two Horses

Height 7.2 cm　Width 5.2 cm

Glass

Marks: "Imitating brushwork of the Qing Dynasty. Yi Shi imitated in March of the year of WuWu."

On one side of this bottle is a painting of two horses grazing next to each other. On the other side of the bottle is a depiction of two horses rubbing against each other. Both paintings are realistic in their portrayals of the horses; they are excellent imitations of old paintings. This is the only bottle the artist painted of this subject matter.

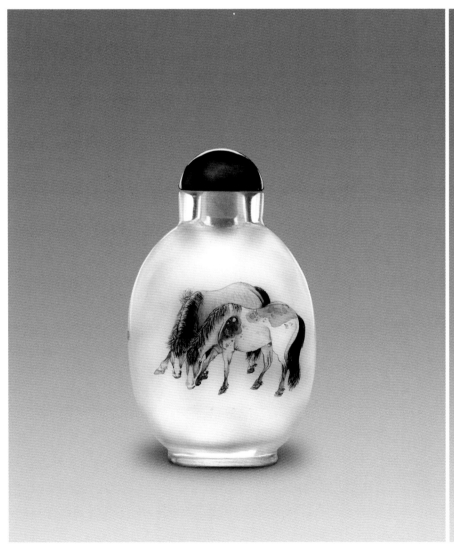
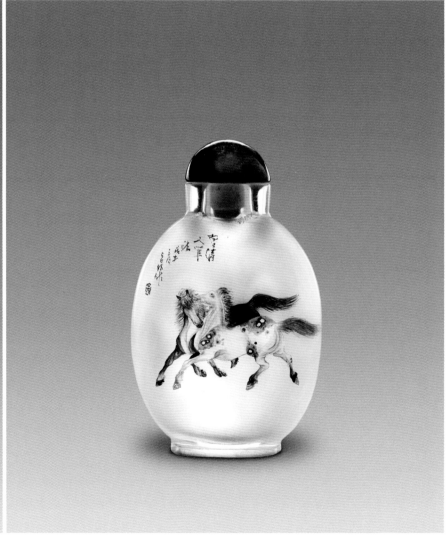

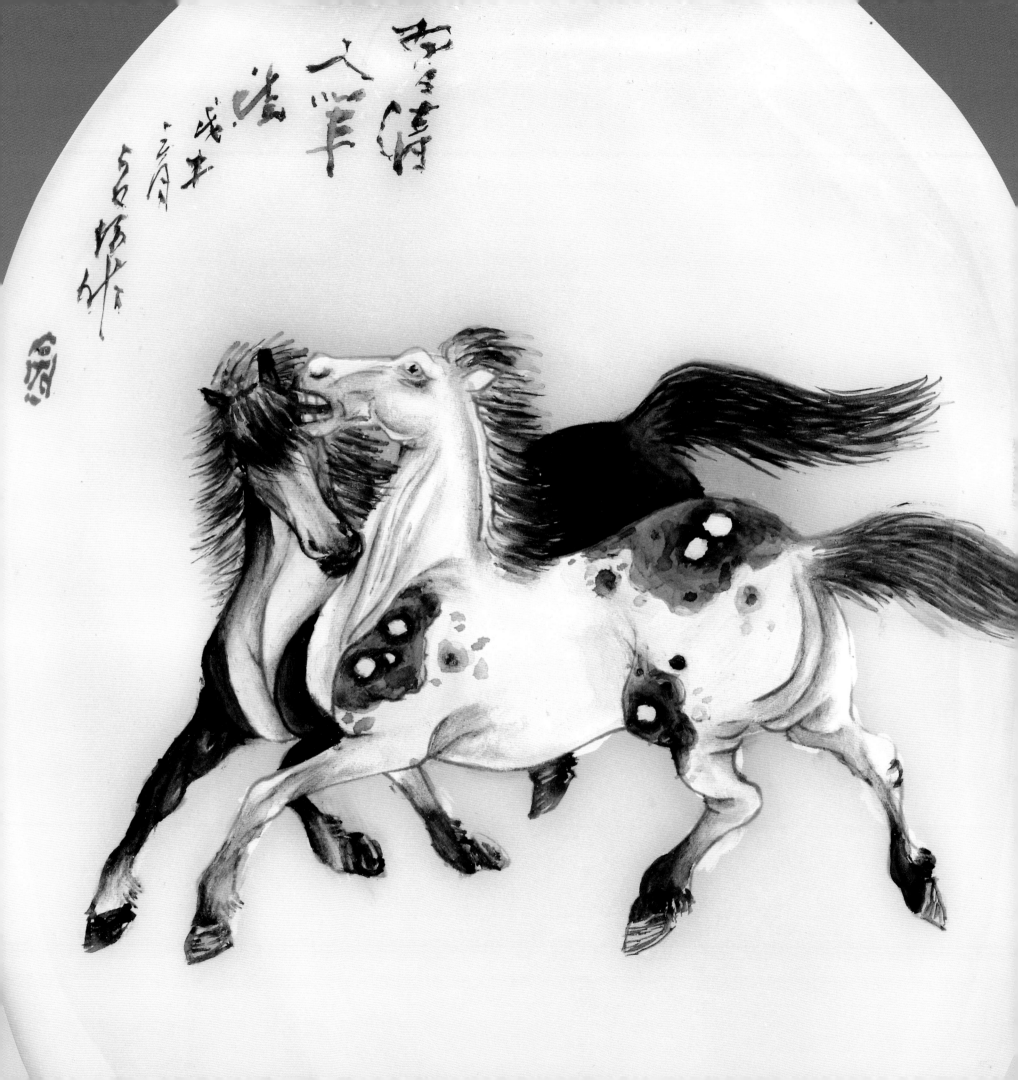

101. 飞龙夺珠

高 5.5 厘米　腹宽 6.8 厘米

玻璃

款识："戊午冬索振海一石作。"

作者时有个别生肖壶的作品，此作品为较精彩之作。龙飞腾云逐火珠，只以黑白浓淡造云深背景，蛟龙也以墨色勾勒，更显威武，红橘色的龙口、火球、飞焰成了焦点，牵动着整个画面。

101. Flying Dragon Pursuing a Ball of Flame

Height 5.5 cm　Width 6.8 cm

Glass

Marks: "Suo Zhenhai Yi Shi painted in the winter of the year of WuWu."

The artist paints bottles with individual zodiac animal from time to time, and this piece is his best on the subject. The dragon is shown flying on top of a cloud while pursuing a ball of flame. The background is painted in various shades of black and white and the dragon is outlined with black ink to emphasize its majestic appearance. The bright, red orange colored dragon mouth, fireball, and flames easily become the focal point of this artwork.

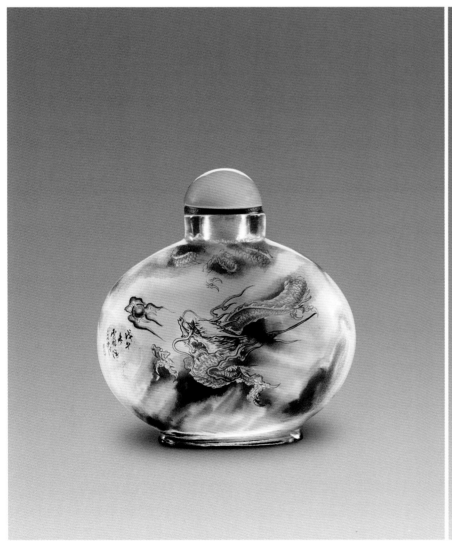
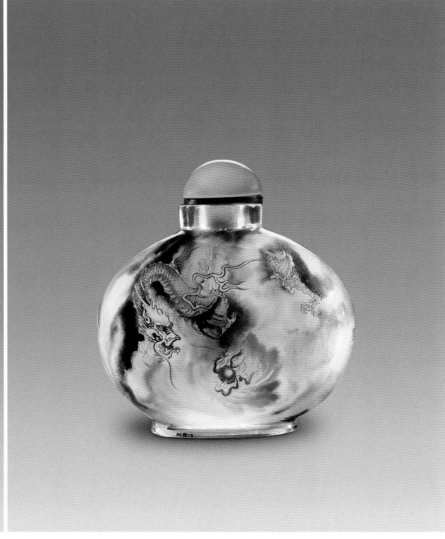

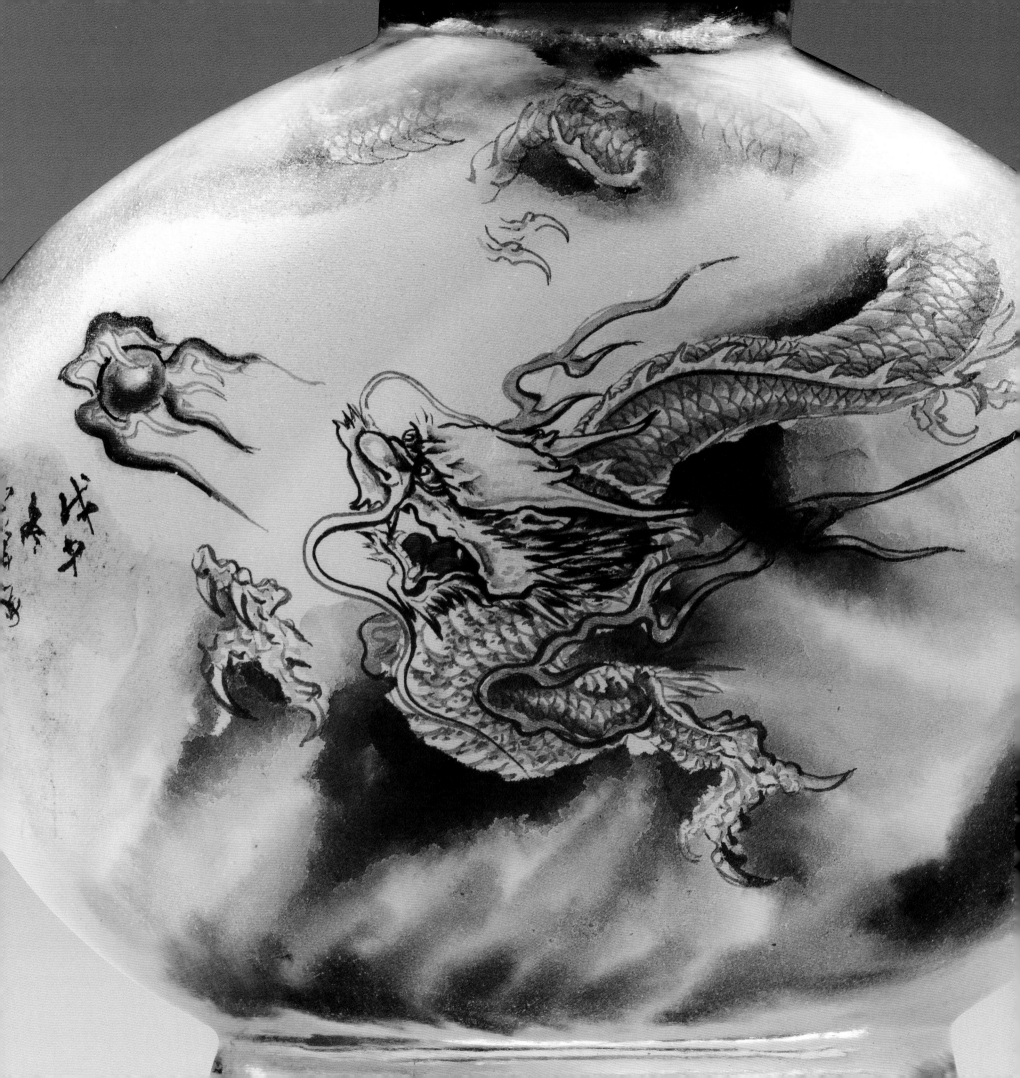

102. 松鼠

高 7.5 厘米　腹宽 6.5 厘米
玻璃

　　画家一般往往会较专注擅长于某一特定领域，如山水、人物、花鸟、动物、肖像；笔法偏重写实、写意或工笔，画风或古或今、或中或西。而作者作内画，有如生花妙笔，可粗可细，通古通今，能山水、能人物、能花鸟、能动物、也能肖像，且各种画作功夫样样不马虎，时有惊人之作。

　　此壶的松鼠图综合了工笔写实和写意花草背景，又在西方美学根基上添加东方的传统色调。松鼠的神气活现，马上触动了观者的感官反应，呼应着作者的敏锐观察力和纯熟的描绘能力。此精彩动物内画杰作，更加证明了作者全面的绘画能力。

102. Squirrels

Height 7.5 cm　Width 6.5 cm
Glass

Artists typically have a single area in which they specialize, such as landscape, human characters, flowers and birds, animals, or portraits. They might also specialize in a painting style: realism, traditional Chinese free-stroke style, or fine brushwork (detailed-painting) style; either western or Chinese, traditional or contemporary. This artist paints inner paintings with both bold strokes and detailed and precise strokes; he paints in the traditional style and contemporary styles; he is comfortable in painting landscapes, human characters, flowers and birds, animals, and portraits; he is artistically gifted and exceptionally good at everything in his craft. Almost everything he produces is a masterpiece.

The squirrels in this bottle are the combined creation of fine brushwork (detailed-painting), realism, and traditional free stroke styles. The artist also employs both western painting styles and oriental color tones. The squirrels' proud demeanor is conveyed effectively to the viewer. This outstanding portrayal of an animal is just one example of the artist's comprehensive painting ability.

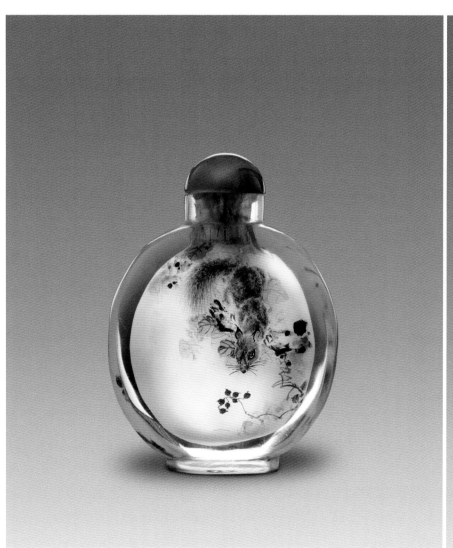
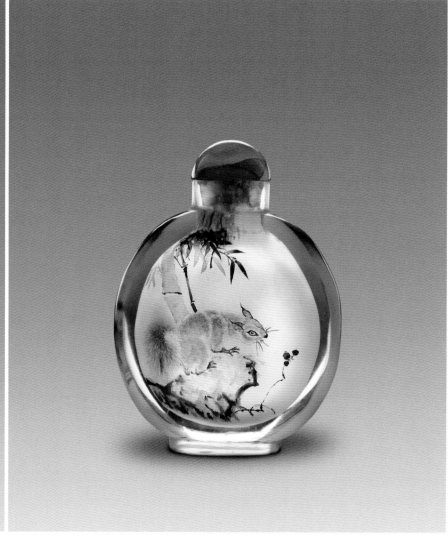

103. 双鼠

高 8.5 厘米　腹宽 6 厘米

玻璃

款识："丁亥冬月一石作于京门。"

不同于山水的着重整体观感，动物是内画中当然的主角。此壶中两对松鼠的互动，牵引着观画者的目光，似乎活生生地诉说彼此的巧妙关系，或依偎相靠，或驻足凝视。仔细瞧，才又进一步发现，原来松鼠毛茸茸的质感来自一毛一毫的工夫。

103. Two Squirrels

Height 8.5 cm　Width 6 cm

Glass

Marks: "Yi Shi painted at Jing Gate in a winter month of the year of DingHai."

While landscapes focus on conveying an overall mood or atmosphere, portrayals of animals are different in that they usually focus on a single subject (the animal) within the painting. The interactions between the two pairs of squirrels easily capture the viewer's attention. The painting brings the squirrels to life, making you aware of their subtle relationships as they lean against each other or pause to stare. The viewer might notice that the squirrels' furry appearance is the result of the artist's detailed brushworks.

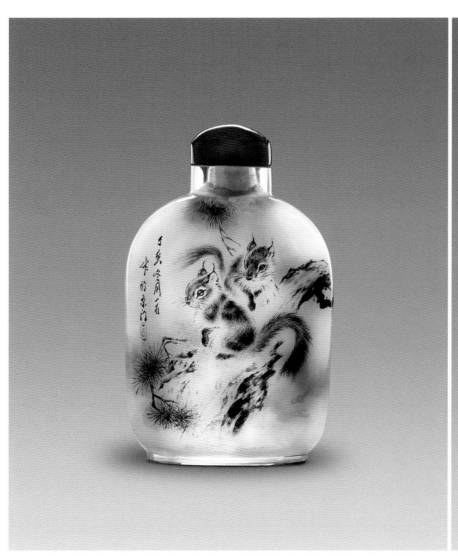
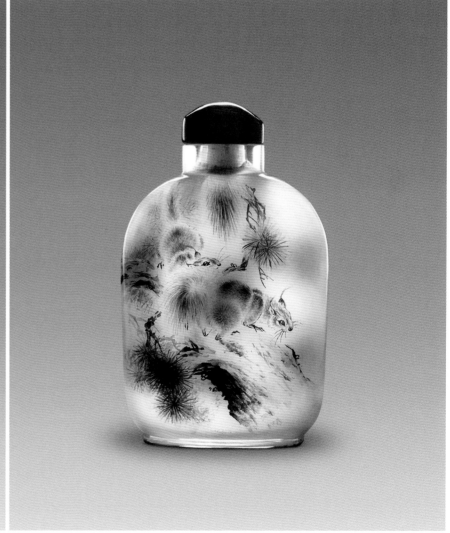

104. 山猫

高 7.8 厘米　腹宽 8.7 厘米

玻璃

　　山猫题材不常见于国画或内画中，作者以其纯熟的画技，凸显出山猫的矫捷灵巧，体态可爱及毛色自然柔美；尤其毛发的层次感和细腻，是动物内画神乎其技的最佳佐证。作者同题材作品只此一件。

105. Mountain Cat

Height 7.8 cm　Width 8.7 cm

Glass

　　Mountain cats are seldom used as subjects in traditional Chinese paintings. The artist uses his marvelous painting skills to convey the mountain cat's agility, poise, and the texture of the animal's natural soft fur. This is an incredible piece of work, and the artist only has one artwork of this kind.

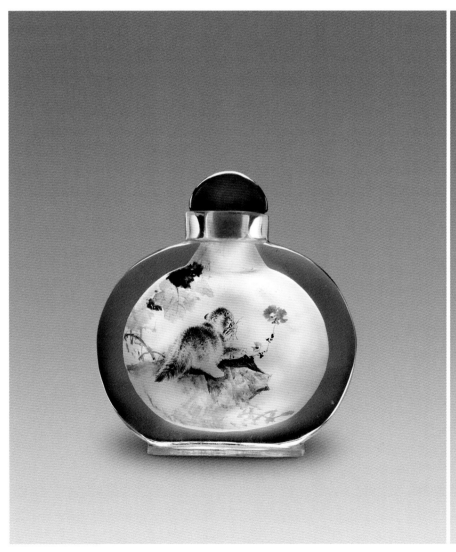

105. 雄风

高 9 厘米　腹宽 7.8 厘米

玻璃

款识："雄风。辛丑三月下浣索振海一石作于津门。"

另一面款识："一石作。"

万兽之王一般不出现在国画中。作者才情洋溢，心中双狮影像随笔拈来，活生生的、精神奕奕的出现在中国画的景致中，雄姿昂然，又古意盎然，亦是难得雅致精品。

104. Majestic

Height 9 cm　Width 7.8 cm

Glass

Marks: "Majestic. Suo Zhenhai Yi Shi painted at Jing Gate in late March of the year of XinChou."

The other side marks: "Yi Shi painted."

The lion, king of all animals, is not a common subject for traditional Chinese paintings. The artist is so talented; he was able to paint the image of two lions with relative ease. These paintings are brilliant works of art that exude the scholarly essence of traditional Chinese painting. This is truly an exquisite piece of work.

106. 林中之王

高 8.5 厘米　腹宽 6 厘米

玻璃

款识："一石作。"

壶中狮的无畏经画家的诠释，以狮子们状似悠哉的神态自若，无所惧，透过炯炯眼神，摄人神魄，也主宰着观画者的目光，令人望之生畏。

优秀画家能巧妙地搭起画内画外之间的感染力通道，达到作者欲达到的效果。

106. King of the Forest

Height 8.5 cm　Width 6 cm

Glass

Marks: "Yi Shi painted."

The lion's fearlessness is conveyed through bold and carefree brushstrokes. The animal's ferocity and power is evident in its eyes and easily attracts the attention of viewers.

This painting bridges the effects created inside the bottle and the feelings of fear viewers might experience during an encounter with the king of the forest.

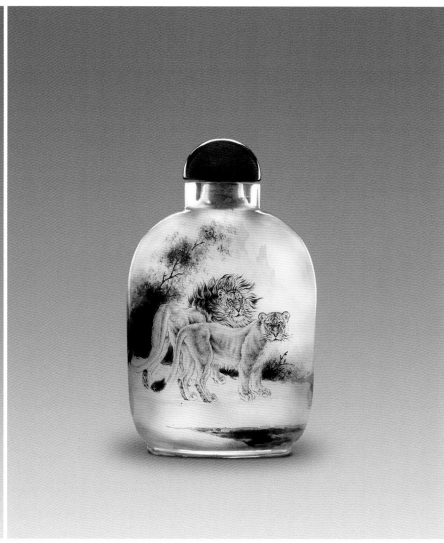

107. 寒林双虎

高 8.7 厘米　腹宽 8.3 厘米

玻璃

款识："丁亥冬十月下浣一石作。"

此壶一面画双虎踌躇睨视，不可一世，望之生畏，加上淡墨轻描背景衬托，更烘托出双虎主人翁的中心地位；壶另一面画二虎咆哮怒视，似乎剑拔弩张，也衬着淡墨雪景，更显画面张力。

107. Two Tigers in a Freezing Forest

Height 8.7 cm　Width 8.3 cm

Glass

Marks: "Yi Shi painted in winter late October of the year of DingHai."

One side of this bottle portrays two tigers staring with questioning eyes as if to pose a challenge; they seem to consider themselves to be a world above all others. The light-ink backdrop of the painting emphasizes the tigers as the focal point of the artwork. The other side of the bottle pictures two tigers snarling with anger, ready to fight. The light-ink backdrop contributes to the tension in the picture.

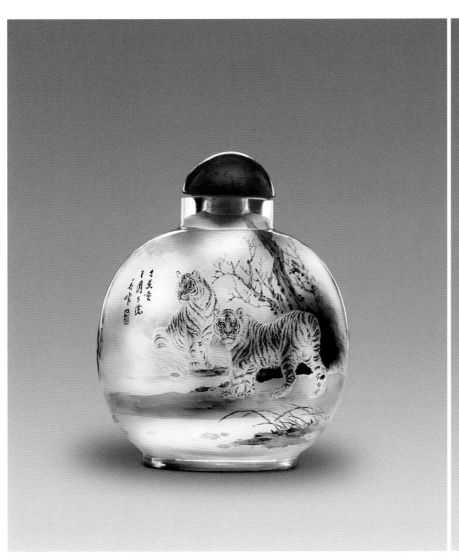
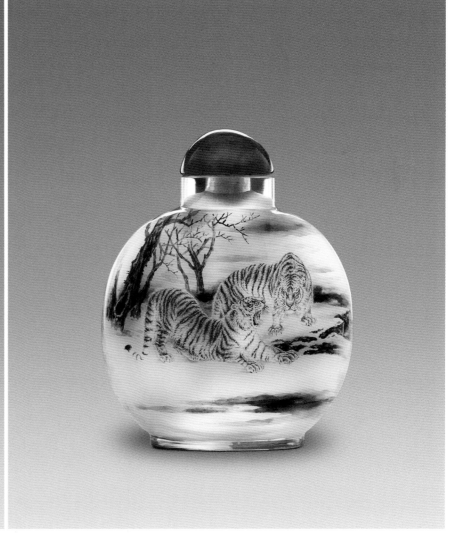

108. 塞雪双雄

高 5.5 厘米　腹宽 6.3 厘米

玻璃

　　款识："塞雪双雄。一石作。"

　　另一面款识："伴侣。丙戌七月一石作。"

　　老虎是不易表达的美丽动物，因为画虎的难度高，不乏专攻画虎的画家。但要画得传神，虎虎生威，又是画者梦寐以求的。作者不但作到了，还以内画方式来表达的。

108. Two Tigers at the Snow Covered Border

Height 5.5 cm　Width 6.3 cm

Glass

　　Marks: "Two Tigers at the Snow Covered Border, Yi Shi painted."

　　The other side marks: "Companionship. Yi Shi painted in July of the year of BingWu."

　　Tigers are beautiful animals and are not easy to paint. However, for this very reason, many artists seek to specialize in painting these symbolic creatures. All of them strive to paint vivid and majestic tigers in their paintings. This artist did an exceptional job through the art of inner painting.

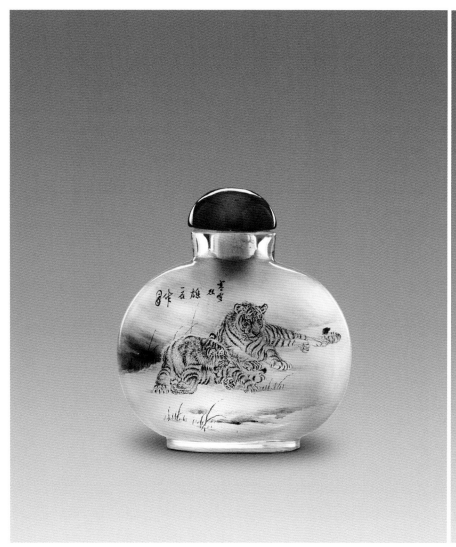
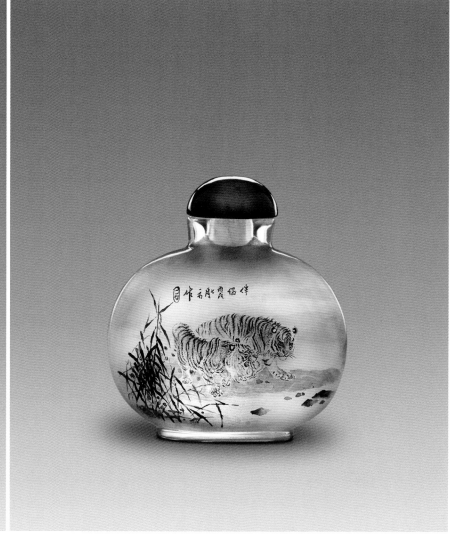

109. 松林象吼

高 5.8 厘米　腹宽 4.8 厘米

玻璃

　　作者不畏尝试新题材，以小壶作画庞然大象，不生硬，不拘泥于一种方式。主以国画笔法辅以西画技法，画成两幅动态大象的内画作品；一象仿佛前进中，一象仿佛仰首着。小品中见大家风范，亦是此题材唯一作品。

109. Elephants Trumpeting in a Pine Forest

Height 5.8 cm　Width 4.8 cm

Glass

　　With this bottle, the artist took a risk and painted a subject he had not worked with before; he chose to paint elephants in a tiny bottle. The artist uses Chinese traditional painting techniques combined with some elements of western techniques to produce two inner painting artworks portraying elephants—one walking and the other one standing with its face turned towards the skies. Viewers see incredible detail and the unique style of a master when they look at this piece. This bottle is the artist's only one on this subject matter.

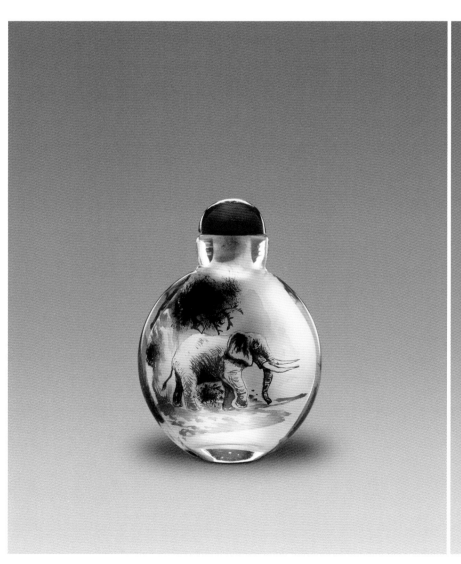
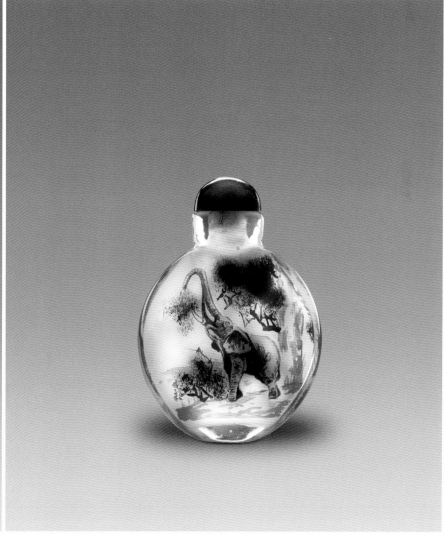

110. 冬

高 9 厘米　腹宽 6.3 厘米

玻璃

　　款识: "冬。丙辰冬十一月索振海一石作。"

　　壶体两边侧雕有兽面环。壶主要画面为工笔细钩的大树，展现出凄凉枯冬的气氛，灵巧的狐狸小心翼翼地蹑近不设防的孤鹤，牵动了冬天危机重重的感触；壶另一面工笔绘枯树葫芦，羚羊斗顶，扩散了深冬易燥的心境。这都是作者透过艺术语言描述冬天魅力的精品，同时也是独件绝品。

110. Winter

Height 9 cm　Width 6.3 cm

Glass

　　Marks: "Winter. Suo Zhenhai Yi Shi painted in November of the year of BingChen."

　　The two narrow sides of this bottle have animal head carvings. The artist used fine brushstrokes to carefully outline a big tree that occupies the majority of this inner painting. An agile fox carefully stalks a lone crane, creating a suspenseful and dangerous atmosphere. On the other side of the bottle, the smooth and refined brushstrokes used to paint the tree and squash in the background contrast the tension in the image of the two brawling antelopes in the foreground. This bottle is an exquisite and exclusive work; the artist employed artistic language to convey the charm of the winter season.

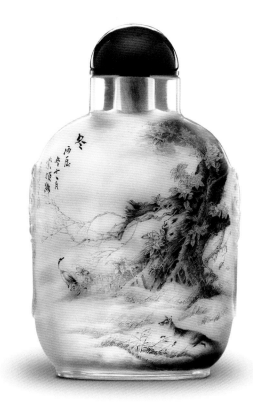
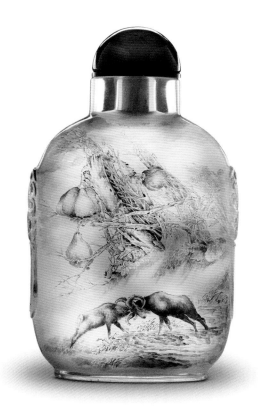

111. 犬追蝶

高 8 厘米　腹宽 8.5 厘米

玻璃

　　图中哈巴狗目不转睛的盯着飞蝶，全身肌肉紧张，蓄势待发。再细看小犬毛发绵密，色彩层次丰富，黑白相间，富于变化，灰黑中又带斑白，光是它的色调搭配和肢体语言，已臻出神入化；壶另一面画拙憨的两幼犬相依偎着，惹人爱怜的眼神，很容易抓住观众的心。整个画面，生动逼真。

111. A Dog Playing with a Butterfly

Height 8 cm　Width 8.5 cm

Glass

　　In this painting, a pup is staring at a butterfly with every muscle in its body tense, ready to pounce on the butterfly at any moment. If one looks closely at the dog's hair, one will notice the thick, rich layering of the paint, alternating between black and white – hints of white appearing in areas of grey and vice versa. The colors match together beautifully, and the artist's treatment of the pup's movements in a still painting is superb. On the other side of the bottle, two clumsy pups are leaning against each other; their heartwarming gazes will undoubtedly move those admiring this piece.

112. 伴

高 7.8 厘米　腹宽 8.7 厘米

玻璃

款识："伴。壬午三月一石作。"

猎犬英姿勃发，眼神忠实，鬃毛细密有致，模样讨人喜欢。作者讲求整体感觉，从最细微的毛发，笔笔用心，慢慢地、认真地组织起画面。

112. Companion

Height 7.8 cm Width 8.7 cm

Glass

Marks: "Companion. Yi Shi painted in March of the year of RenWu."

The hunting dogs in this painting are portrayed handsomely; their eyes resemble those of loyal fighters. Their furs appear smooth and well groomed, each distinct strand of hair painted with precision and care. The artist was striving for a holistic impression, the result of all the individual brushstrokes combined.

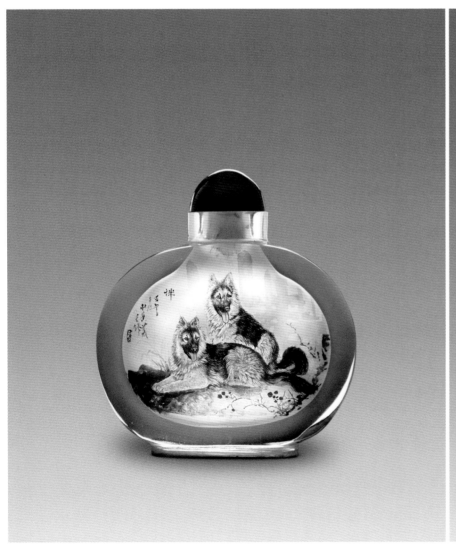
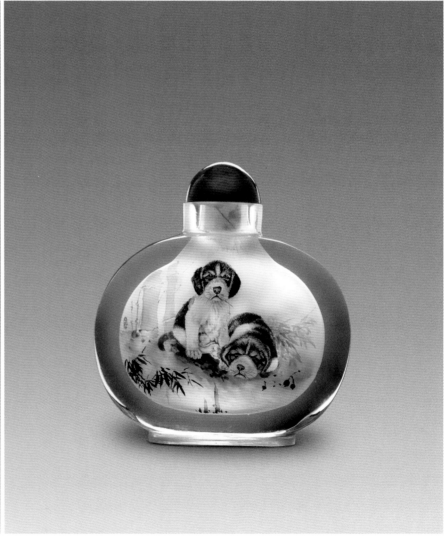

113. 犬相

高 6.7 厘米　腹宽 5.2 厘米
玻璃

款识："戊寅二月上浣索振海一石作。"

此壶形特别。作者以哈巴狗回身形象，正能衬着香水瓶似的烟壶，神情凄哀，似人表情。回首驻足亦非犬之常态，此画颇有拟人化，动物有情之作。

113. Image of a Dog

Height 6.7 cm　Width 5.2 cm
Glass

Marks: "Suo Zhenhai Yi Shi painted in early February of the year of WuYin."

This bottle has a unique shape; it resembles the shape of a perfume bottle. The position in which the Beijing pup is sitting allows the pup's figure to complement the distinct shape of the snuff bottle. Artists do not typically depict dogs with their back turned; however, this position was picked to best fit the bottle in which the dog is painted. Its sad expression is almost humanlike.

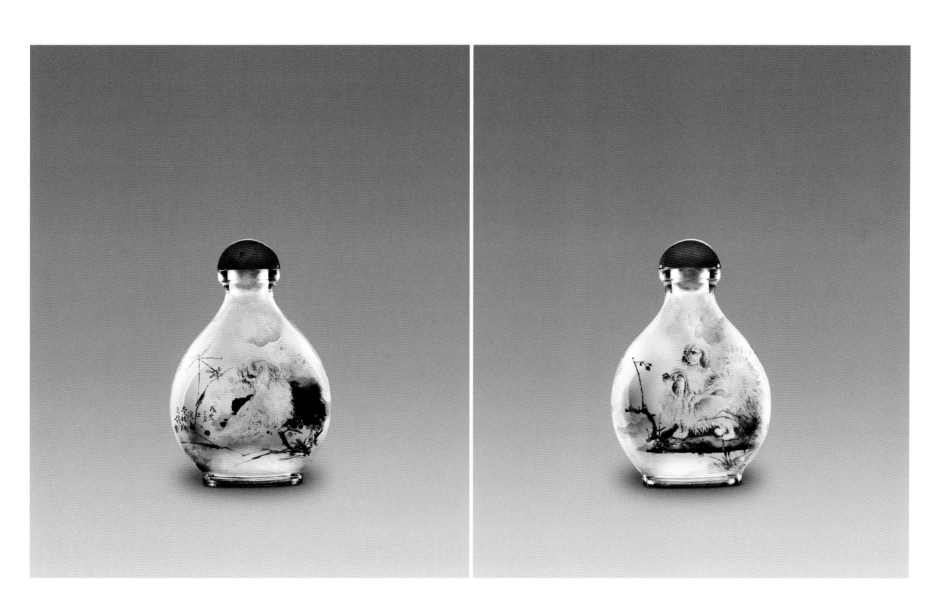

114. 猴戏人生

高 8.5 厘米　腹宽 6 厘米

玻璃

款识："丁亥冬十月下浣一石作于京师。"

此内画作品是作者的典型截景山水动物。值得一提的是，其动物非呆板的静物，常常彼此间有互动，似有情节的生态描述。壶一面一猴向着长猴诉说着，而长猴认真的听着；另一面双猴同望远处，仿佛同被一件事物吸引着。

114. Playful Lifestyle of the Monkey

Height 8.5 cm　Width 6 cm

Glass

Marks: "Yi Shi painted at Jing Du in October of the year of DingHai."

This inner painting is a typical partial landscape, partial animal portrayal piece. It is worth mentioning that the animals painted by the artist's are never stiff and still objects. They often portrayed interacting with one another in a way that tells a story. On one side of the bottle, a young monkey is communicating with an elder monkey; the other side of the bottle pictures two monkeys gazing into the distance, both seemingly attracted by the same subject .

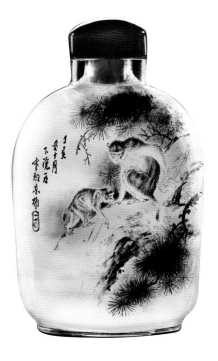

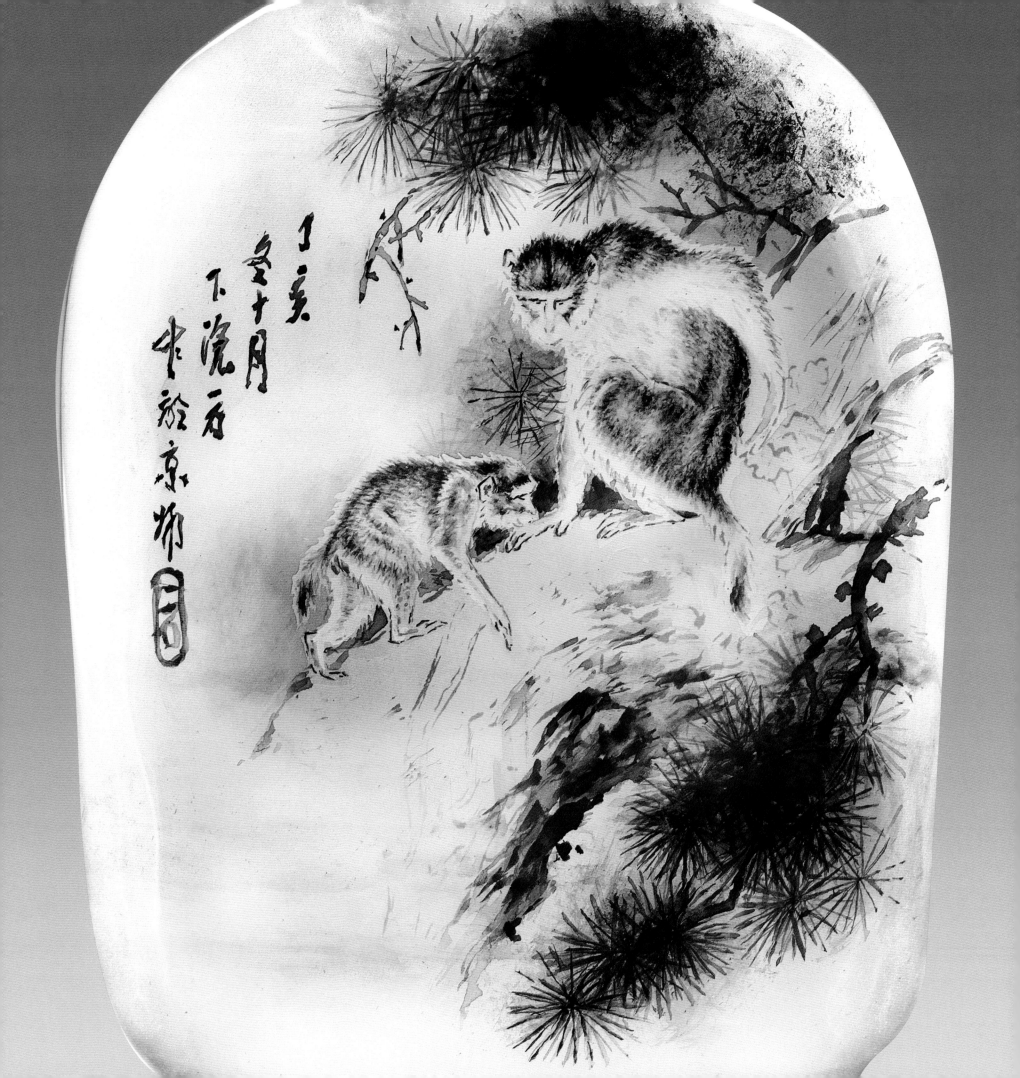

115. 十二生肖 （一组十二个）

高 7 厘米　腹宽 3 厘米

玻璃

鼠壶款识："子鼠。丁丑春月索振海一石作于津南古城"；

牛壶款识："丑牛。丁丑春月索振海一石作于津南古城后房"；

虎壶款识："寅虎。丁丑春月一石索振海作"；

兔壶款识："卯兔。丁丑夏月索振海一石作于津南古城"；

龙壶款识："辰龙。丁丑夏日索振海一石作于津南古城"；

蛇壶款识："巳蛇。丁丑夏月索振海一石作"；

马壶款识："午马。丁丑秋月索振海一石作于津南古城"；

羊壶款识："未羊。丁丑秋索振海作于津南古城"；

猴壶款识："申猴。丁丑秋八月索振海一石作于津南古城"；

鸡壶款识："丙鸡。丁丑冬月一石索振海作于津南古城"；

狗壶款识："戊狗。丁丑冬月索振海一石作"；

猪壶款识："亥猪。丁丑冬十月一石索振海作于津南古城。"

无论用何标准创作十二生肖图，不落俗套，图图生动雅致都是不易之事。这组壶正反两面各有一形貌不同的生肖图，二十四幅画中之生肖动物皆活灵活现，跃然壶上，更属大师之作。目前存世完整的十二生肖组壶仅有两套。此组壶用壶小巧精致，另一套组壶用壶大器些，两组壶皆收录于此。

115. Zodiac Animals Series

(A Set of 12 Slender Bottles)

Height 7 cm　Width 3 cm

Glass

Mouse bottle marks: "Zi mouse. Suo Zhenhai Yi Shi painted at the south of Jing Old Town in a spring month of the year of DingChou;"

Cow bottle marks: "Chou cow. Suo Zhenhai Yi Shi painted at the back room of the south of Jing Old Town in a spring month of the year of DingChou;"

Tiger bottle marks: "Yin tiger. Suo Yi Shi painted in the year of YiChou;"

Rabbit bottle marks: "Mao rabbit. Suo Zhenhai Yi Shi painted at the south of Jing Old Town in a summer month of the year of DingChou;"

Dragon bottle marks: "Chen dragon. Suo Zhenhai Yi Shi painted at the south of Jing Old Town in a summer day of the year of DingChou;"

Snake bottle marks: "Si snake. Suo Zhenhai Yi Shi painted in a summer month of the year of DingChou;"

Horse bottle marks: "Wu horse. Suo Zhenhai Yi Shi painted at the south of Jing Old Town in an autumn month of the year of DingChou;"

Goat bottle marks: "Wei goat. Suo Zhenhai painted at the south of Jing Old Town in an autumn August of the year of DingChou;"

Monkey bottle marks: "Shen monkey. Suo Yi Shi painted in an autumn month of the year of DingChou;"

Chicken bottle marks: "Bing chicken. Yi shi Suo Zhenhai painted at the south of Jing Old Town in a winter month of the year of DingChou;"

Dog bottle marks: "Wu dog. Suo Zhenhai Yi Shi painted in a winter month of the year of DingChou;"

Pig bottle marks: "Hai pig. Yi Shi Suo Zhenhai painted at the south of Jing Old Town in a winter October of the year of DingChou."

Painting the twelve symbolic zodiac animals with such elegance is no easy task. Each bottle in this series depicts a different zodiac animal. The two sides of a bottle portray the animal in two different ways. The paintings of the twenty-four animals in this set are all vivid and life-like, making this series a true masterpiece. There are only two complete sets of the zodiac animal series painted by the artist. This set uses slender bottles and the other set uses larger sized bottles; both sets can be found in this book.

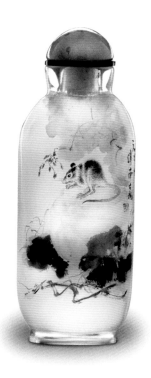
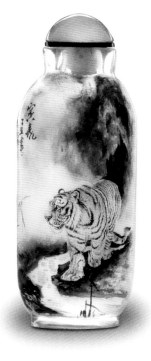
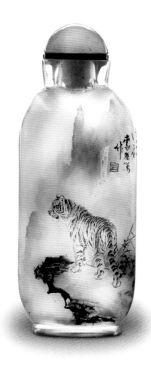
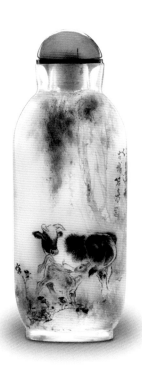
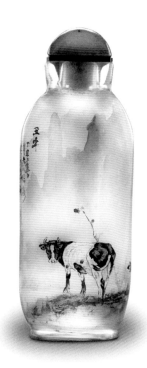
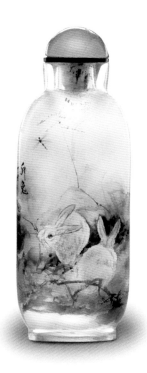
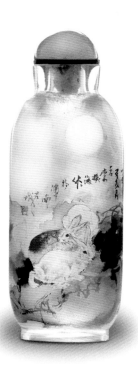

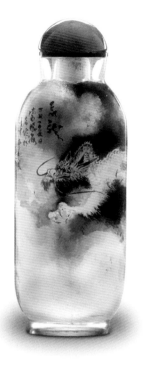
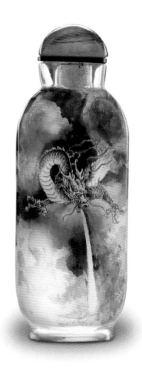
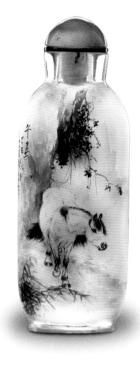
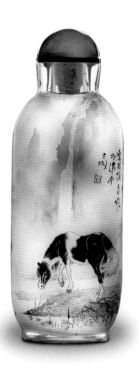
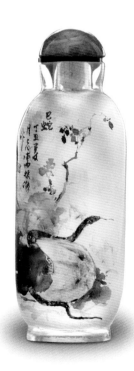

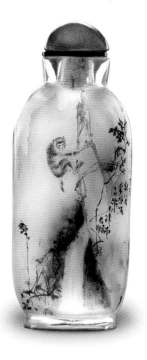
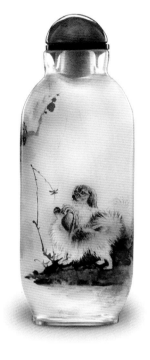
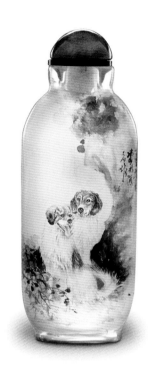

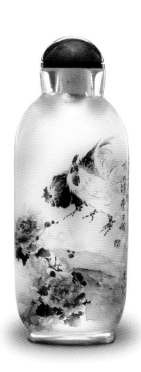

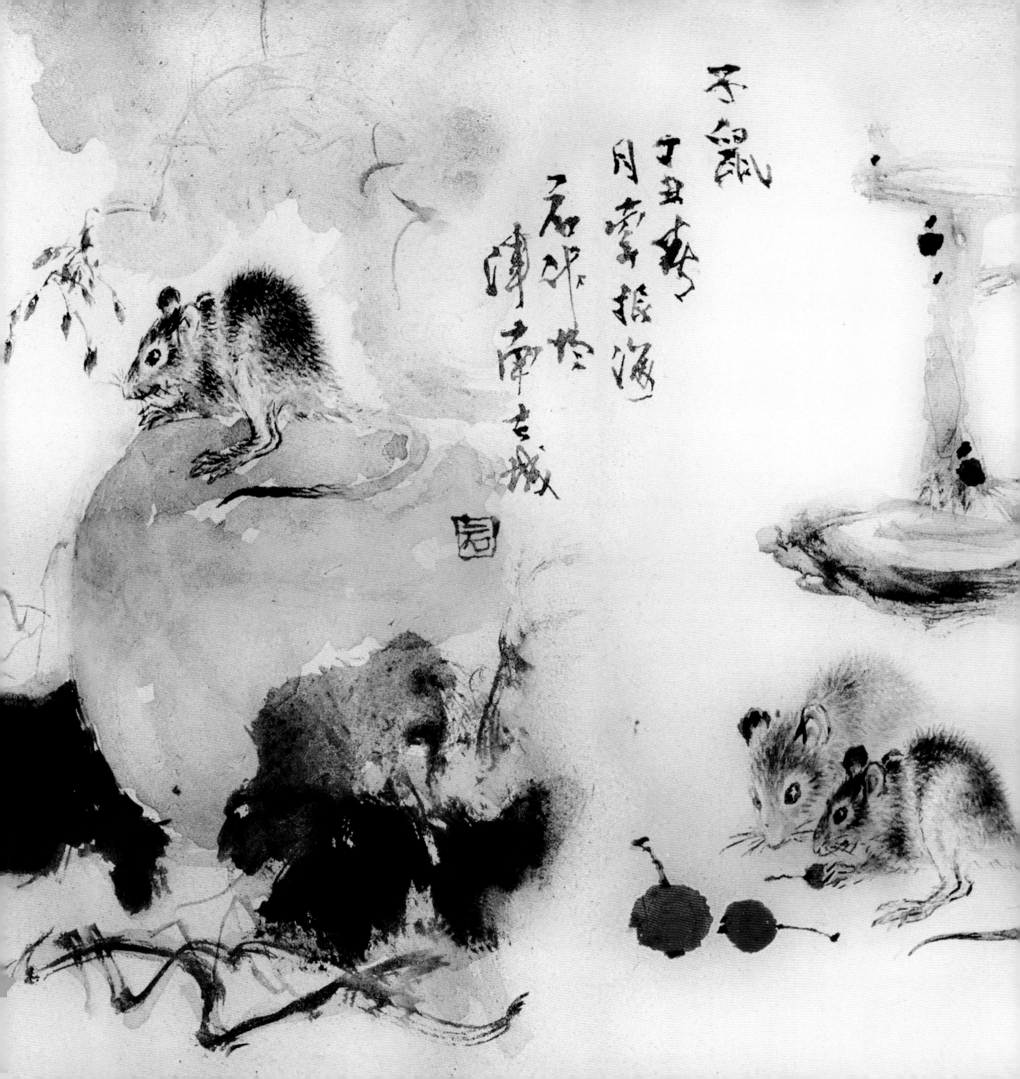

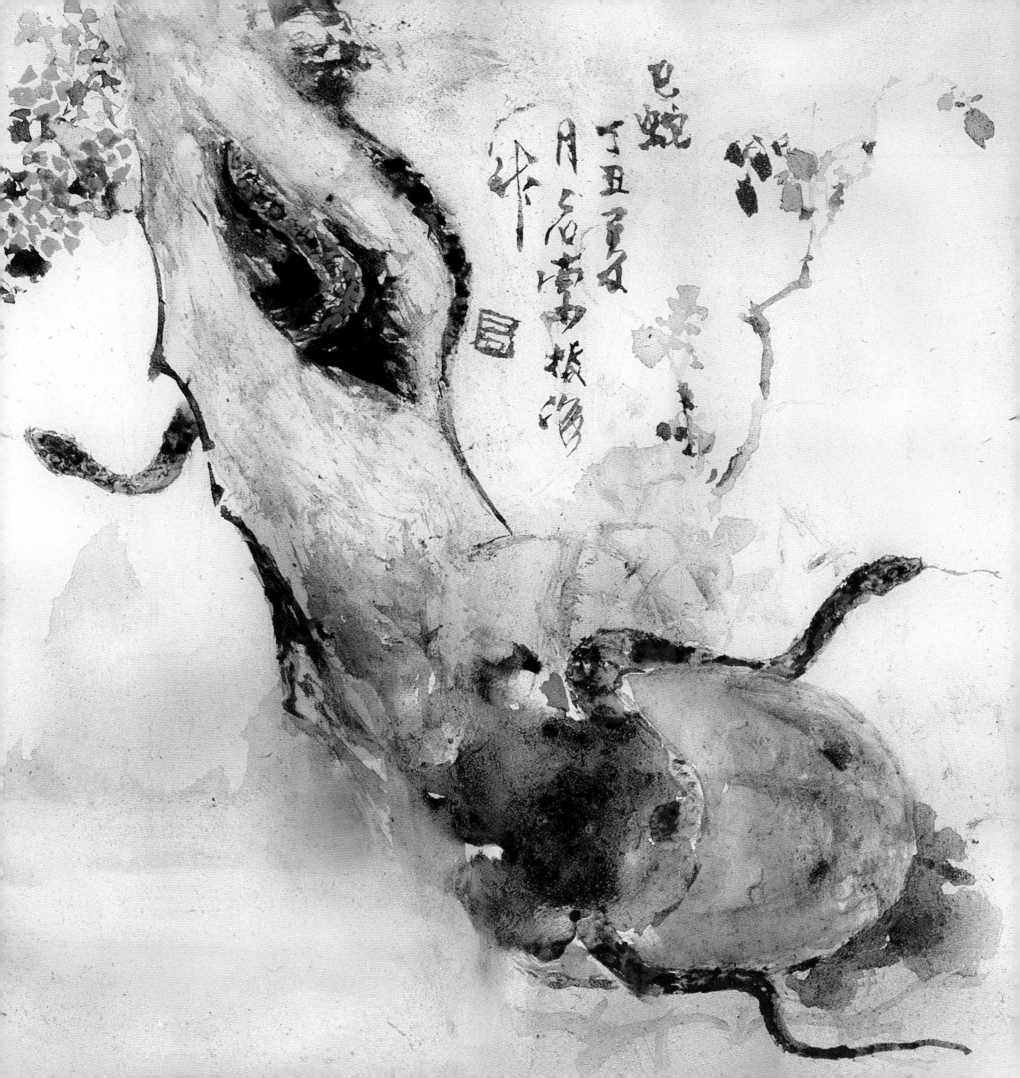

116. 十二生肖（一组十二个）

高 7 厘米　腹宽 5.5 厘米

玻璃

鼠壶款识："子鼠。乙酉索一石作"；

牛壶款识："丑牛。乙酉八月索一石作"；

虎壶款识："寅虎。乙酉索一石作"；

兔壶款识："卯兔。乙酉索一石作于京城"；

龙壶款识："辰龙。乙酉秋月索一石作"；

蛇壶款识："巳蛇。戊午夏月索一石作"；

马壶款识："午马。乙酉夏月索一石作"；

羊壶款识："未羊。乙酉夏月索一石作"；

猴壶款识："申猴。乙酉夏月索一石作"；

鸡壶款识："丙鸡。乙酉秋月索一石作"；

狗壶款识："戊狗。乙酉秋月索一石作"；

猪壶款识："亥猪。乙酉索一石作。"

116. Zodiac Animals Series

(A Set of 12 Slender Bottles)

Height 7 cm　Width 5.5 cm

Glass

Mouse bottle marks: "Zi mouse. Suo Yi Shi painted in the year of YiYou;"

Cow bottle marks: "Chou cow. Suo Yi Shi painted in August of the year of YiYou;"

Tiger bottle marks: "Yin tiger. Yi Shi painted in the year of YiYou;"

Rabbit bottle marks: "Mao rabbit. Yi Shi painted at Jing Town in the year of YiYou;"

Dragon bottle marks: "Chen dragon. Suo Yi Shi painted in an autumn month of the year of YiYou;"

Snake bottle marks: "Si snake. Suo Yi Shi painted in a summer month of the year of WuWu;"

Horse bottle marks: "Wu horse. Suo Yi Shi painted in a summer month of the year of YiYou;"

Goat bottle marks: "Wei goat. Suo Yi Shi painted in a summer month of the year of YiYou;"

Monkey bottle marks: "Shen monkey. Suo Yi Shi painted in a summer month of the year of YiYou;"

Chicken bottle marks: "Bing chicken. Yi Shi painted in an autumn month of the year of YiYou;"

Dog bottle marks: "Wu dog. Suo Yi Shi painted in an autumn month of the year of YiYou;"

Pig bottle marks: "Hai pig. Yi Shi painted in the year of YiYou."

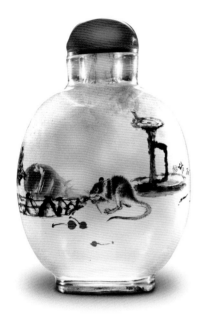
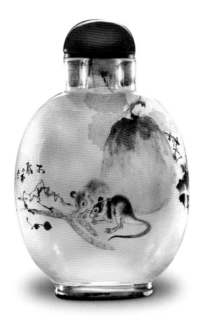
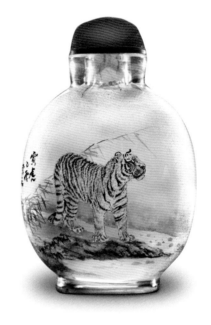
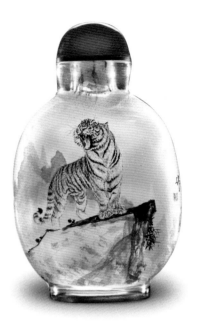
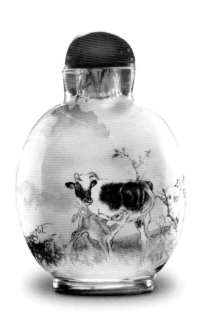
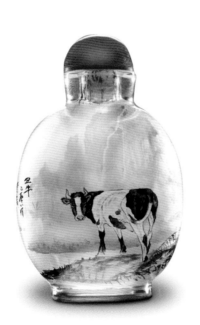
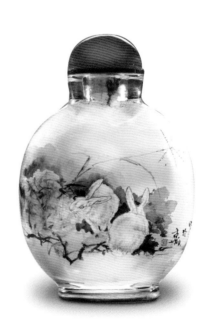
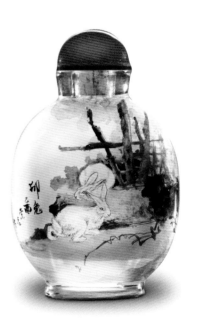

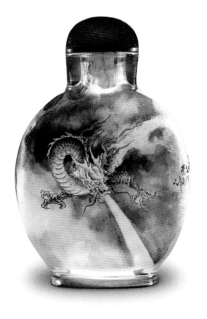

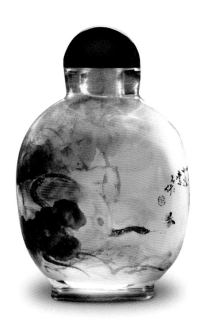
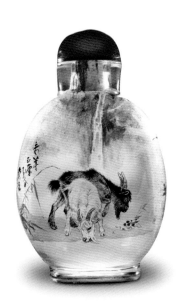
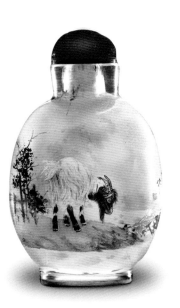

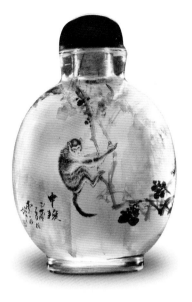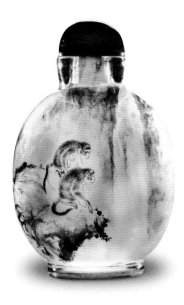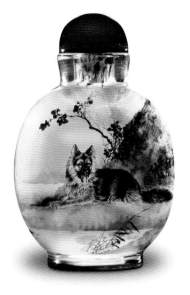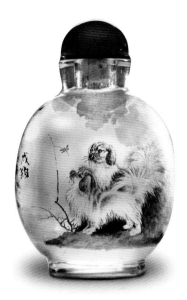

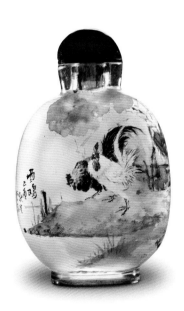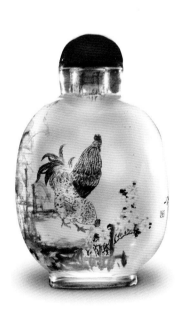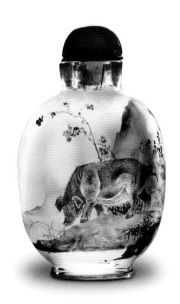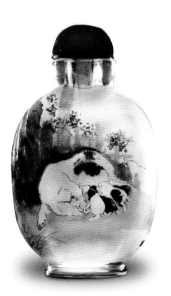

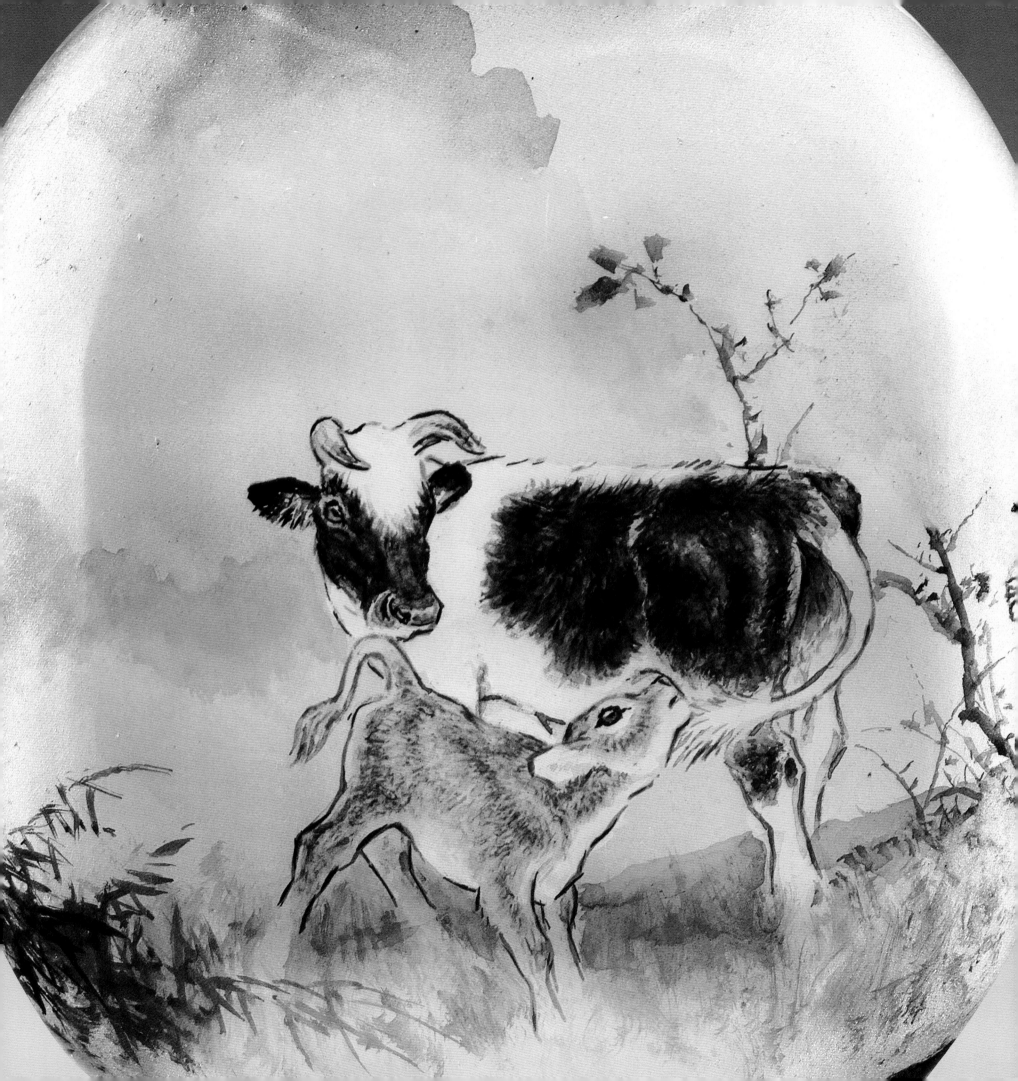

仿古 Imitation of
Ancient Master Pieces

117. 彩蝶

高 7.7 厘米　腹宽 3.3 厘米

玻璃

款识："乙丑冬日作。"

另一面款识："乙丑冬月。百样精神百样春，小园深处静无尘，笔花妙得天然趣，不是寻常梦里人。乙丑马少宣。"

此壶型特别，彩蝶素雅清丽，适当留白，有静空无杂念之意境；另一面为楷书七言绝句，是马少宣经典画风。壶通体古典秀丽，优雅细致，是临摹精品，类似仿作包括此壶仅两件。

117. Colored Butterfly

Height 7.7 cm　Width 3.3 cm

Glass

Marks: "Signed in a winter day of the year of YiChou."

The other side marks:"In a winter month of the year of YiChou. Hundreds of spring scenes evoke hundreds of magical reveries. In the deserted part of a small garden, there is silence and no dust. Paintings flow forth from the artist's brush; butterflies dream of people dreaming of butterflies. Ma Shaoxuan in the year ofYiChou."

This bottle's shape is unique. The butterfly painting is simple yet elegant. The image is framed in an appropriate circle of blank space. The other side has regular scripts of a seven-character phrase poem. Ma Shaoxuan's typical style is to include such a poem on one side of his bottles. The bottle looks classical and elegant, graceful and refined, and is an excellent imitation piece. There is only one other piece s of the same subject.

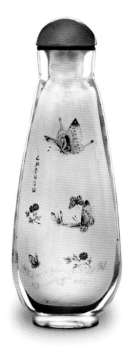

118. 雪中骑驴

高 6 厘米　腹宽 3.2 厘米

无色水晶

图侧款识："少宣作。"

另一面楷书四行款识："马少宣。"

此壶一面绘老翁骑驴踏雪寻梅，一旁小童负着葫芦，亦步亦趋，似乎举步维艰，形态生动，但笔触朴拙内敛，为仿马少宣之作，功力直透图面。

另一侧书写楷书："一夜北风起，万里彤云厚；长空雪乱飞，改画江山旧；仰面观太虚，疑是玉龙斗；骑驴过小桥，独叹梅华瘦。"

此壶是马少宣作品的典型风格，书法表现，亦不逊于图画。此五言诗，骑驴者应为诸葛亮岳丈黄承彦，此图为刘备二访诸葛亮不遇、黄承彦正骑驴返家、吟唱此诗之情景。作者仿马少宣作此题材数量极其有限。

118. Riding a Donkey in the Snow

Height 6 cm　Width 3.2 cm

Rock Crystal

Marks next to the picture: "Shaoxuan signed."

The other side marks next to the four lines of regular script: "Ma Shaoxuan."

One side of this bottle pictures an old man riding a donkey in the snow looking for plum flowers; nearby, a boy struggles to make his way through the deep white snow whilst carrying a dry squash in his hand. Their gestures are very vivid, almost as if they were alive; the brushstrokes that achieve this effect are light and simple. This is an imitation of Ma Shaoxuan's work. On the other side of the bottle the characters are written in regular script:"The north wind blows at night, the red cloud is thick and spreads out tens of thousands of kilometers in the sky. Snow flakes are scattered in the sky; the land appears to have changed its face. Looking face-up into empty space, wondering if jade dragons are fighting a fierce battle. Riding a donkey over the little bridge, the plum flowers sigh as they wither alone."

This bottle demonstrates Ma Shaoxuan's distinct artistic style, and the calligraphy is as good as the painting within the bottle. The donkey rider is probably the father-in-law of Zhu Geliang, Huang Chengyan; this picture shows Liu Bei missed Zhu Geliang twice and Huang Chengyan is riding the donkey home singing this five-word poem. The author's imitation of Ma Shaoxuan's work of this subject is very rare.

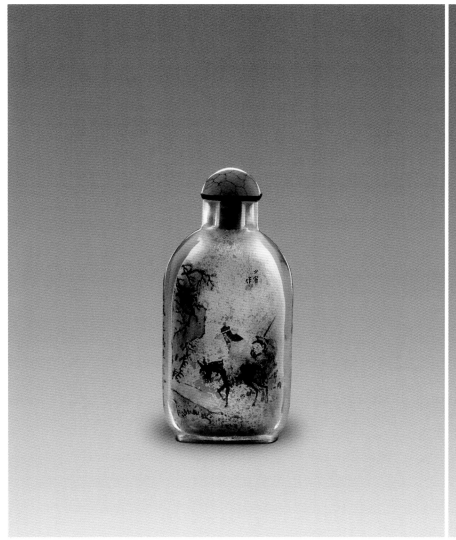
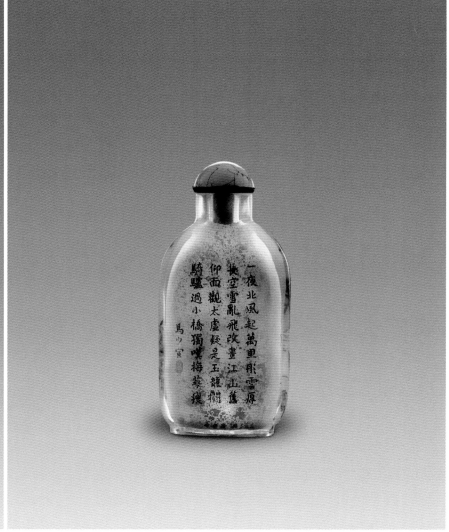

119. 耄耋

高 6.6 厘米　腹宽 3.3 厘米

无色水晶

　　款识："时在丙申仲秋少宣。"

　　另一面楷书侧款识："观花匪尽，着手成春；生气远山，流莺比邻；绿林野屋，花草精神；脱有形似，明月前身。马少宣作于京城。"

　　仔细玩味古韵十足的猫蝶壶面，朴拙典雅，构图线条洗练，色秀淡丽，加上仿旧铁锈色的处理，俨然马少宣大师作品重现，背面的楷书也是规规矩矩的佳作。作者此题材马少宣仿作仅此一件。

119. Long Life

Height 6.6 cm　Width 3.3 cm

Rock Crystal

　　Marks: "Shaoxuan at the mid autumn of the year of BingShen."

　　The other side marks next to the regular scripts: "Watching flowers endlessly as spring approaches. The distant mountains are with the spirits as the sparrows fly next to one another.Humble homes are in the green forest; the flowers and plants are full of vitality;as the moon was once. Ma Shaoxuan painted at Jing City."

　　If one carefully studies this old fashioned bottle that portrays a cat and a butterfly, one will notice that the painting has smooth and refined outlines as well as a simple layout. The bottle is painted with light and graceful colors and treated with the color of rust to emulate the aged effect. It is similar to the original master piece of Ma Shaoxuan. The regular script on the other side of the bottle is a fine work with the precision of its imitation. This is Suo's only piece on this particular subject matter.

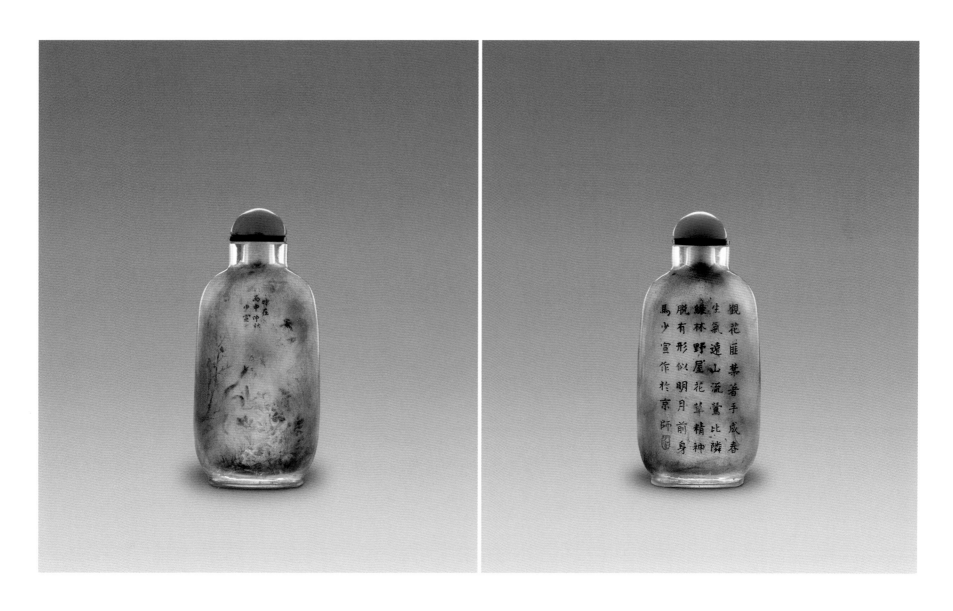

120. 风中稚鸡

<u>高 5.5 厘米　腹宽 3.3 厘米</u>

<u>玻璃</u>

款识："花农六兄大人清玩周乐元为。"

另一面款识："辛卯骄夏。"

此壶是仿周乐元笔意，是壶中尺寸稍小的一件，却因其小，别有一番趣味。画面虽小，但雅致不拥挤，用色古朴，淡雅不俗；风中劲草枝干，摆动有致，小鸡乘风，或掉头，或缩颈，或闭眼，生动有趣；另一面绘湖石盆景梅花，颇具文人风格。此壶认真追随周乐元作品，风华再现。

120. Chickens in the Wind

Height 5.5 cm　Width 3.3 cm

Glass

Marks: "Zhou Leyuan painted this bottle to be admired by the sixth brother, Huanong."

The other side marks:"The hot summer of the year of XinMao."

This is an imitation of Zhou Leyuan's brushworks. The bottle is smaller in size when compared to other inside painted snuff bottles; therefore, it is intriguing in itself. Although the images are small, each one is painted elegantly, and the limited space does not appear crowded. The colors are simple and unique, reminiscent of colors used in the olden days. The bottle depicts chickens flapping their wings against strong winds that threaten to snap the sturdy branches of a tree. Each chicken responds differently to the wind; some turn their heads, some shrink their necks, and others close their eyes. All the different reactions shown in this scene bring the painting to life. The other side of the bottle pictures an ancient vase with a lake stone and plum flower branches . This piece is a careful imitation of Zhou Leyuan's work; it is almost as if the piece is able to demonstrate Zhou's style and talent.

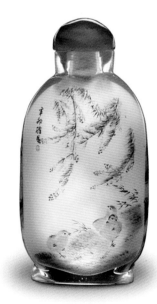
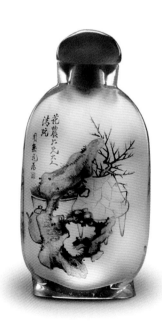

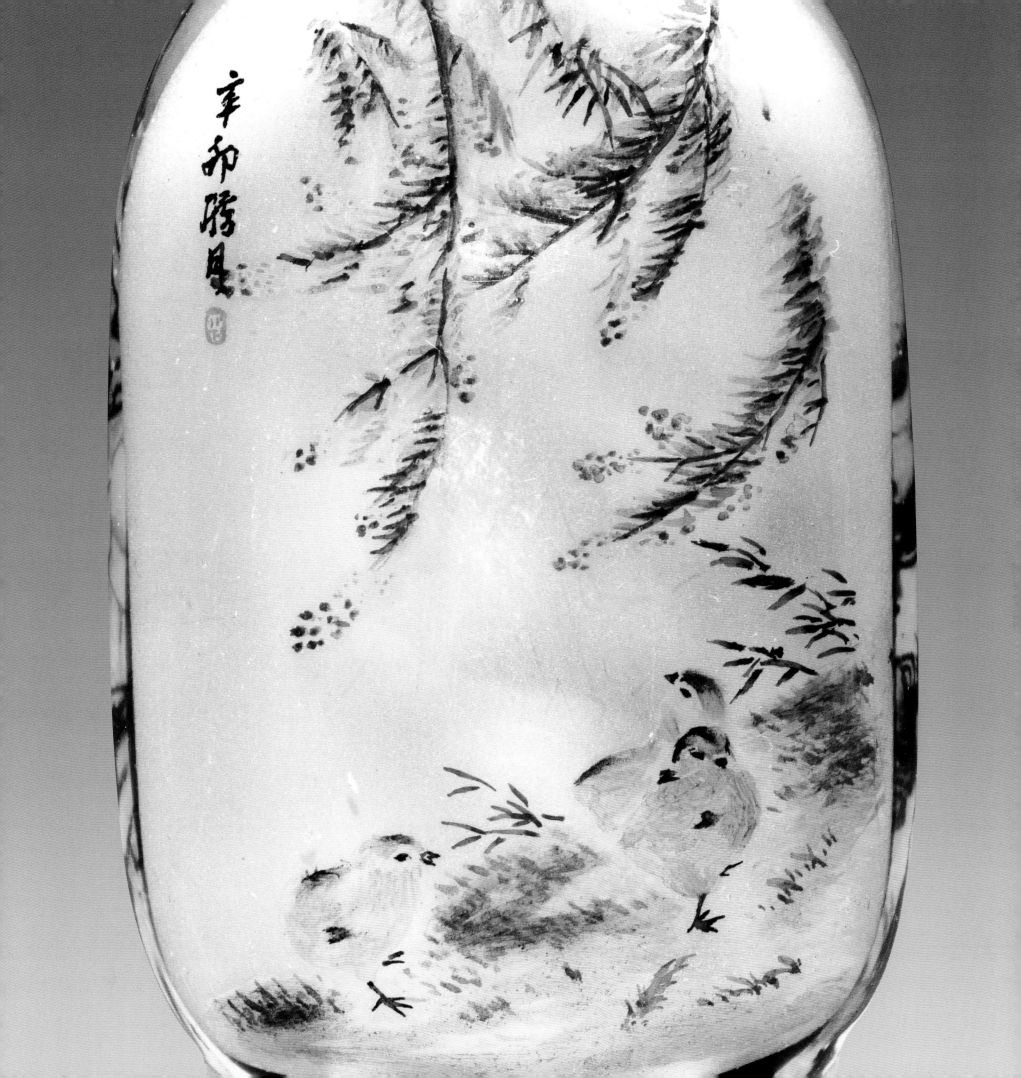

121. 山石草虫

高 5.8 厘米　腹宽 3.5 厘米

玻璃

　　款识："戊子首发于室南房舍周乐元作。"

　　此壶仿周乐元笔意。山石蚱蜢、湖石博古盆景和梅枝是较常见的题材，以一贯的朴雅着色和内敛笔意，熟悉的完成此古意盎然的作品。

121. Grasshopper among the Plants on a Mountain Stone

Height 5.8 cm　Width 3.5 cm

Glass

　　Marks: "Zhou Leyuan signed at the south of the house room in the year of WuZi."

　　This work is an imitation of Zhou Leyuan's brushworks. The mountain stone, grasshopper, an old-fashioned vase with a lake stone, and plum flower branches are all common subjects within Zhou Leyuan's artwork. This piece was painted with simple yet elegant colors and light brushstrokes, making it possible to produce such a magnificent antique-styled bottle.

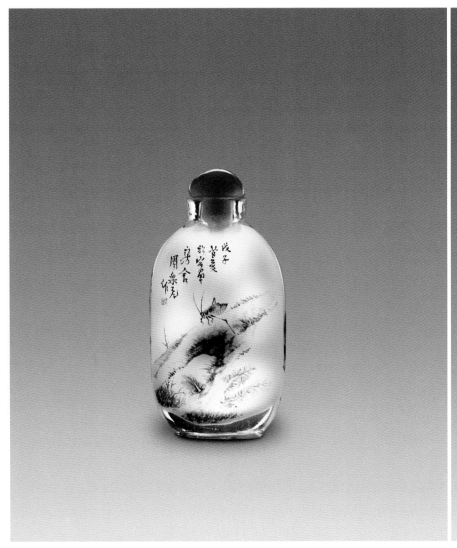
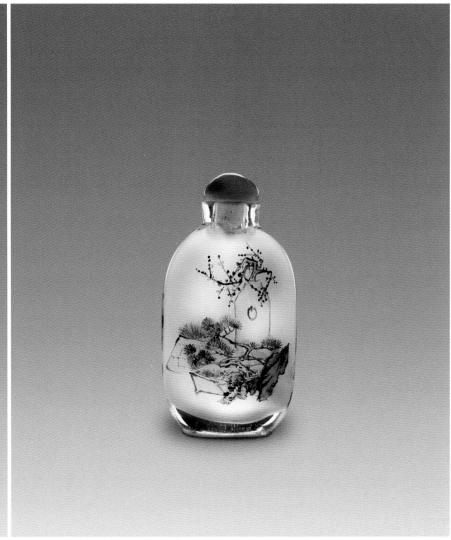

122. 金鱼牧童

高 5.8 厘米　腹宽 3.3 厘米

无色水晶

款识："写于京师周乐元。"

此壶仿周乐元笔意。壶一侧是金鱼满藻，取金玉满堂吉祥之意；壶另一侧仿周乐元擅长之牛上牧童。设色请雅，除画工不含糊，整体透出文人清秀典雅气质。

122. Goldfish; Shepherds Boy

Height 5.8 cm　Width 3.3 cm

Rock Crystal

Marks: "Zhou Leyuan wrote at Jing Shi."

This bottle is an imitation of Zhou Leyuan's brushworks. One side of the bottle pictures goldfish and algae which symbolize the auspicious sign of a wealthy and affluent home; the other side of the bottle pictures a young shepherd on a cow; something which Zhou Leyuan was good at himself. The colors of these paintings are elegant and high levels of technique and detail are evident; this piece is an example of the scholarly nature of aesthetic beauty.

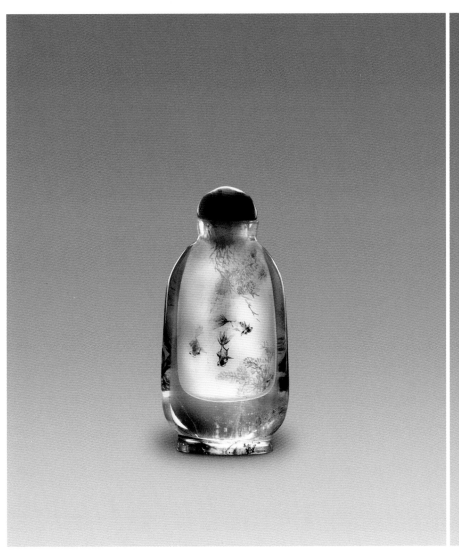
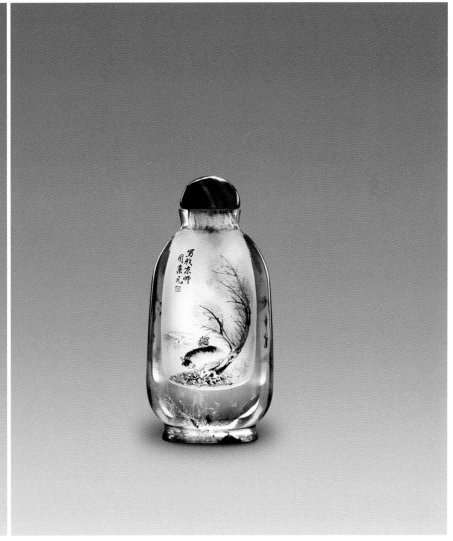

123. 摹静山老人笔

高 5.3 厘米　腹宽 3.5 厘米

玻璃

　　款识："摹静山老人笔，周乐元作。"

　　另一面款识："画于京都周乐元作。"

　　此壶仿周乐元笔意。以墨色、赭色间以青绿，宽松的笔触和繁密的苔点绘成的山丘，颇具江南湿润土坡特色，江边蓑衣翁雨后孤独摇橹，文人品味极为浓厚。

123. Imitation of Jing Shan's Landscape Painting

Height 5.3 cm　Width 3.5 cm

Glass

　　Marks: "Following Jing Shan Old Man's brushworks, Zhou Leyuan signed."

　　The other side marks:"Zhou Leyuan signed at Jing Du."

　　This work is an imitation of Zhou Leyuan's brushworks. The pictures are painted mostly with ink and dark colors, with a few fine touches of dark green here and there; the earthy pattern of the hills is created by light brush strokes along with dense moss dots ; the lone fisherman wearing a straw rain cape contributes to the scholarly feel of the piece.

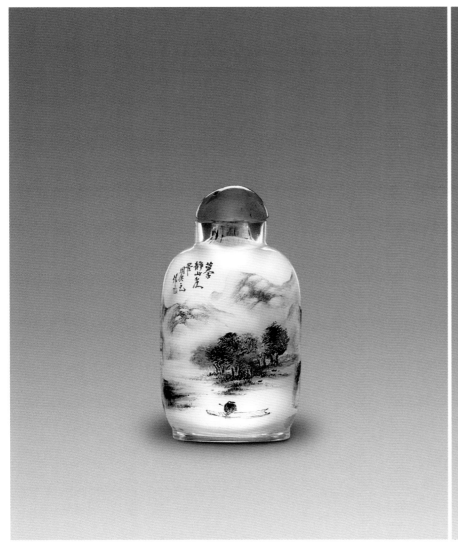
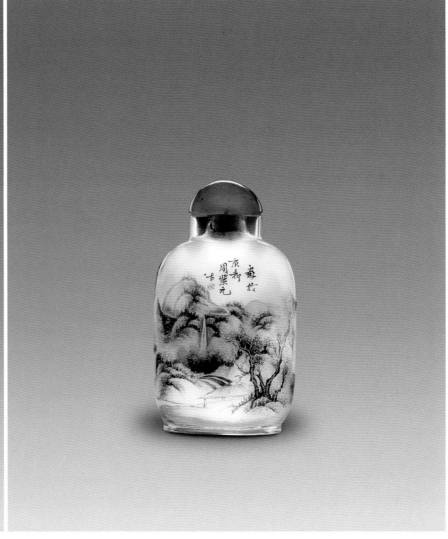

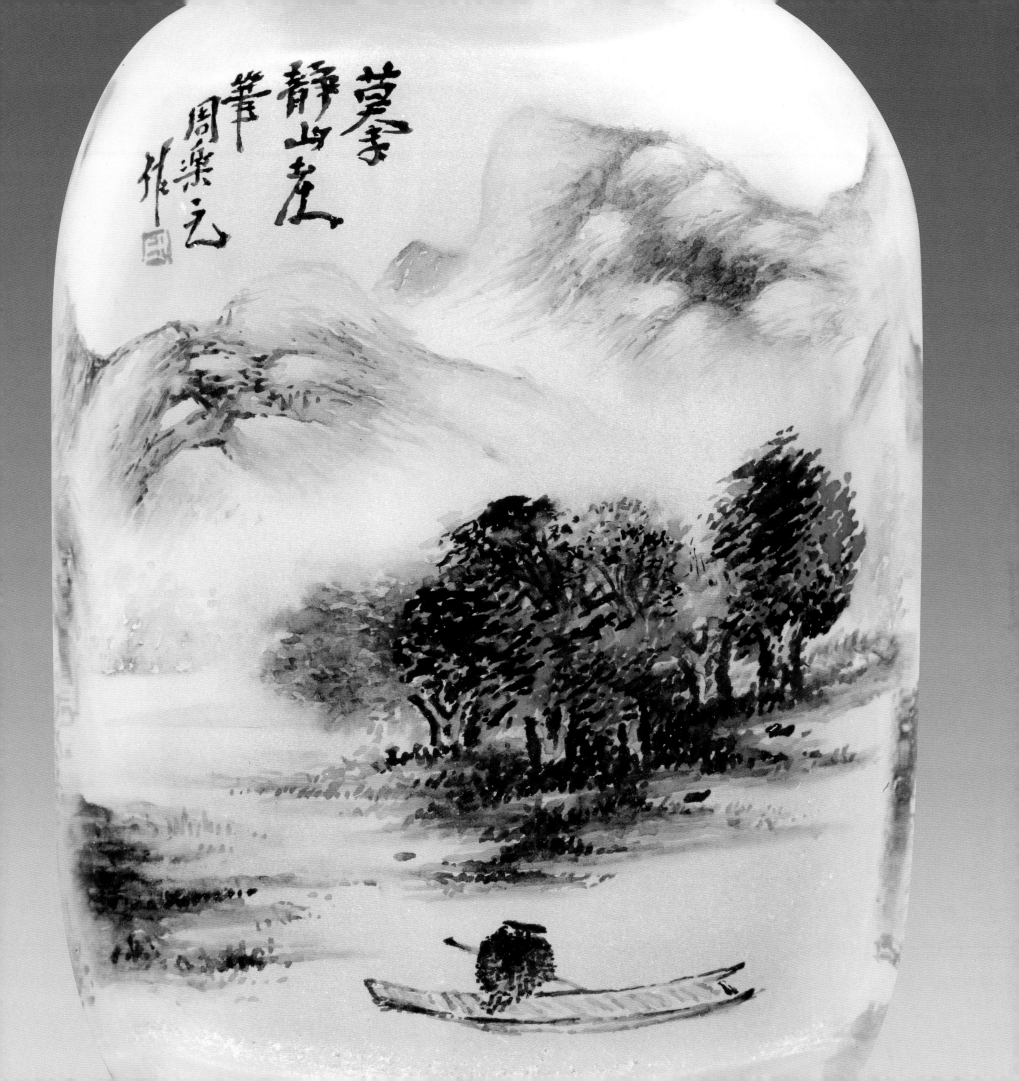

124. 山水虫草

高 6.4 厘米　腹宽 3 厘米

高 4.5 厘米　腹宽 2.5 厘米

玻璃

款识："戊子首发于室南房舍周乐元作，周氏。"

另一面款识："戊子秋月于京师周乐元，周氏为。"

此双连壶同时包括了周乐元大师擅长的山水、虫草、金鱼和盆景静物。笔法轻松随意，又直追大师原创，配上仿古壶型，分外清秀。

124. Landscape, Plants and Insects

Height 6.4 cm　Width 3 cm

Height 4.5 cm　Width 2.5 cm

Glass

Marks: "Zhou Leyuan signed at the south of the house room in the year of WuZi, Zhou Shi."

The other side marks: "Zhou Leyuan at Jing Shi in an autumn month of the year of WuZi, Zhou Shi did."

These twin bottles include a variety of Master Zhou Leyuan's signature painting subjects; landscapes, insects, plants, goldfish, and a vase; all these elements are present within the twin bottles. The brushstokes are casually dabbed against the interior walls of the bottles, creating an artwork similar to the master's original piece. The antique-style bottles make the entire piece appear especially elegant.

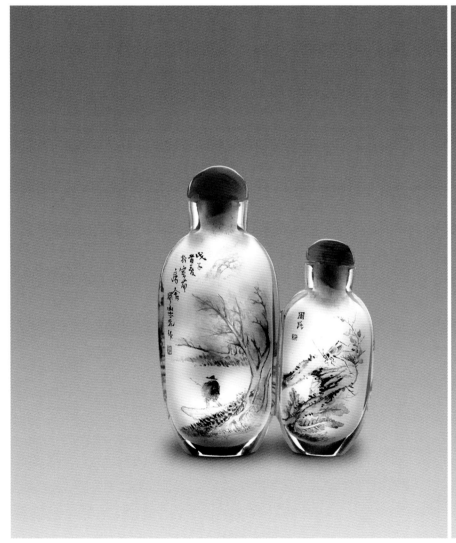
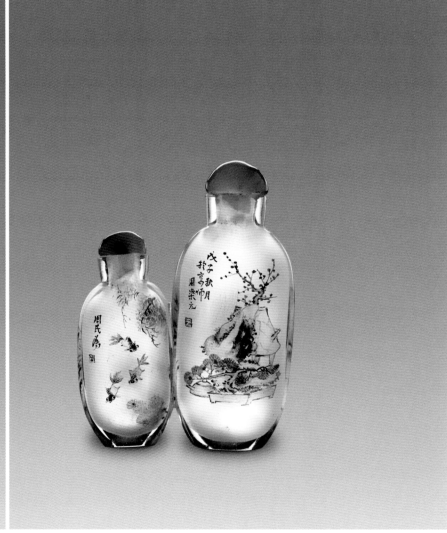

125. 牧童骑牛

高 6.8 厘米　腹宽 2.5 厘米

高 6.8 厘米　腹宽 2.5 厘米

玻璃

款识："己未荷月叶仲三作。"

另一面款识："庚午杏月叶仲三作。"

此壶仿叶仲三笔意。绘牧童骑牛放风筝，荷塘鹭鸶，江边亭阁渡舟；设色古朴，再现叶派大师的画样。一样的笔法，一样的精彩，或许是颜色完整，笔迹清晰，好像在老画注入了新精神，却有说不出的生命力。

125. Young Shepherd Riding a Cow

Height 6.8 cm　Width 2.5 cm

Height 6.8 cm　Width 2.5 cm

Glass

Marks: "Ye Zhongsan signed in a lotus flower month of the year of JiWei."

The other side marks: "Ye Zhongsan signed at the apricot month of the year of GengWu."

This bottle is an imitation of Ye Zhongsan's brushworks. The bottle depicts a young shepherd riding a cow and flying a kite, a lone egret wandering in the lotus pond, a boat crossing a river, and a pagoda on the shore. The artwork employs simple colors to replicate Ye Master's paintings. The imitation and Ye Master's artwork demonstrate similarities in style; however, Suo's wonderful coloration and brush strokes bring new life to an old object.

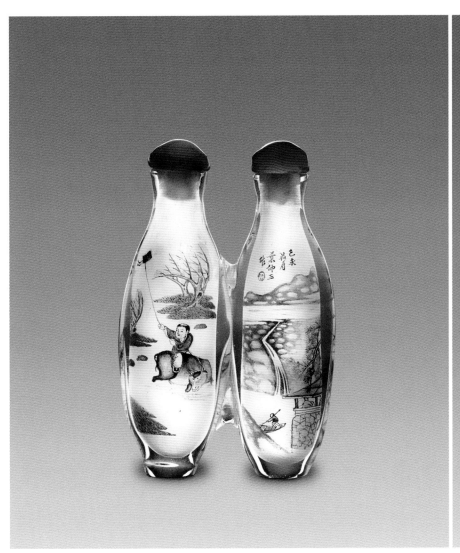

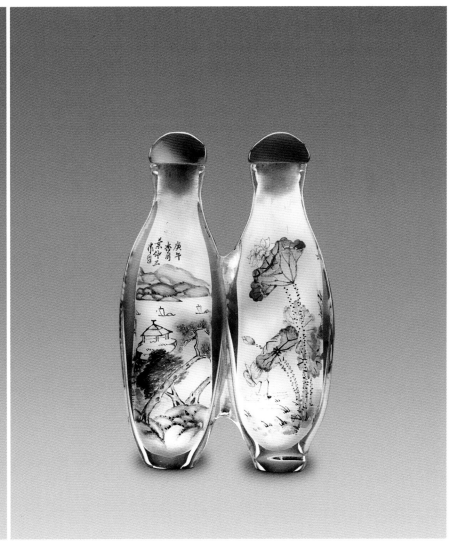

126. 猫蝶

<u>高 5.3 厘米　腹宽 3 厘米</u>

<u>无色水晶</u>

　　款识："丁未孟春写于都门叶仲三。"

　　另一面款识："叶仲三。"

　　此为临摹叶仲三早期作品，用色较淡雅。猫蝶"耄耋"、公鸡、牡丹喻长寿、功名、富贵，可能是订制壶，猫蝶之间的互动，鸡转身模样生动，尤其可爱。

126. Longevity

<u>Height 5.3 cm　Width 3 cm</u>

<u>Rock Crystal</u>

　　Marks: "Ye Zhongsan wrote in the first Spring mouth of the year of DingWe."

　　The other side marks: "Ye Zhongsan."

　　This is an imitation of Ye Zhongsan's early works; compared to his later works, this bottle shows lighter and more elegant colors. The cat and butterfly (pronounced as mau die, i.e. long life), cock, and peony symbolizes long life, official rank, and fortune, respectively. This bottle might be a custom-made bottle; it portrays a chicken turning its back and the intimate interactions between a cat and butterfly.

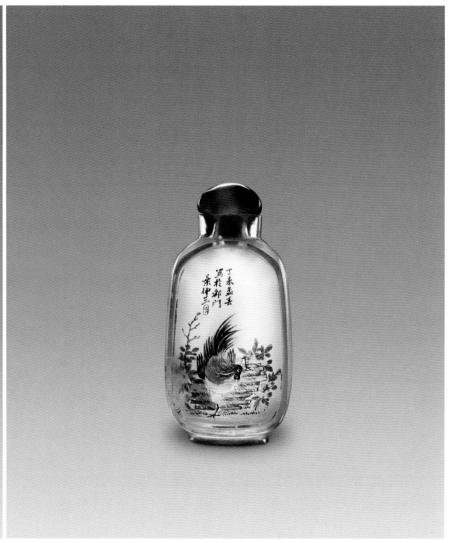

127. 太平有象

<u>高 5.8 厘米　腹宽 5 厘米</u>
<u>玛瑙</u>

款识："甲寅秋月写于京师叶仲三。"

此壶仿叶仲三笔意。壶面绘西洋士兵傍着白象，寓意太平有象；另一侧绘松鹤牡丹，寓意长寿富贵，两画作均是传统内画常见之题材。由于玛瑙天然色晕及纹路，对映着古色线条彩绘，更显得古朴典雅。

127. A Symbol of Peace

<u>Height 5.8 cm　Width 5 cm</u>
<u>Agate</u>

Marks: "Ye Zhongsan wrote at Jing Shi in an autumn month of the year of JiaYin."

This bottle is an imitation of Ye Zhongsan's brushworks. The depiction of a western soldier standing next to a white elephant symbolizes peace; the other side of the bottle pictures a crane, a pine tree, and colored peony flowers which symbolize long life and good fortune. Both subjects are commonly used in inner painting artwork. The color of natural agate offsets the simple and elegant antique-style color painting.

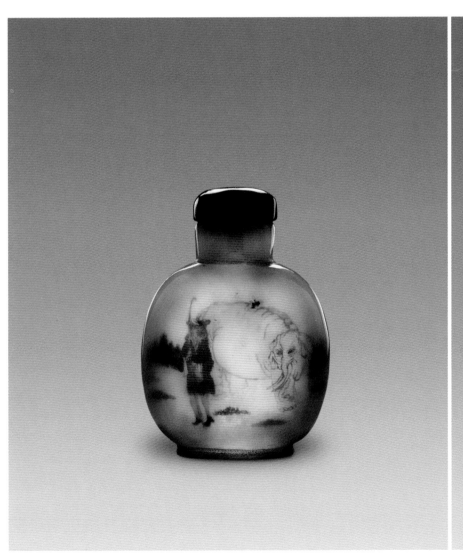
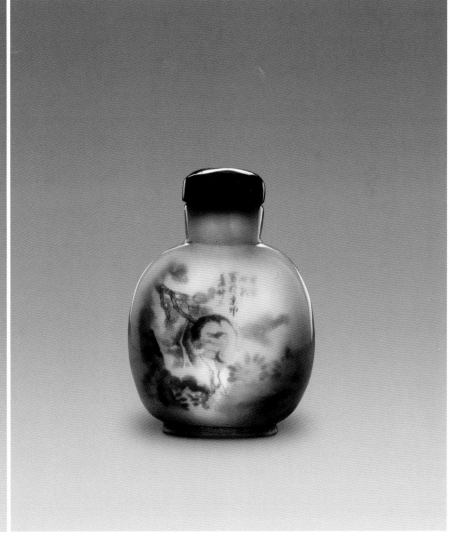

128. 鱼鹰

高 6.3 厘米　腹宽 2.8 厘米

高 5.2 厘米　腹宽 2.5 厘米

玻璃

款识："壬辰仲春叶仲三。"

另一面款识："甲寅仲秋月写于京师叶仲三。"

此壶仿叶仲三笔意。绘松鹰金鱼白鹤，容于仿古双连壶中。虽习叶派宗师笔意，用色素雅，构图规矩，却沁透出不俗气质，颇令人玩味。

128. Goldfish and Eagle

Height 6.8 cm　Width 2.8 cm

Height 6.8 cm　Width 2.5 cm

Glass

Marks: "Ye Zhongsan at mid-spring of the year of RenChen."

The other side marks : "Ye Zhongsan wrote at Jing Shi in an mid-autumn month of the year of JiaYin."

This bottle is an imitation of Ye Zhongsan's brushworks. The pine eagle, goldfish, and white crane in the antique style twin bottles are similar to Ye Master's brushworks. The elegant coloration and orderly layouts show extraordinary quality and are worthy of one's admiration.

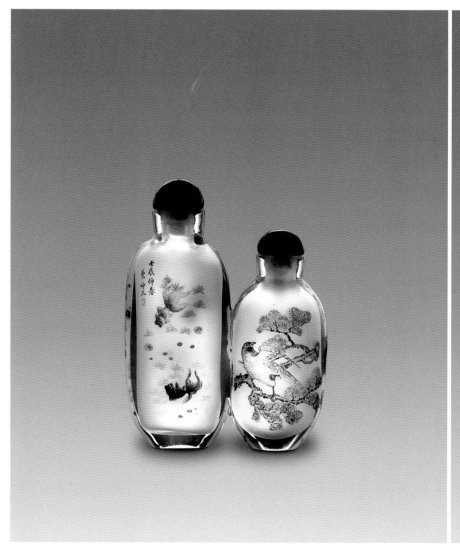
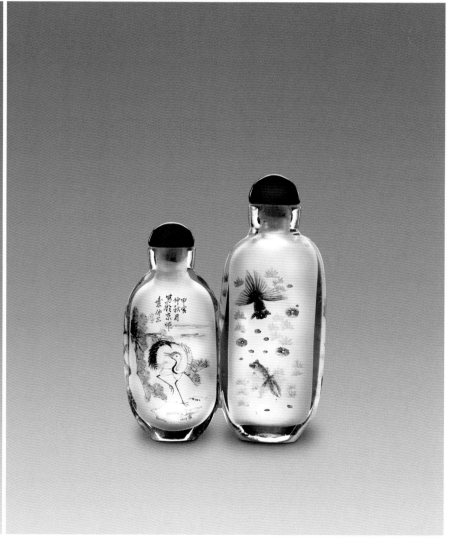

129. 五余

高 5.4 厘米　腹宽 4 厘米

无色水晶

款识："庚辰杏月叶仲三作。"

另一面款识："仲三。"

此壶仿叶仲三笔意。焦点是鲤鱼，四周金鱼围绕着，色彩艳丽。叶仲三画鲤鱼不多见，唯作者能生动描绘，入木三分，加上仿旧铁锈色，此壶益加散发前大师作品的风韵。

129. Five Fish

Height 5.4 cm　Width 4 cm

Rock Crystal

Marks: "Ye Zhongsan signed in the apricot flower month of the year of GengChen."

The other side marks: "Zhongsan."

This bottle is an imitation of Ye Zhongsan's brushworks. The focus of this piece is the lone carp surrounded by the swarm of goldfishes. The artist employs bold colors. Ye Zhongsan rarely uses carps as the dominant subject of his artwork. Only Suo would have the ability to make the carps in an imitation painting come to life. Furthermore, the rust color applied to the painting creates an aged look and makes the imitation even more similar to Master Ye's original work.

130. 犬

高 4.2 厘米　腹宽 3.7 厘米

清玻璃

款识："己未冬月叶仲三作。"

"气韵生动"尚不足以形容对此壶双犬图的直观印象，不经意的就被二犬的古雅色调、高贵优美的造型，加上老壶本身因岁月包浆增添的质感深深的吸引住。刻意留淡彩的地面，不夺料器的岁月光华，无论是一草一木，都完美搭配，多一点太多，少一笔不够，真是大师级的精品。此壶仿叶仲三笔意而成。

130. Dog

Height 4.2 cm　Width 3.7 cm

Qing Dynasty Glass Bottle

Marks: "Zhongsan signed in a winter month of the year of JiWei."

"The artwork comes to life" is not sufficient to describe the visual impression left by this inner painting of two dogs. Those who lay their eyes on this piece will undoubtedly be fascinated by the quaint blend of elegant colors, and the graceful historic feel of an old Qing dynasty bottle. The artist carefully employs light colors for the ground, without depriving the old glass bottle of its natural shine. Be it a small piece of grass or a tall tree, all individual items in the bottle are carefully positioned next to each other to create a true masterpiece. Not one brush can be added, and not one stroke can be spared. This bottle is an imitation of Ye Zhongsan's brushworks.

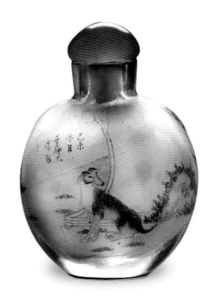

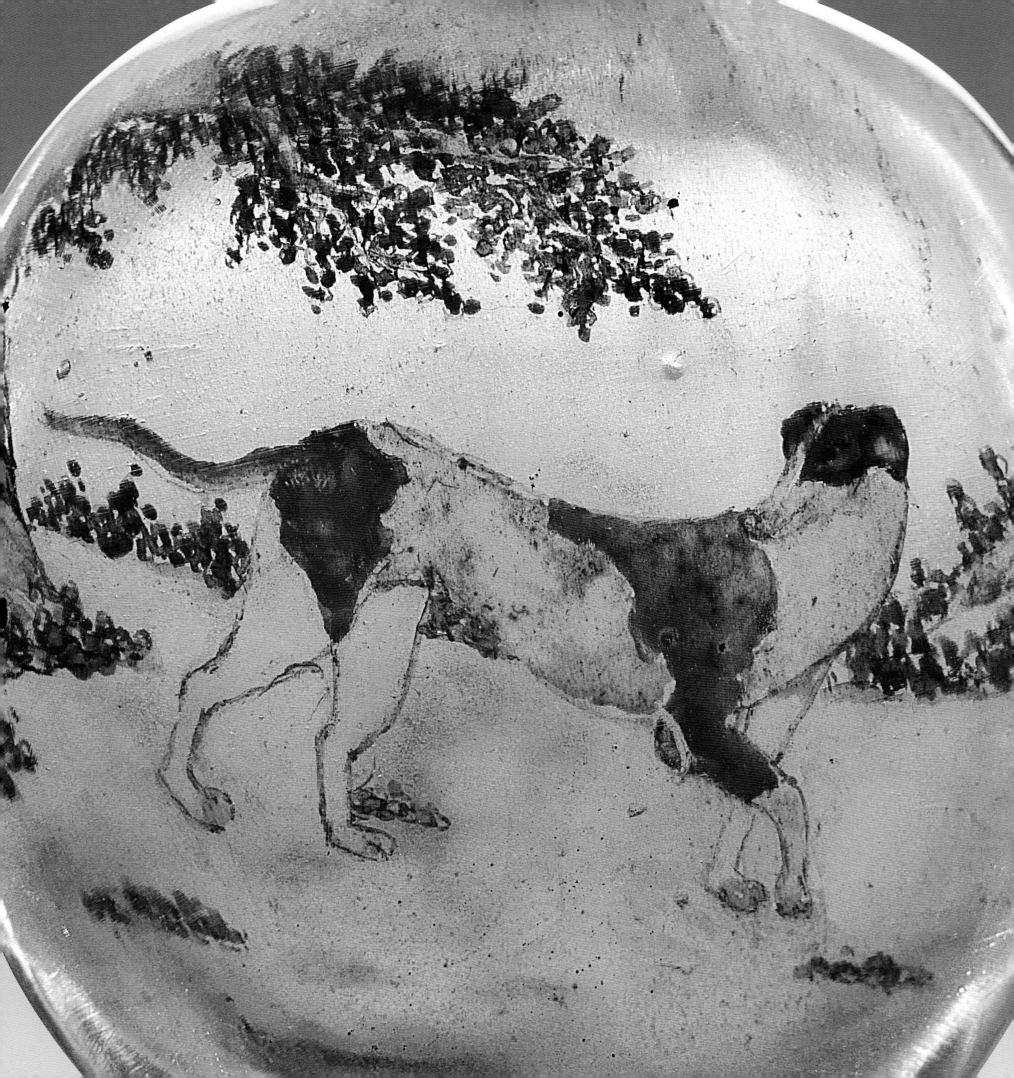

特制 Custom Made

131. 马寿华像

高 7.2 厘米　腹宽 5.5 厘米

玻璃

款识："马寿华先生像。1893～1977。"

另一侧款识："马寿华作品。乙酉五月一石索振海仿作。"

马寿华先生文质彬彬，温文儒雅，玉树临风，文人风范；生前为首届台湾美术家协会及书家法协会理事长，连任直到辞世。

作者绘其肖像，将马老神韵风华重现，与一般内画肖像的匠气，不可同日而语；壶另一面临的是台北故宫收藏马寿华先生的《平安盘石图》局部，作者初次临摹，即达到气韵生动，如真迹再现，实属不易。

此壶乃作者应邀约完成此绝妙孤品。

131. Ma Shou Hua Portrait

Height 7.2 cm　Width 5.5 cm

Glass

Marks: "Mr. Ma Shou Hua Portrait. 1893-1977."

The other side marks: "Ma Shou-Hua's work. Yi Shi Suo Zhenhai imitated in May of the year of YiYou."

Mr. Ma Shou-Hua was a gentle, sophisticated, and handsome statesman; he was the first Chairman of Taiwan's Artist Association and Calligraphy Association until he passed away. The artist painted Mr. Ma Shou-Hua's portrait and expertly incorporated the spirit and handsome appearance of Ma Shou-Hua (a.k.a. Ma Mulao). This piece exceeds the ordinary standards of inner painting portraits. On the other side of the bottle, the artist partially imitated Mr. Ma Shou-Hua's "Peace Stone Picture" treasured in Taipei's National Palace Museum.

This exquisite work was done by the artist at the request of a customer.

马寿华像

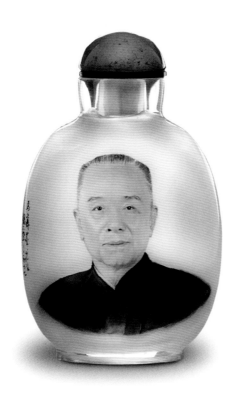

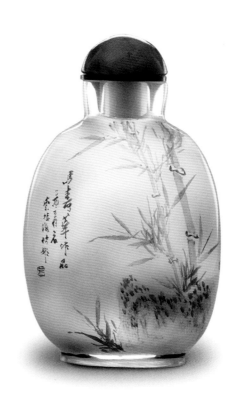

132. 寒冬烟火（瑞璟弥月赠礼）

高 7.2 厘米　腹宽 4.2 厘米

玻璃

款识："次男瑞璟弥月 2001 年冬。"

此壶乃受邀替小儿子准备满月礼品，订了一百多个壶。因邀者有一女二子都是下雪天出生，所以要求壶的一面画一女二男在下雪天玩耍，由一男童点炮；另一面画小儿子生肖（蛇）。虽是随笔小品，却将小孩雪中嬉戏情景画的异常生动。

此壶订制时和作者接触不久，以为可以批量生产的价格得到索老的作品，结果由学徒完成之作品被多次退件，最后终于和作者说明要求，由作者亲自操刀，样品一次就被接受。其他壶即由他的学生照着样品画。得学生仿作赠品者亦爱不释手。图中即是该样品。

132. Fireworks in Winter
(Rayjing's First–Month–After–Birth Gift)

Height 7.2 cm　Width 4.2 cm

Glass

Marks: "Second son Rayjing. First month after birth in winter of 2001."

This bottle was prepared for the special purpose of the customer's youngest son's first-month-after-birth gift. The customer ordered over a hundred custom-made bottles. The customer has one daughter and two sons born on snowy days; therefore, the customer asked the artist to paint an image which portrays a girl and two boys playing in a snowy day. One of the boys is shown lighting a firework. On the other side of the bottle, the youngest son's zodiac animal (snake) is shown.

When the order was placed, the customer had not yet been acquainted with the artist for a long period of time and thought he could simply ask the artist to paint all the custom-made bottles for a mass production price. The first few bottles were painted by the artist's students and were instantly rejected by the customer. The customer negotiated with the artist, and eventually he agreed to paint the prototype himself. The first time this artwork was presented to the customer, it was approved without hesitation. While the prototype was painted by the artist himself the remaining hundred or so other bottles were completed by his students based on his original design. Those who received the snuff bottles as gifts expressed their deepest appreciation. The bottle shown in this photo is the master prototype, painted by the master artist himself.

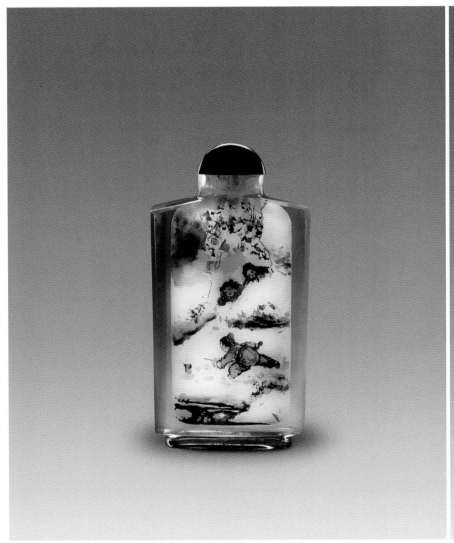
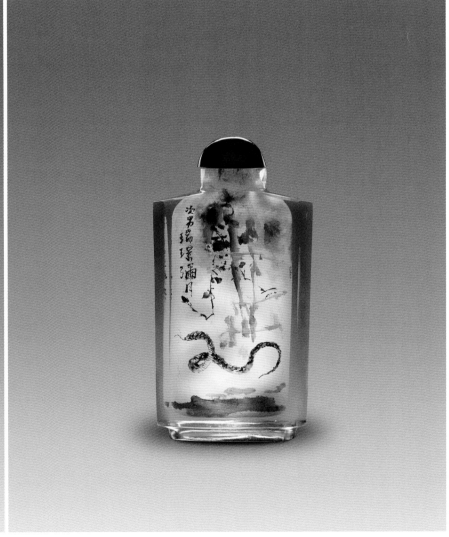

133. 马瑞璞像

高 7.3 厘米　腹宽 5.7 厘米

玻璃

　　款识："马瑞璞猪年吉祥。乙酉秋月一石索振海作。"

　　此肖像作品也是作者按提供的学生照绘制。同样发挥了其艺术悟性，在原貌重现的基础上，加上一些生活化的色彩，使其更具亲和力和感染力；壶另一面以马瑞璞的属相猪为主题，小猪占据着主画面，雄赳赳、气昂昂的模样，也讨人喜欢。

133. Ma Raypu's Portrait

Height 7.3 cm　Width 5.7 cm

Glass

　　Marks: "Ma Raypu of the auspicious year of the pig. Yi Shi Suo Zhenhai signed in an autumn month of the year of YiYou."

　　This portrait was painted by the artist based on a school picture. The artist used his own artistic genius to interpret the original image; in his creation, he adds fresh elements to the portrait, brining the piece to life. The other side of the bottle is a picture of Ma Raypu's zodiac animal (pig). The pig stands gallant and full of pride in the center.

马瑞璞像

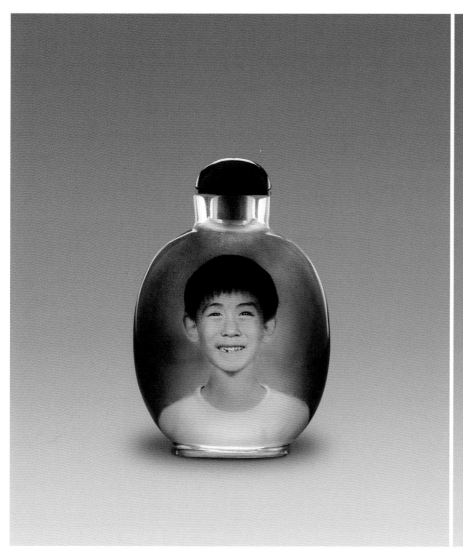

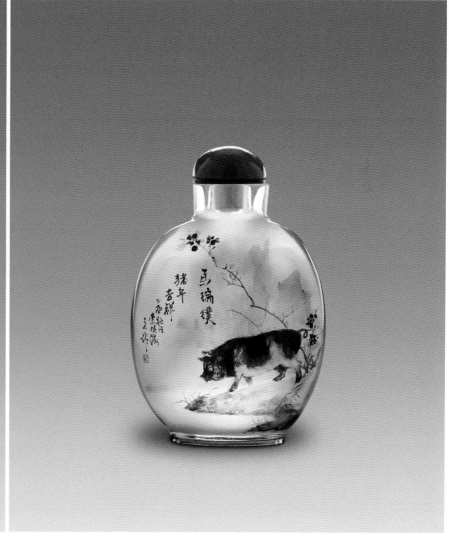

134. 马瑞璟像

高 6.8 厘米　腹宽 4.8 厘米

玻璃

款识："马瑞璟蛇年吉祥。乙酉秋月索振海一石作。"

此肖像作品是临摹生活照而来，作者有较大再创作空间，所以马瑞璟的轮廓较柔，姿势较生活化。随着整个画面能更生动活泼的发挥，色调的搭配也跟着活起来，达到表现小儿惹人疼爱的模样，画活了他的本性和照片表现不出来的气质，远远超过了简单的肖像。壶另一面也是以马瑞璟属蛇为主题，画了灵蛇出洞的景观。

134. Ma Rayjing's Portrait

Height 6.8 cm　Width 4.8 cm

Glass

Marks: "Ma Rayjing of the auspicious year of the snake. Suo Zhenhai Yi Shi signed in an autumn month of the year of YiYou."

This portrait is based on a candid photograph that was taken of the young boy. Ma Rayjing's profile looks softer and his poise looks more casual. The colors and the creativity put into this piece helps bring the portrait to life. It shows the youngest son's charming appearance and nature. The artwork is able to express feelings and impressions beyond what an ordinary photo can. The other side of the bottle centers Ma Rayjing's zodiac animal (snake); the agile snake is shown slithering out from a hole.

马瑞璞像

135. 马瑞琦像

高 7.4 厘米　腹宽 5.7 厘米

玻璃

　　款识："马瑞琦鸡年吉祥。乙酉秋月一石索振海作。"

　　此肖像作品也是作者按提供的学生照绘制。学生照原本较规矩呆板，他以自己的艺术理解和敏感度，在临摹照片的前提下，添上了精神色彩，带入正面阳光的元素，让肖像更生动，更精神，又远离一般肖像画的匠气和俗套；壶另一面以马瑞琦属鸡生肖绘成一幅精彩的雏鸡嬉戏图。

135. Ma Raychi's Portrait

Height 7.4 cm　Width 5.7 cm

Glass

　　Marks: "Ma Raychi of the auspicious year of the Chicken. Yi Shi Suo Zhenhai signed in an autumn month of the year of YiYou."

　　This portrait was painted by the artist based on a school picture. The original photograph portrays an unexciting image of a well-behaved young girl. The artist used his own artistic understanding and sensitivity to adapt the picture and make it his own. While interpreting the original image, the artist added fresh elements to the portrait, revealing the spirit in the child's expression and brining the piece to life, On the other side of the bottle, the artist used Ma Raychi's zodiac animal (Chicken) to paint a heartwarming image of chicks at play.

马瑞琦像

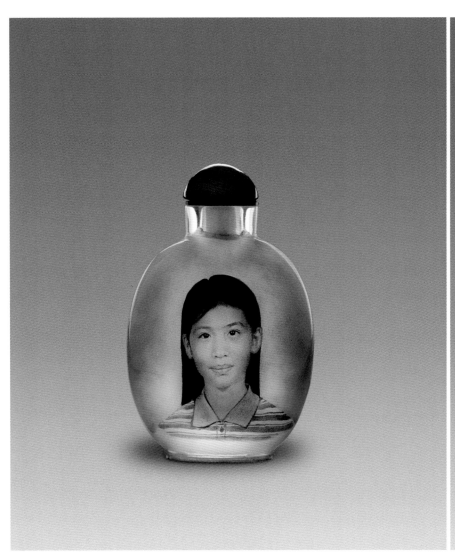

136. 只羨鴛鴦不羨仙（結婚十周年紀念壺）

<u>高 9.3 厘米　直徑 9.6 厘米</u>

<u>玻璃</u>

　　款識："只羨鴛鴦不羨仙，馬毓鴻、馬佑遠結婚十周年紀念。"

　　兩壺肩雕有龍首環。作者按結婚晚宴照中夫婦的部分，重現結婚十周年夫婦的莞爾一笑。背景選擇暈開的紅色淡彩，營造出喜氣洋洋的氛圍；而省略原背景裡喜幛等諸多細節，適當的放大強調新人的臉部表情，抓住一剎那向往永恒幸福所散發出的光輝。

　　作者控制色彩的功力誠屬上乘，清楚地區分出禮服裡不同層次的黑、白、紅、綠，色調沉穩高雅，是極富現代感的內畫肖像精品。壺另一面按要求繪一對鴛鴦，以志十年婚慶。

136. Mandarin Ducks
(Tenth Wedding Anniversary Celebration Bottle)

<u>Height 9.3 cm　Width 9.6 cm</u>

<u>Glass</u>

　　Marks: "You will envy the mandarin ducks (because they symbolize love that lasts a lifetime); then you will forget to envy the gods. Ma Yuh-hung and Ma Yu-yuan's tenth wedding anniversary celebration."

　　Both shoulders of the bottle have dragon head ring carvings. The artwork is based on a photograph taken at the newly-wed couple's wedding banquet. The light red color background and the smiles on the couple's faces create a joyful atmosphere. The close up on the couple's facial expressions allows their desire for eternal happiness to be emphasized.

　　The artist's use of colors is superb. He adopts elegant color tones of black, white, red, and green; by employing various shades of these colors, he creates and outstanding piece of work. This inner painting portrait exudes a refined contemporary feel. At the request of the customer, the other side of the bottle pictures a pair of mandarin ducks which symbolizes eternal love and companionship. This bottle was painted to celebrate the couple's tenth wedding anniversary.

馬毓鴻、馬佑遠像

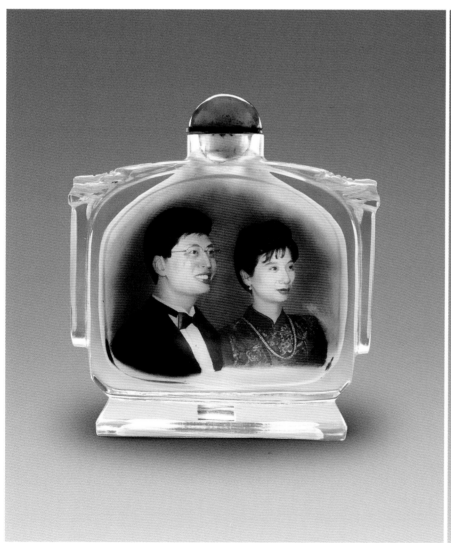

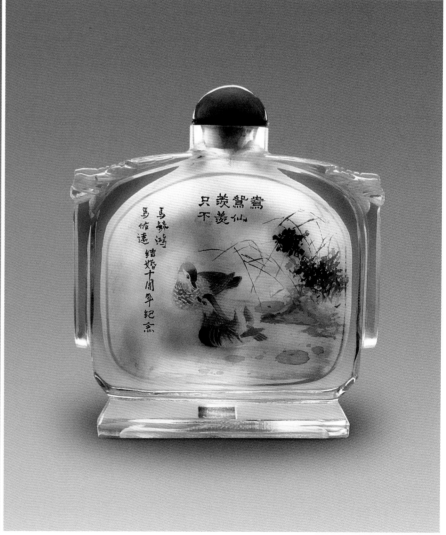

137. 松竹石

高 6.8 厘米　腹宽 3 厘米

玻璃

款识："马寿华先生笔意。索振海习作。"

另一面款识："乙酉五月索一石仿作愧未似。"

马寿华先生擅书法、写竹及指画，生前任台湾美协及书协理事长，艺术地位崇高，又身居政府要职，作品多为海内外博物馆、著名机构及名士珍藏。

作者按《马寿华先生书画特展目录》中绘画作局部临摹，于壶中再现马寿华先生作品风华，非一笔一画照着描，涵咏画意笔法，融会贯通，一气呵成，可见其国画功底之深，诚属上乘之作。此壶和上件作品同时期完成，亦是绝世精品。

两幅原作皆收藏于台北故宫博物院，并收录于 1980 年台北故宫出版的《马寿华先生书画特展目录》中。一为《蕉林竹窝图》（353.6×145.5 厘米，1965 年作），一为《三友长寿图》（177×93.9 厘米，1969 年作）。

137. Pine Tree, Bamboo and Rock

Height 6.8 cm　Width 3 cm

Glass

Marks: "Mr. Ma Shou-Hua's brushworks. Suo Zhenhai learned."

The other side marks: "Suo Yi Shi imitated in May of the year of YiYou and felt guilty of not doing a good job."

Mr. Ma Shou-Hua was very good at calligraphy, bamboo paintings and finger paintings. When he was alive, he was the chairman of Taiwan's Artist Association and Calligraphy Association, and he was considered to be of very high status in the world of art. He was also held critical positions in the government and was an honorable official. His work has been collected and exhibited by both domestic and overseas museums, reputable institutions, and celebrities.

The artist imitated parts of the paintings that were in the Special Exhibition of The Paintings & Calligraphic Works By Ma Shou-Hua Bequeathed To The National Palace Museum. Mr. Suo did not imitate the paintings stroke by stroke, but for the most part interpreted the spirit and patterns of Mr. Ma Shou-Hua work, and an imitation of his style came naturally. This shows that Mr. Suo is skilled and gifted in Chinese painting. This bottle along with the other one listed above were done in the same period, and both of them are considered exquisite pieces.

The original paintings by Ma Shou-Hua have been collected by Taipei's National Palace Museum. Both paintings were included in a 1980 publication Special Exhibition of The Paintings & Calligraphic Works By Ma Shou-Hua Bequeathed To The National Palace Museum by the Taipei Palace Museum.

One is "Field of Bananas and Bamboo Groves" (353.6×145.5 cm, 1965); the other one is "Pine Tree, Bamboo and Rock." (177×93.9 cm, 1969)

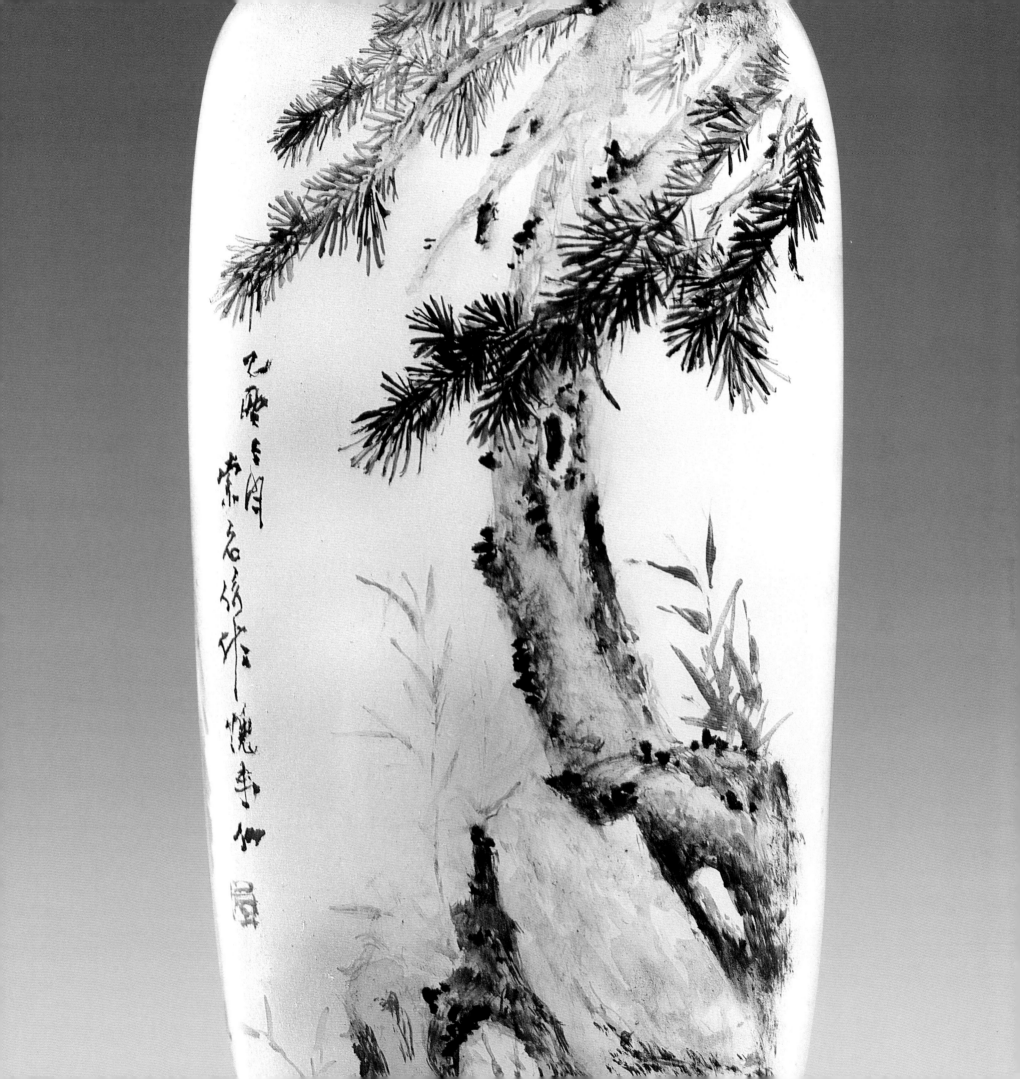

138. 春

高 7.2 厘米　腹宽 3.6 厘米

玻璃

　　款识："春。甲子冬索一石作。"

　　此壶乃应祝寿要求而绘。山涧布满春
色桃花,倍添喜气,因此多画了一壶而留下,
不同于作者其他春景壶。

138. Spring

Height 7.2 cm　Width 3.6 cm

Glass

　　Marks: "Spring. Suo Yi Shi signed in winter of the year of JiaZi."

　　This bottle was a custom-made birthday gift. Peach flowers flourish and bloom all over the valley, creating a joyful atmosphere. While other similar pieces painted by the master artist were taken by the customer placing the order, this one was kept because it stood out even among his other bottles depicting similar scenes of spring.

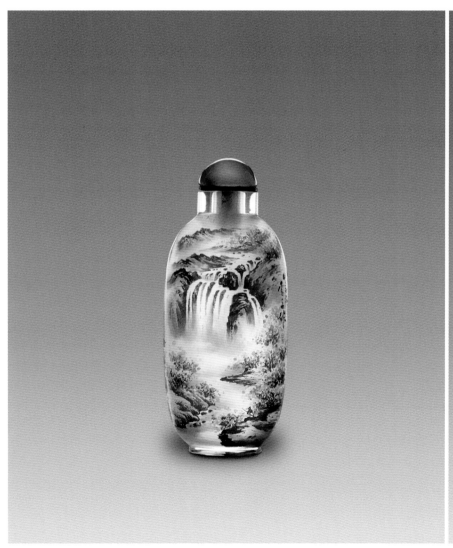

139. 外国风光

高 7 厘米　腹宽 5.5 厘米

玻璃

　　此壶为仿作客户提供之外国风景画图片而成，唯委作之人从未回头验收成品取件，所以成为唯一作品；也是作者作此类画作的尝试，亦可佐证其能西能中的艺术造诣。

　　壶面以水墨布色造就水彩的效果，融入西方绘画技法，从精准的尺寸、比例拉出景深，自近而远；用色恰当，典雅清丽，马车亮丽生动，跃然壶面。

139. Foreign Scenery

Height 7 cm Width 5.5 cm

Glass

　　This bottle is based on photographs of foreign scenery provided by a customer. The customer never came back to claim the piece when it was complete. This is the only piece of its kind, as the artist only painted one bottle on this subject matter. This piece is a great example of the artist's talents in both Chinese and western painting styles.

　　The bottle's inner surface is entirely covered in ink-colors to emulate water color effects. The artist also employs western-style painting techniques, such as accurate proportions and precise portrayals of depth; employing realistic colors, and showing simple elegant beauty. The horse-drawn carriage in the picture is extremely realistic; it almost seems as if it is jumping off the bottle's surface.

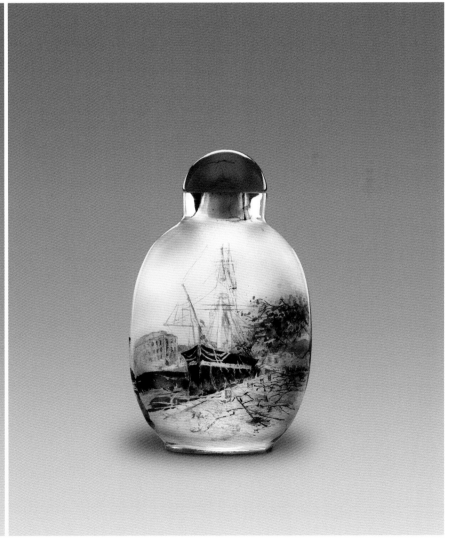

图版索引

山 水

1. 渔 /031

2. 访友 /032

3. 寿山访友 /034

4. 秋林放牧 /035

5. 四季山水 /036

6. 飞瀑直下三千尺 /038

7. 读 /040

8. 居山图 /042

9. 松岭探幽 /043

10. 晚霞满天 /044

11. 访友 /046

12. 雪月 /047

13. 平沙落雁 /048

14. 风雪夜归人 /050

15. 山林亭阁 /051

16. 山溪待渡 /052

17. 雪月寒林 /054

18. 冬 /055

19. 山水渔家 /056

20. 丛林密雪 /057

21. 四季山水 /058

22. 塞外 /068

23. 雪山访友 /070

24. 大漠走骑 /072

25. 残雪 /073

26. 秋山访友 /074

27. 诗中画 /076

28. 风雨图 /078

29. 清明上河图 /079

30. 米芾拜石 /082

31. 山远志清 /084

32. 云山胜境 /085

33. 渔樵耕读 /086

34. 秋江放艇 /088

35. 云山访友 /089

36. 云山雨意 /090

37. 风雨云月 /092

38. 风雨云月 /096

39. 论古访友 /098

40. 耕 /099

41. 春 /100

42. 夏 /101

43. 大山水 /102

花 鸟

44. 鹭鸶晓月 /107

45. 双雀 /108

46. 林间翠鸟 /110

47. 初春戏雀 /112

48. 雉鸡 /114

49. 雪 /115

50. 风雨月雪 /118

51. 荷塘戏蟹 /120

52. 游 /122

53. 荷塘戏蛙 /123

54. 田园野趣 /124

55. 吉祥富贵 /125

56. 雅房闲赋 /126

57. 草间虫 /128

58. 草田蜻蜓 /129

59. 闲趣 /130

60. 虫趣 /131

61. 虫草 /132

62. 石趣 /133

63. 夏荷 /134

64. 长夏清趣 /135

65. 草间虫趣 /136

66. 动中取静 /138

67. 草间偷活 /139

68. 四君子 /140

69. 戏虾 /141

70. 梅兰竹菊 /142

71. 草间野趣 /144

72. 虫草 /154

73. 山雉 /155

人 物

74. 清江渔隐 /157

75. 竹林高卧 /160

76. 竹林七贤 /161

77. 老叟 /164

78. 浓荫仕女 /166

79. 月下倩女 /167

80. 武松打虎 /168

81. 赏菊图 /170

82. 淑女 /171

83. 柔风含情 /172

84. 爱鹅图 /173

85. 老翁骑虎 /174

86. 红衣骑士 /176

87. 鹤童骑翁 /177

88. 木兰从军 /178

89. 木兰补裘 /180

90. 乐在其中 /181

91. 皆大欢喜 /182

92. 西情 /183

93. 西游记 /184

94. 长板坡 /188

95. 古城会 /189

96. 武松 /190

走 兽

97. 宁拙勿巧 /193

98. 狸奴 /196

99. 二马 /197

100. 双驹 /198

101. 飞龙夺珠 /200

102. 松鼠 /202

103. 双鼠 /203

104. 山猫 /204

105. 雄风 /205

106. 林中之王 /206

107. 寒林双虎 /207

108. 塞雪双雄 /208

109. 松林象吼 /209

110. 冬 /210

111. 犬追蝶 /212

112. 伴 /214

113. 犬相 /215

114. 猴戏人生 /216

115. 十二生肖 /218

116. 十二生肖 /226

仿 古

117. 彩蝶 /235

118. 雪中骑驴 /236

119. 毫耄 /237

120. 风中稚鸡 /238

121. 山石草虫 /240

122. 金鱼牧童 /241

123. 摹静山老人笔 /242

124. 山水虫草 /244

125. 牧童骑牛 /245

126. 猫蝶 /246

127. 太平有象 /247

128. 鱼鹰 /248

129. 五余 /249

130. 犬 /250

特 制

131. 马寿华像 /253

132. 寒冬烟火 /254

133. 马瑞璞像 /255

134. 马瑞璟像 /256

135. 马瑞琦像 /258

136. 只羡鸳鸯不羡仙 /259

137. 松竹石 /260

138. 春 /262

139. 外国风光 /263

Index

Landscape

1. Fishing / 031

2. Visiting a Friend / 032

3. Visiting a Friend at Shou Mountain / 034

4. Grazing in the Autumn Woods / 035

5. Landscapes in Four Seasons / 036

6. Falls PlummetingThree Thousand Feet / 038

7. Study / 040

8. Mountain Dwelling / 042

9. Pine Cliff Excursion / 043

10. Red Dusk / 044

11. Visiting a Friend / 046

12. Snow Moon / 047

13. Wild Geese Landing on the Sandy Shore / 048

14. A Man Returns Home in a Blizzard / 050

15. Pagoda in a Mountain Forest / 051

16. Mountain Stream Expecting the Arrival
 of a Boat / 052

17. Snow Moon in the Freezing Woods / 054

18. Winter / 055

19. Fisherman and Landscape / 056

20. Heavy Snow in a Thick Forest / 057

21. Landscapes in Four Seasons / 058

22. Outside a Stockade / 068

23. Visiting a Friend in the Snowy Mountains / 070

24. Rider in the Desert / 072

25. Lingering Snow / 073

26. Visiting a Friend in the Autumn Mountain / 074

27. Painted Poems / 076

28. Rain and Wind / 078

29. Scroll Painting of the Upper River during
 the Qing Ming Festival / 079

30. Mi Fu Worshipping Stones / 082

31. Ambitions Inspired by Distant Mountains / 084

32. Paradise of Cloudy Mountains / 085

33. Fishing; Woodcutting;Farming; Studying / 086

34. Boating in the Autumn River / 088

35. Visiting a Friend at Yun Mountain / 089

36. Cloudy Mountains before the Rain / 090

37. Wind; Rain; Clouds; Moon / 092

38. Wind; Rain; Clouds; Moon / 096

39. Discussing the Past;Visiting a Friend / 098

40. Farming / 099

41. Spring / 100

42. Summer / 101

43. Grand Landscape / 102

Birds and Flowers

44. Egret Acquainting itself with the Moon / 107

45. Twin Sparrows / 108

46. Kingfisher in the Woods / 110

47. Playful Sparrows in Early Spring / 112

48. Pheasant / 114

49. Snow / 115

50. Wind; Rain; Moon; Snow / 118

51. Playful Crabs in a Lotus Pond / 120

52. Swimming / 122

53. Playful Frogs in a Lotus Pond / 123

54. Playful Insects in a Garden / 124

55. Honor and Good Fortune / 125

56. Resting in an Elegant Study Room / 126

57. Insects in a Meadow / 128

58. Dragonflies in a Meadow / 129

59. Casual Fun / 130

60. Playful Insects / 131

61. Insects and Plants / 132

62. Insects in the Cracks of Stones / 133

63. Summer Lotus / 134

64. Relaxing during a Long Summer / 135

65. Insects among Plants / 136

66. Stillness in Movement / 138

67. Thriving among the Plants / 139

68. Four Gentlemen / 140

69. Playful Shrimps / 141

70. Plum Flower, Orchid, Bamboo,
 Chrysanthemum / 142

71. Insects Thriving among Plants / 144

72. Insects and Plants / 154

73. Pheasant / 155

People

74. Hidden Fisherman in a Clear Stream / 157

75. Resting in the Bamboo Forest / 160

76. Seven Solons in a Bamboo Forest / 161

77. Old Man / 164

78. Lady in Heavy Shadows / 166

79. Fair Lady under the Moonlight / 167

80. Wu Song Beating a Tiger / 168

81. Gazing at Chrysanthemums / 170

82. Lady / 171

83. Love Carried on a Breeze / 172

84. Loving Geese / 173

85. Old Man Taming a Tiger / 174

86. Rider Dressed in Red / 176

87. Boy and Crane; Old Man Riding an Ox / 177

88. Mu Lan Joins the Military / 178

89. Mu Lan Sewing a Leather Jacket / 180

90. Loving Life / 181

91. Happiness All Around / 182

92. Story of the West / 183

93. Journey to the West / 184

94. Zhang Ban Slope / 188

95. Meeting in an Old Town / 189

96. Wu Song / 190

Animals

97. Mindless over Mischievous / 193

98. Cat / 196

99. Two Horses / 197

100. Two Horses / 198

101. Flying Dragon Pursuing a Ball of Flame / 200

102. Squirrels / 202

103. Two Squirrels / 203

105. Mountain Cat / 204

104. Majestic / 205

106. King of the Forest / 206

107. Two Tigers in a Freezing Forest/ 207

108. Two Tigers at the Snow Covered Border / 208

109. Elephants Trumpeting in a Pine Forest / 209

110. Winter / 210

111. A Dog Playing with a Butterfly / 212

112. Companion / 214

113. Image of a Dog / 215

114. Playful Lifestyle of the Monkey / 216

115. Zodiac Animals Series / 218

116. Zodiac Animals Series / 226

Imitation of Ancient Master Pieces

117. Colored Butterfly / 235

118. Riding a Donkey in the Snow / 236

119. Long Life / 237

120. Chickens in the Wind / 238

121. Grasshopper among the Plants

on a Mountain Stone / 240

122. Goldfish; Shepherds Boy / 241

123. Imitation of Jing Shan's Landscape Painting / 242

124. Landscape, Plants and Insects / 244

125. Young Shepherd Riding a Cow / 245

126. Longevity / 246

127. A Symbol of Peace / 247

128. Goldfish and Eagle / 248

129. Five Fish / 249

130. Dog / 250

Custom Made

131. Ma Shou-Hua Portrait / 253

132. Fireworks in Winter / 254

133. Ma Raypu's Portrait / 255

134. Ma Rayjing's Portrait / 256

135. Ma Raychi's Portrait / 258

136. Mandarin Ducks / 259

137. Pine Tree, Bamboo and Rock / 260

138. Spring / 262

139. Foreign Scenery / 263

后 记

马毓鸿

在准备出图册的过程中，作品经放大后，更进一步了解到索振海作画的过程，非透过描红填色成图，皆为纯熟笔法，下笔准确，不容后悔。但是许多作品，追随其数十年的学生仍无法临摹，可知天分才是最大的本钱。

由于收录的许多孤品和题材涉猎之广，证实了作者敢于尝试各种新题材，及作品一次即成功的把握和才气。举如同是人物题材，他也无畏于尝试不同的艺术表现方式，充分展现其艺术才华。

索振海毕生致力于艺术创作，多才多艺，虽在国画、剪纸、金石、漫画、版画和珐琅彩亦成积斐然，但作品留存不多，精品亦不知去向，此书仅能胪列一二，供读者参考。

另本书中鼻烟壶的尺寸均为壶本身高度，亦不含瓶盖；图题均以内画鼻烟壶的内容命名。

此图册能付印成梓，实得多方相助，十分感谢故宫博物院副院长、紫禁城出版社社长王亚民大力襄助，魏殿松主任自始对此即尽心协调，鼻烟壶专家张荣主任为文内画鼻烟壶沿革，摄影刘志岗先生精心照相，责任编辑徐小燕女士粗细靡遗。对于内画鼻烟壶王习三大师真情流露的感言和书名题写，著名美术史学家和国画专家薄松年教授的作品赏析及指正，清末内画大师叶仲三孙女叶澍英女士的历史见证，深感荣幸和谢意。值得一提的是，索振海妻付彦珍女士对此图册的支持和帮助，如泉涌不辍，不但对所有作品一一鉴定，更提供了不可多得的宝贵资料和内情。吾女瑞琦及长子瑞璞在中英文编译中亦多有贡献。今日有幸完成此书，实得诸天时地利人和。

于鸿远阁 2011 年 6 月 6 日

Postscript

Mike Y. H. Ma

While preparing for the publication of this book, many of Suo Zhenhai's inner paintings were enlarged, allowing for closer observation; because of this, I had the chance to better understand Suo Zhenhai's painting process. His paintings are not merely composed of outlines and color-fillings to put the pictures together. Each is completed with skilled brushworks and precise touches that leave no room for mistakes. Many of his works cannot be imitated by the students who have studied the craft from him for several decades. We understand that the real bottleneck is the innate talent.

This book includes many exclusive pieces and works depicting a wide variety of subjects. The artist was willing to try many new methods of artistic expression and possessed the confidence and ability to produce a successful piece each time he experimented with a different approach. For instance, when the subjects of his paintings were human characters—he was not afraid to employ both abstract and realistic painting styles to fully demonstrate the range of his artistic gift.

Suo Zhenhai dedicated his entire life to creating art and was also skilled at traditional Chinese painting, paper cutting, seal carving, comic drawing, block printing and enamel painting; unfortunately, these works were not well preserved and only a few pieces are left; the most exquisite works are all gone. There are just one or two pieces illustrated in this book for the readers' reference. The heights of the snuff bottles mentioned in the book do not include the stoppers. The title of the snuff bottles reflect the contents of the inside paintings. The materials from which the bottles are made are not mentioned in the title of each piece.

The publication of this book was made possible by the hard work and assistance of many. I am very grateful that the Palace Museum's Vice President also President of the Forbidden City Publishing House, Wang Yamin, has been highly supportive of the publication. I would also like to recognize Director Wei Diansong, who has assisted tremendously in coordinating parts of the project from the very beginning. Furthermore, I would like to extend my gratitude to the internationally well-known snuff bottle expert and Palace Museum Director, Zhang Rong, for writing an article on the history of inside-painted snuff bottles; Editor Xu Xiaoyan, who took care of the small details of the preparation process; Photographer Liu Zhigang who did a wonderful job taking professional photographs It was an honor to have the Inner Painting Master Wang Xisan write the title of this book as shown on the front cover; furthermore, I am thankful for the time and energy he spent writing the moving essay about Suo Zhenhai. This publication would not be complete without the artworks appreciation article and the valuable comments made by the famous art historian and Chinese painting expert Professor Bo Songnian, as well as the historical testimony by the late Qing Dynasty Inner Painting Master Ye Zhongsan's grand daughter Ye Shuying. It is also worth mentioning that Suo Zhenhai's wife, Fu Yanzhen, has offered tremendous support and assistance for the publication of this book; she diligently authenticated the bottles, one by one, and provided invaluable data and insider information. My daughter Raychi and elder son Raypu also contributed their efforts in the English and Chinese editing process. Today, the fact that we are fortunate enough to be able to publish this book is due only to the right combination of timing, location and people.

Hong Yuan Villa June 6, 2011